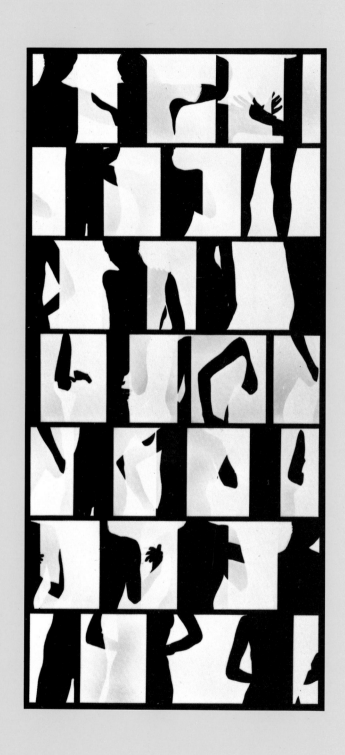

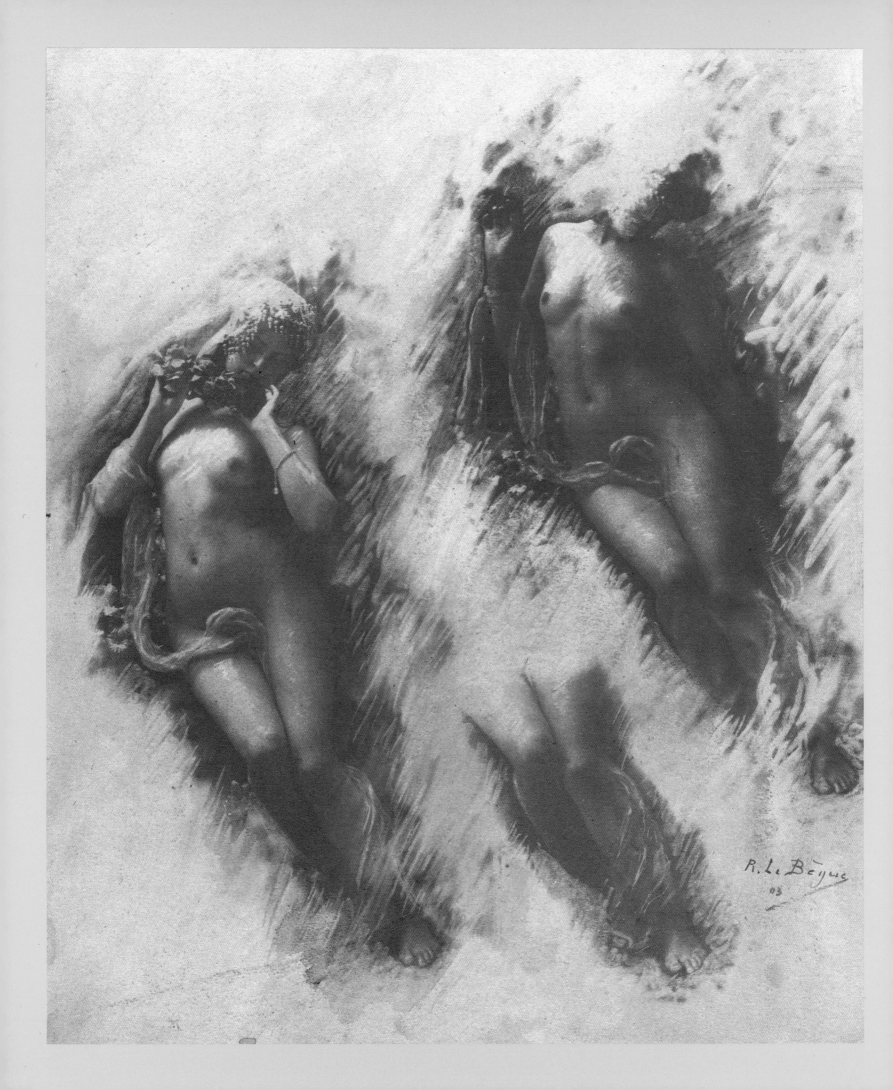

THE LIBRARY OF WORLD PHOTOGRAPHY

PHOTOGRAPHY AS FINE ART

Introduction by

Douglas Davis

Hill & Company, Publishers · Boston

The editors and publisher express their sincere thanks to the photographers, collectors, and museums who have made this selection of pictures possible. The photographs in the book follow a general chronological order decade by decade, but for technical as well as artistic reasons, certain departures have been made. Biographical notes on the photographers are included at the end of the book, as well as a glossary of photographic-process terminology.

On page 1: Ray K. Metzker
Nude Composite/Gelatin silver print from multiple negatives, 1966-1982

On page 2: René Le Bègue
Study in Orange/Gum bichromate print, 1903

On page 5: Thomas Eakins
Female Nude from the Back/Platinum print, ca. 1880

On page 6: Frederick H. Evans
Aubrey Beardsley/Photogravure, 1894

On page 21: Arnold Genthe
Anna Duncan/Toned gelatin silver print, ca. 1915

Series conceived and originated by Shueisha, Tokyo
Published by Shueisha under the title 'The Gallery of World Photography'
Project director: Hiroyuki Yamagata. Project consultant: Koen Shigemori

Editor-in-chief: Bryan Holme. Consultant: Weston Naef
Director of photographic research: Joan Morgan. Designer: Robert Scudellari

First published in the United States of America in 1987 by Hill & Company, Publishers · Boston

Copyright © 1982, 1983 by Shueisha Publishing Co. Ltd, Tokyo

Library of Congress Cataloging-in-Publication Data

Fain āto. English.
 Photography as fine art.

 (The Library of world photography)
 Translation of: Fain āto.
 Reprint. Originally published in English: New York:
Dutton, 1983. (The Gallery of world photography; v.1).
 1. Photography, Artistic. I. Holme, Bryan,
1913– . II. Title. III. Series: Sekai shashin
zenshū. English (Boston, Mass.)
TR650.F2513 1987 779'.092'2 86-33557
ISBN 0-940595-01-X (pbk.)

Printed and bound in Japan

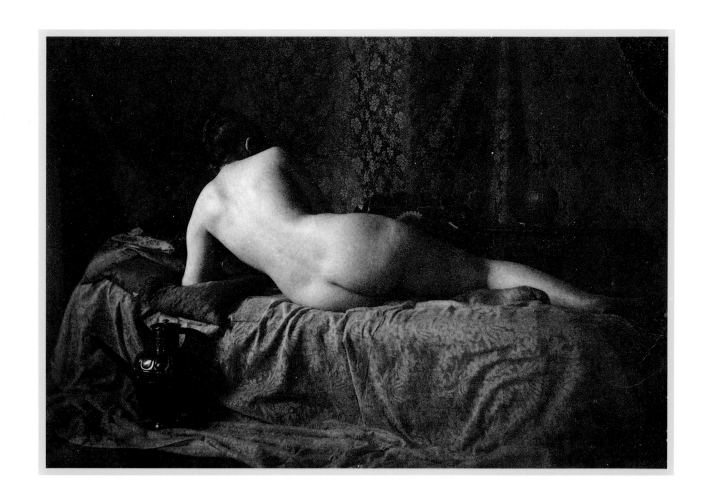

CONTENTS

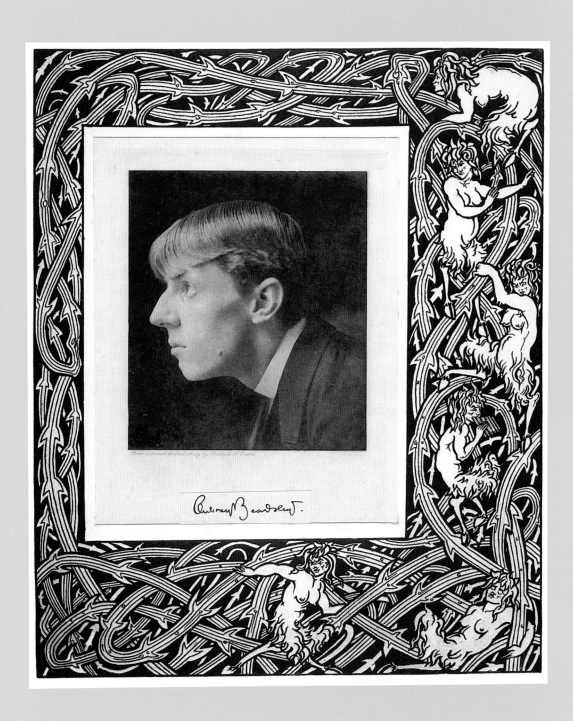

From a private portrait study by Frederick H. Evans.

Aubrey Beardsley.

Introduction by Douglas Davis

Yes, photography is widely, universally beloved, in all countries. Yes, the camera is the simplest of tools, comparable — in its ease of execution — to the pencil. Yes, the photograph is as direct in its appeal as a sunset, or a young mother. But beneath this charming façade, photography is a medium that swarms with contradictions, ambiguities, and provocations, rather like Janus, the two-faced Roman god who ruled because he could look forward and backward at once. Photography has both repelled and attracted the finest minds in the arts. In 1859, the French poet Charles Baudelaire raged in print when he saw photographs displayed in the Grand Salon of Paris, where painting once reigned, supreme: "In these deplorable times, a new industry has developed," he announced in the *Revue Française,* "which has helped in no small way to confirm fools in their faith, and to ruin what vestige of the divine might still have remained in the French mind." He mimicked the wide-eyed claims of the new medium's defenders: "Since photography provides us with every desirable guarantee of exactitude (they believe that, poor madmen!), 'art is photography.' From that moment onwards, our loathsome society rushed, like Narcissus, to contemplate its trivial image on the metallic plate."

Nothing provoked Baudelaire or his allies more than the notion that the painter and the photographer were equals — that both of them practiced, in brief, a fine, high art. On this ground, he was not and is not alone. Though he fired the first salvo in the innocent morning after photography's birth (at the hands of his fellow countryman, Nicéphore Niépce in 1827), he touched off a controversy that is still raging. Even now, at high noon on the following day, when photography is not only widely practiced (six billion prints per year in the United States alone) but widely admired, collected and exhibited, the dispute goes on. It is one thing to draw quickly and easily with a pencil — so the argument goes — quite another to press the button that opens the camera lens. The hand on the pencil maintains human control of its line from start to finish while the hand on the button simply activates a mechanism. At the close of his attack, Baudelaire conceded photography only one legitimate function; recording what might otherwise be lost to the human eye or memory: microscopic insects, astronomical objects, crumbling ruins, engravings and manuscripts. If you will only lie down and behave, dear photography, he pleaded. If you will act as "humble handmaiden" of the arts and sciences — akin to printing and shorthand — you will deserve our "thanks and applause."

Now of course, photography has refused to do anything of the kind. Far from keeping to its humble place, merely recording for the archives of art and science, photography has literally reshaped and reinvented the world. Fifty years after Baudelaire wrote, the entire 38th regiment of the Indian Army lined up on the steps of the Great Pyramid in Egypt to pose for one of the largest group photographs in history. In the poet's own day, subjects anxious to see themselves photographed would carefully compose their faces, bodies, and dress, then sit for endless hours in a studio, suffering interminable exposures and hot, searing lights. The photographic portrait became a double agent, as much the invention of the subject as of the photographer. Already the world was beginning to think of itself primarily as a *reproduction* on flat, glossy paper. Baudelaire may have been bothered by this phenomenon in the 1859 Salon, when he undoubtedly saw both the direct, incisive portraits of Nadar and the smooth, sugared concoctions of Antoine-Samuel Adam-Salomon, in which models posed like draped and radiant manikins before the camera.

Today the photographic portrait is so quick, so common that most of us are prepared at any moment to present our rehearsed faces to the lens, conditioned in turn by having seen thousands of previous portraits (Baudelaire himself stared mordantly, self-consciously into the camera for Étienne Carjat in 1863). Politicians, actors, and actresses devote themselves constantly to the perfection of their photographic appearance. Resorts throughout the world proclaim their beauty

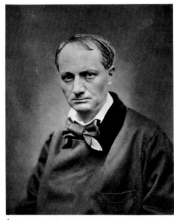

ÉTIENNE CARJAT / *Charles Baudelaire, 1863*

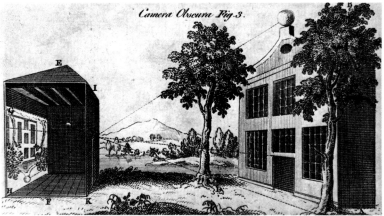

ANONYMOUS / *Camera Obscura showing upside-down image of a house*

in photographs reproduced in countless magazines and newspapers. Often, indeed, we are shown hordes of tourists trooping through these pictures with cameras aloft, as if to assure us that nature is waiting here to pose for us, too. And when the American astronauts landed on the moon in 1968, they immediately photographed the Earth, hanging behind them in the sky, the reverse of Ansel Adams's classic rendition of the moon as seen from New Mexico — perhaps the most famous photograph ever made, until the astronauts hoisted their camera.

No, photography is not content to act either as handmaiden or as a branch of industry, renouncing all claims to inspiration, intuition, or imagination. Let Baudelaire and his followers denounce the pretensions of photography. An ever-growing band of articulate champions has risen to defend them, ranging in depth and articulation from the formidable American, Alfred Stieglitz, and the impassioned German, Walter Benjamin, to the foppish, spellbound Frenchman, Alphonse de Lamartine, who threw all reservations to the wind when he gazed upon one of Adam-Salomon's immaculate, pretentious portraits: "I can no longer maintain that photography is a trade; it is an art; it is better than an art; it is a solar phenomenon in which the artist collaborates with the sun!"

What all the participants in this controversy forgot — and continue to forget — is this: in its origins, photography was linked as closely to art as industry, or science. The ancestor of the modern camera was the camera obscura (literally, "dark room"), which dates from the distant preindustrial past. The principle behind the camera obscura — that light passing through a small aperture in one wall of a dark room projects an image on the opposite wall — was known to Aristotle, to the ancient Chinese, to the Arabian scholar Alhazen, and to Leonardo da Vinci, who recommended placing a paper under the image ("You will see all those objects [outside] in their natural shapes and colors!"). Early written accounts of the camera obscura always stressed its use as an aid in drawing perfect renditions of nature. Here is Daniel Barbaro, a professor at the University of Padua, in 1568:

> Close all the shutters and doors until no light enters the camera except through the lens, and opposite hold a sheet of paper, which you move backward and forward until the scene appears in the sharpest detail. There on the paper you will see the whole view as it really is, with its distances, its colors and shadows and motion, the clouds, the water twinkling, the birds flying. By holding the paper steady you can trace the whole perspective with a pen, shade it and delicately color it from nature.

But the camera obscura did not gain popular acceptance until the eighteenth century, when it was reduced to a "portable" size easily carried out of doors by eager draftsmen. There natural vistas could be sighted in the lens and reflected by a mounted mirror inside the box onto a ground-glass screen at the top, where the artist could trace the reflected image.

It is no accident that the rise of the portable camera obscura in the West coincided almost exactly with the rise of realism in painting. The nineteenth century was not only the

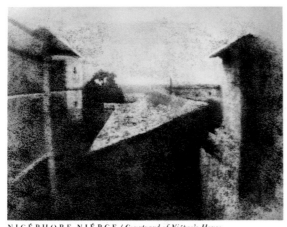

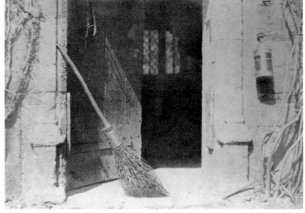

NICÉPHORE NIÉPCE / *Courtyard of Niépce's House* WILLIAM HENRY FOX TALBOT / *The Open Door*

century of photography's birth, it was also the century of Jean-Baptiste Camille Corot and Gustave Courbet. They preceded and influenced the rise of Impressionism, which turned from the exact reproduction of what the eye recollected — Courbet and Corot's preoccupation — to focus on the exact instant or sight, the "chance" impression of the world outside, marked and stained with the instantaneous contingencies captured so easily by the camera: the lock of hair ruffled by the wind, the rumpled shirt of an old farmer, the blurred streak of a racing carriage. Certainly Baudelaire sensed this enormous change coming in the salons of the 1850s. He railed in his infamous review not only at photography but at paintings that maintained an unimaginative fidelity to nature, unlike the fiery neoclassic idealism of Ingres and Delacroix, whom he adored. It is now acknowledged that the first truly successful attempt to "preserve" the image transmitted through the aperture of the camera obscura was Nicéphore Niépce's, in Chalon-sur-Saône, France in 1826–7. Yet Niépce was a gentleman inventor, driven not by the desire to industrialize the world but simply by the urge to record nature more perfectly with the camera than he could with his hand (he was an enthusiastic, awkward draftsman). The result: a hazy, panoramic view of his own garden, in which all shadows are missing, since the sun is seen shining on both sides of the yard — thanks to the seemingly interminable eight-hour exposure required by his invention.

 Neither is it an accident that William Henry Fox Talbot, who discovered the first truly "modern" photographic process (he employed a negative, thus allowing for infinite reproduction of the image), called his invention "photogenic drawing." A landed, leisured English gentleman, Fox Talbot did not rush to publicize or patent his early (1834) experiments in "fixing" the camera obscura image on sheets of writing paper with silver nitrate. It was only when Louis Daguerre later dramatically demonstrated his own new process in Paris — which produced pencil-sharp renditions of buildings and people on tiny copper plates — that Fox Talbot was moved to announce his discovery and display his early images. Even when he greatly improved this process with his sharper, clearer "calotypes," Fox Talbot continued to speak of his "Sun Pictures" as artistic collaborations with nature. In his theoretical writings, he constantly compares and contrasts his work with that of the painter and sculptor, not the scientist: "[The camera] chronicles whatever it sees," he wrote, emphasizing the very quality that most disturbed Baudelaire, "and certainly would delineate a chamber pot or a chimney-sweeper with the same impartiality as it would the Apollo of Belvedere." When he published the first book illustrated with photographs in 1844, he called it *The Pencil of Nature.* It is filled with portraits, still lifes, and landscapes derived almost entirely from painterly conventions. But it introduces glimpses of a new, contingent realism as well, most memorably in "The Open Door" in which we see a humble broom leaning in lonely splendor against a garden door in the midday sun. Fox Talbot delighted in the immediacy of these casual, non-Apollonian images: "But a single shutter standing open projects far enough," he exclaimed, "to catch a gleam of sunshine!"

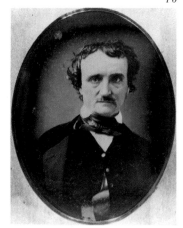 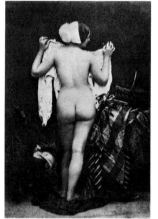

ANONYMOUS (AMERICAN) / *Edgar Allan Poe* JULIEN VALLOU DE VILLENEUVE / *Female Nude*

These are hardly the sentiments of a tough-minded industrialist. For all his flair and public-relations genius, Louis Daguerre was also an artist by instinct and training. A painter and stage designer, he created huge dioramas displayed in the theaters under a barrage of carefully manipulated lights. He knew nothing about physics or chemistry, but he sensed the extraordinary potential of the camera obscura. When he learned how to "fix" images on tiny metallic plates with iodine fumes, he did more than simply perfect the hazy images produced by Niépce. He set Paris afire. His hyper-real images, burned into gleaming plates, were nothing less than perfect, timeless mirrors. They were widely proclaimed a "miracle." Though Baudelaire was infuriated by the triviality of the images trapped there, Edgar Allan Poe in America claimed that they disclosed "a more absolute truth than the work of ordinary art." A newspaper in Leipzig, Germany, testified to their power when it railed against the daguerreotype, calling it a "blasphemy" and asked: "Could God have allowed . . . a Frenchman to give the world a devil?"

Unlike the internal combustion engine or nuclear power, photography is thus a cultural phenomenon in its origins, sired by gentlemen artists who were clearly inspired by many of the same goals that attracted painters throughout the middle and late Renaissance. It is fundamental to the understanding of photography to grasp this distinction. The technological and industrial applications of the medium followed its birth by at least half a century, from the moment in 1888 when Eastman Kodak introduced a cheap Everyman's camera and proclaimed, "You push the button, we do the rest." Until very recently, historians have largely ignored this fact. They have perpetuated the fallacy endorsed by Baudelaire — that the medium is primarily "objective" and scientific in its nature. This assumption is fatally mistaken. It leads us to expect from photography an impersonal rectitude that it does not possess. Worse, it fails to prepare us for the open-ended, highly personal, and innately unpredictable aesthetic paths that photographer-artists have pursued with such eclectic zeal since the medium's birth. Louis Arago, director of the Paris Observatory, who persuaded the French parliament to buy Daguerre's invention and offer it to the world, knew better. In his speech to the deputies on January 7, 1839, he noted prophetically, "When inventors of a new instrument apply it to the observation of nature, the hopes that they place upon it are always insignificant when compared with the number of subsequent discoveries of which the instrument was the origin."

It is one of the ironies of history — and aesthetics — that Arago's prophecy was proven when the paper positive-negative print replaced the daguerreotype. For almost a decade after Daguerre's triumph, the term *daguerreotype* was used to define the new medium in all its guises. In the early 1850s, however, the rise in prestige of the paper positive-negative print, thanks to vast improvements in the method pioneered by Fox Talbot, dictated the appearance of a broader, more inclusive term, *Photography*. The new prints, washed in pure water, toned with gold salts, and dried to a silken finish, were sensuous both to the eye and the hand. They were richer in tone than any-

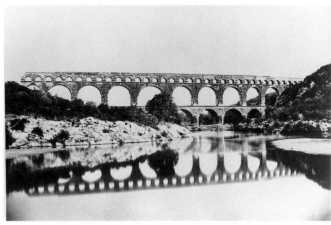 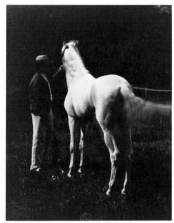

ÉDOUARD DENIS BALDUS / *Pont du Gard* C. FAMIN / *Horse*

thing that preceded them, juxtaposing dark against light, tinted here and there with purple grays, violet browns, and silvers. Best of all, they did not fade quickly away but retained their brilliance for years. In an era when photographs were seen more readily in the original state than in mass-media reproductions, the galleries and shops were filled with these luscious concoctions. Of course the critical press in every country was filled with debates about the pretensions of the new medium to "art": the threat, at last, seemed credible. It was the advent of the paper print that intimidated Baudelaire (he later admitted to Nadar that he was attacking the medium in general, not the Salon exhibition) and led Walter Benjamin to rhapsodize — almost one hundred years later — about the "preindustrial" glories of photography.

Between 1850 and 1880 first-class laboratories appeared in France, willing to print from negatives for a fee. Simpler, smaller cameras were also available. They allowed easy access to the street and to the countryside for the first time, freeing photography from the studio where the old daguerreotype had been confined. It was a time, in brief, when the medium was open to painters and poets as well as to brilliant inventors. Courbet, Ingres, Delacroix, Millet all became involved now with photography, either as practitioners, occasional users (Courbet and Ingres sometimes painted from the photograph), or as theoreticians. Around them, many younger artists deserted to the new medium completely, as did journalists, teachers, and historians.

In the hands of this complicated melange of talents, photography began to charge off in several directions at once. Gustave Le Gray, a young painter who had studied under the tempestuous Paul Delaroche (famed for declaring, upon seeing his first daguerreotype, "From this day on, painting is dead"), began to compose exquisite studies of seascapes and landscapes, matching together two negatives, one focused on the land, the other on the sky, achieving a richly textured effect. Vallou de Villeneuve, painter and lithographer, photographed nudes with the same freedom and authority commanded by Ingres, but with a decidedly different tone: like Fox Talbot, he delighted in the unstudied, unprepared nuance — a nude cradling a humble water jug, another caught from the back in the act of dressing, standing on a sprawled, ungainly robe.

Édouard Denis Baldus, yet another painter, specialized in recording grand architectural vistas, but never simply in the service of perfect realism, that most illusive of illusions. When he photographed the famous bridge of the Pont du Gard, Baldus clearly knew that he was creating a trompe l'oeil vision superseding reality: here we find the black-white mirror image below the bridge as compelling as the bridge itself — an effect enhanced by the flattening of the image on the two-dimensional print surface itself. Baldus's lust for the photographic truth — as opposed to the "real" truth — is even clearer in an extraordinary picture made at the Palais Royal in Paris in 1860. Mounted on a rooftop nearby, his camera "records" four restless carriages charging across an open square, followed closely by four ghostly partners — blurs caught in the lens by film moving a step behind the charging action of the horses.

Powerful images like this hover between pure painting and pure photography, suspended in an enchanting realm that cannot be encapsulated by words or logic. Yet another triumphant example of this surreal genre, beyond the power of any of photography's early prophets to predict, is the fantastic "horse" captured by the little-known artist C. Famin in 1874. The radiant white animal and his master stand bathed in a dark-brown albumen sea, as abstract as any painterly effect. But the sense of abstraction is richly counterposed by the faintest blur of the moving horse's tail, testifying to the presence of time in the making of the image — that is, the horse is authentic, as real as it is surreal.

Difficult as they are to define, these are the moments when photography begins to describe its own unique boundaries. These pictures take their stand far from the territory occupied by painting, with which photography is constantly — and erroneously — compared. Virtually the first theorist to chance upon this ingenious truth was Lady Elizabeth Eastlake in England. Wife of the director of the National Gallery of Art in London, she wrote an exceptional review for a British periodical in 1854, in which she discoursed with wit and perception upon both the history of photography and some of its surprising strengths:

> *Photography is a new form of communication between man and man — neither letter, message, nor picture. . . . Far from holding up the mirror to nature, which is an assertion usually as triumphant as it is erroneous, it holds up that which, however beautiful, ingenious, and valuable in powers of reflection, is yet subject to certain distortions and deficiencies for which there is no remedy. The science therefore which has developed the resources of photography, has but more glaringly betrayed its defects. For the more perfect you render an imperfect machine the more must its imperfections come to light: it is superfluous therefore to ask whether Art has been benefited, where Nature, its only source and model, has been but more accurately falsified.*

Photography dissembles, in fine, like all the arts. Though it appears to present us the truth, in fact, it lies, sometimes subtly, sometimes overtly. Which is not to say that photography has no link to the real, perceived world. It does. Sourced in what the lens perceives at the moment it records, this link is the source of the medium's public power. But it is only one segment of the entire experience that we can begin to call *photographic*.

Lady Eastlake's finely tuned thesis was converted into a discordant symphony by the "Pictorialist" photographers in her native country. Perhaps the first and boldest of these was Oscar Gustave Rejlander, a Swedish painter who defected to photography in London, after barely an afternoon's training. He was determined to prove that the camera could be as imaginative as the paintbrush if it gave up its shortsighted preoccupation with simply reproducing nature. Rejlander conceived and executed an immense allegorical composition, "The Two Ways of Life," in which twenty-five models played roles ranging from "Religion" and "Charity" to "Gambling" and "Wine." Rejlander posed the models in small groups, taking many pictures. Later he masked the negatives together to produce one large print, nearly three feet long. It delighted Queen Victoria, who purchased it in 1857. But for all his boldness, Rejlander didn't impress his colleagues quite so permanently as Henry Peach Robinson, who employed some of the same photomontage techniques but relied upon more concise and powerful themes — the last moments of a dying girl surrounded by her family, the anguish of a tight-lipped farmhand as his lady fair passes by ("He Never Told His Love," as the title tells us). More than the steady, unremitting stream of Robinson's pictures, his

verbal rhetoric won the day. In his immensely influential book, *Pictorial Effect in Photography*, published in 1869, he sounded like Lady Eastlake on a holiday:

> *Any dodge, trick, any configuration of any kind is open to the photographer's use. . . . It is his imperative duty to avoid the mean, the bare, and the ugly, and to aim to . . . correct the unpicturesque. . . . A great deal can be done and very beautiful pictures made, by a mixture of the real and the artificial. . . .*

But it was not merely the force of Robinson's words that converted his generation. He wrote and worked in a time when the prevailing tone in all the arts was intensely romantic. Further, this was the moment when photographers were desperately trying to persuade the public that they practiced a trade as noble as any painting, and when they began to retouch their negatives (erasing "mean" blemishes on faces or in sunsets) and profusely tint their prints, particularly their portraits. Gone were the days when photography in England was dominated by the rough-textured calotypes of David Hill and Robert Adamson, in which every wrinkle and grimace on their subject's faces was fearlessly recorded in the honest sunshine of the out-of-doors. No, in the Pictorialist era the photographer hired a model to play "Don Quixote" (as in Lake Price's 1857 albumen study) or applied watercolor to Lady Filmer's drawing room (dashed on the print by Lady Filmer herself). In that these techniques reminded both the public and the critics of lordly painting, they were successful, first in England then throughout the Western world. "Photographers do not copy nature any more," proclaimed a Polish critic, "they interpret it. They reject superfluous details, introduce generalization. They return to the humble Canossa of aesthetics."

But the Pictorialists were propping photography up on a trick-bottomed stage, preparing it for a fall. They became, finally, more academic than Delacroix, Ingres, or any of the neoclassic painters soon to be routed by the *plein-air* Impressionists and Postimpressionists, who took painting out of the confines of the studio into the streets and the countryside. Seen from a century's distance, Robinson and Rejlander appear less photographic, less faithful to the evidential nature of the lens (which always records exactly what is seen at the instant that it sees), than Monet and Manet, who scrupulously recorded retinal experience. Painting temporarily changed places with photography, in other words, to the benefit of the former. The Pictorialists gave up what critic Max Kozloff calls the medium's "territory" — its base in reality, in "the flow of events." In its lust for painterly respectability, photography betrayed itself, save for two stunning exceptions, both of which provide object lessons in the meaning of the medium.

The first exception was Julia Margaret Cameron, an eccentric Victorian lady who ranks today as one of the great pioneering photographers in her century. That she has achieved this stature in the face of her technical clumsiness is yet another important lesson. Obsessed with portraying the "inner man," as she put it, Cameron ignored all the accepted methods of her time in focusing, exposure, lighting, and finishing. She did everything the hard way, holding her subjects in front of the lens for up to twenty minutes at a time and using extra-large plates that were difficult to develop and perfect. Sitting before her lens was a physical ordeal. Often it was the face alone that she wanted, or the eye, or the cheekbone. To get these points of emphasis, she darkened the room and shoved her lens virtually down the throat of the subject (a technique later used by the innovative Polish artist Stanislaw Witkiewicz when he created a monumental series of self-portraits by pressing his face flat against the lens). Cameron forced her subjects to sit there, immobile, until she was

satisfied. Here we find no painterly intelligence at work, lusting after smooth, idealized images. When the plate turned up blemished, or the negative cracked, she would produce prints anyway and send them off for exhibitions. Of course she was called "amateurish" by the Pictorialists. They disliked intensely the harsh clarity of her portraits—Tennyson's vaulting brow, Sir John Herschel's aged, white locks, the gleaming eyes of Alice Liddell (who posed for Lewis Carroll's camera as a little girl—and for his pen in *Alice in Wonderland*). But these images have survived their critics.

By implication, Cameron's photographs take their stand in behalf of her medium's indigenous (if protean) strengths. P.H. Emerson left very little unsaid in his defense of "pure," no-nonsense photography. He assailed the Pictorialists in lectures and books as well as images. He derided Robinson's work as "the quintessence of literary fallacies and art anachronisms." In his book, *Naturalistic Photography* (1889), he advocated a rigorous set of principles: (1) photography is an "independent" medium, with no need to borrow from or imitate others; (2) individual vision can be expressed with the camera, unaided; (3) emotional content lies in the untouched image alone; (4) no handwork or "combined" negatives are allowed; (5) composition has nothing to do with formulas or mystical theories. Emerson's photographs of peasant life in East Anglia exemplified his ideas, despite his preference for soft-focus texture (to keep all the planes of vision equal in clarity) and delicate, gray-toned platinum printing. Compared to Rejlander and Robinson, Emerson is refreshingly simple, even candid, concentrating on the most casual, spontaneous facets of his subjects' lives—gathering water lilies on the pond, stitching sails in a loft, harvesting reeds in the field.

At first, Emerson believed that he had discovered the "scientific" approach to photography, devoid of romantic or literary clutter. In time he deserted these beliefs, but his colleagues did not. If Emerson and Robinson stand at the two extreme theoretical poles in photography, there is no doubt that Emerson's position attracted the most adherents at the end of the nineteenth century. The images that excited the most attention in that era of unprecedented exploration were direct, almost reportorial. What led Francis Frith to praise the ability of his chosen medium to reproduce "every tone, every little perfection or dilapidation, the most minute detail" was doubtless the drama of the exotic Holy Land sights he photographed and brought back to Britain, where they were seen—literally—for the first time. The photograph-as-discovery was even more rampant in the United States, where an immense western frontier was opened to settlement in the 1850s and 1860s. The new mammoth-plate cameras allowed extraordinary artists like Carleton Watkins, Timothy O'Sullivan, William Henry Jackson, and Eadweard Muybridge to produce large prints crammed with overpowering detail, down to the leaves on distant trees sighted across immense ravines, and tiny linear networks etched into the faces of ancient New Mexico canyons.

Here in these pictures, painting seems at once matched and eclipsed: matched in grandeur, eclipsed in the actuality of fact. Muybridge's heroic experiments in photographing motion in 1872, conducted not long after his picture-taking tour of Yosemite Valley in California, is yet another *apparent* proof that photography thrived best when it dealt its own hand. Muybridge lined up rows of cameras (from 12 to 24), then snapped the shutter on each in order, as his subjects— which ranged from horses to troupes of leaping females—passed by the staggered lenses.

Even Walter Benjamin later complimented photography because it alone could record the instant when "a man *starts* to walk," as opposed to the completed action itself, which is

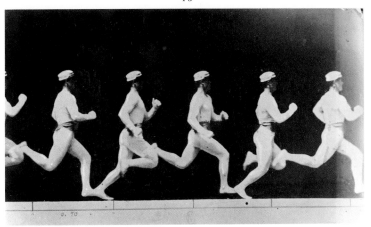

ÉTIENNE-JULES MAREY / *Successive Phases of the Motion of a Running Man*

the province of painting. In Muybridge's case, he was able to prove that the horse in flight actually lifts all four legs off the ground, a fact too rapid for the human eye to catch unaided. But there is a parallel lesson in all of these wondrous images. Despite their rigor and honesty, the images brought back from California by Watkins, O'Sullivan, Jackson, and Muybridge are as different, one from the other, as the personalities of the men who made them. Watkins's views of Yosemite are as sober and direct as Muybridge's are moody and romantic. O'Sullivan's landscapes are florid and grand, like Ingres' nudes, while Jackson's records of spouting geysers in full cry are as anecdotal, as literary as Henry Peach Robinson's *He Never Told His Love*. Of course, we are better able to sense today such nuances than were those who saw these pictures when they first appeared, in the years when the drama of their content overwhelmed all other distinctions. It was a moment when the medium was new, its subjects spectacular, and its documentary power expanding beyond all expectations. It is no wonder that the respected *Studio Magazine* in London found a majority of its learned readers responding negatively to the question, "Is the Camera the Friend or Foe of Art?" Over and again in their replies the readers grant that the medium has "scientific value," but that it cannot be related to art, "which is essentially human and emotional," as one correspondent put it. In the nineteenth century, photography was simply too vital, immediate, and explosive for the mind to contain, judge, or control.

Enter Alfred Stieglitz, American artist, theorist, editor, dealer, collector, and formidable propagandist for modern photography—and art. Stieglitz was a second-generation photographer, a man who was born well after the medium had become an accepted fact. He was thus able to accept and analyze photography from a remove not possible among his predecessors. Stieglitz came to Europe to study engineering as a young man, arriving in the midst of the Pictorialist controversy. He bought a small camera by chance in Berlin and began making photographs immediately. P.H. Emerson awarded him a prize for an animated, snapshot-style picture of Italian street children laughing and talking. When he returned to the United States, Stieglitz bought a smaller camera he could hold by hand and deliberately tried to capture the antipictorial appearance of the city in snowstorms, driving rain, and twilight shadows. Most important of all, he founded both a magazine, *Camera Work*, and a gallery, the legendary "291" (its address on Fifth Avenue), which propagated two heresies: that photography was a fine, high art, and that "modern" painting, whether Cubist or Surrealist, was also fine and high. When Stieglitz finally relinquished these pursuits, three decades later, he did so in triumph: by the advent of World War II, his double heresy had become a monolithic truism.

Not that Stieglitz pursued a simple, unremitting thesis about the nature and meaning of his medium. He was no latter-day Emerson, though he clearly preferred the "straight" unstaged image and the simple, silver-gelatin print; he often called *The Steerage*—a chance juxtaposition of moving bodies, forms, faces, captured on a transatlantic steamer—his favorite photo-

graph. But Stieglitz could be decidedly picturesque in his own pictorial language, and in his decisions as an editor and dealer. His *Net Mender* (1894) is as soft in focus and meaning as any of Robinson's fabrications. In the early days he filled *Camera Work* with the painterly prints of Robert Demachy, Gertrude Käsebier, Clarence White, and, most of all, Edward Steichen. In his insistence on immaculate printing — each issue of his magazine contained a hand-tipped gravure portfolio by a single artist (printed, in the early issues, on Japanese tissue) — Stieglitz betrayed the same eagerness to prove the preciosity of the photograph as Rejlander or Robinson. In later years, influenced by the hard, bright tones of modern painting and the high-gloss sharpness of the new silver prints, he displayed a different preference. In 1917, the last two issues of *Camera Work* displayed the prints of Paul Strand, a decided purist. Strand focused in so sharply on his humble, inanimate subjects — tiny matchboxes, front yard fences, the spokes of a motorcycle wheel — that they verged on hard-edged abstraction, completely divorced from the pleasures of surface texture or literary sentiment.

No, Stieglitz understood photography to be a medium that acts primarily in the service of the mind. He saw its final meaning not in the camera itself, in a certain technique or a specific printmaking process but in the intention of the photographer, who can employ any tool or method in the pursuit of his own unique goal. Late in his life, Stieglitz endorsed the prolixity of styles that had developed during his lifetime. "Why shouldn't photography have lots of movements, making war with each other?" he asked. "It's happened in painting all my life." Of course, Stieglitz was profoundly shaped in his views by the art he displayed side by side with photography in his gallery. He was at ease with the conceptual dynamism of the modern movement. He knew Marcel Duchamp, Man Ray, Georgia O'Keeffe (who later became his wife and the subject of countless portraits). Of course, his last, great series of pictures perfectly expressed this position. His *Equivalents* are simple renditions of clouds in the sky. He saw them as metaphors for his "life experience," not as a means of parading his awesome technical skills, which proved less important to him in the end than the content of his photographs.

If Stieglitz began to rescue photography from its obsession with painting, mass-media reproduction finished the task. In the twentieth century the use of photographs to illustrate magazines, newspapers, and books flourished. In this context, it was the visual message carried by the photograph that counted, not the textural quality of the "original" print. For the first time, the public encountered the work of great photographers like Henri Cartier-Bresson, Alfred Eisenstaedt, and Brassaï on the printed page, not on the walls of a gallery or shop. As the presses increased in speed, turning out instantaneous news and photographs overnight, so did the cameras and the film used in them, which could "stop" action in a split second. Cartier-Bresson's resonant phrase, "The Decisive Moment," speaks thematically for the entire epoch, in which the photograph became the prime bearer of news about the world. But it must be kept in mind that the decisive moment requires a *decision*. Behind the instants captured by Cartier-Bresson — the lonely girl racing up a column of stone steps in Siphnos, Greece, for example — there is an eye-mind, initiating the action. In this sense, Cartier-Bresson's pictures are linked to Stieglitz's *Equivalents*. Though they are radically different in appearance, the decisive moment and the "equivalent" are both metaphorical representations of the photographer's entirely subjective instincts.

The compelling photographs of Edward Weston seem to deny this thesis. They are exquisite triumphs of frontal clarity and clean-cut printing. They confront their subjects — shells

lying on the sand, luxuriant cabbage leaves, a gleaming nude basking in the sun — so directly that we are often moved to reach out and touch them, as if the surface of the print were an open window. Weston, in fact, believed that the realism afforded by the camera exceeded the powers of the human eye. He often called it "super realism," overlooking the fact that the camera is limited to monocular vision and to an inflexible depth-of-field (the human eye can focus instantly on several planes of vision at once). But Weston's images and his rhetoric were uniquely powerful. He argued persuasively — in the wake of Emerson — for the reduction of photographic means: visualize the print completely before taking the picture, he said; adjust the lens to the sharpest, clearest focus; contact-print the negative, avoiding cropping or manipulation of any kind. "Photographic beauty," he announced, "is an end to be attained only by photographic means."

Are Weston's shells, his plants, his nude figures real? Super real? Look again. *Realism* implies that we understand what we see in terms of our own lives, that the object perceived in the photograph is an object known — in advance — to us. But Weston's images are often so close to the lens, so divorced from the context of ordinary living, so abstract — in essence — that they have no objective meaning. Often they are illusions, not facts: His shells and flowers appear to be human genitalia, now male, now female; the fissures in canyons look like running water; the limbs of his models take on the solidity of stone. These images are closer to poetic conceits than literal renditions. If photography begins in the world, as Weston so often said, his pictures are hardly as "pure" as the early snapshots of Stieglitz or the hyper-candid photographs made in the 1960s by Lee Friedlander and Garry Winogrand, in which we see cars racing by the lens in a blur, faces bleached beyond recognition by the flash-gun, pedestrian arms cropped off by a lens that can't contain all the figures moving back and forth at a busy intersection. The same can be said of the whole range of carefully manicured images produced by the photographers who followed in Weston's footsteps in the 1930s — Ansel Adams, Imogen Cunningham, Willard van Dyke, and others (they proudly called themselves "Group F/64" to proclaim their adherence to the smallest aperture on the lens, a guarantee of sharp-focused detail). Even the "social realists," even Walker Evans and Dorothea Lange, betrayed the influence of the "F/64" myth. Yes, they reduced and refined their means and methods, as Weston advised. But time and again, in their lust for perfection (which drove them to select, refine, and simplify subject matter), they produced epithets, isolated faces, peeling wallpaper, rusting automobiles, not realism. Pretending to be recorders of the world, they recorded their own visions.

In their ghostly, intangible quality, the "super real" works of Edward Weston are surprisingly close to the inimitable photography of Eugène Atget, darling of the Surrealists in Paris in the Twenties. In his *Short History of Photography*, written in 1931, Walter Benjamin was the first critic properly to hail these strange, lonely pictures. Benjamin saw in their loneliness a Surrealist quality, as though each one of the deserted street corners, vacant park sites, and empty houses had just been visited by a crime. But the Surrealist painters loved most of all the endless reflections and trompe l'oeil illusions they spotted in his store windows and theater lobbies. These are the prints they purchased — saving the aging little-known photographer from starvation — and pinned up on the walls of their studios. The point is that Atget's pictures begin in realism but end in mystification — like Weston's — prompting the involvement, the interpretive powers of the viewer. To put it another way, they provoke continual thought and discussion.

 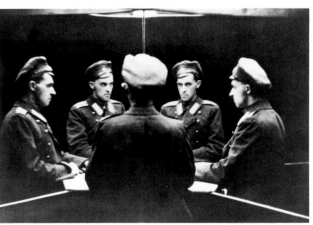 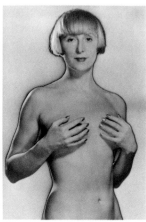

EUGÈNE ATGET / *Boulevard de Strasbourg* STANISLAW WITKIEWICZ / *Multiple Self-Portrait* MAN RAY / *Untitled (Susie Solidor)*

This is precisely why they delighted Man Ray, the first Surrealist to recognize Atget. Along with Marcel Duchamp, Man Ray viewed photography as an extension of all his work in several different media — painting, film, sculpture. As Duchamp had striven to "return painting to the mind," Man Ray tried to rescue photography from the mechanics, even from the camera: by placing objects on chemically treated paper, he was able to expose the area around them under strong light, creating emotive silhouette forms, or what he called "Rayographs" (László Moholy-Nagy invented a similar process at the Bauhaus). He learned to soften the profiled edges of his portraits by immersing them in a sensitive emulsion and exposing — or "solarizing" — them under a strong light. His friend Duchamp produced an eery multiple portrait of himself by using a battery of mirrors in 1917, five years after the Polish artist Waclaw Szpakowski produced five amazing images of himself multiplied in as many mirrors — and three years after the Polish artist and playwright Stanislaw Witkiewicz managed the same feat, dressed in the uniform of the Czar's army (which he had just joined) in St. Petersburg.

In the case of an obsessive, almost hallucinatory photographer like Atget, of flamboyant artists like Man Ray, Duchamp, and Witkiewicz, it is easy to see the indelible hand of the maker. The evidence is still there in Weston and his followers, however disguised by ideology and technique. What is not so easy to detect is the subjectivity of *all* photography. Weston himself was convinced that the average man believes that the photograph is real — no matter how fragmentary, how badly focused, how brutally cropped. Those who agree with Weston find photography more dangerous than pleasing. Because the photograph induces instant credibility — unlike the drawing or painting — it can mislead the unwary eye, leading us to accept a fabricated fiction as an empirical truth. Susan Sontag's devastating attack on the medium, *On Photography*, published in 1974, is based entirely on this premise:

> *The most grandiose result of the photographic enterprise is to give us the sense that we can hold the whole world in our heads — as an anthology of images. . . . To photograph is to appropriate the thing photographed. It means putting oneself into a certain relation to the world that feels like knowledge . . . and therefore, like power. What can be* read *about the world is frankly an interpretation, as are older kinds of flat-surface visual statements, like paintings and drawings. Photographed images do not seem to be statements about the world so much as pieces of it: miniatures of reality that anyone can make or acquire.*

Yet the photograph *is* a statement about the world, as anyone who has made one — and compared it, in his memory, to the total experience of that moment when he released the shutter — can attest. If in the beginning the camera seemed magical, its products exact replicas of the world, this no longer seems so. We are not as credulous as Susan Sontag believes we are. The camera is now as commonplace, as available, as the pencil or the typewriter. It is no longer a remote, privileged object. We know, most of us, that the real world is three-dimensional, perceived through two eyes, not one,

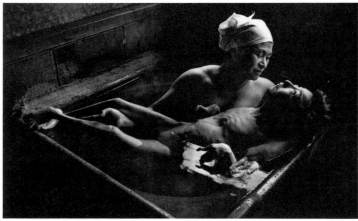

W. EUGENE SMITH / *Tomoko in the Bath.*　　　　　　　　　　　　DIANE KEATON / *The Fontainebleau Hilton*

charged with colors, sounds, movements, a thousand distracting thoughts and events occurring at every moment. No still, flat image on glossy paper — much less a full-color slide — can replicate this reality. If the photograph was accepted as a faithful "window" by the kind of mind Sontag identifies as "modern" — formed by the Industrial Revolution, when new machines and new technology were automatically hailed and welcomed — then the "postmodern" mind, formed in a new era, when software analysis drives the machine, is likely to see the photograph as a "mirror," not a window.

The time is ripe, then, finally to understand photography for what it is: a tool of personal interpretation, like writing or drawing, not of corporate or national acquisition. Not only is photography into its young adulthood now, it is nearing middle age. Its gathering diversity of styles proves that the medium is not limited to any one method or ideology. At the same time, we are witnessing the decline of the photograph as the main source of visual information about the world. Since the end of World War II, television has rapidly replaced the magazines and newspapers as the central conduit of information. Equally rapidly the art museum has opened its halls and walls to the photograph on a scale never before known. The photograph is now an object of intense critical and collecting interest, secured at once by an awareness of its history, its present inclinations, and its unpredictable vanguard future. What Baudelaire feared most has come to pass: though separated by their differences, the painting and the photograph are equal in stature.

Now the "museumization" of photography has many perils, not the least of them being the estrangement of strong documentary work from its immediate source. When a searing Donald McCullin record of battlefront carnage is hung beside a Grecian urn or when a tragic Eugene Smith portrait of a dying child in Minimata, Japan, is placed on a dainty white wall, they lose the immediacy provided by a newspaper page. But certainly the photographer no longer needs to proclaim the seriousness of his enterprise — in the manner of Nadar or Stieglitz — even in the face of continuing attacks. "What's All This About Photography?" asked painter Richard Hennessey, as recently as 1981, in a series of articles and lectures. Yet his argument lacked the outraged innocence that distinguished Baudelaire, who wrote at a time when there was precious little evidence to survey. Hennessey even resorts to counting the bristles of hairs on a paintbrush (there are "hundreds," of course) to prove the subjectivity of the painter's touch, as opposed to the photographer's distant hand on the button.

But subjectivity is not simply a matter of touch, of applying paint to canvas or watercolor to negative. By definition, the subjective choice begins in the brain and ends — in photography — in dozens of decisions, from the selection of camera, film, shutter setting, and lighting, to the choice of subject, time, and place. To say that these decisions are simplified by technical advances (automated shutter controls, for example) does not render the construction of an incisive, effective photograph any easier. No, the task grows in difficulty as the tool simplifies. The pencil and the typewriter are perfect cases in point. Millions can draw and write, very few can excel. Why?

As any medium becomes accessible to wit and imagination as opposed to specialized skills, its critical mass of work enlarges and improves. This is why we now live in a time when the finish and perfection of the photograph is secondary — in importance — to the finish and perfection of the idea.

The merest glance at recent photography reveals that this is now the case. The medium has been invaded by an awesome variety of talents with goals as diversified as those operative in literature, the theater, and painting. Perhaps the first sign of this change was Robert Frank's landmark book, *The Americans* (1958), in which the tragic vision of the photographer — exemplified most of all in the bleak, rolling continuum of U.S. Highway 285 — caused more discussion than the means of presentation. Diane Arbus's shocking portraits of people living on the physical and psychic margin of society were yet another example. One hundred years before, neither Frank nor Arbus would have resorted to photography — then a difficult, time-consuming process — to make their impassioned statements. Neither would they have succeeded so dramatically, either in print or on the canvas.

For the photograph stubbornly retains a scent of reality, even when the photographer's personal touch is so evident, as in Frank or Arbus, even in an age when we are prepared for its tricks and distortions. This is perhaps the most striking of the photograph's several contradictions. The scent of realism is always there, whether the photographer wants it or not, forcing us to half-believe what we see. Diane Keaton's comic but affecting snapshots of deserted hotel lobbies and hallways derive their bizarre edge from this irrepressible fact. So does the absurd box caught in mid-air by the Japanese photographer Ryoji Akiyama, on its way back to a waste-filled dump. John Pfahl's *Triangle, Bermuda* would only be a clever trompe l'oeil deceit if it didn't present us with a real ocean at a real moment on a real day (when he roped the distant rock in the water, hoping to convince us that his three-dimensional lines were in fact flat). In all of the recent exploration into the domain of gorgeous, free-wheeling color, this paradox remains. Color was ignored in the past, when the fascinating ambiguity of the hues produced by color film (they are never faithful to reality) disturbed the F/64-inspired purists, who preferred reliable black-and-white. But not even here, in the fantasy land of the "New Color," can the scent of truth be shaken. Though the hues in the work of Eliot Porter, Joel Meyerowitz, Stephen Shore, and Jan Groover are florid and distracting, elegant lies to the last, we are still aware of a factual world there, lurking beneath the rivers, sunsets, porches — even beneath the knives and forks in that radiant Grooverian sink.

Yes, of course photography is a medium in which the finest minds can act. Of course it is a fine art; but, at the same time, it *isn't* a fine art at all, if we mean by "fine" something high, noble, lofty, divorced from the world of the living; no, this photography can never be. It is far too provocative a medium for that. Like Janus, the photograph looks two ways at once — up, toward the vision of a pure, photographic beauty, as Edward Weston would say, and down, alas, beyond the mundane reality of fact, toward something even deeper. We know that whatever we see before us in the photograph has appeared at a specific moment in time before the lens of that camera. When Fox Talbot exclaimed over the wonder of trapping a "gleam of sunshine," he was moved, I am sure, by the ineffable mystery of time, which is at the root of his, or our, experience of living, and dying. This is why photography has such a magnificent and terrible appeal, beyond the more sedate and static arts. Paintings are masters of their moments, imposed on time; photographs are servants of time, and in their presence we are reminded of ourselves, of our own servitude, our own mortality. Let's conclude, then: Photography is not completely a fine art, in the traditional sense. It is a protean phenomenon, perpetually suspended between life and art. Photography is finer than art.

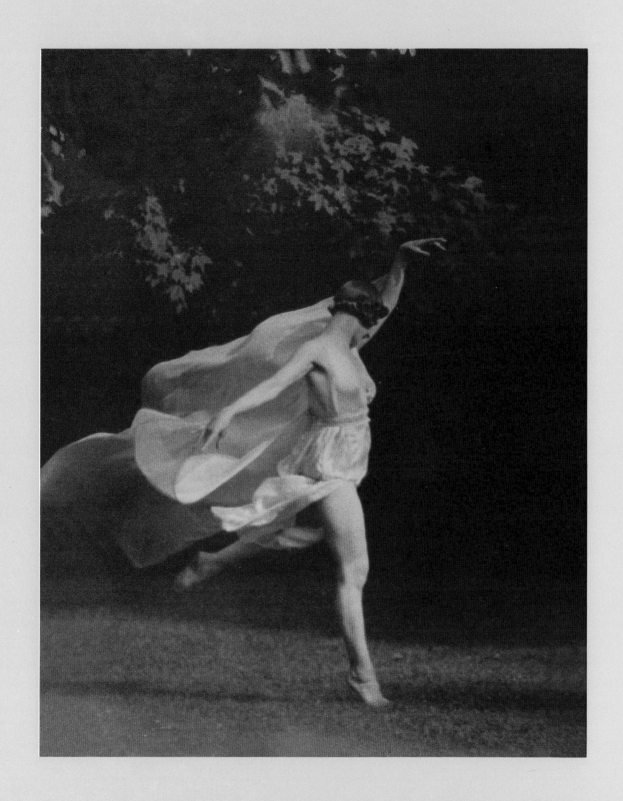

Plates

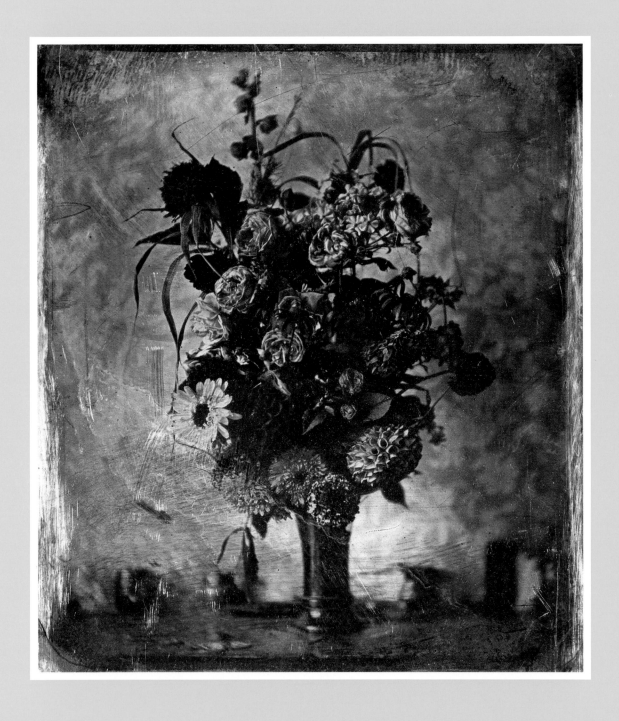

"CROMER'S AMATEUR"

STILL LIFE OF FLOWERS / *Daguerreotype, ca. 1845*

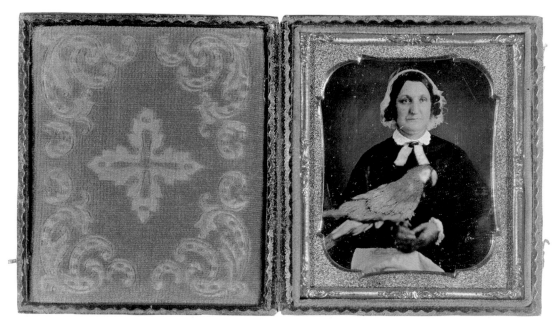

ANONYMOUS (AMERICAN) WOMAN WITH A PARROT / *Hand-colored daguerreotype, ca. 1847*

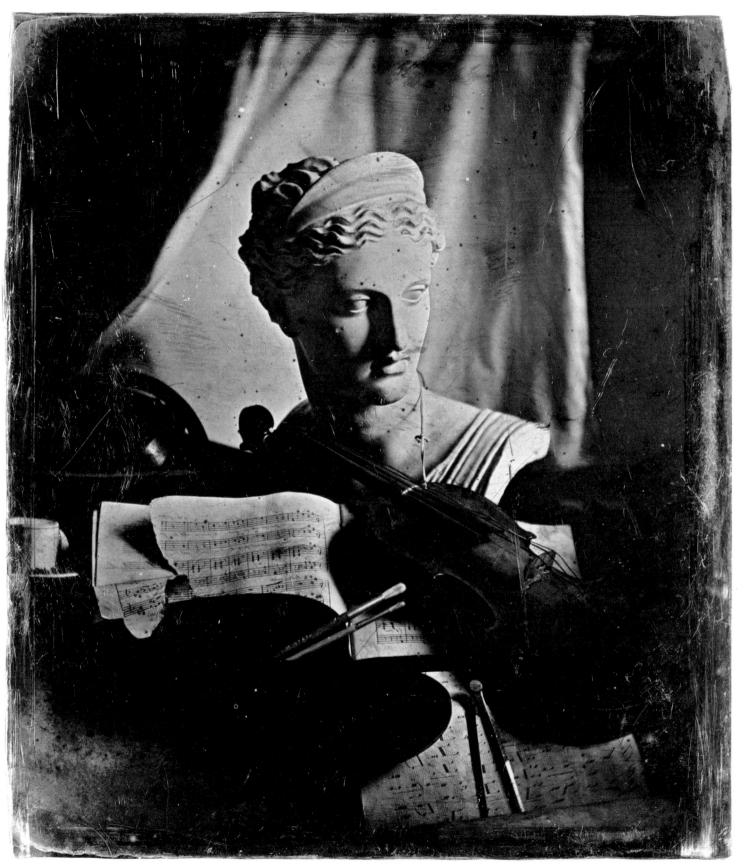

''CROMER'S AMATEUR'' STILL LIFE / *Daguerreotype, ca. 1845* [*enlarged*]

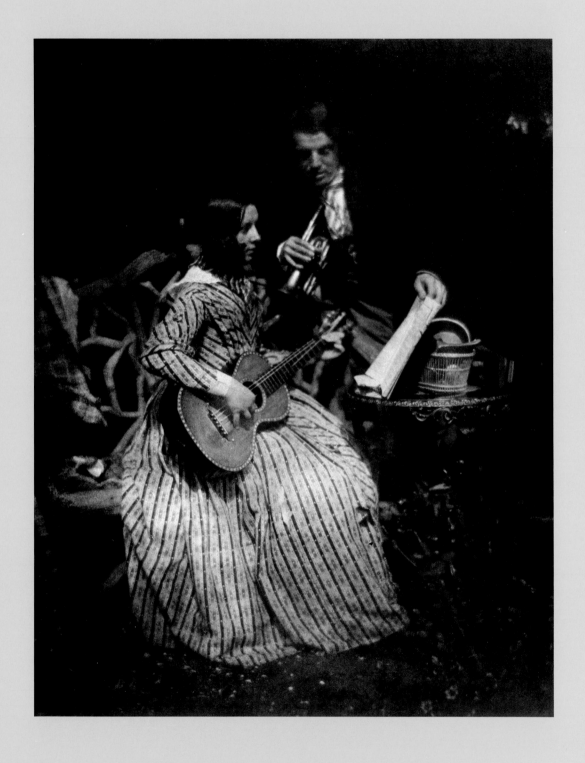

DAVID OCTAVIUS HILL *and* **ROBERT ADAMSON** MISS CHALMERS AND HER BROTHER / *Calotype, ca. 1844–1848*

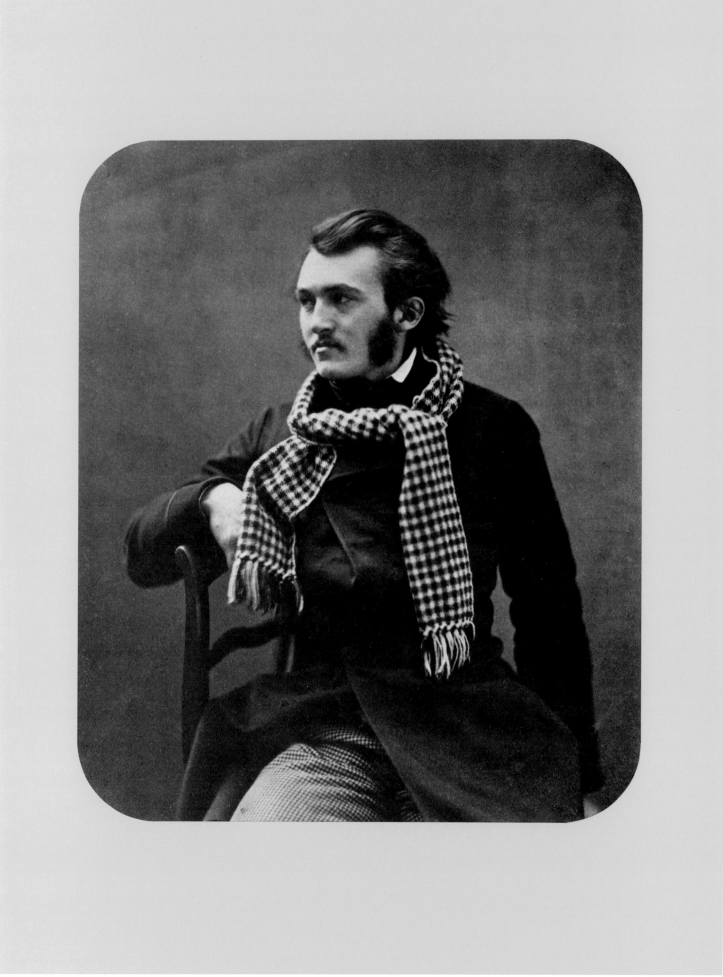

NADAR

GUSTAVE DORÉ / *Albumenized salt print, 1854*

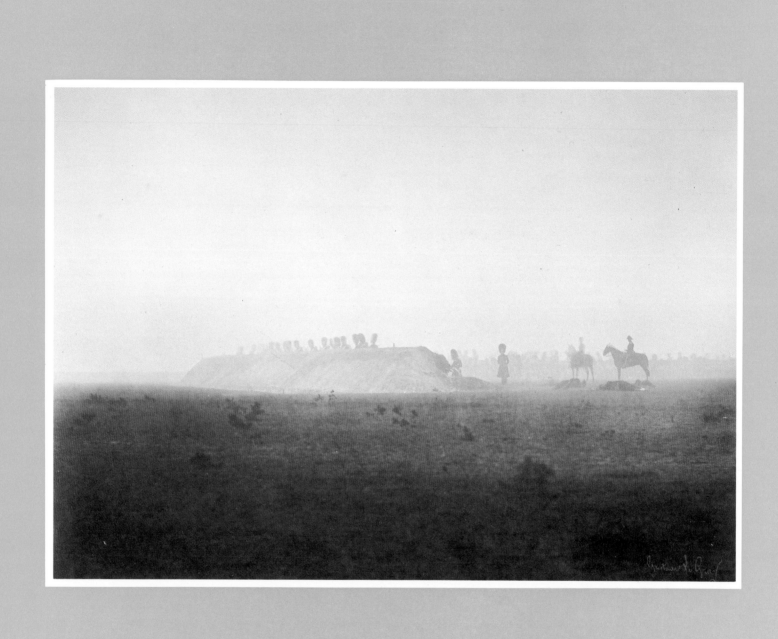

GUSTAVE LE GRAY MANEUVERS AT CAMP CHÂLONS / *Albumen print, 1857*

WILLIAM HENRY JACKSON OLD FAITHFUL GEYSER, YELLOWSTONE PARK / *Albumen print, ca. 1875*

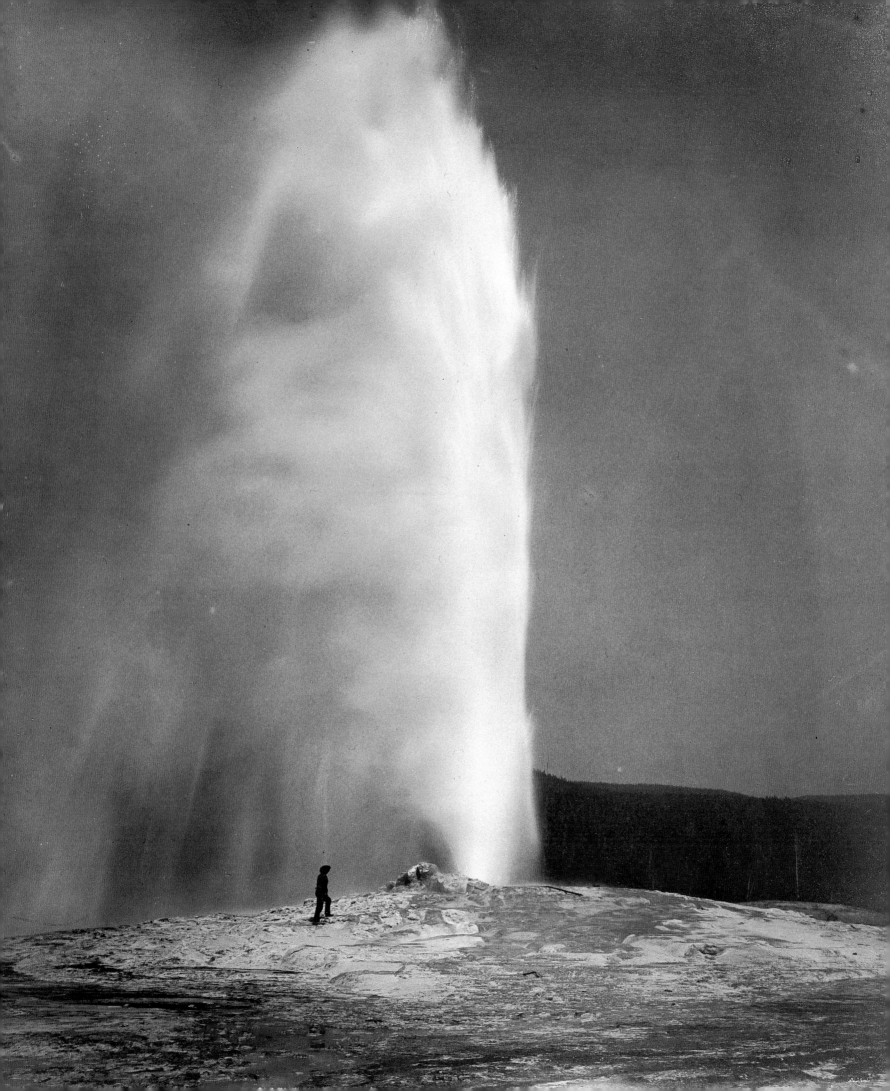

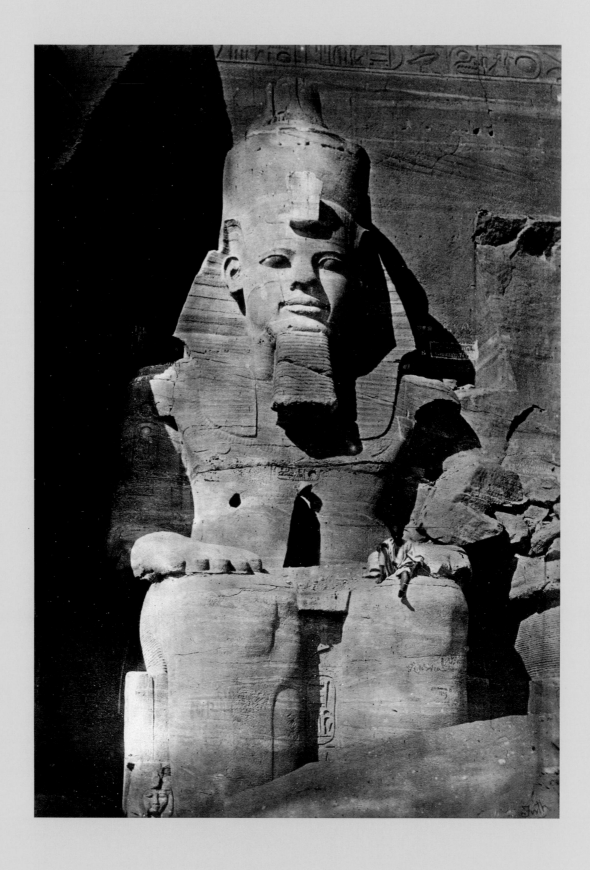

FRANCIS FRITH COLOSSUS OF RAMSES II AT ABU SIMBEL, NUBIA / *Albumen print, ca. 1862*

FRANCIS FRITH

ROGER FENTON

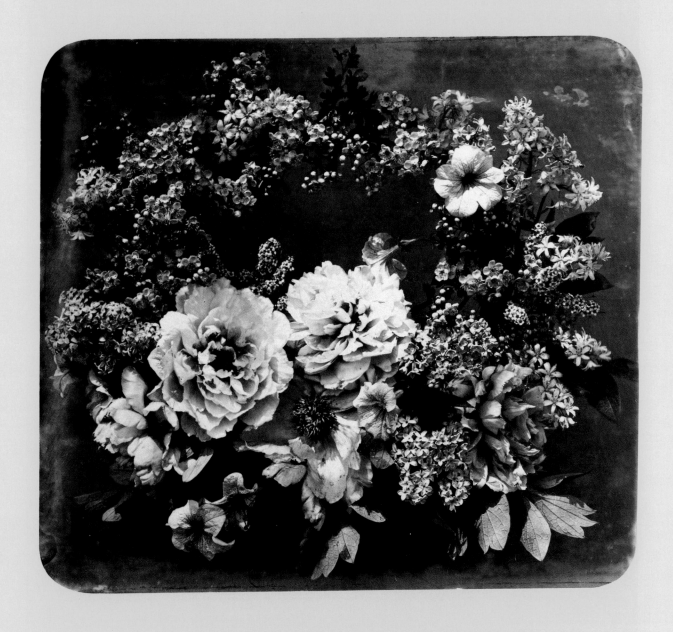

ADOLPHE BRAUN FLOWER STUDY / *Albumen print, 1857*

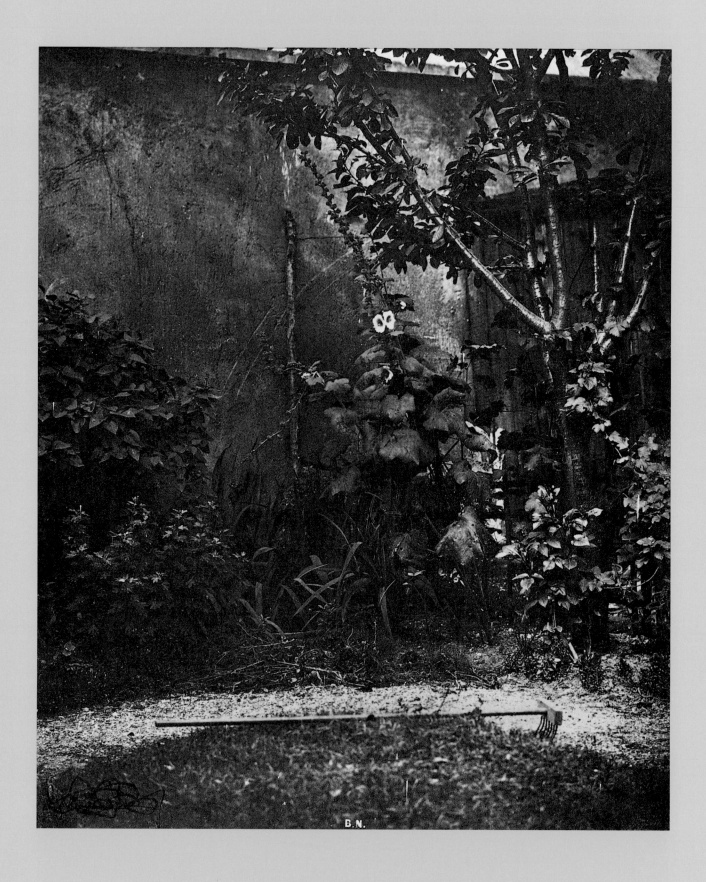

GUSTAVE LE GRAY

CORNER OF A GARDEN / *Albumen print, ca. 1853*

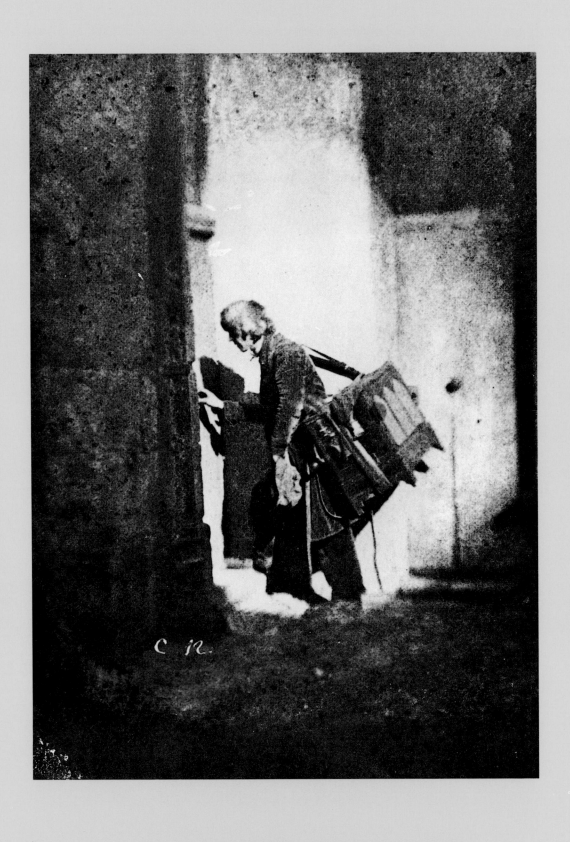

CHARLES NÈGRE *THE ORGAN GRINDER / Albumen print from paper negative, 1853 [enlarged]*

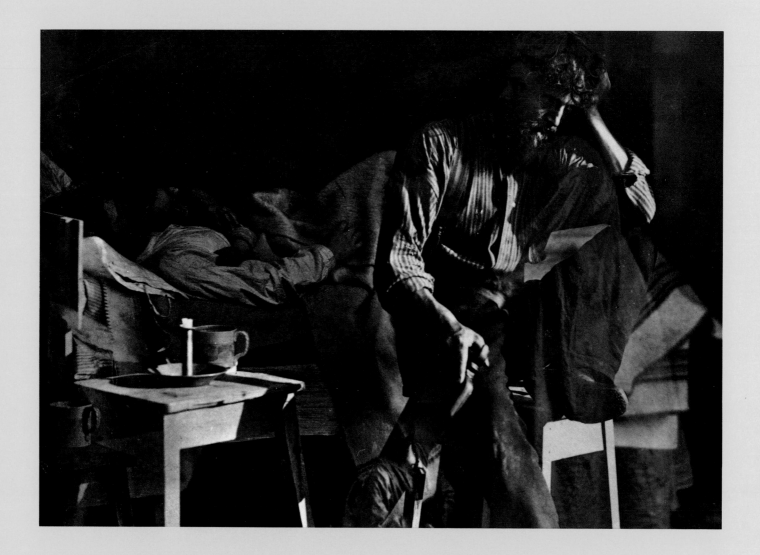

OSCAR GUSTAVE REJLANDER HARD TIMES: SPIRITISTICAL PHOTO / *Albumen print from multiple negatives, 1860*

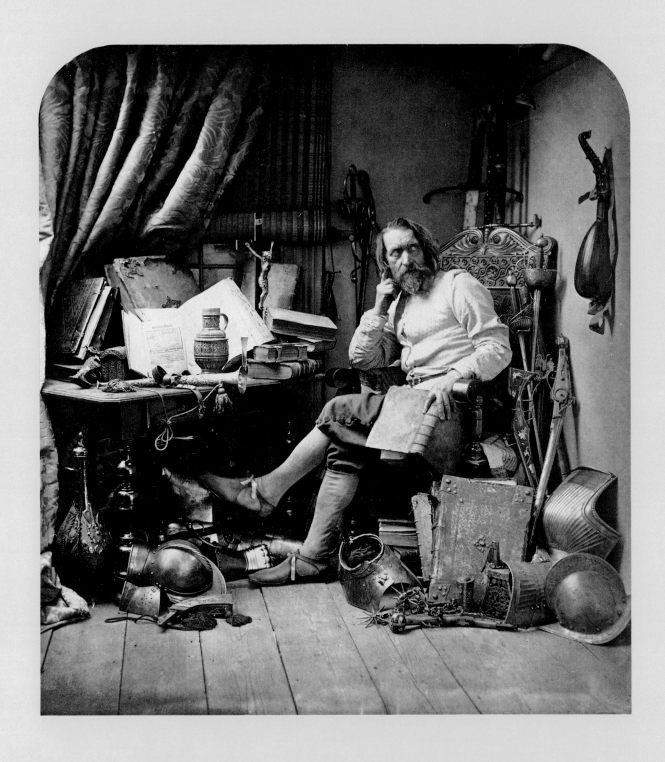

WILLIAM LAKE PRICE

DON QUIXOTE IN HIS STUDY / *Albumen print, 1857*

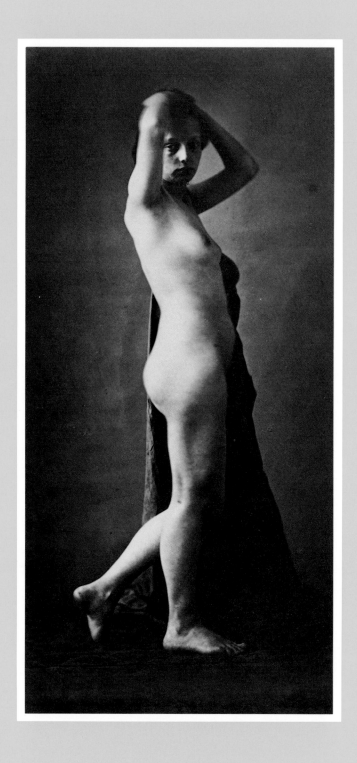

HENRI VOLAND

STANDING NUDE / *Albumen print, ca. 1861*

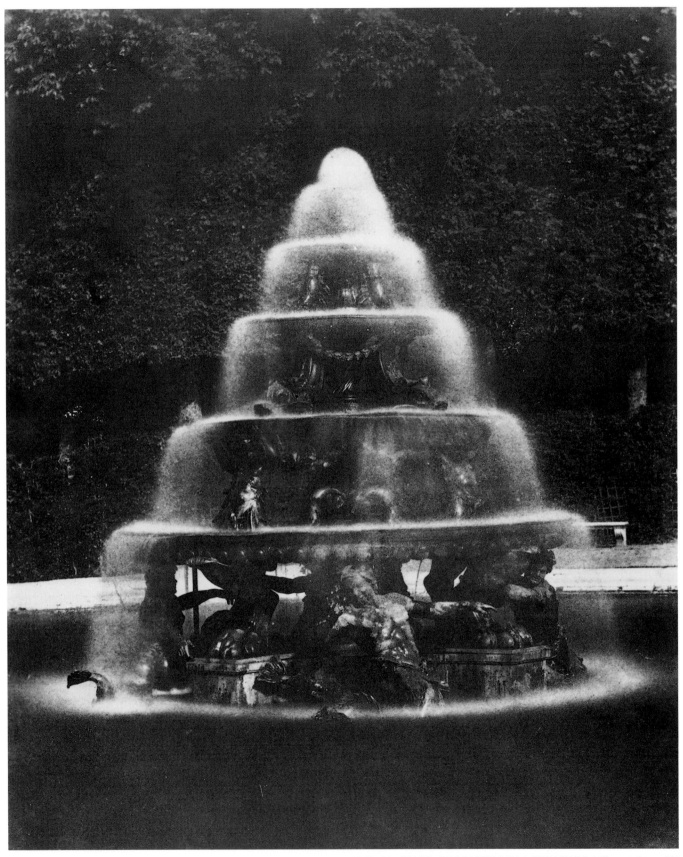

LOUIS ROBERT GARDEN OF VERSAILLES, FONTAINE DE LA PYRAMIDE / *Albumen print, ca. 1854*

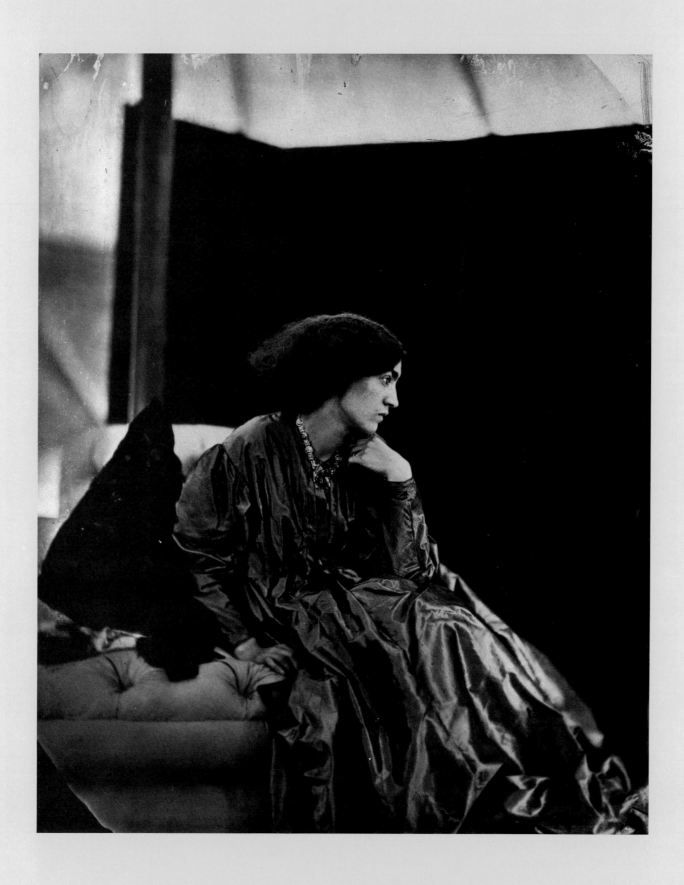

ANONYMOUS (BRITISH) MRS. WILLIAM MORRIS / *Albumen print, ca. 1865*

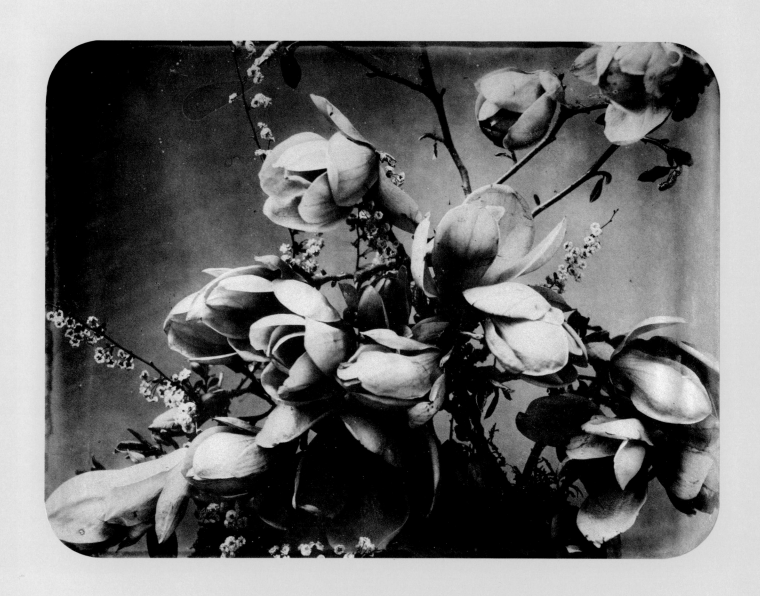

ADOLPHE BRAUN

FLOWER STUDY / *Albumen print, 1857*

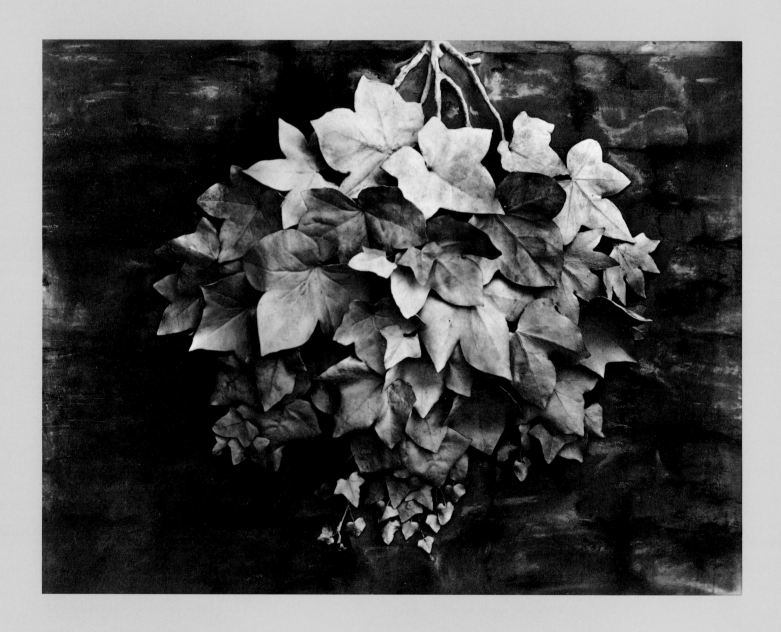

CHARLES AUBRY

CLUSTER OF SEVERAL IVIES / Albumen print, 1864

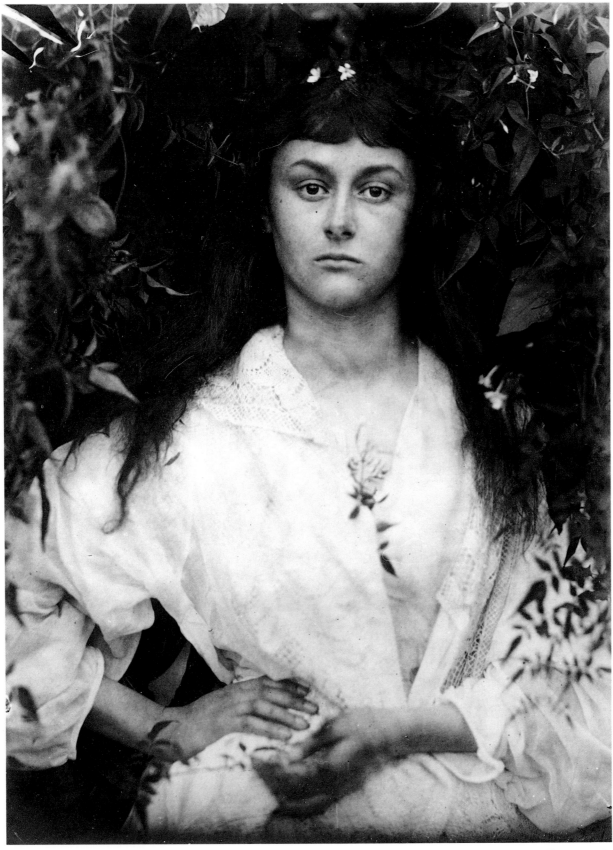

JULIA MARGARET CAMERON ALICE LIDDELL AS POMONA / *Albumen print, 1872*

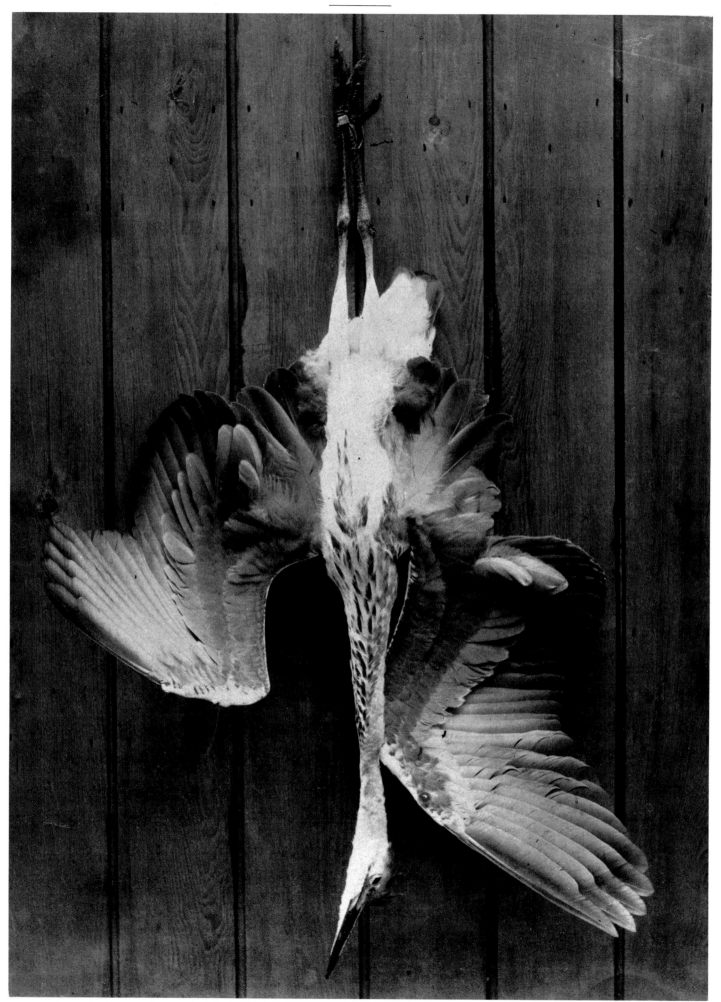

FRANCIS EDMUND CURREY THE HERON / *Albumen print, ca. 1865* [*enlarged*]

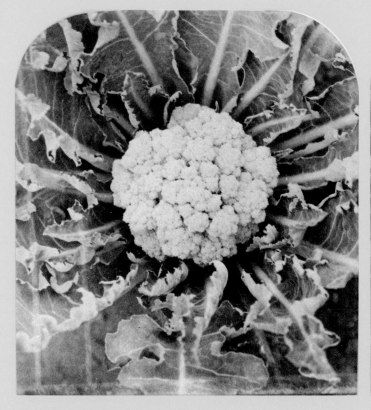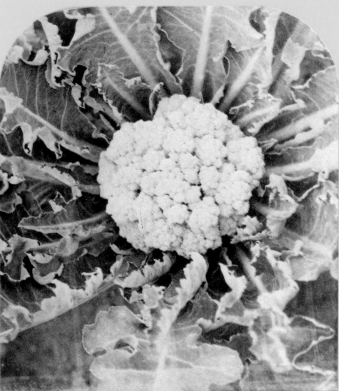

ANONYMOUS (BRITISH)

CAULIFLOWER / *Albumen stereograph, 1860s*

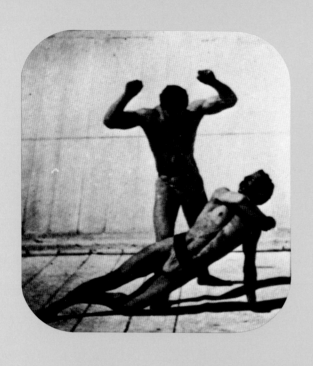
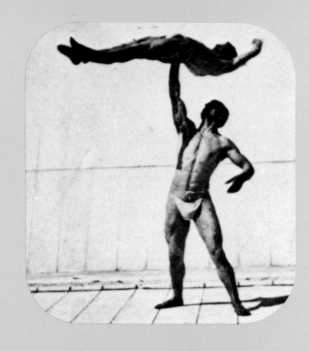

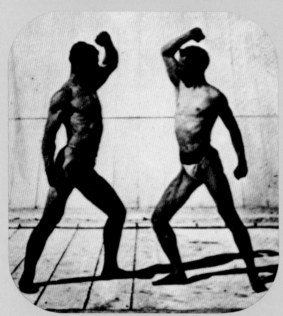
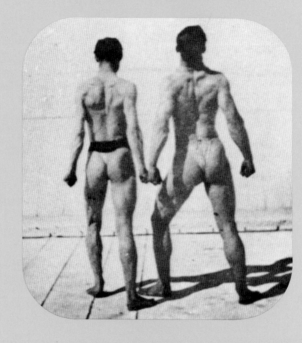
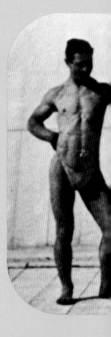
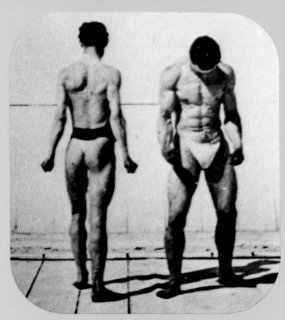
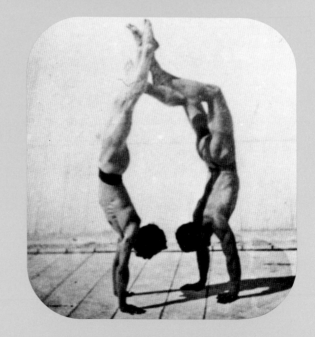

EADWEARD MUYBRIDGE

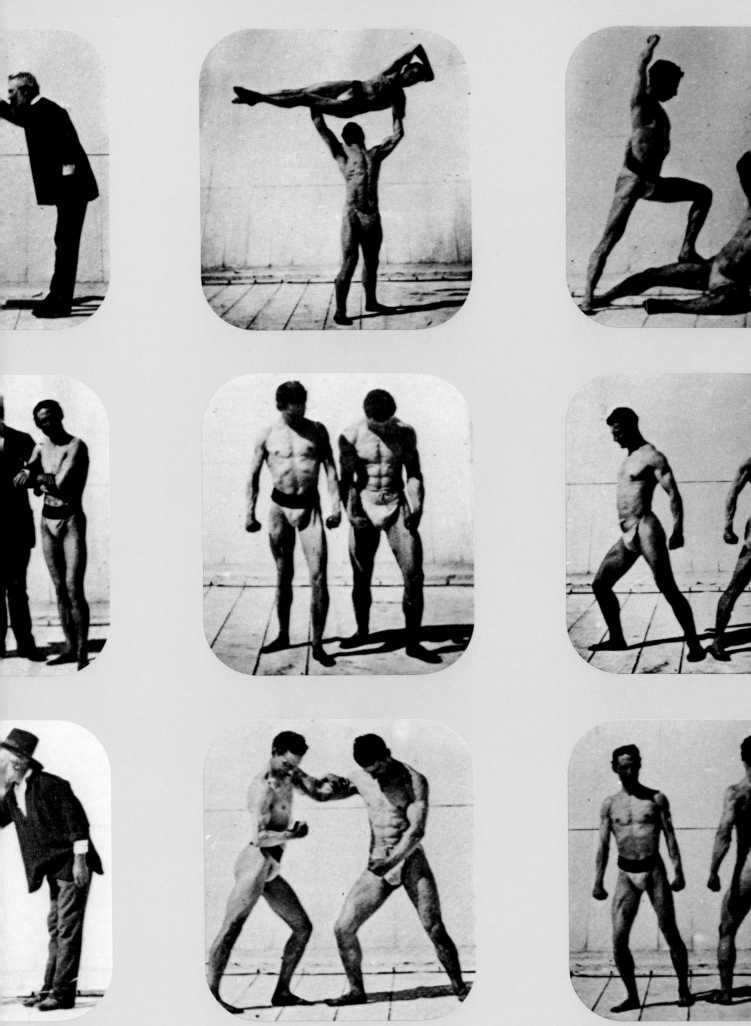

ATHLETES AND CLASSICAL GROUPINGS / *Albumen print, 1879* [*enlarged*]

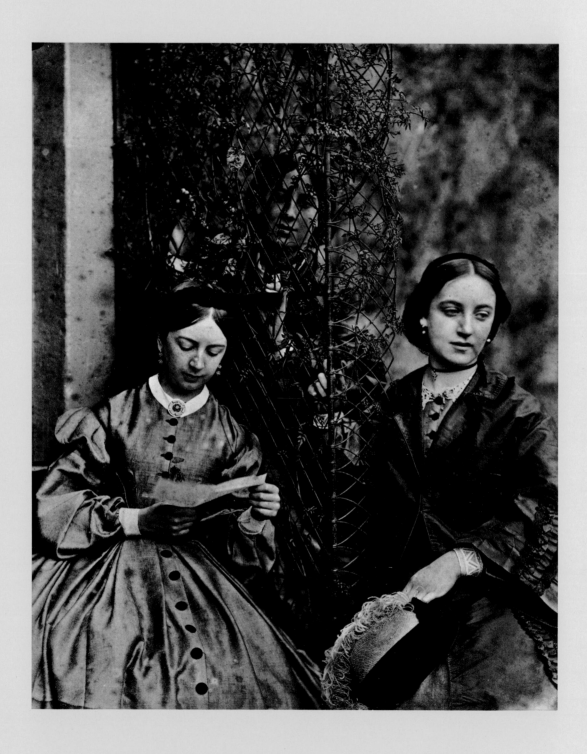

DAVID OCTAVIUS HILL *and* ALEXANDER MCGLASHAN

THROUGH THE TRELLIS / *Albumen print, 1862*

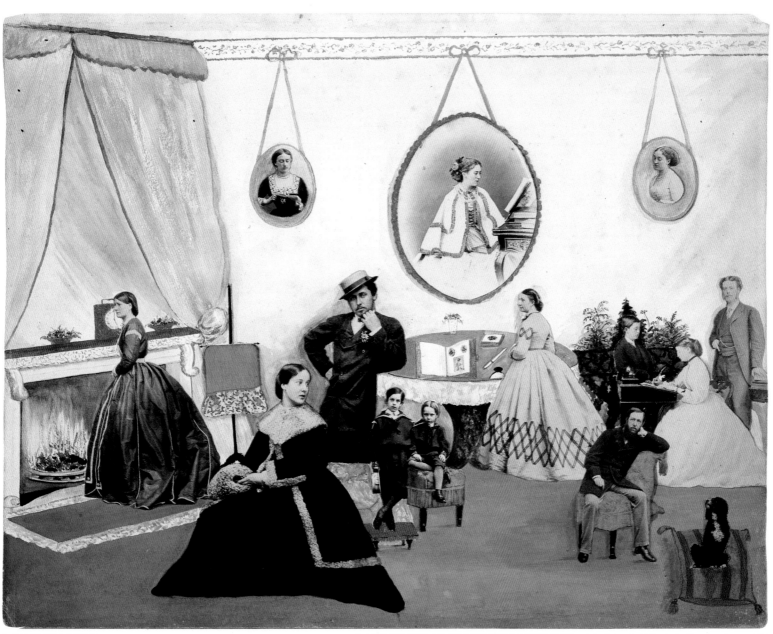

LADY FILMER

LADY FILMER IN HER DRAWING ROOM / *Mounted albumen print touched with watercolor, ca. 1860*

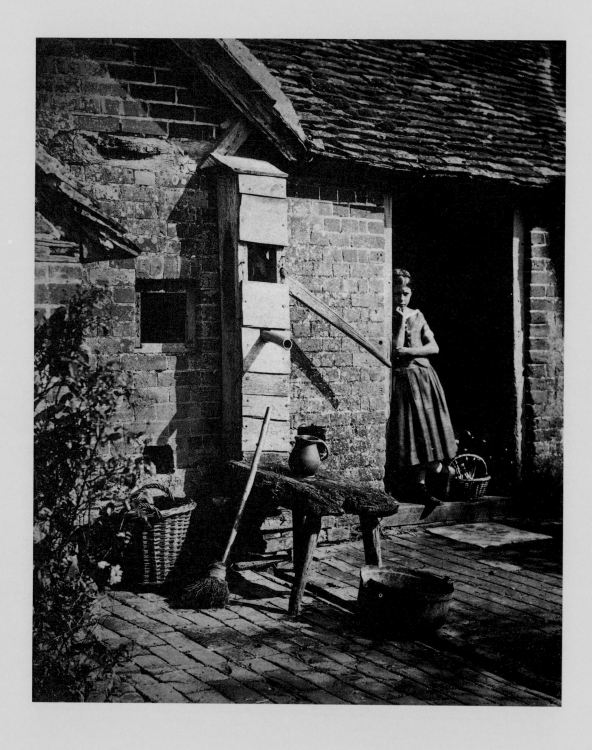

JOHN WHISTLER

NAN AT THE PUMP / *Albumenized salt print, ca. 1855*

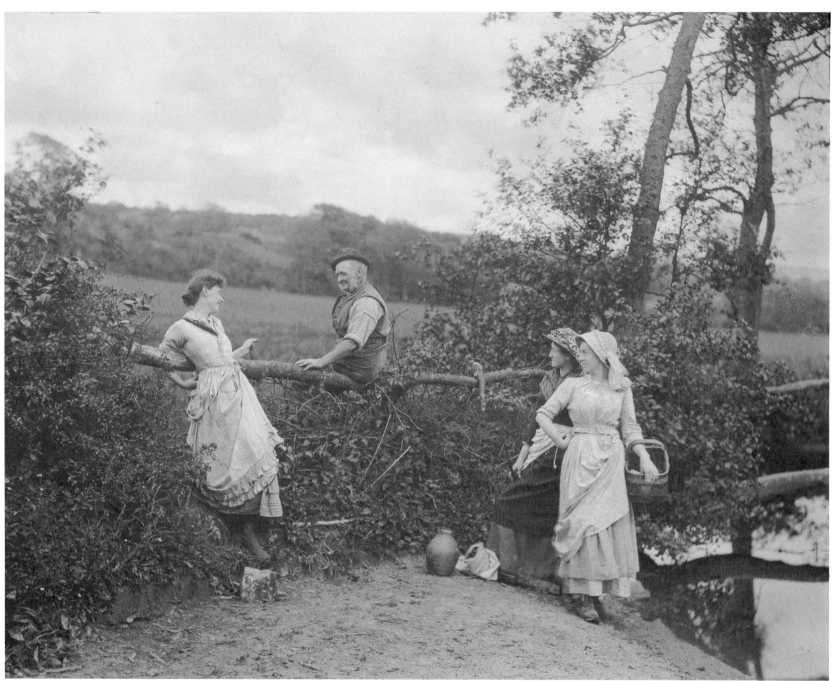

HENRY PEACH ROBINSON

HE NEVER TOLD HIS LOVE [A MERRY TALE] / *Albumen print, 1884*

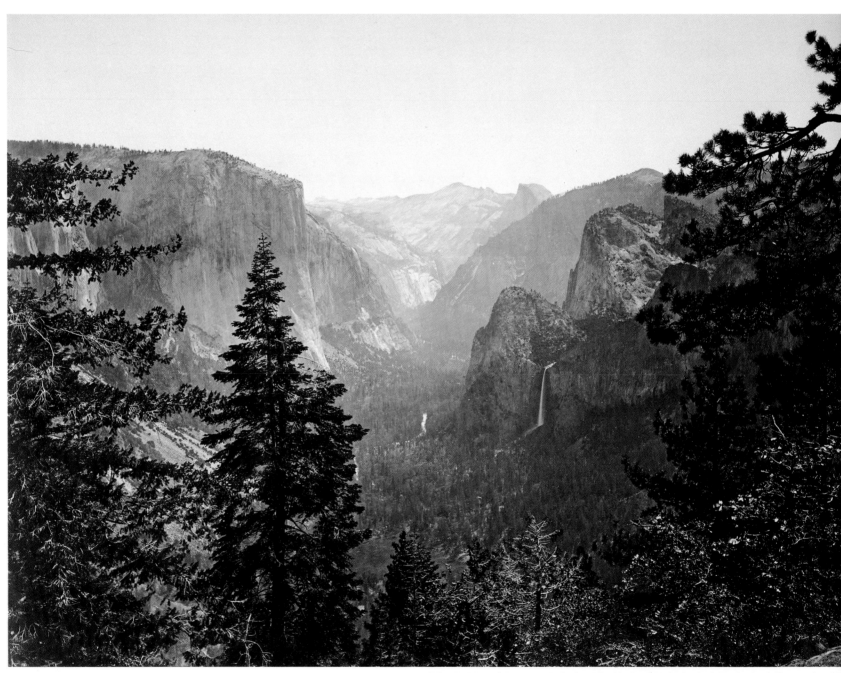

CARLETON E. WATKINS THE VALLEY FROM MARIPOSA TRAIL, YOSEMITE, CALIFORNIA / *Albumen print, 1863*

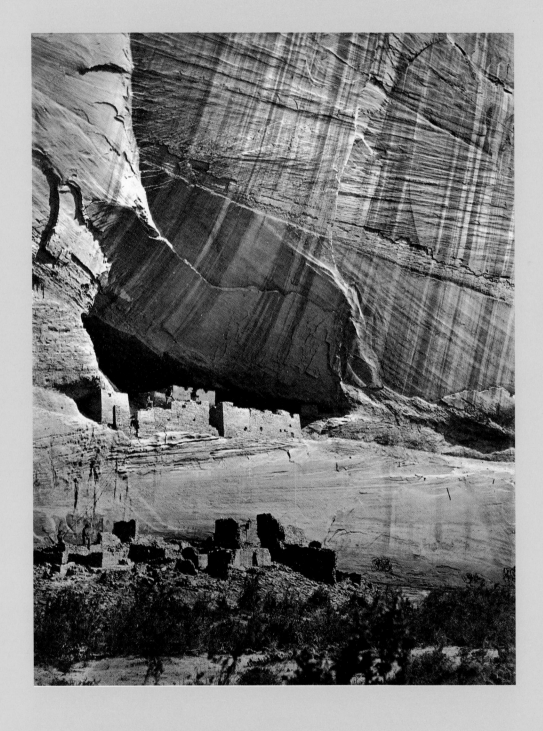

TIMOTHY H. O'SULLIVAN ANCIENT RUINS IN CANYON DE CHELLY, ARIZONA / *Albumen print, 1873*

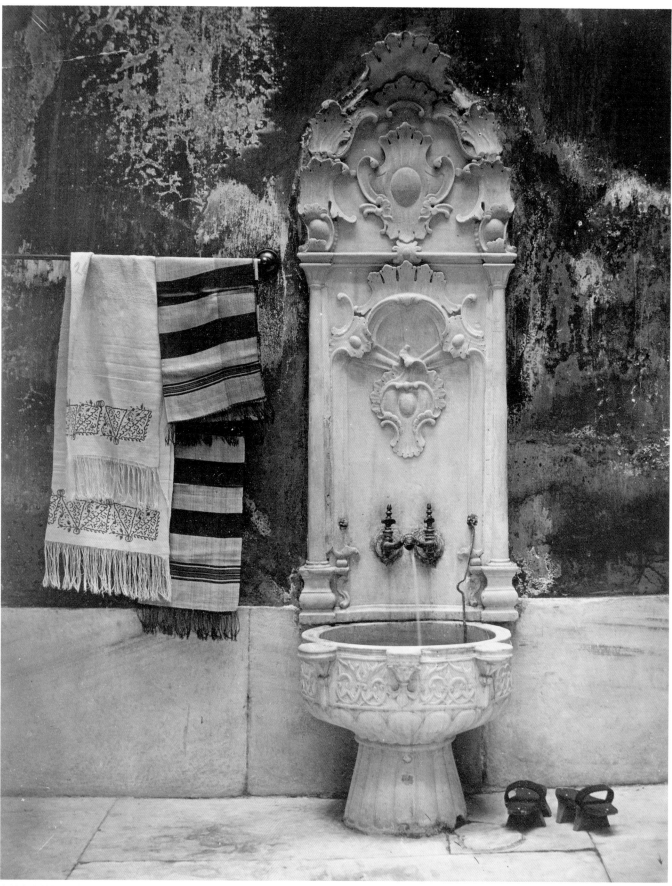

ANONYMOUS (ITALIAN) FOUNTAIN / *Albumen print, 1877*

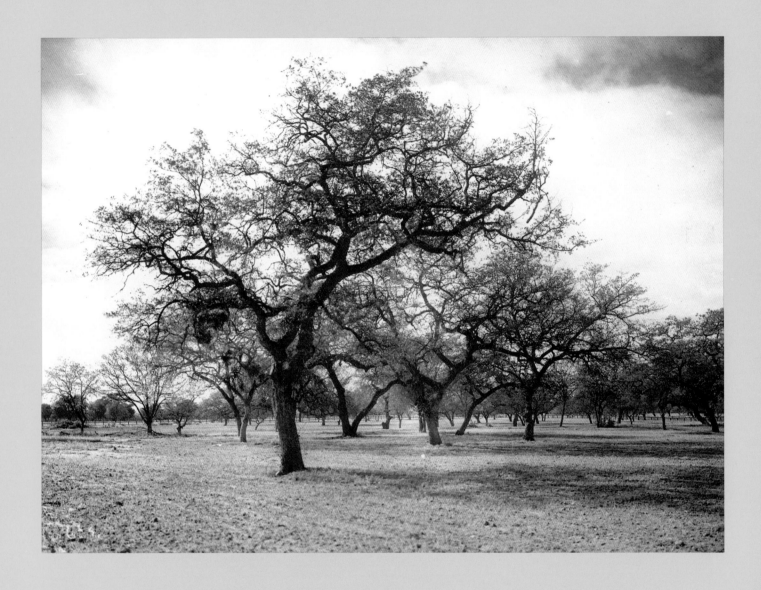

ADAM CLARK VROMAN

LIVE OAKS AT BALDWIN'S RANCH / *Platinum print, 1900*

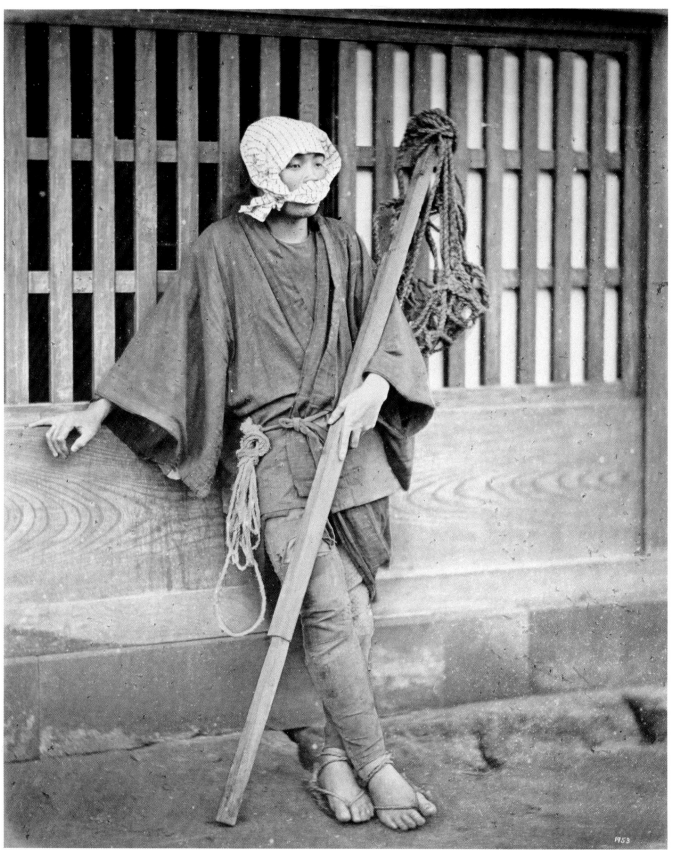

FELICE BEATO *(Attrib.)* JAPANESE LABORER / *Hand-colored albumen print, 1867–1868*

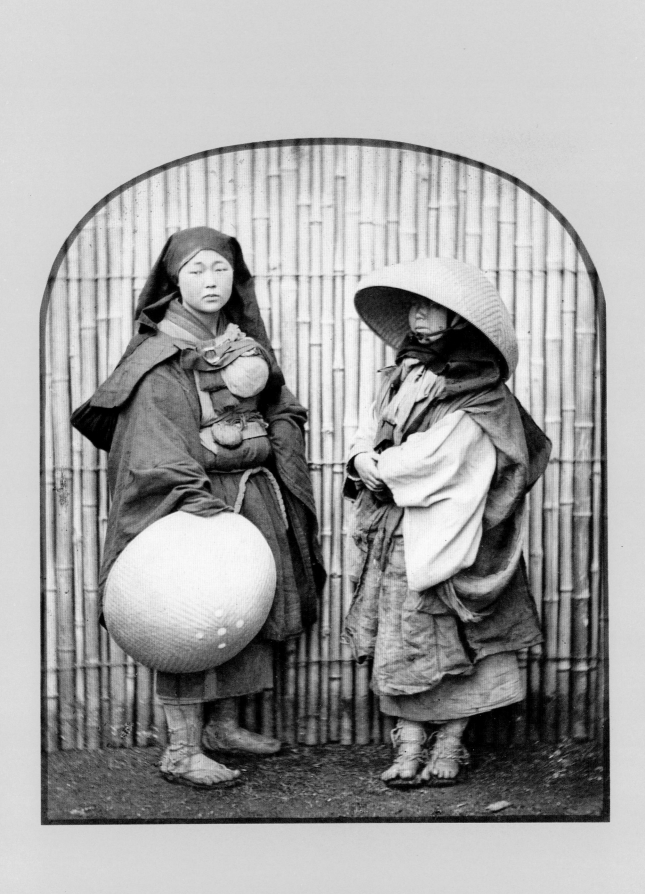

BARON VON STILLFRIED RETINIZ

JAPANESE NUNS / *Hand-colored albumen print, 1870s*

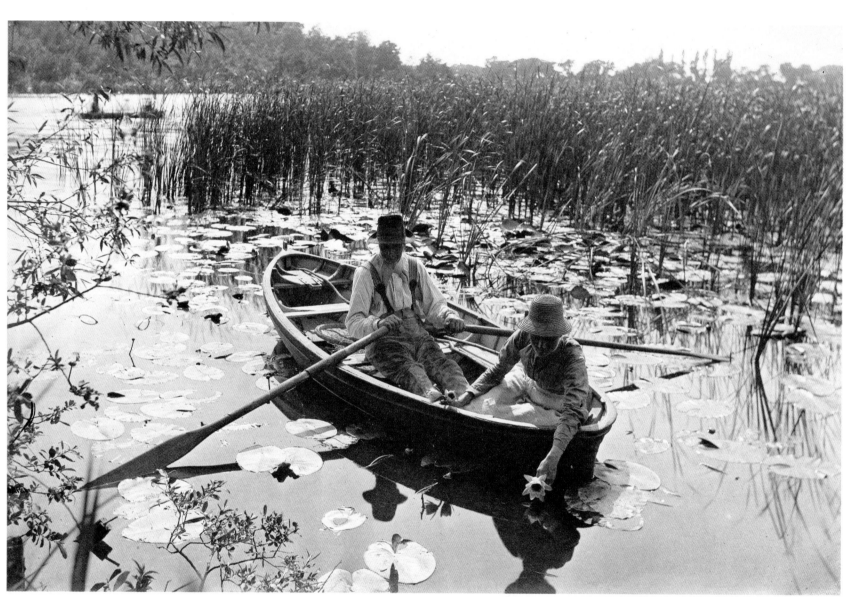

PETER HENRY EMERSON GATHERING WATER LILIES / *Platinum print, ca. 1886*

THOMAS EAKINS

MARY MACDOWELL / *Platinum print, ca. 1880*

ROBERT DEMACHY BEHIND THE SCENES / *Gum bichromate print, ca. 1897*

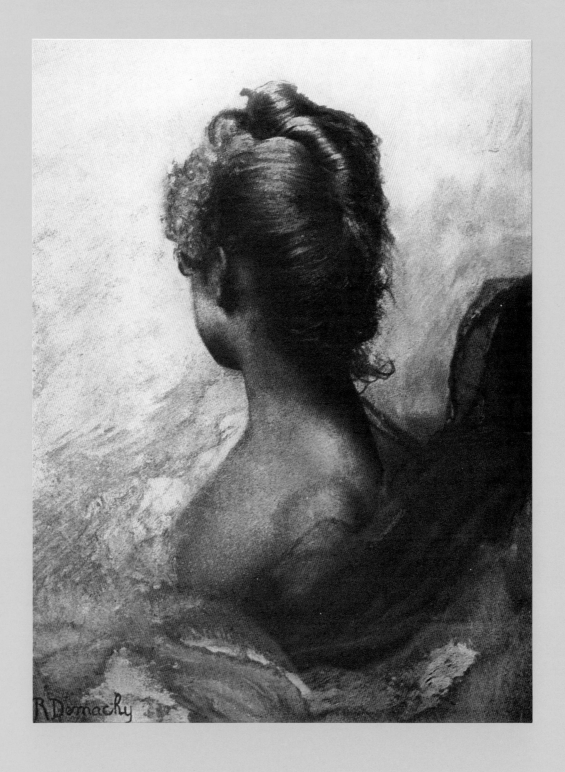

ROBERT DEMACHY

A STUDY IN RED / *Gum bichromate print, ca. 1898*

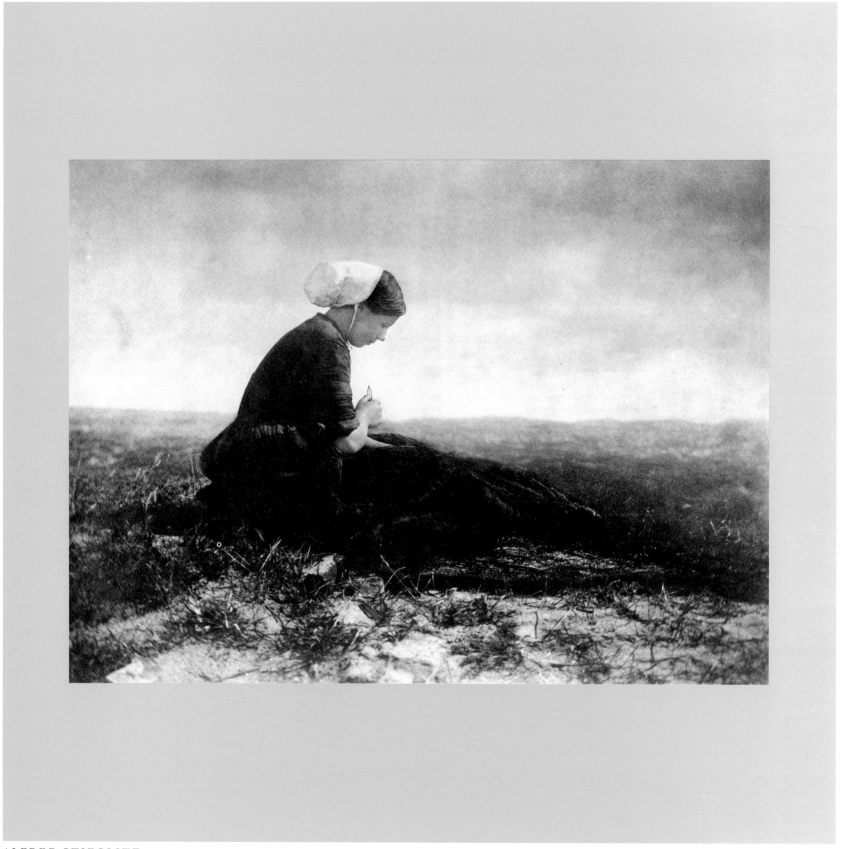

ALFRED STIEGLITZ — THE NET MENDER / *Gum over platinum print, 1894*

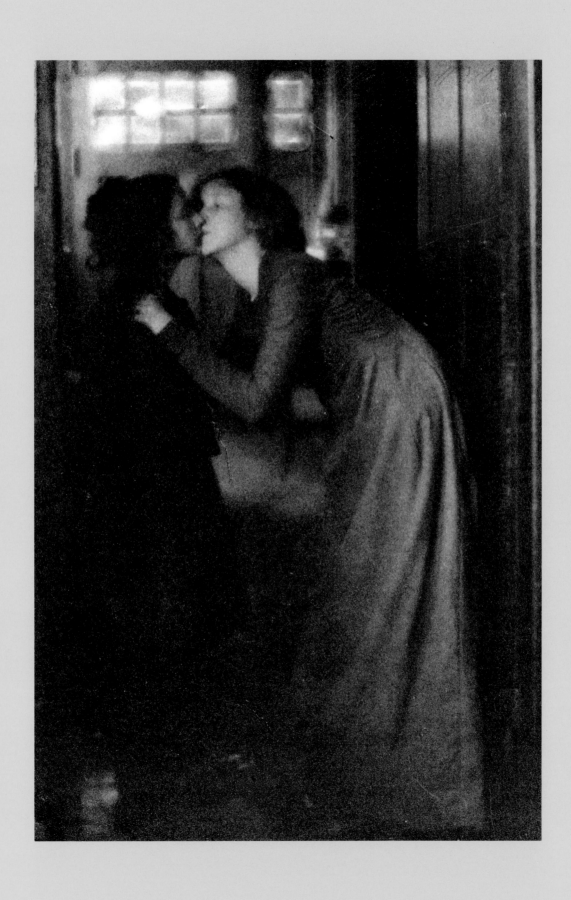

CLARENCE H. WHITE

THE KISS / *Platinum print, 1904* [*enlarged*]

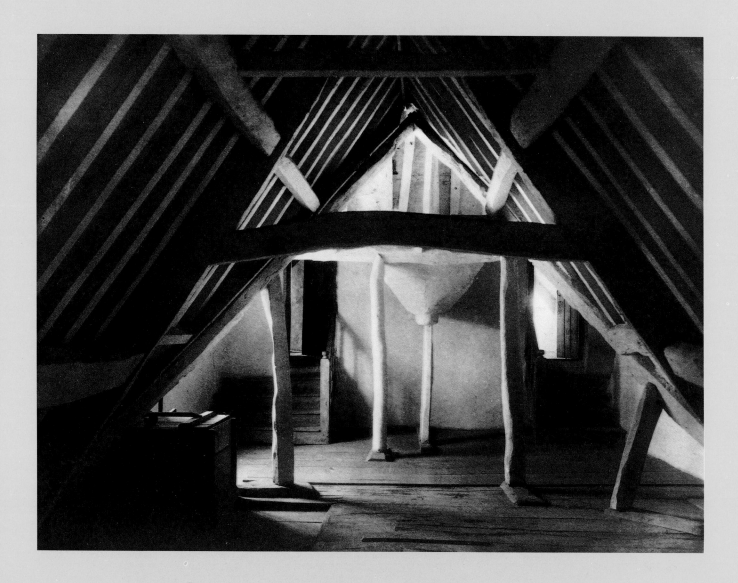

FREDERICK H. EVANS

KELMSCOTT MANOR: IN THE ATTICS / *Platinum print, 1897*

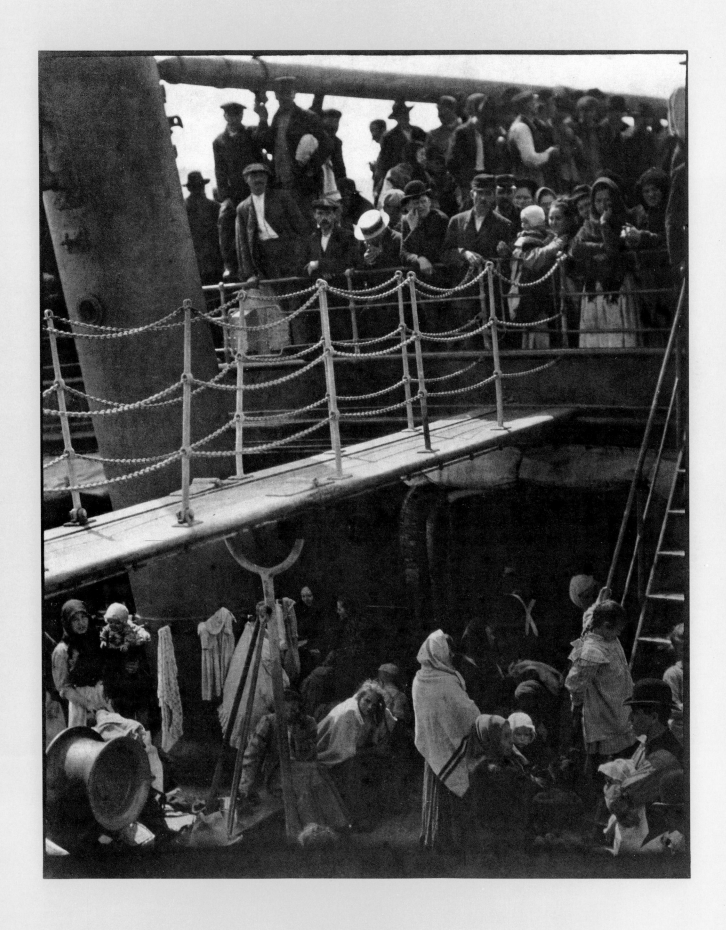

ALFRED STIEGLITZ

THE STEERAGE / *Photogravure, 1907*

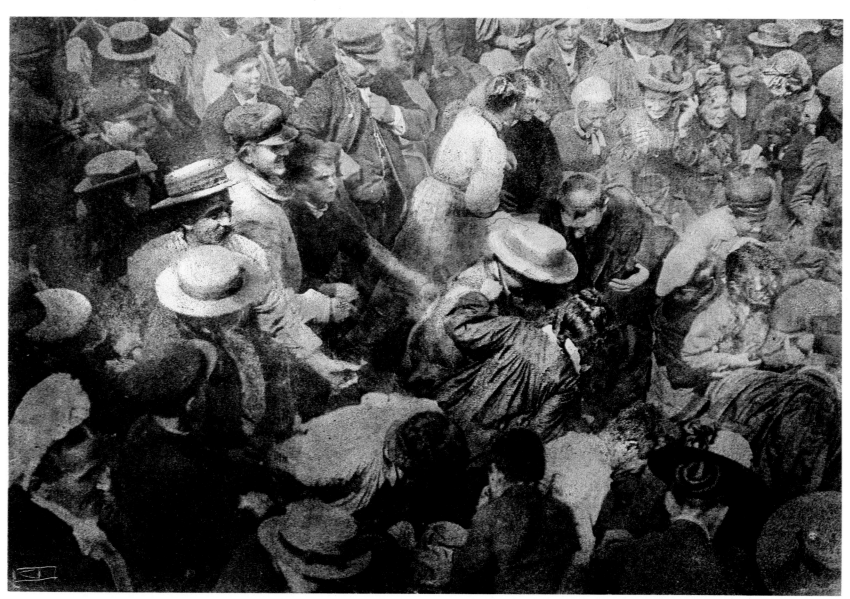

ROBERT DEMACHY

THE CROWD / *Gray pigment oil print, 1910 [enlarged]*

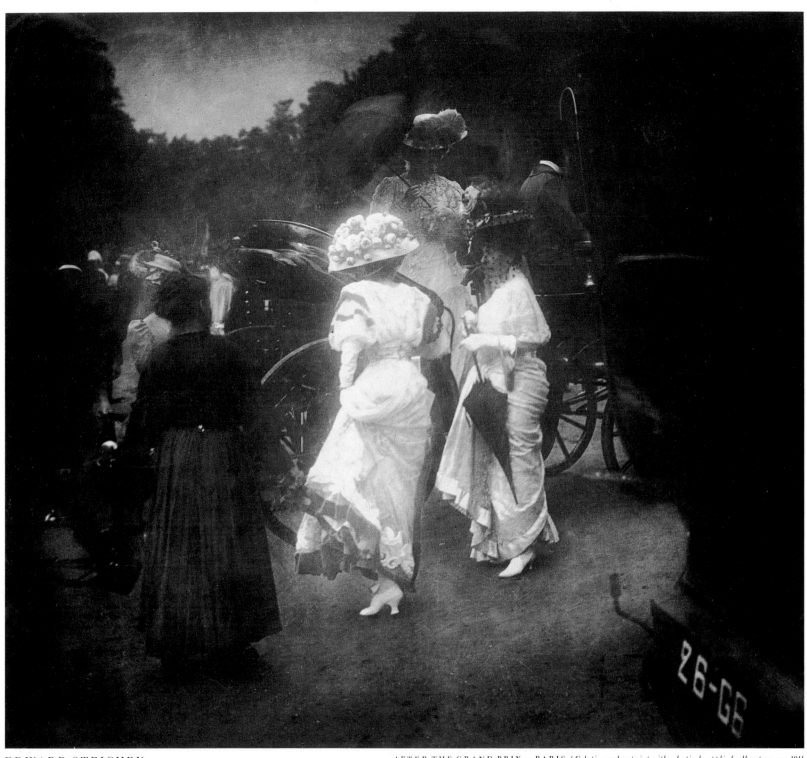

EDWARD STEICHEN AFTER THE GRAND PRIX — PARIS / *Gelatin-carbon print with selectively applied yellow tone, ca. 1911*

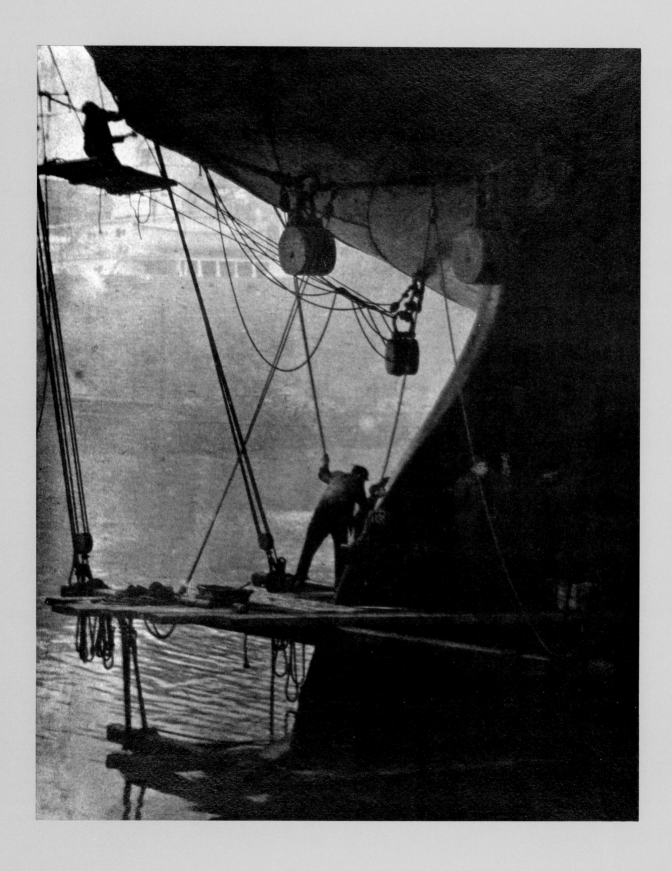

ALVIN LANGDON COBURN

THE RUDDER, LIVERPOOL DOCKS / *Gum platinum print, ca. 1906*

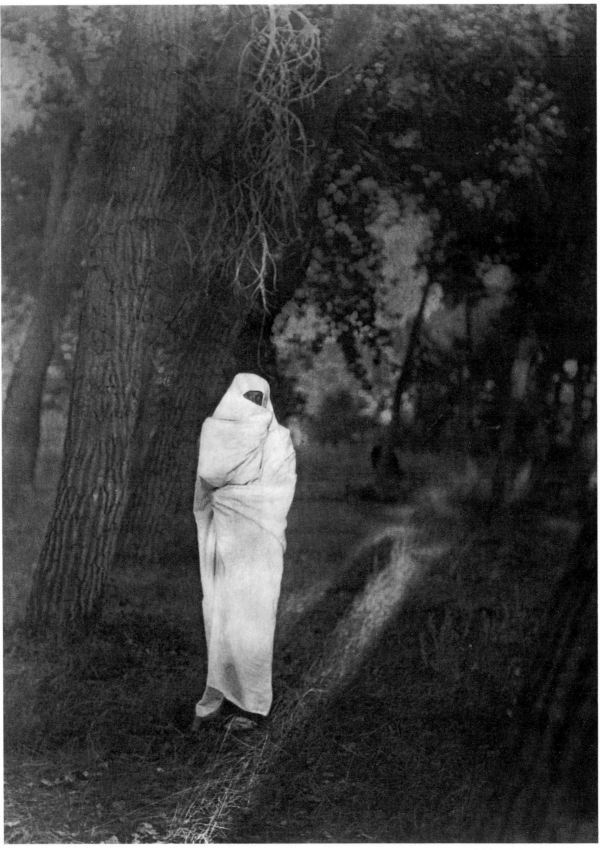

EDWARD S. CURTIS WAITING IN THE FOREST — CHEYENNE / *Photogravure, 1911*

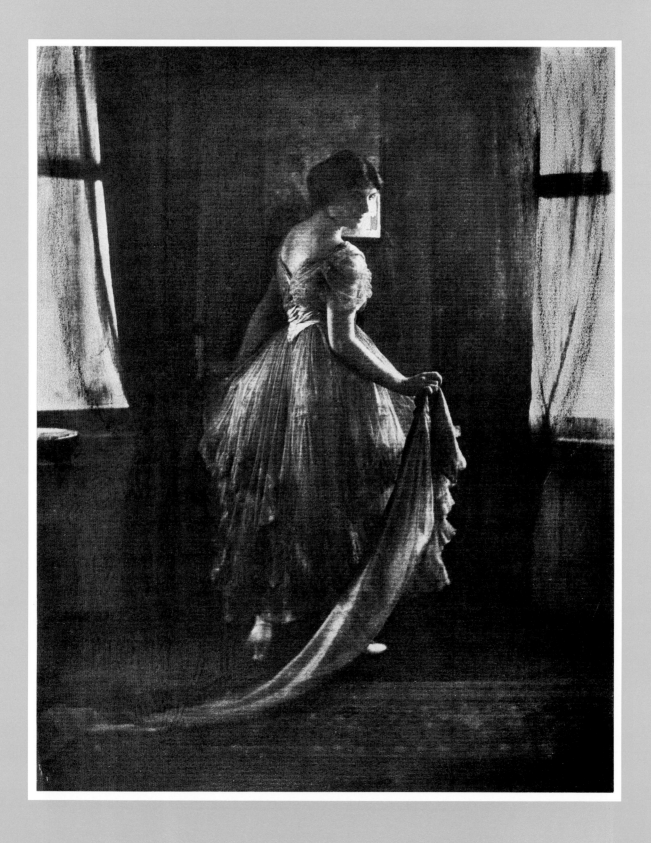

GERTRUDE KÄSEBIER PORTRAIT OF A WOMAN / *Gum bichromate print. ca. 1900*

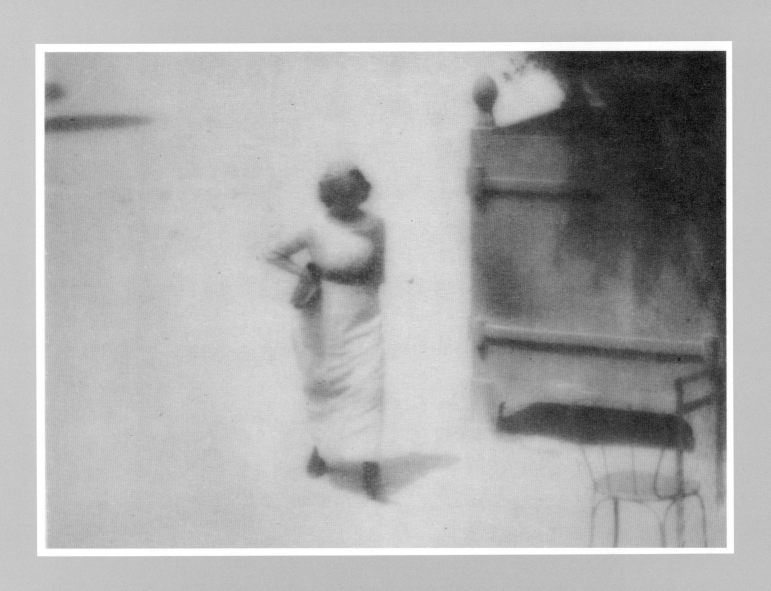

SHINZO FUKUHARA

WOMAN, PARIS / *Gum bichromate print, 1918*

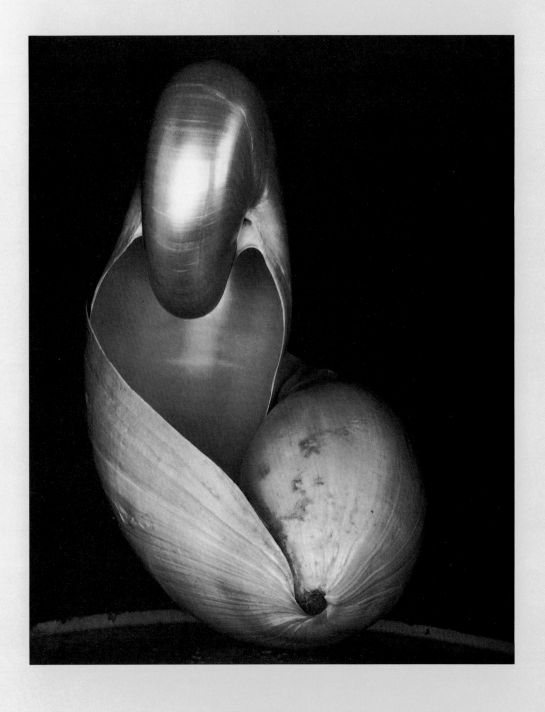

EDWARD WESTON *SHELL / Gelatin silver print, 1927*

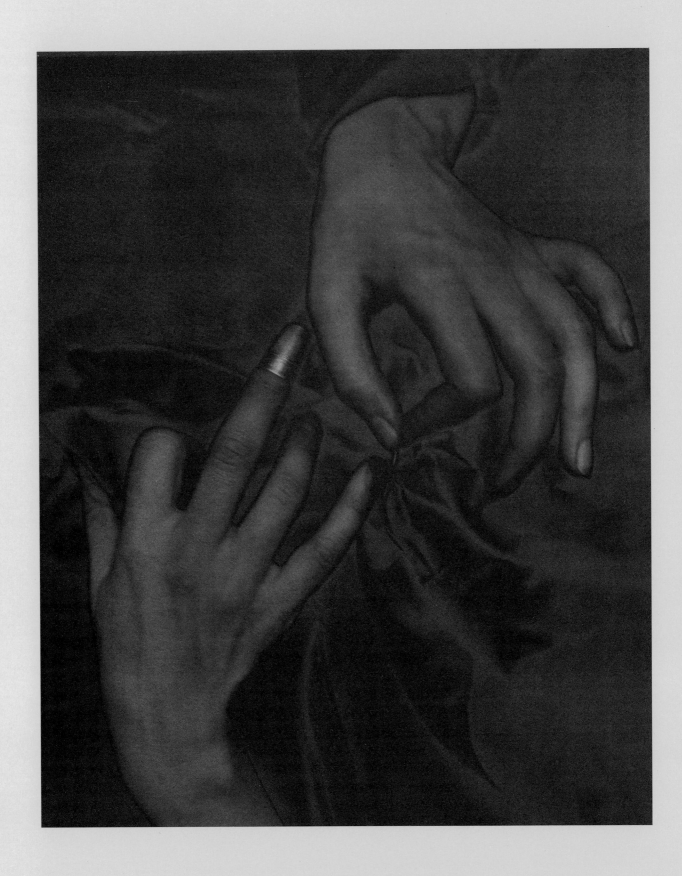

ALFRED STIEGLITZ

HANDS, GEORGIA O'KEEFFE / *Polladium print, 1920*

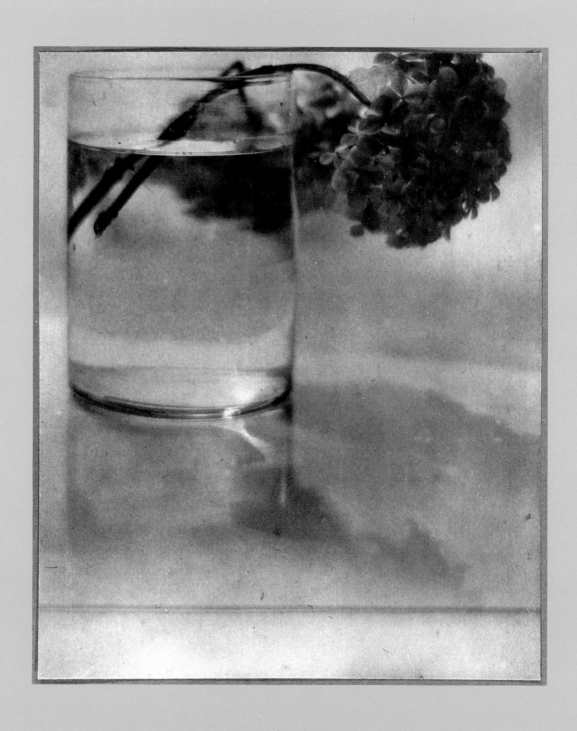

ADOLF DE MEYER STILL LIFE / *Photogravure, ca. 1907*

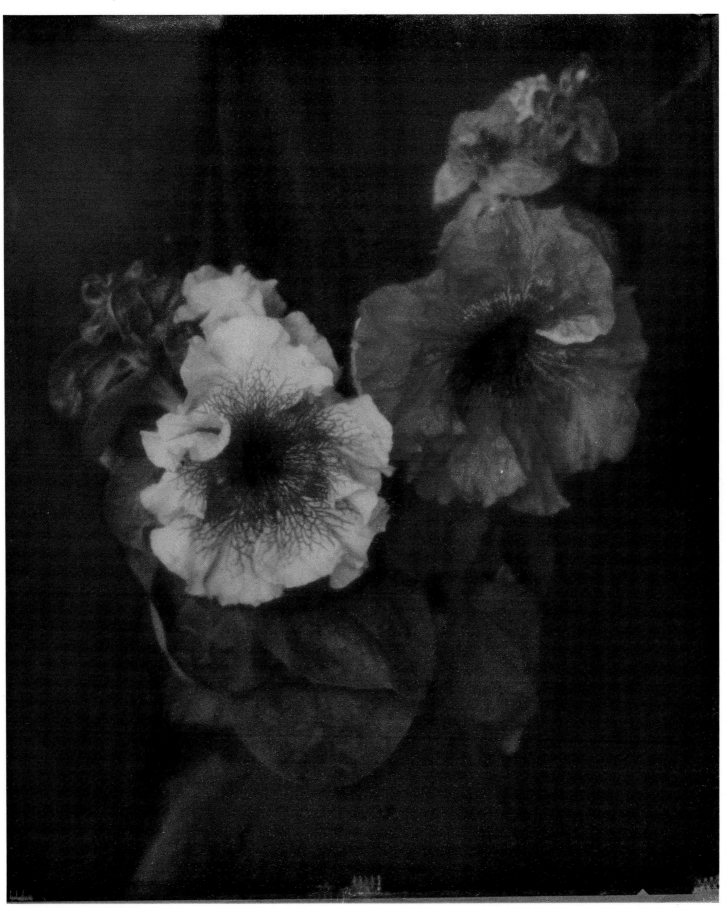

EDWARD STEICHEN

PETUNIAS / *Hicro color print, 1917*

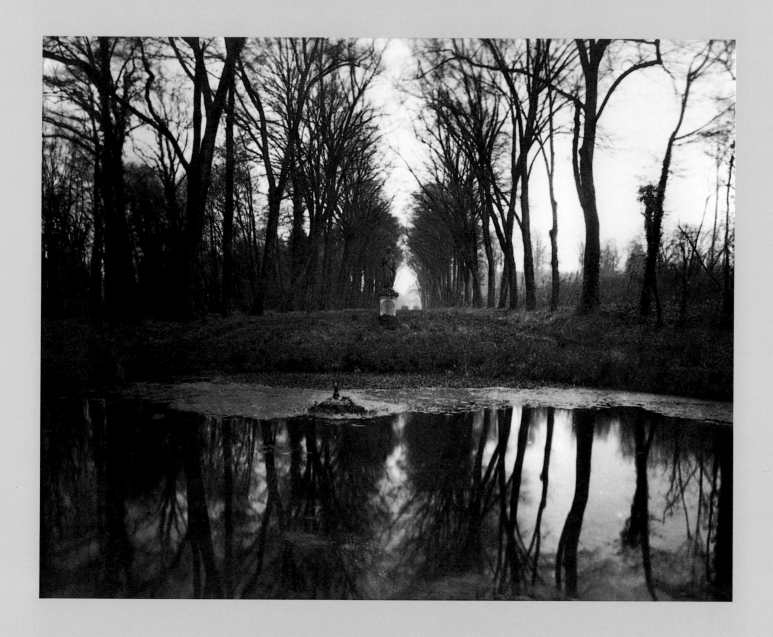

EUGÈNE ATGET THE REFLECTING POOL OF THE PARK AT SCEAUX / *Gelatin silver print, 1925*

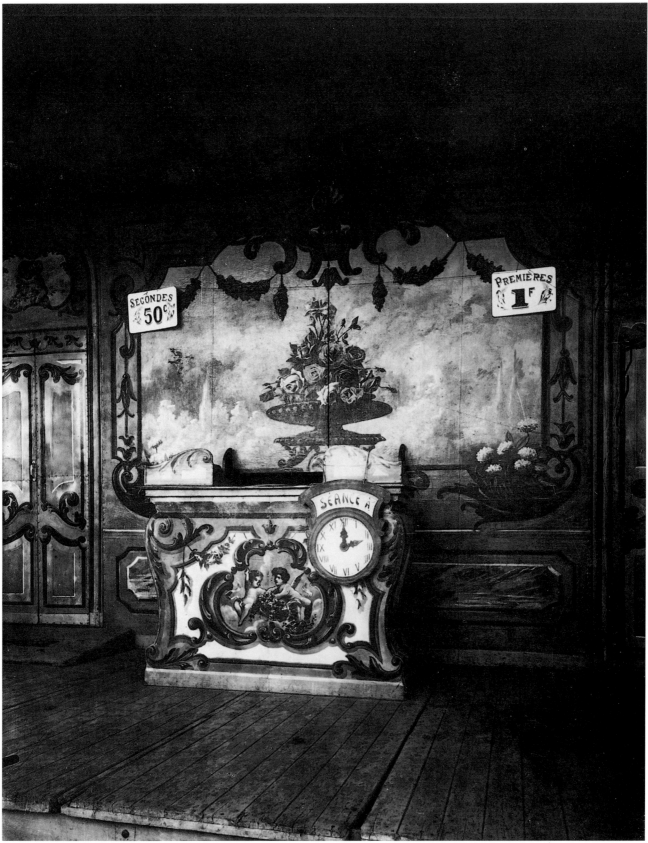

EUGÈNE ATGET FÊTE DU TRÔNE / *Gelatin silver print, ca. 1921–1925*

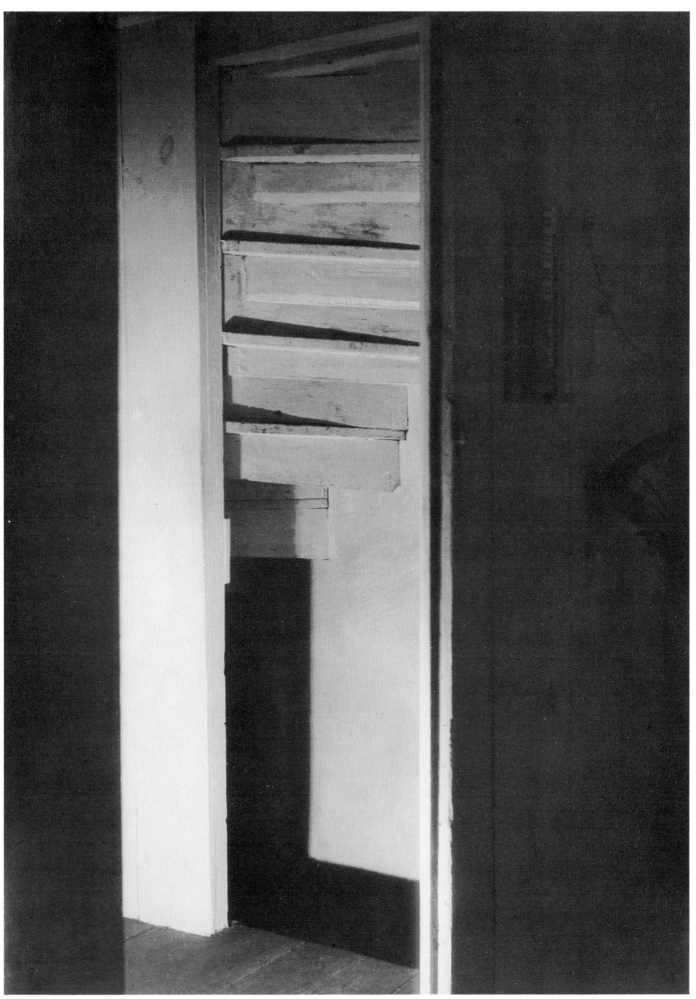

CHARLES SHEELER STAIRWELL (BUCKS COUNTY HOUSE) / *Gelatin silver print, ca. 1914–1917*

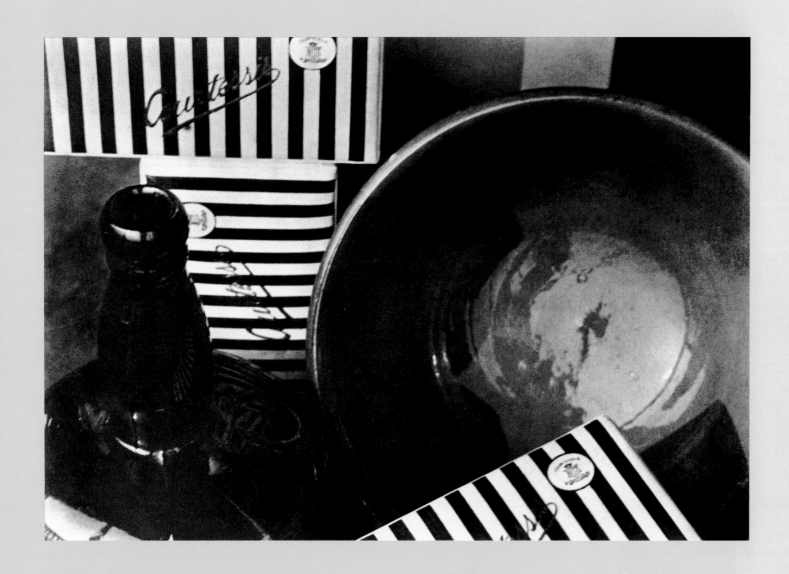

PAUL STRAND MATCHBOXES, BOWL AND BOTTLE, TWIN LAKES, CONNECTICUT / *Platinum print, 1916*

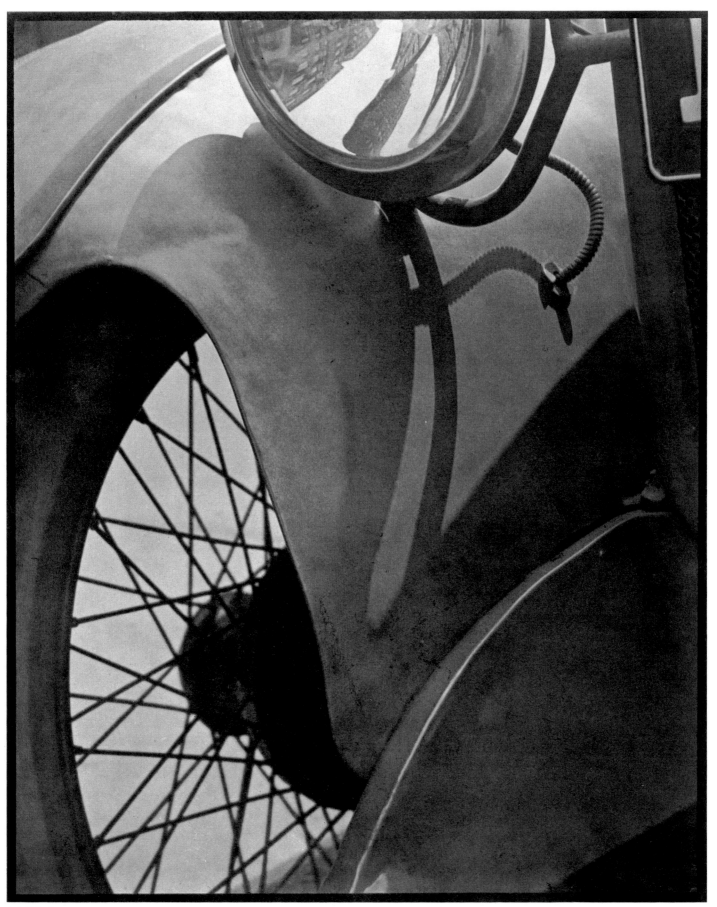

PAUL STRAND

WHEEL AND MUD GUARD, NEW YORK / *Platinum print, 1920*

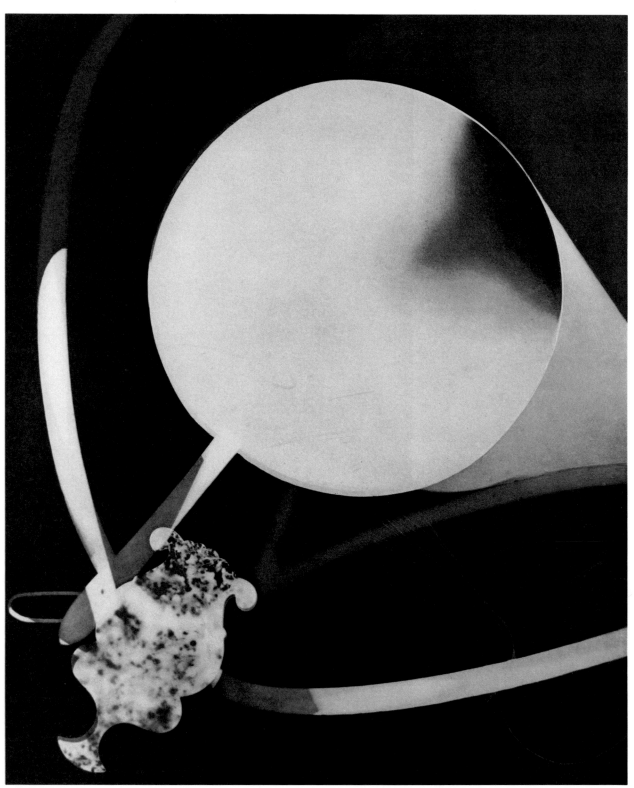

MAN RAY RAYOGRAPH (*from* L'ANGE HEURTEBISE) / *Photogravure, 1925*

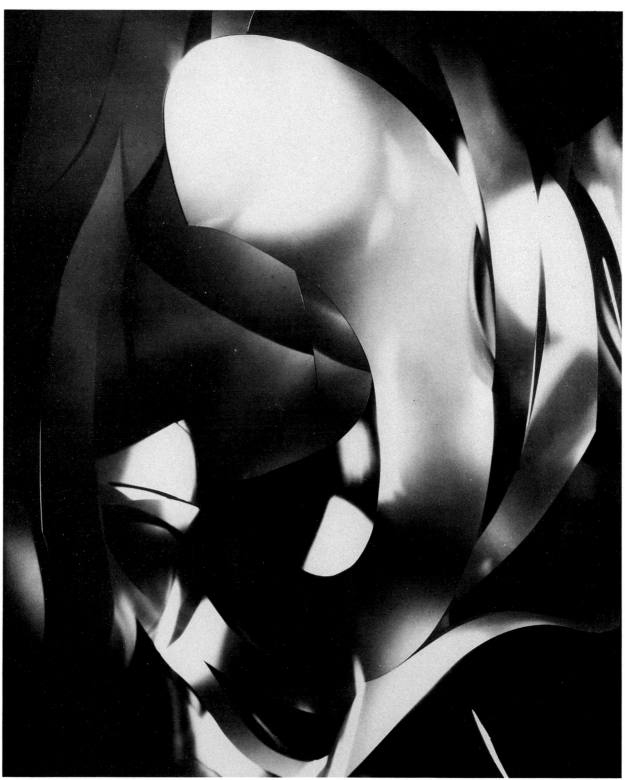

FRANCIS BRUGUIÈRE CUT PAPER ABSTRACTION / *Gelatin silver print, ca. 1925*

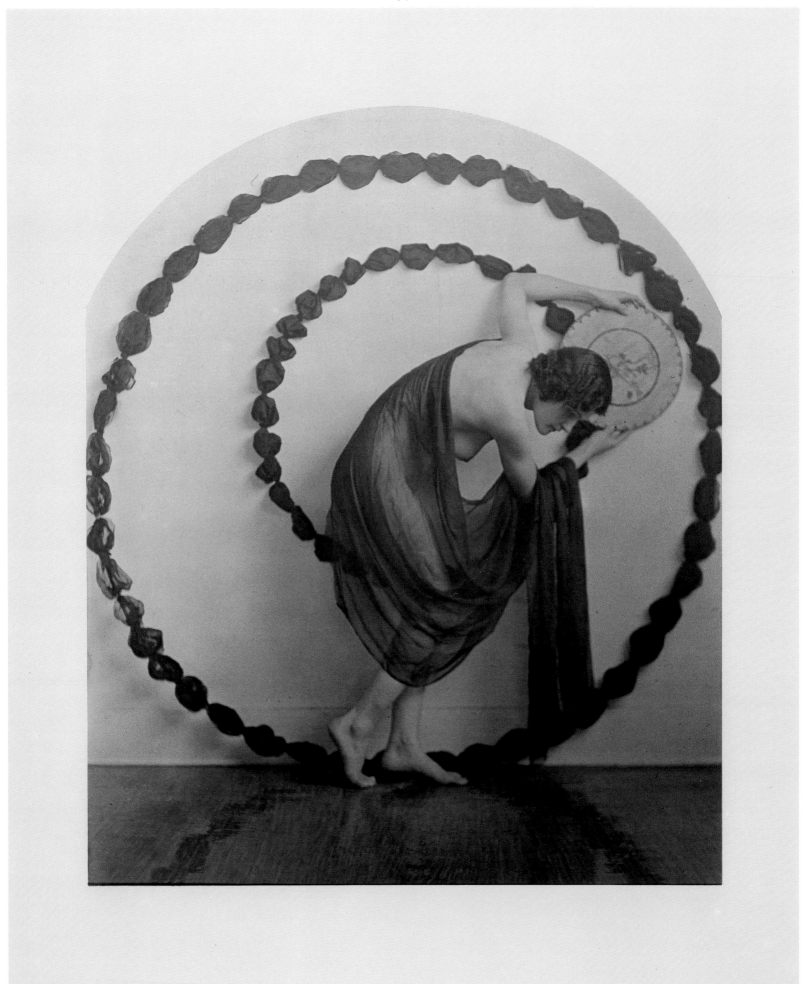

B. J. OCHSNER

STUDY IN CIRCLES / *Toned gelatin silver print, 1920s*

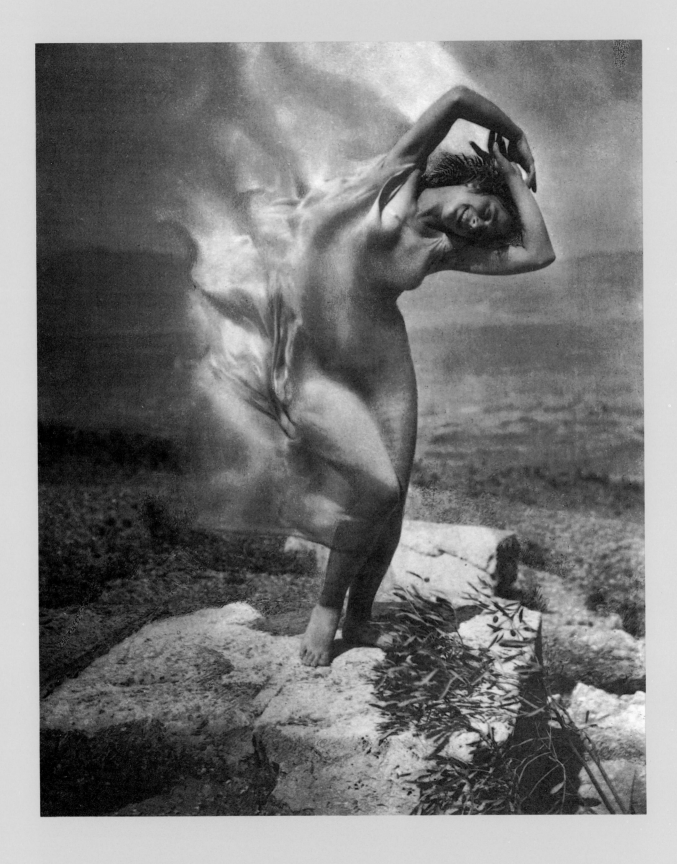

EDWARD STEICHEN WIND FIRE: THÉRÈSE DUNCAN ON THE ACROPOLIS / *Gelatin silver print, 1921*

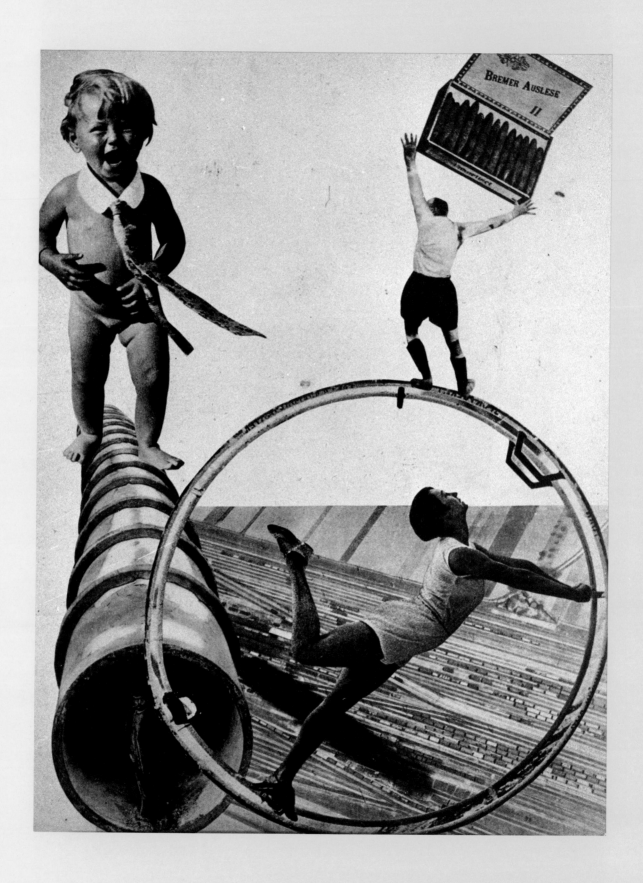

GÜNTHER HIRSCHEL-PROTSCH

UNTITLED / *Gelatin silver print photomontage, 1929*

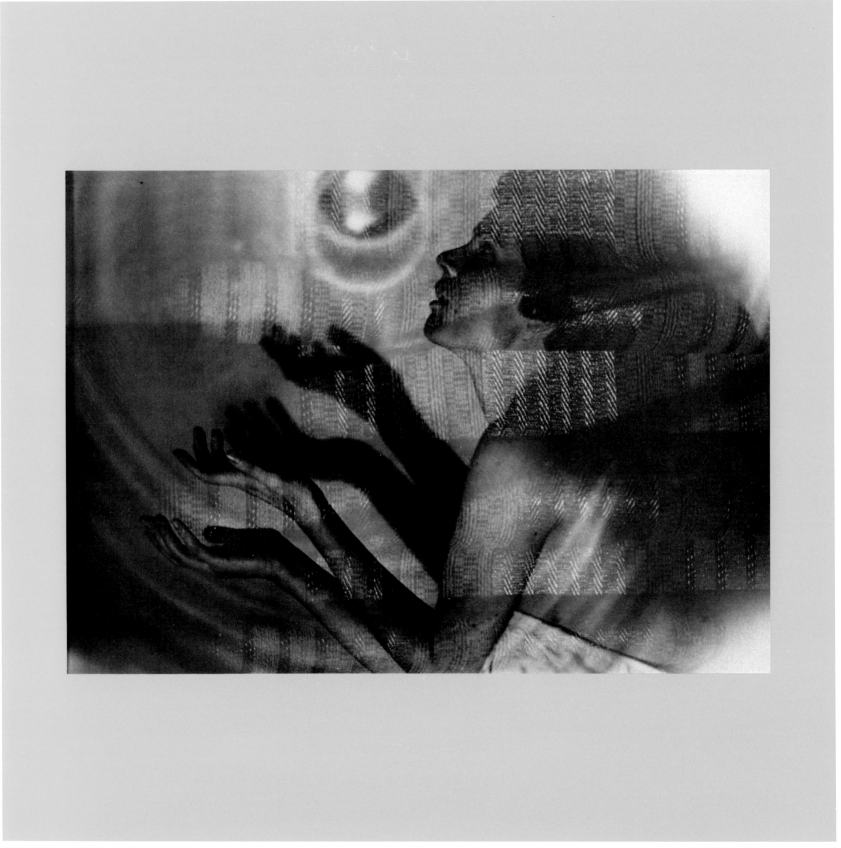

WENZEL AUGUST HABLIK

JUGGLING / *Gelatin silver print, ca. 1929*

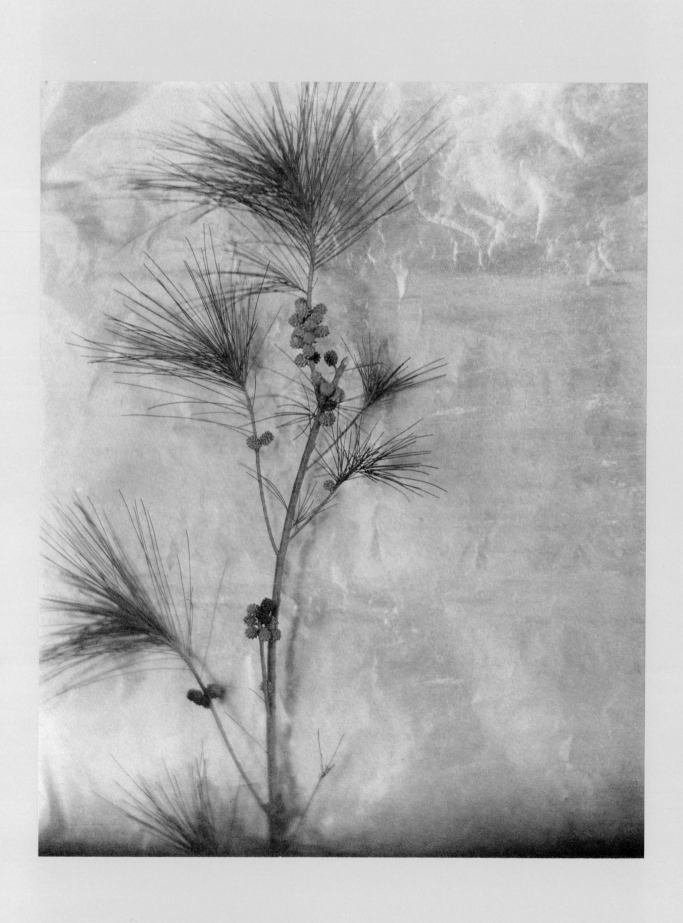

MARGRETHE MATHER

PINE BRANCH / *Platinum print, ca. 1930*

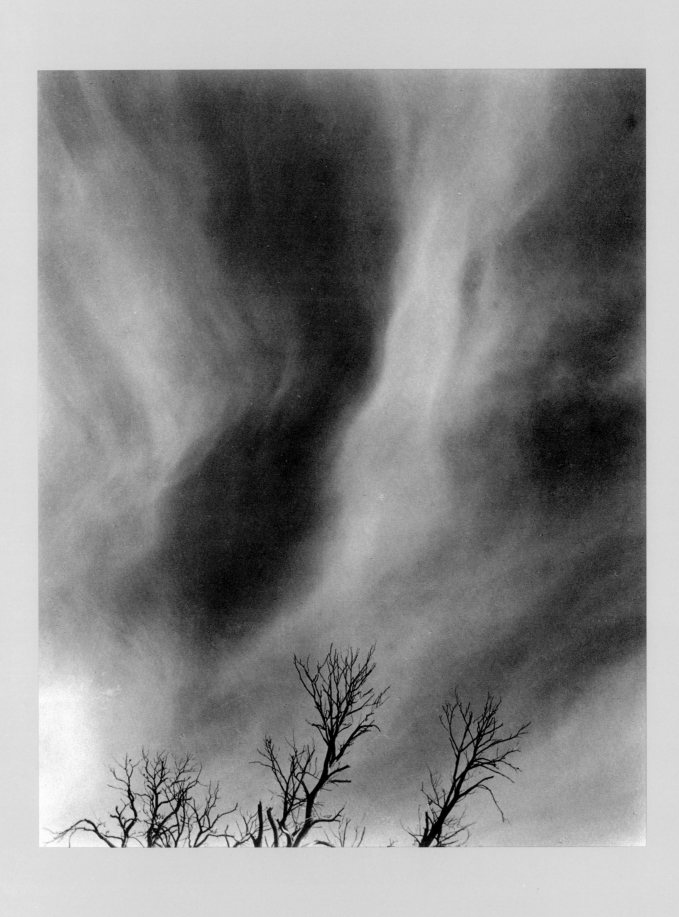

ALFRED STIEGLITZ

EQUIVALENT / *Gelatin silver print, 1930*

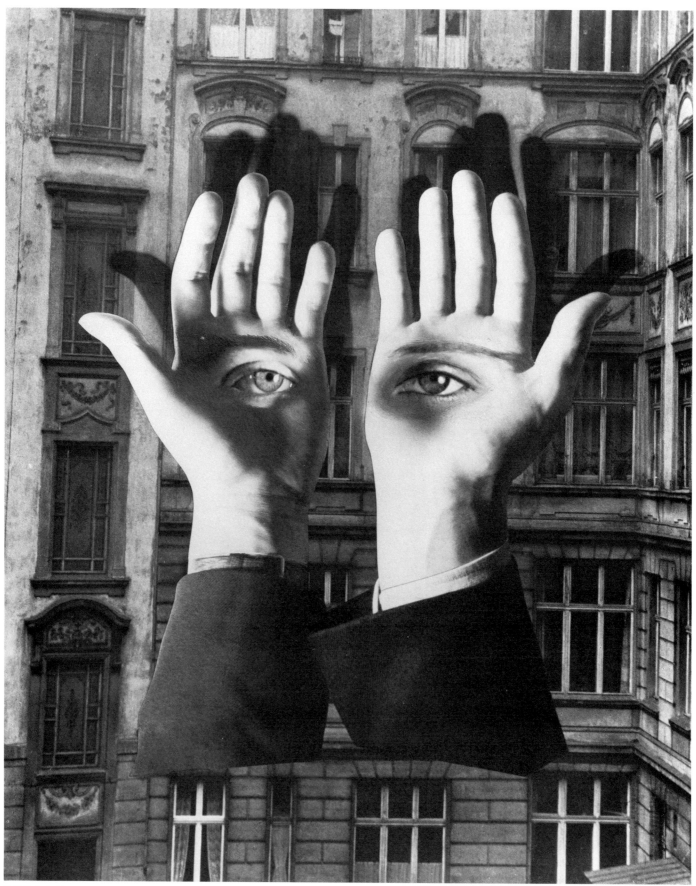

HERBERT BAYER

LONELY METROPOLITAN / *Gelatin silver photomontage, 1932*

PAUL CITROËN UNTITLED / *Gelatin silver print (touched by hand on both negative and print), 1930*

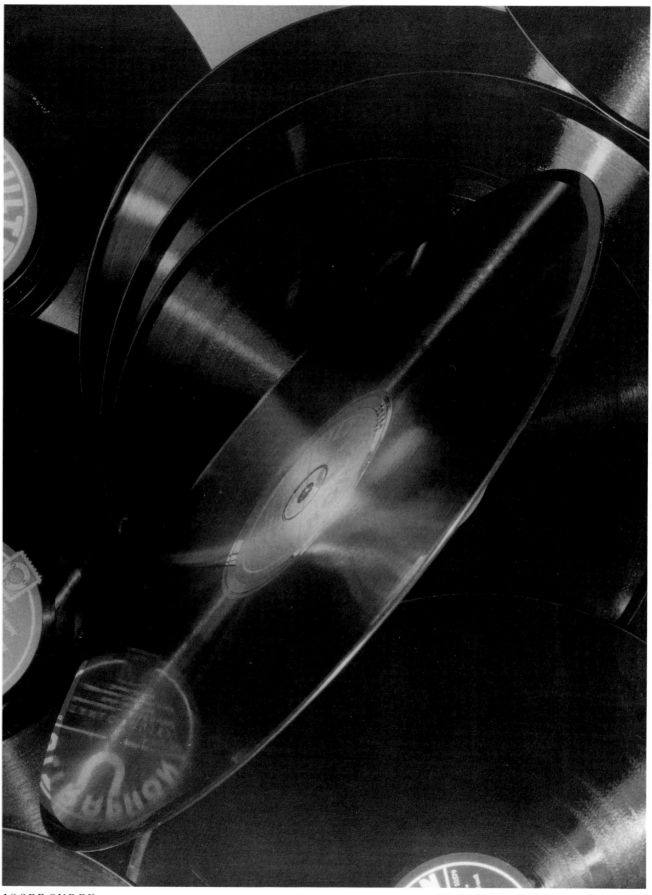

JOSEF SUDEK GRAMOPHONE DISCS / *Gelatin silver print, 1934*

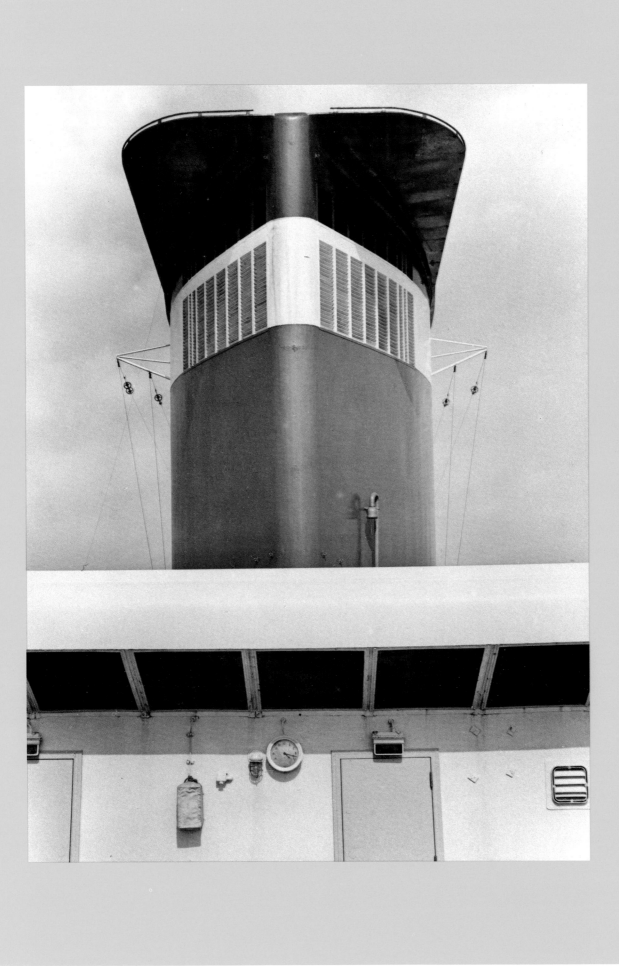

PAUL WOLFF *(Attrib.)* SHIP'S SMOKESTACK: THE S.S. *UNITED STATES* / *Gelatin silver print, 1930s*

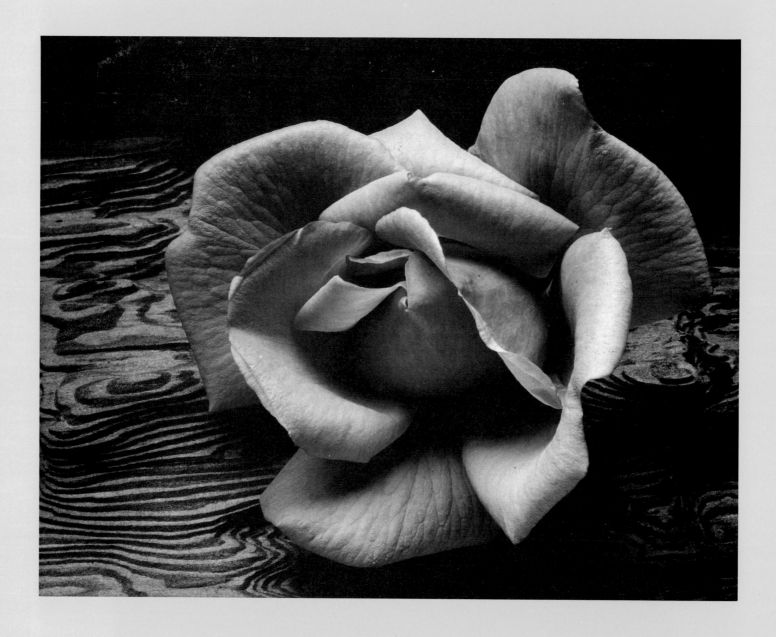

ANSEL ADAMS ROSE AND DRIFTWOOD, SAN FRANCISCO, CALIFORNIA / *Gelatin silver print, ca. 1932*

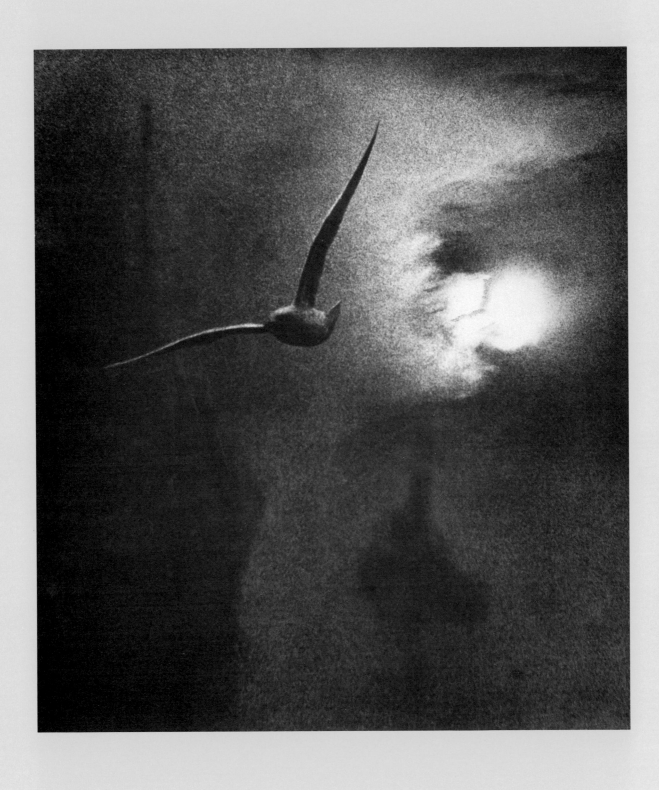

BILL BRANDT

EARLY MORNING ON THE RIVER, LONDON BRIDGE / *Gelatin silver print, ca. 1940*

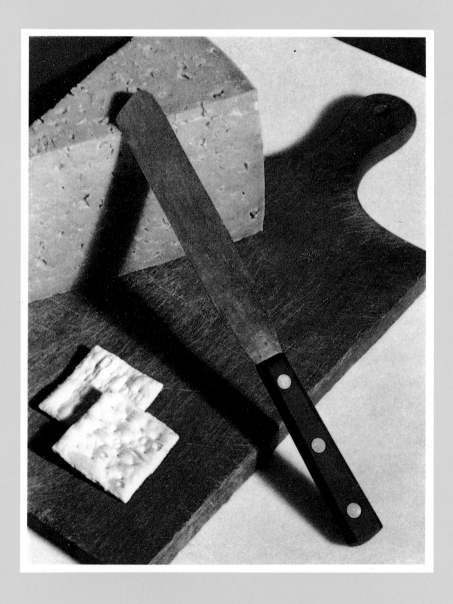

PAUL OUTERBRIDGE, JR.

CHEESE AND CRACKERS / *Platinum print, 1922*

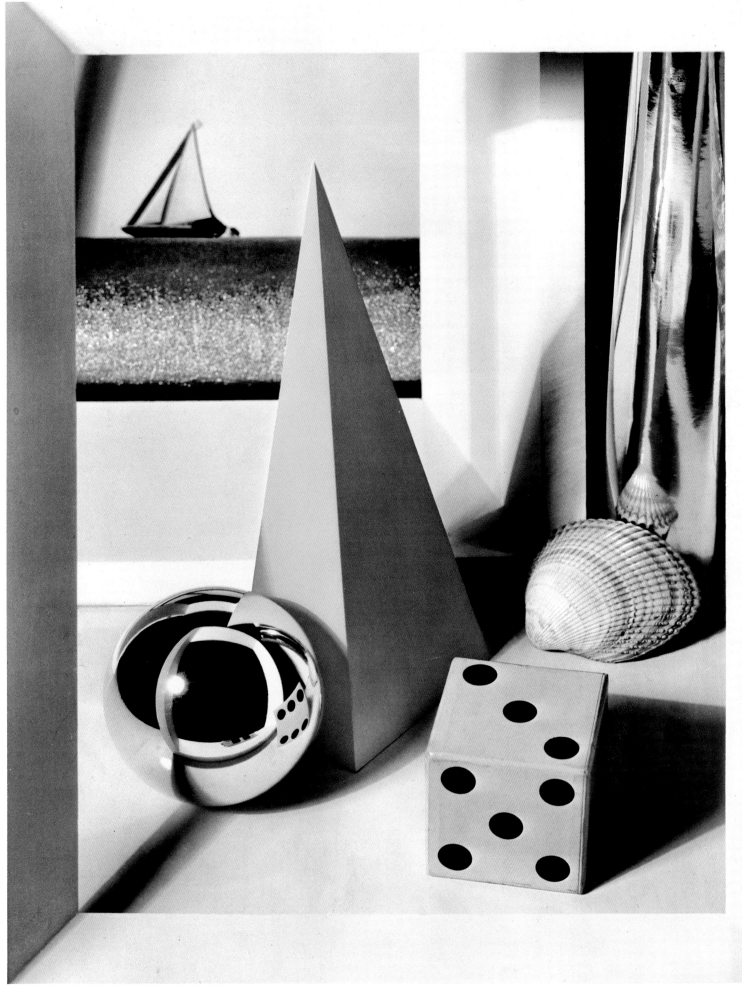

PAUL OUTERBRIDGE, JR.

IMAGES DE DEAUVILLE / *Three-color carbro print, 1938*

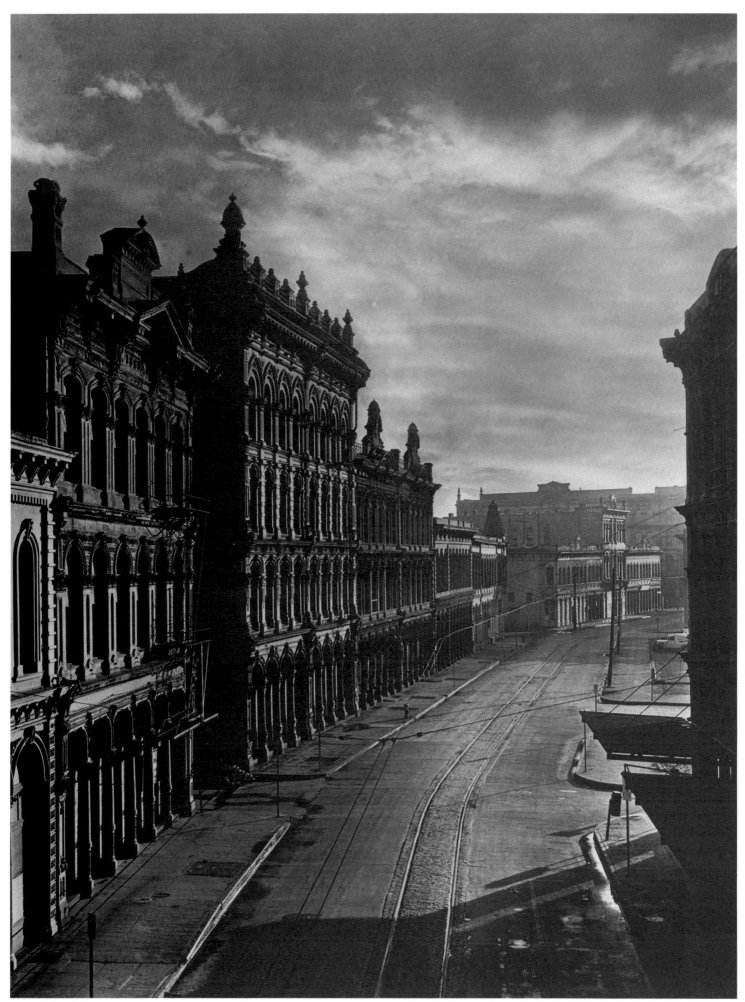

MINOR WHITE

FRONT STREET, PORTLAND, OREGON / *Gelatin silver print, 1939*

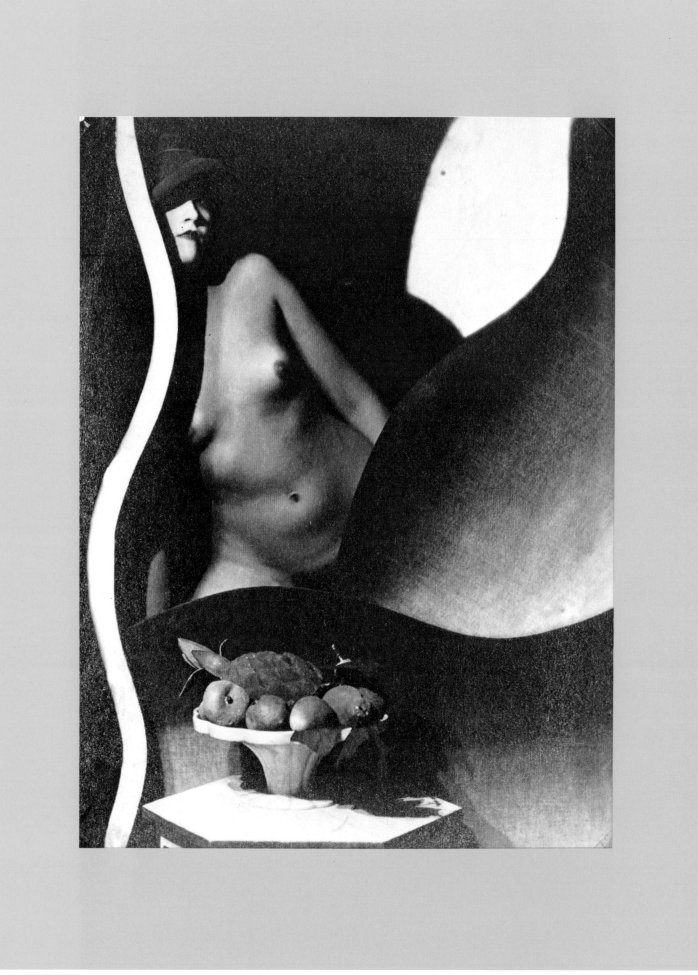

FRANTIŠEK DRTIKOL

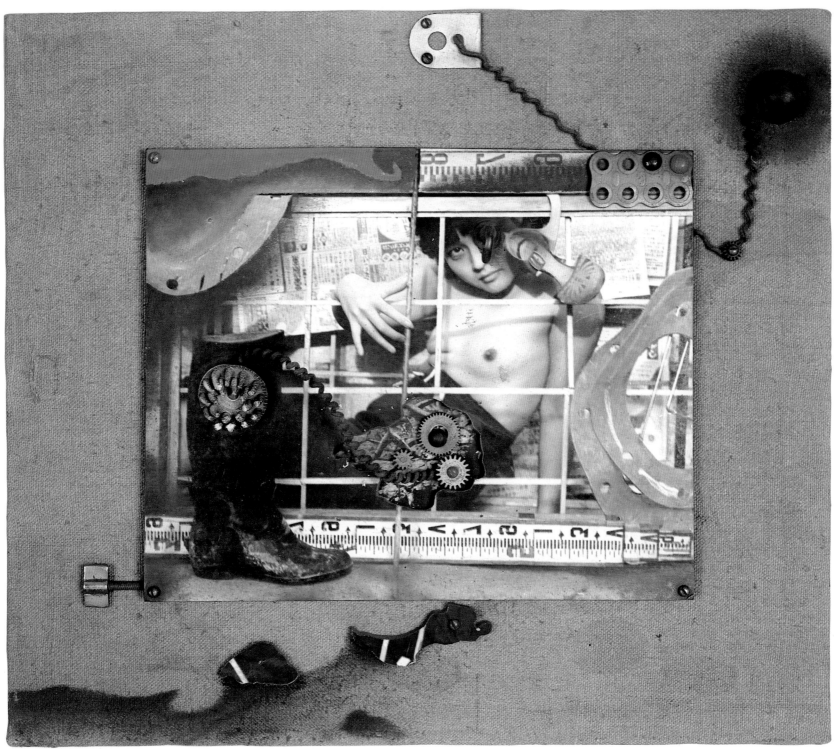

GINGO HANAWA

OBJECT / *Photocollage, 1931*

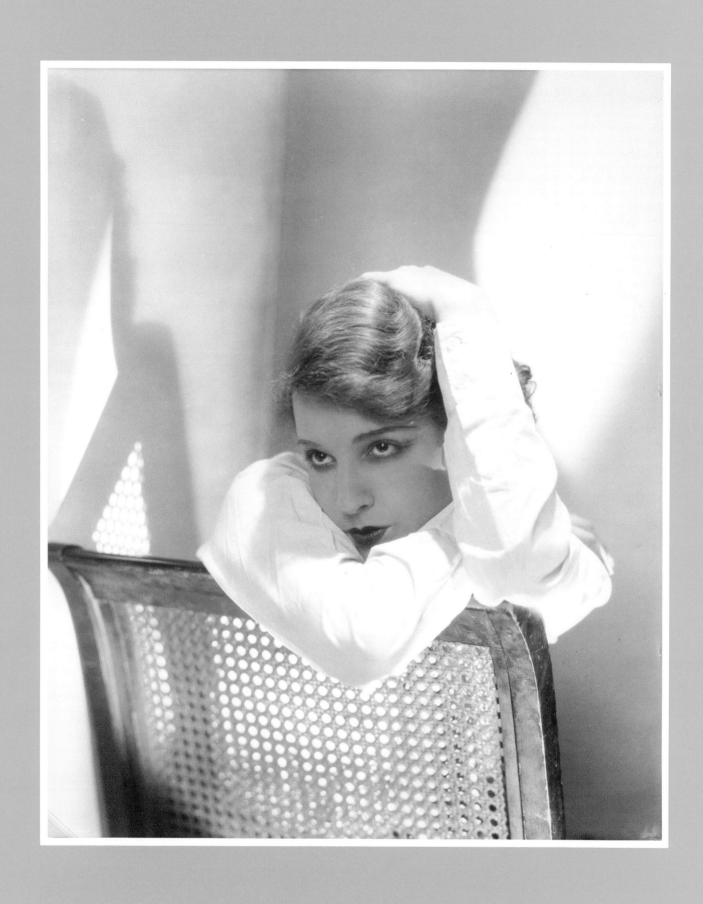

EDWARD STEICHEN

LILY DAMITA / *Gelatin silver print, 1928*

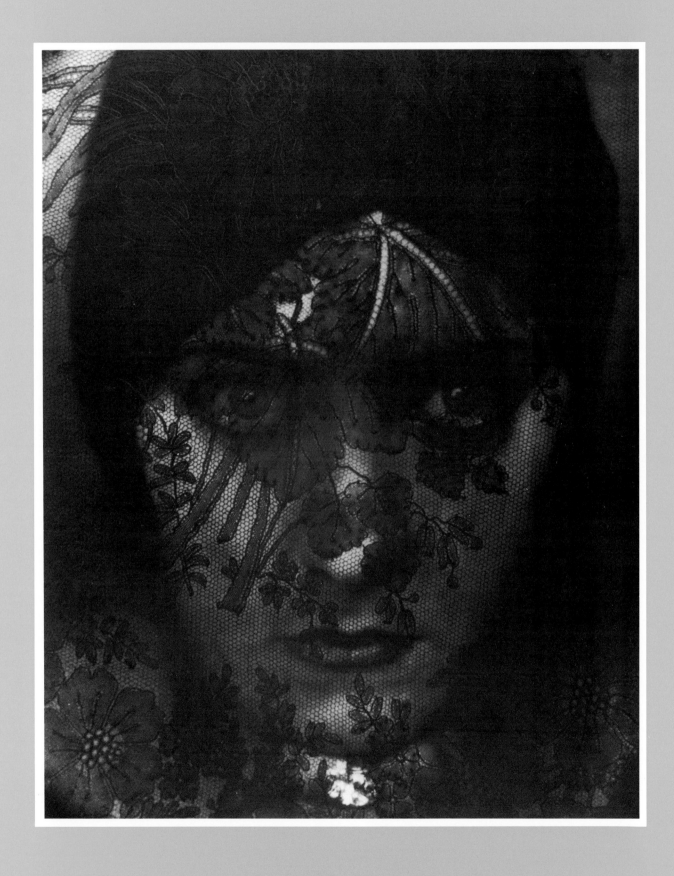

EDWARD STEICHEN

GLORIA SWANSON / *Gelatin silver print, 1920*

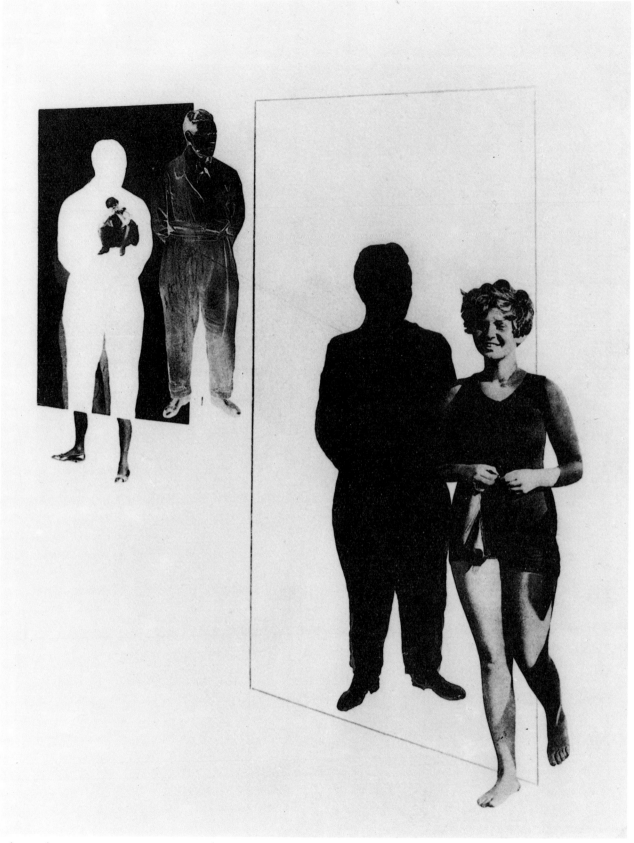

LÁSZLÓ MOHOLY-NAGY PHOTO-PLASTIK JEALOUSY / *Gelatin silver photomontage, 1928*

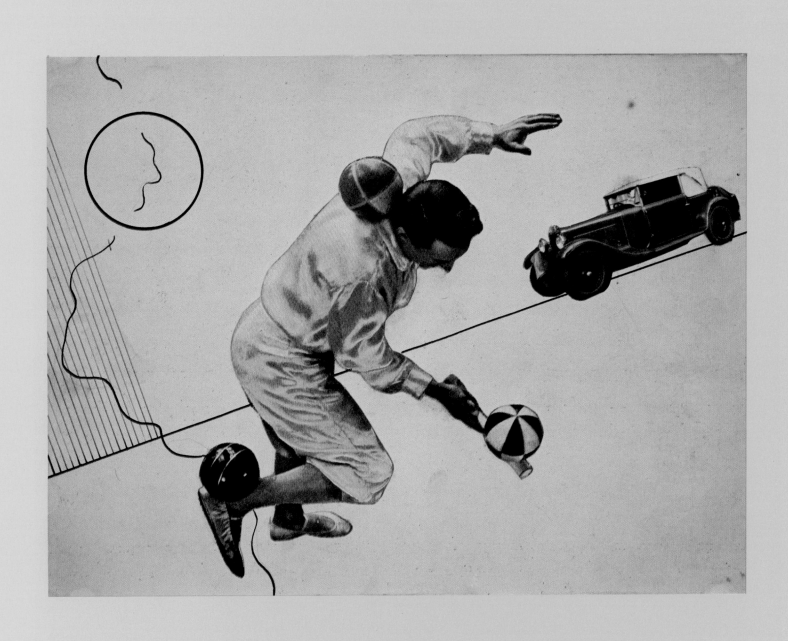

CAS OORTHUYS

UNTITLED / *Gelatin silver photomontage, ca. 1932*

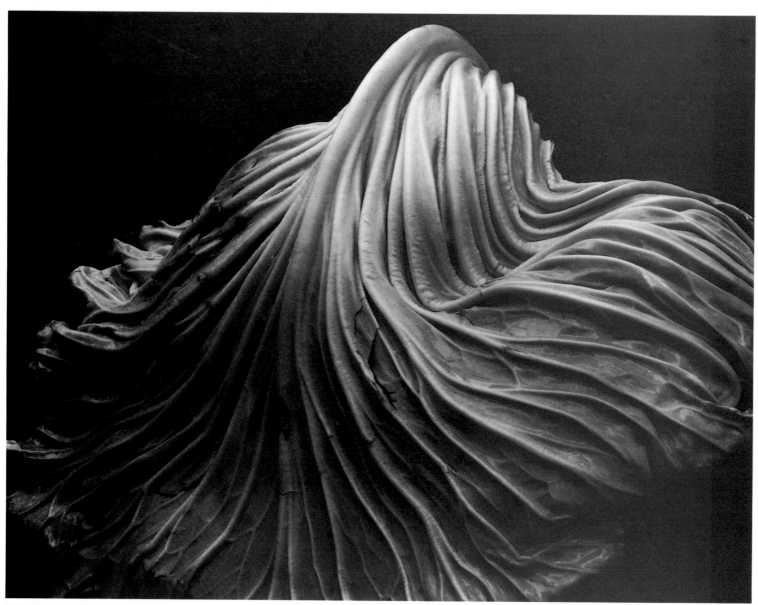

EDWARD WESTON

CABBAGE LEAF / *Gelatin silver print, 1931*

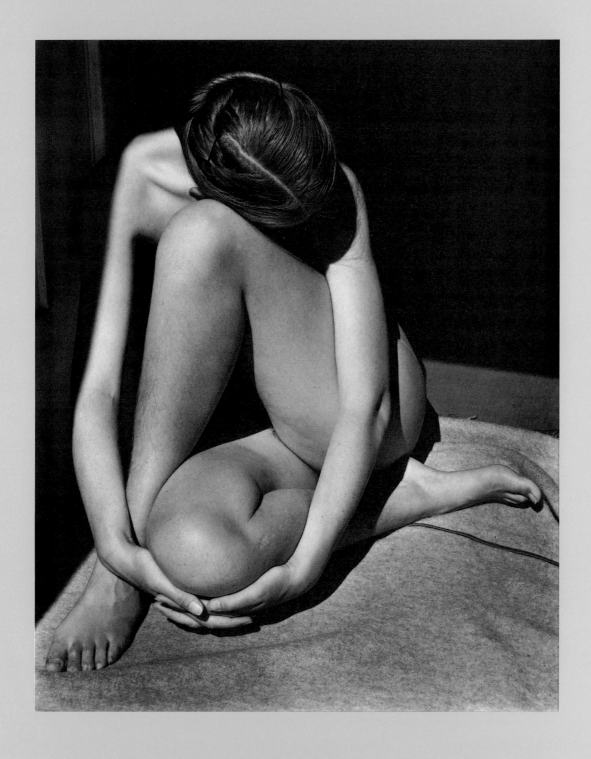

EDWARD WESTON

NUDE / *Gelatin silver print, 1936*

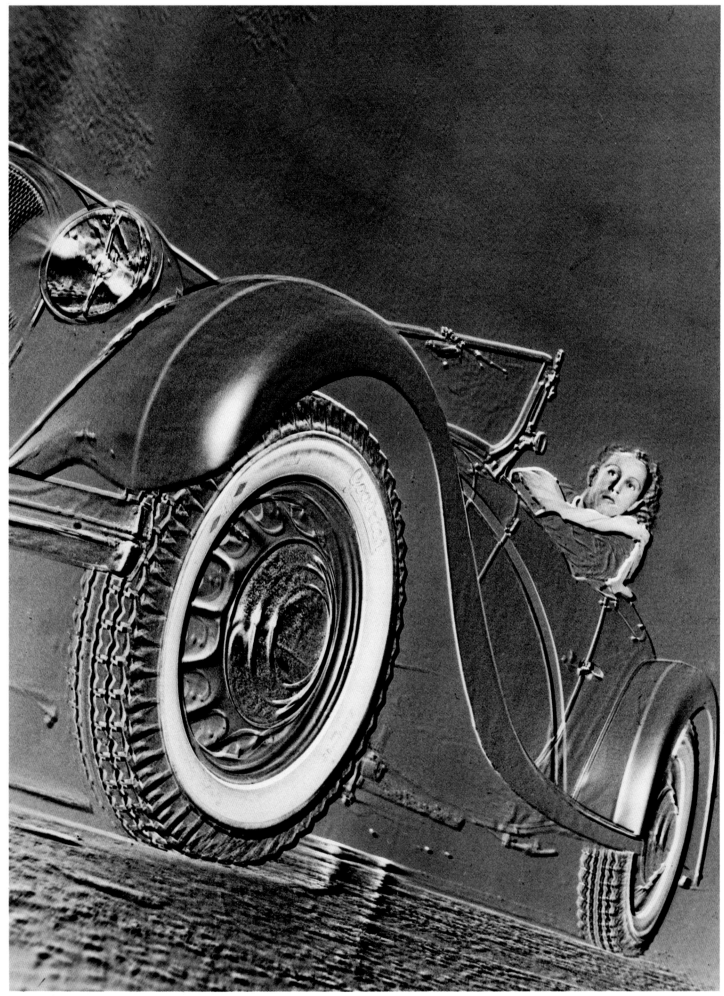

ANDRÉ STEINER UNTITLED / *Gelatin silver print from a solarized negative, ca. 1930*

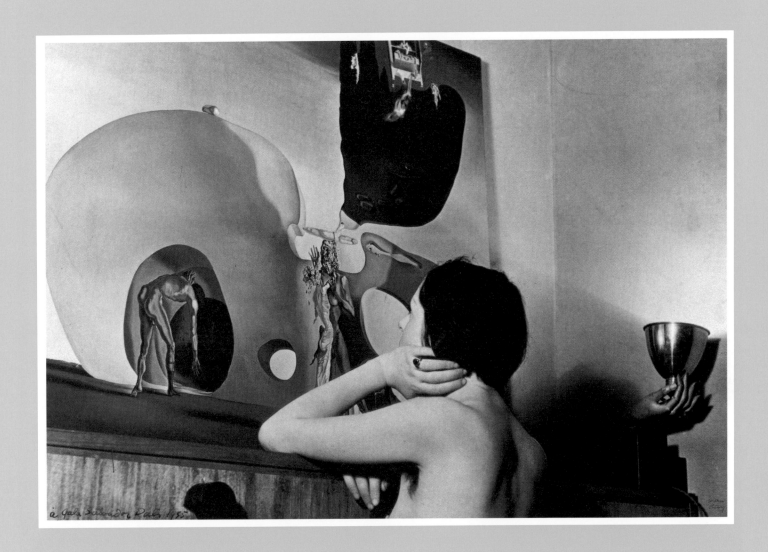

MAN RAY GALA DALI LOOKING AT "THE BIRTH OF LIQUID DESIRES" / *Gelatin silver print, 1935*

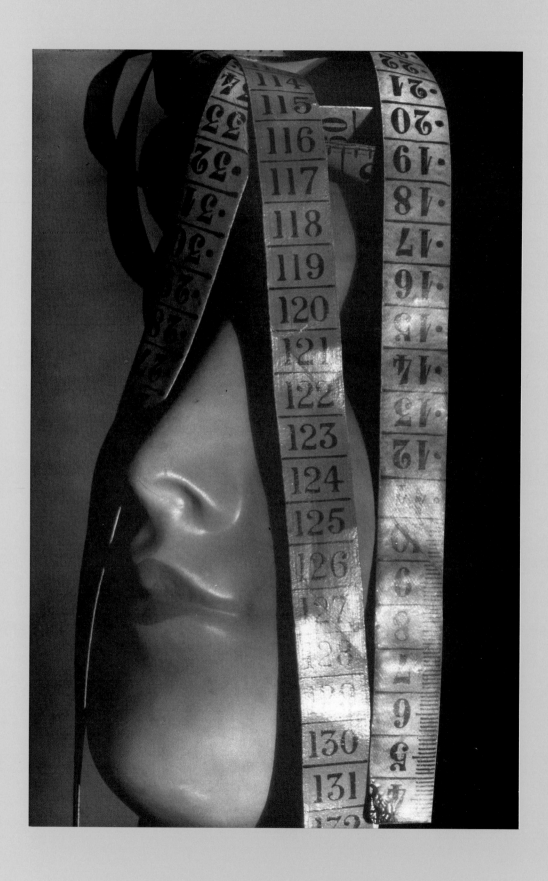

MEHEMED FEHMY AGHA

UNTITLED / *Gelatin silver print, 1930*

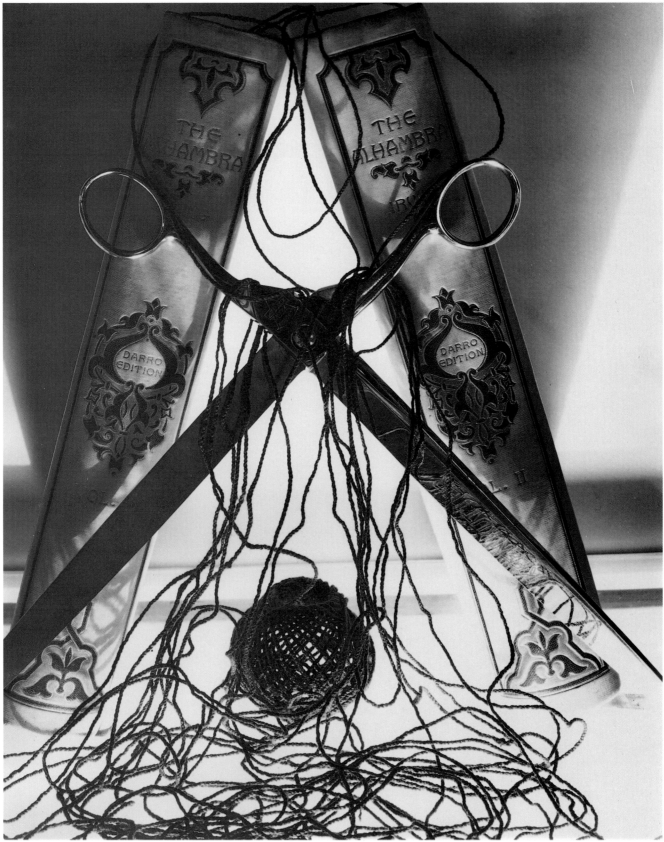

LAURA GILPIN

SCISSORS, STRING AND TWO BOOKS (P . P . A . CAMP) / *Gelatin silver print, 1930*

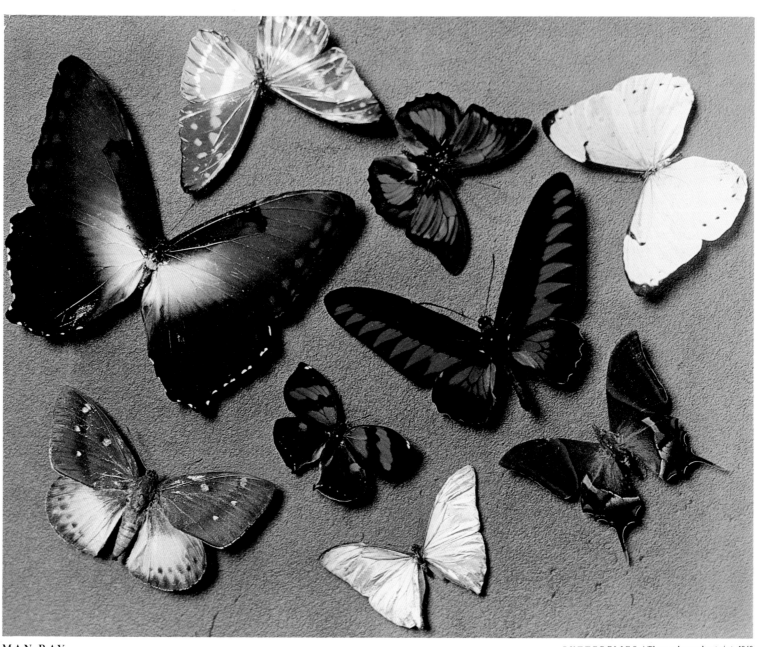

MAN RAY

BUTTERFLIES / *Three-color carbro print, 1940*

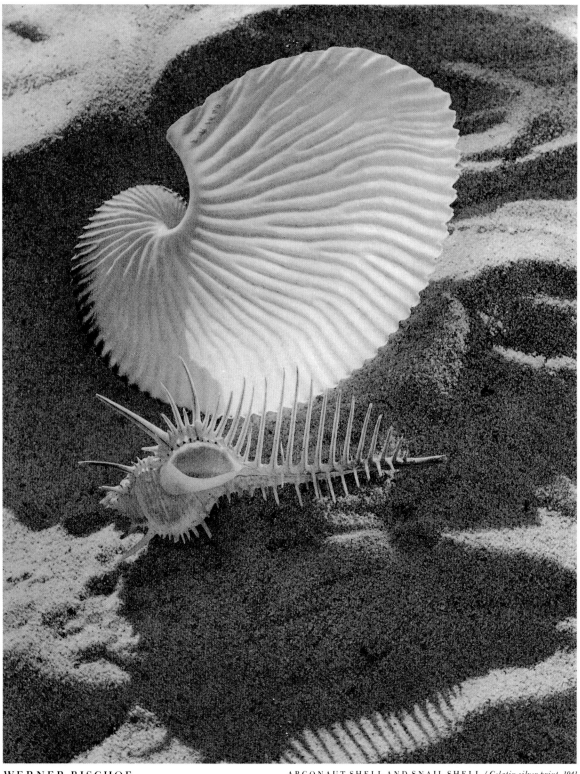

WERNER BISCHOF ARGONAUT SHELL AND SNAIL SHELL / *Gelatin silver print, 1941*

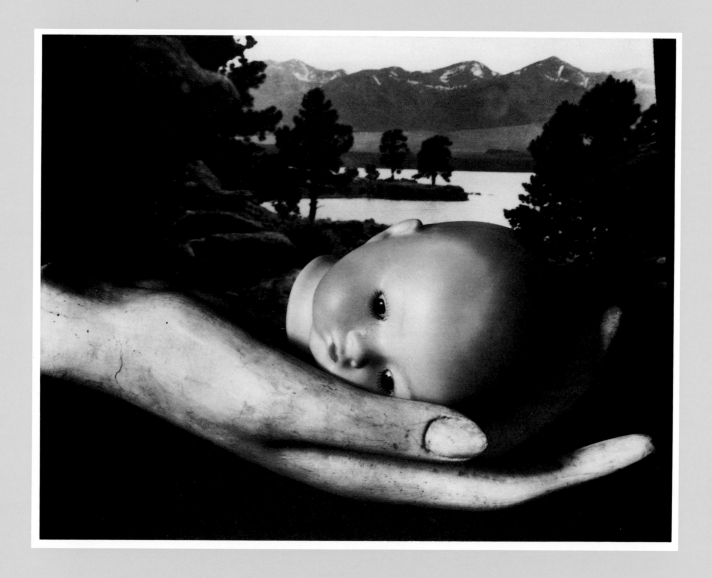

RUTH BERNHARD

CREATION / Gelatin silver print, 1936

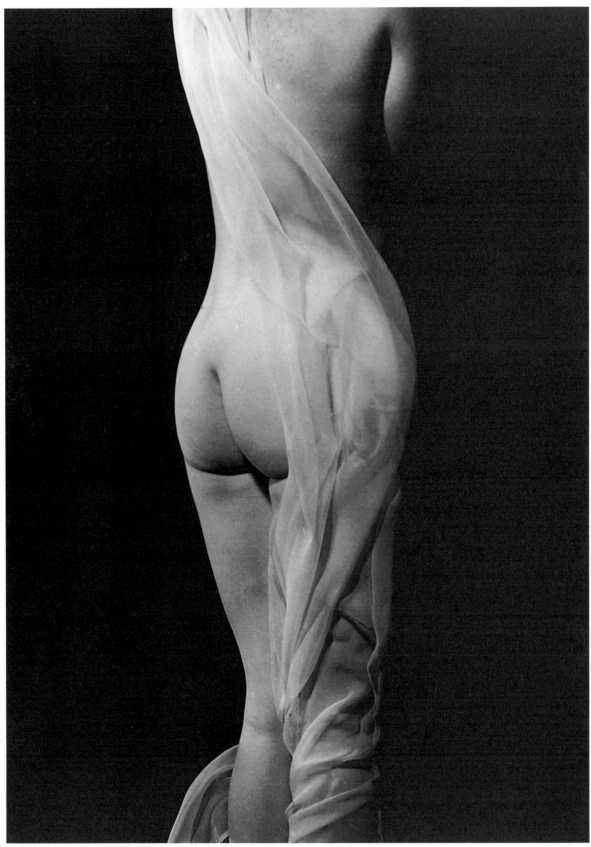

ERWIN BLUMENFELD NUDE WITH VEIL, PARIS / *Gelatin silver print, 1936*

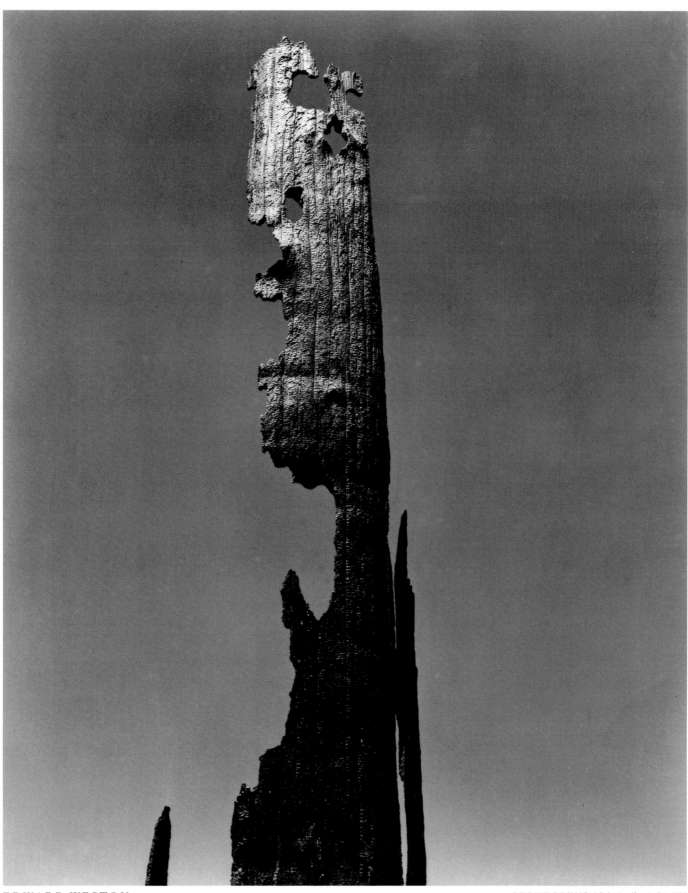

EDWARD WESTON

BURNT STUMP / *Gelatin silver print, 1937*

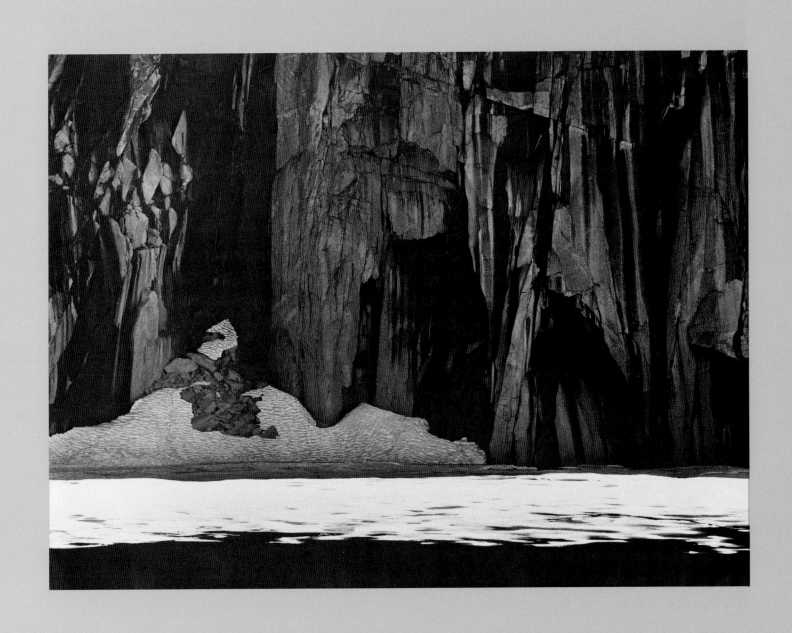

ANSEL ADAMS

FROZEN LAKE AND CLIFFS, SEQUOIA NATIONAL PARK / *Gelatin silver print, 1932*

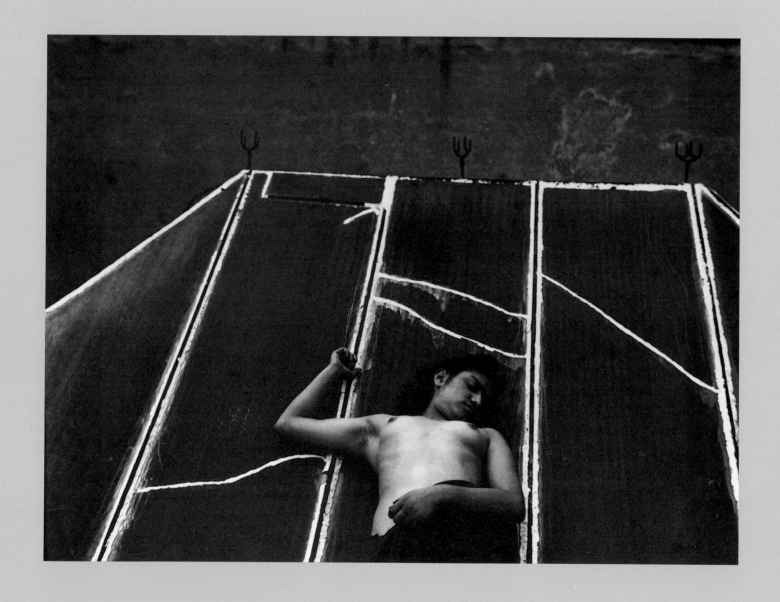

MANUEL ALVAREZ BRAVO

SPARROW, OF COURSE (SKYLIGHT) / *Gelatin silver print, 1938*

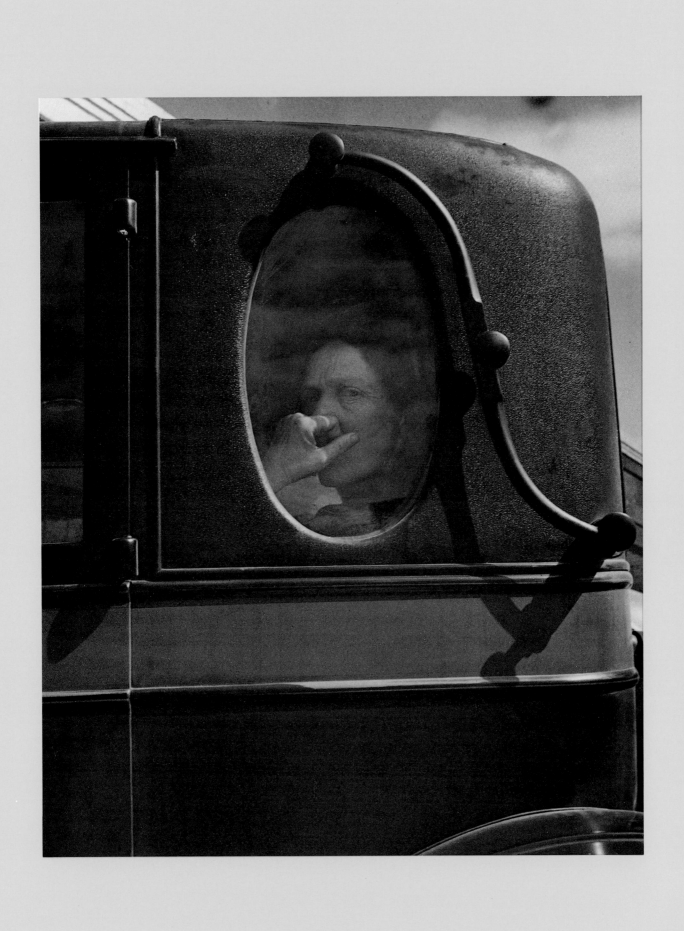

DOROTHEA LANGE FUNERAL CORTEGE, THE END OF AN ERA IN A SMALL VALLEY TOWN, CALIFORNIA / *Gelatin silver print, 1938*

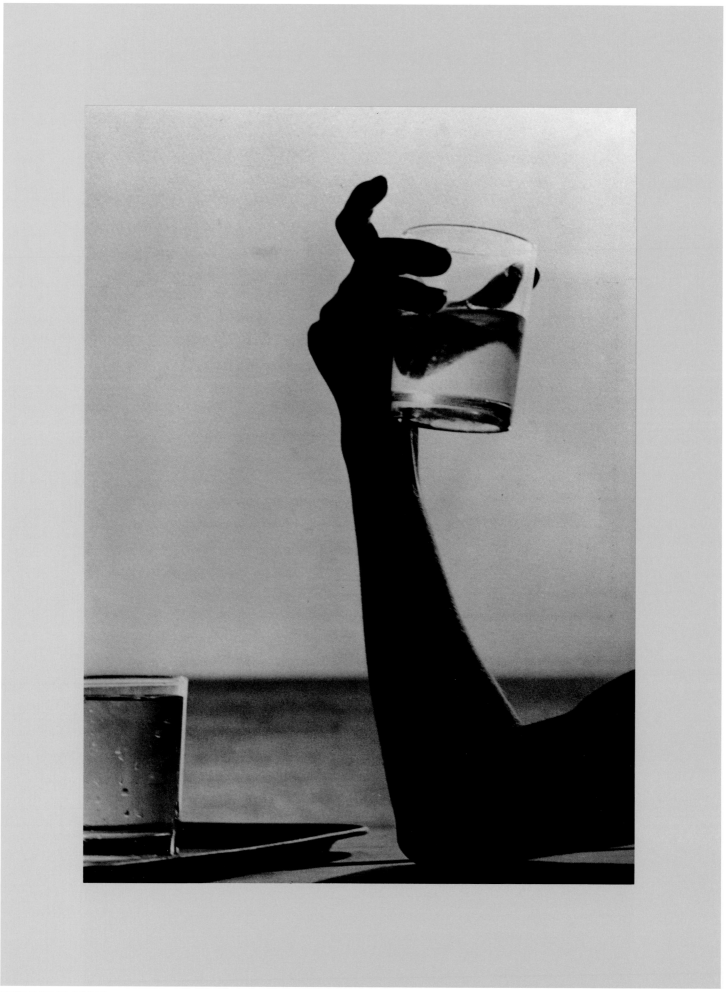

HERBERT LIST

THIRST, GREECE, 1939 / *Gelatin silver print, 1939*

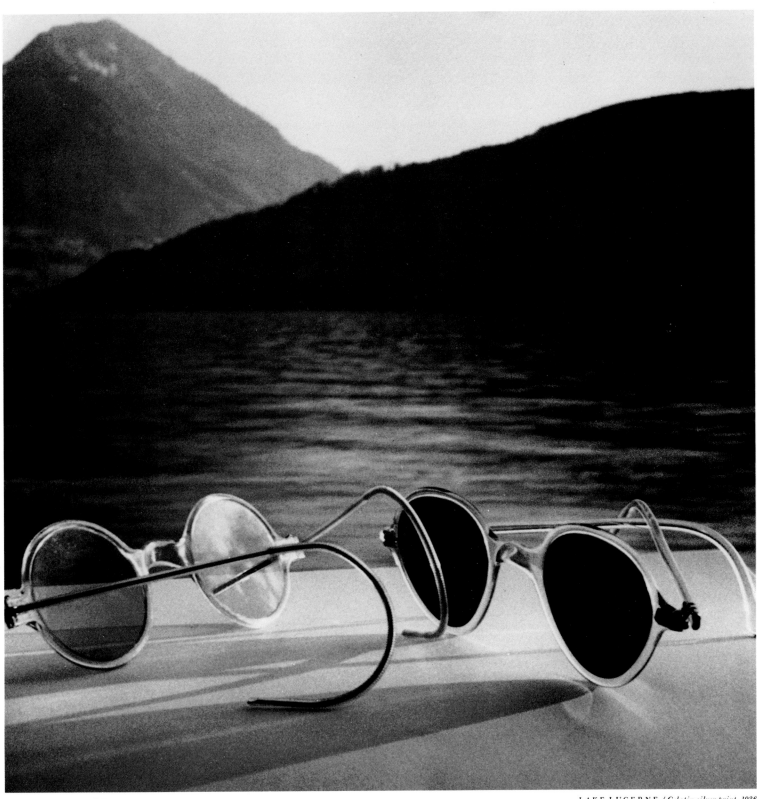

HERBERT LIST

LAKE LUCERNE / *Gelatin silver print, 1936*

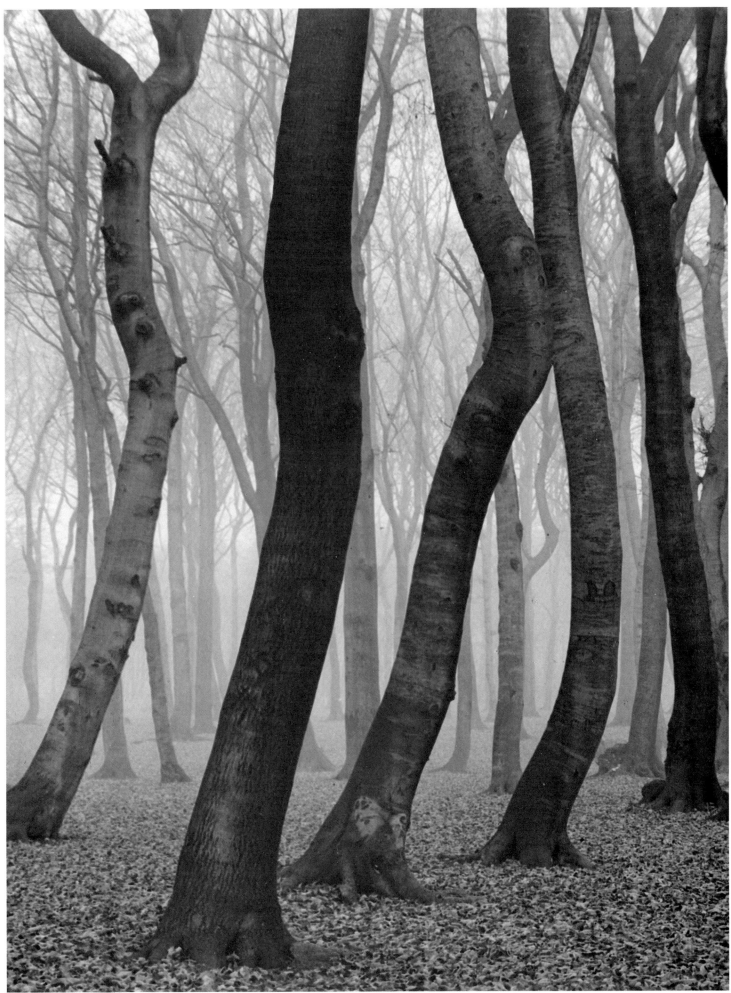

ALBERT RENGER-PATZSCH WOODS IN AUTUMN / *Gelatin silver print, 1936*

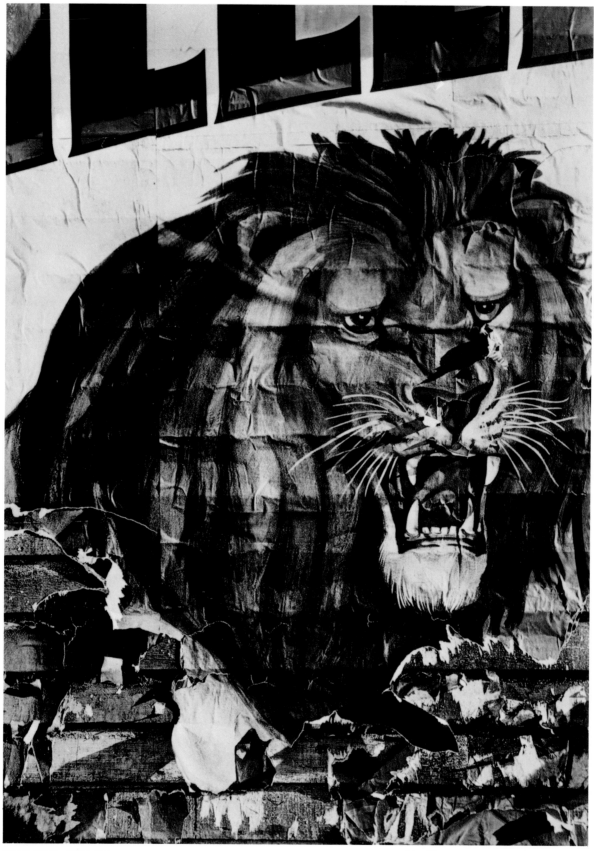

WALKER EVANS CIRCUS POSTER / *Gelatin silver print, 1936*

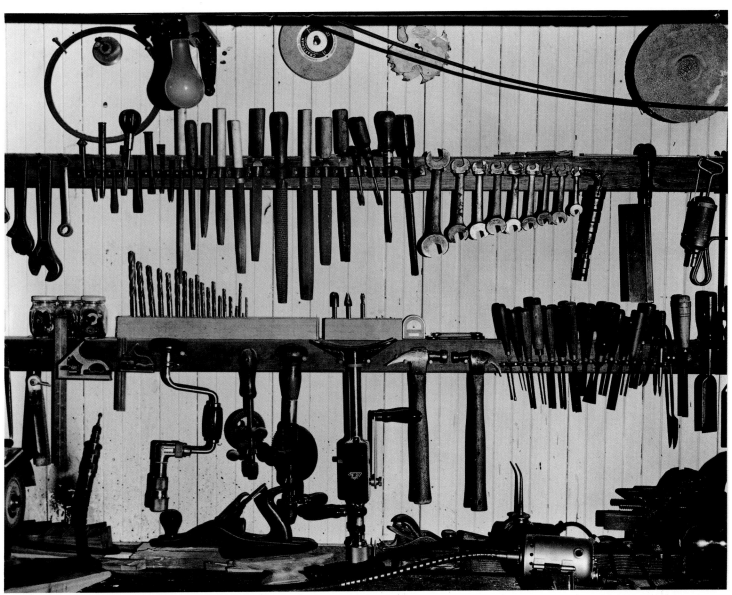

BRETT WESTON

UNTITLED / *Gelatin silver print, 1940*

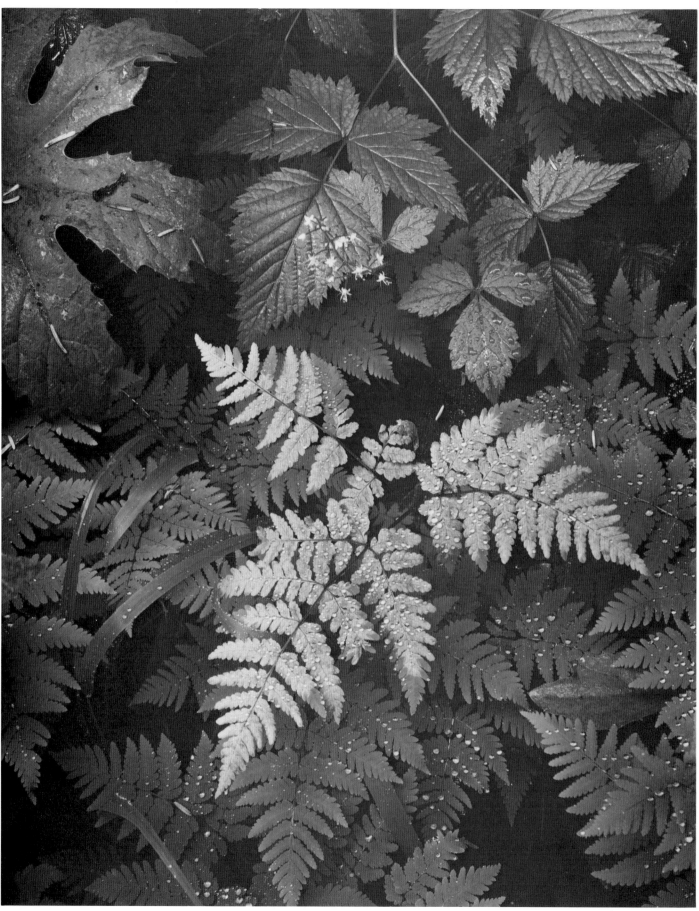

ANSEL ADAMS LEAVES, MOUNT RAINIER NATIONAL PARK, WASHINGTON / *Gelatin silver print, ca. 1942*

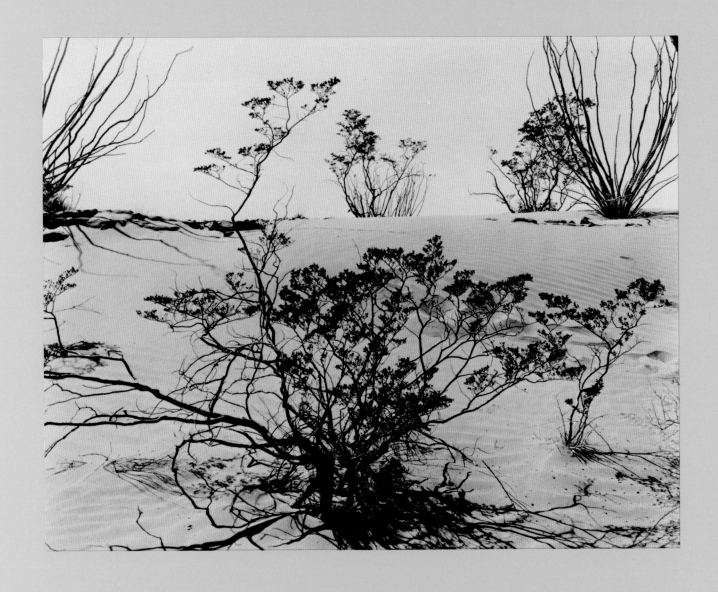

BRETT WESTON

TEXAS DESERT / *Gelatin silver print, 1939*

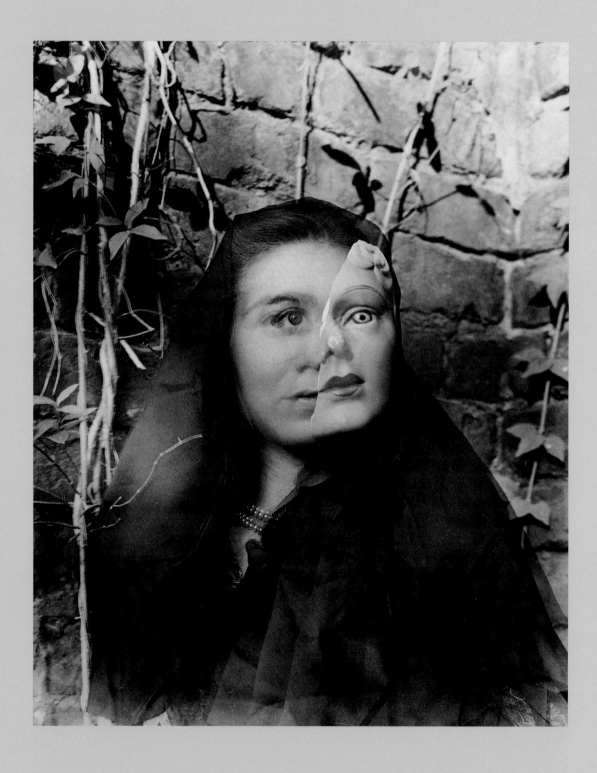

CLARENCE JOHN LAUGHLIN

THE MASKS GROW TO US / *Gelatin silver print from multiple negatives, 1947*

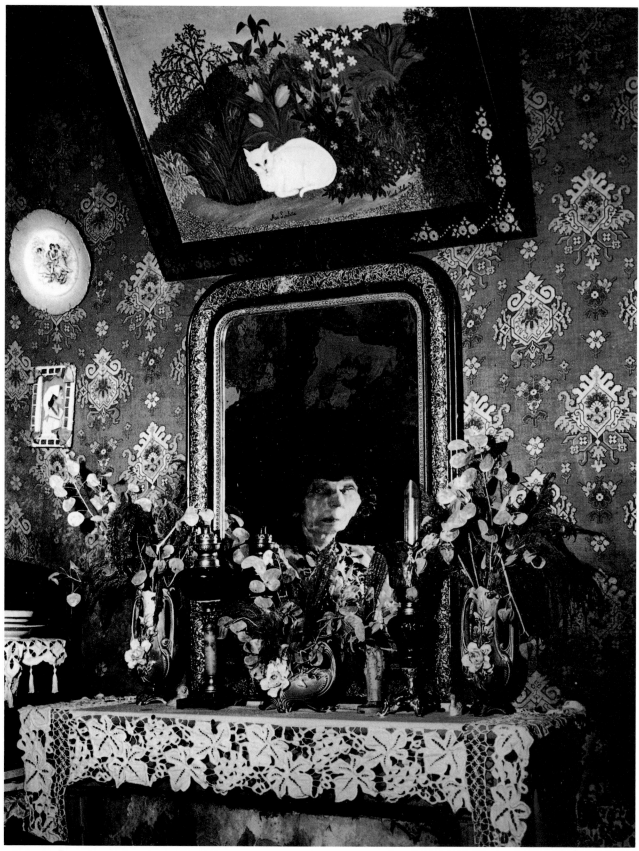

BRASSAÏ *A WOMAN — PRIMITIVE PAINTER / Gelatin silver print, ca. 1930s*

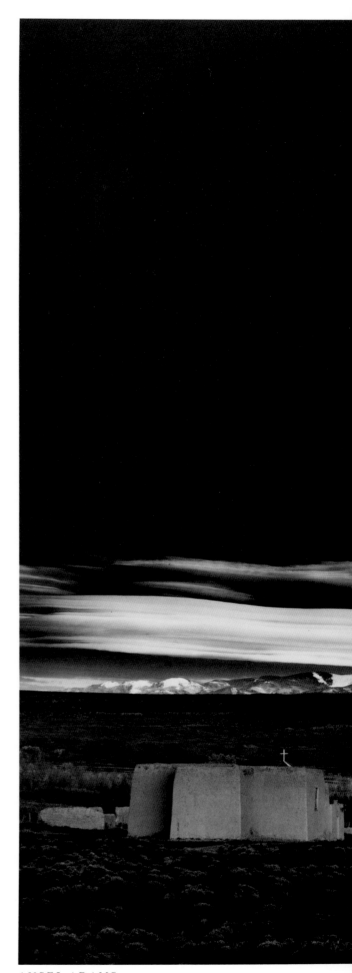

ANSEL ADAMS

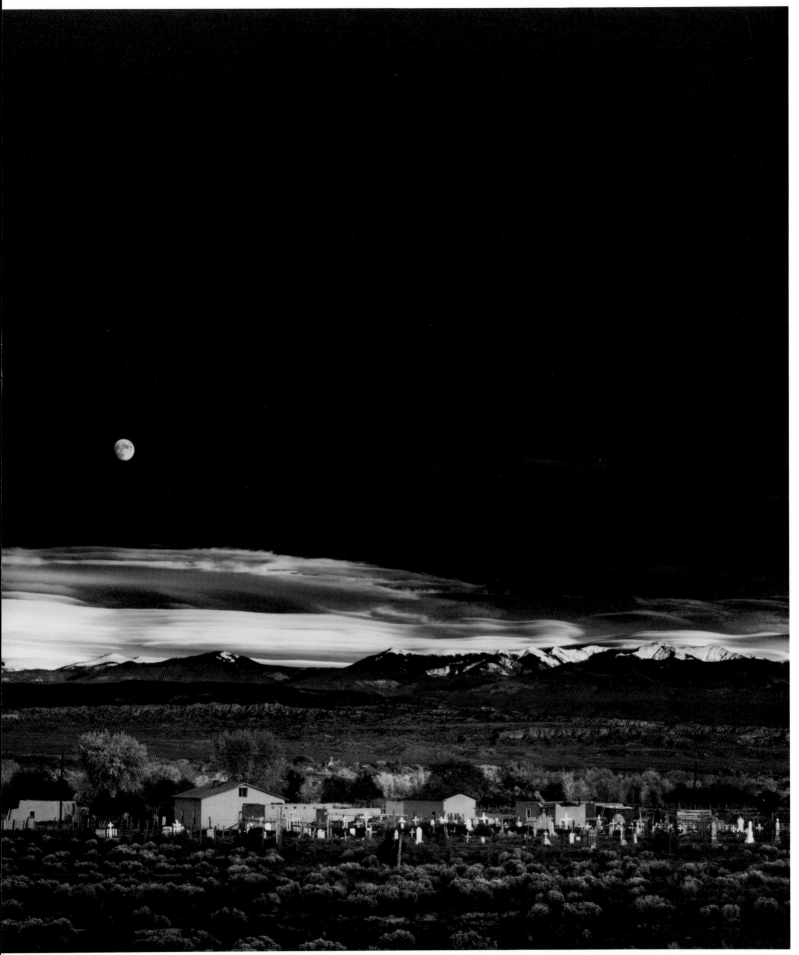

MOONRISE, HERNANDEZ, NEW MEXICO / *Gelatin silver print, 1941*

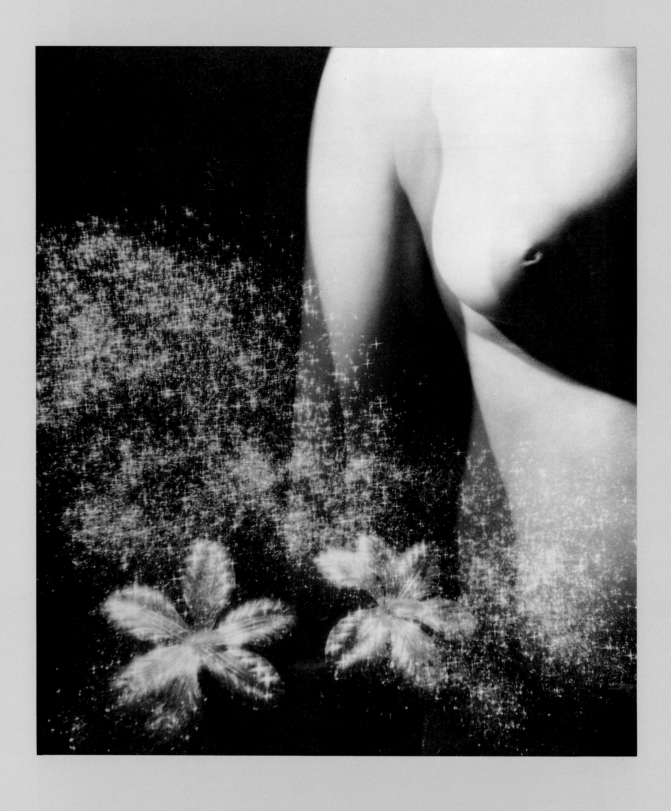

YASUZO NOJIMA

ABSTRACT NUDE / *Gelatin silver print, 1940*

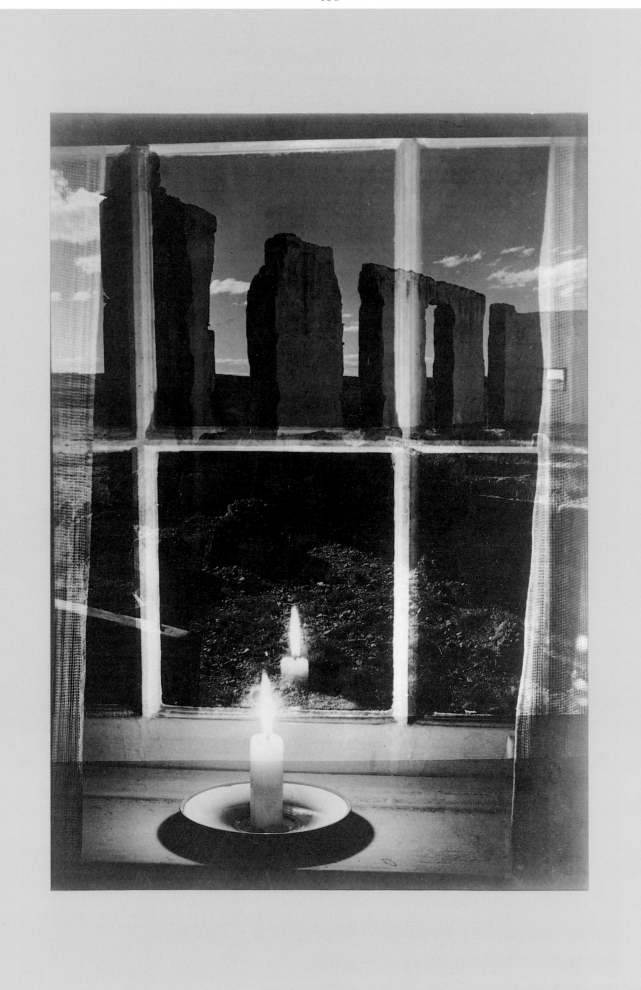

ROLF TIETGENS

UNTITLED / *Gelatin silver print, 1945*

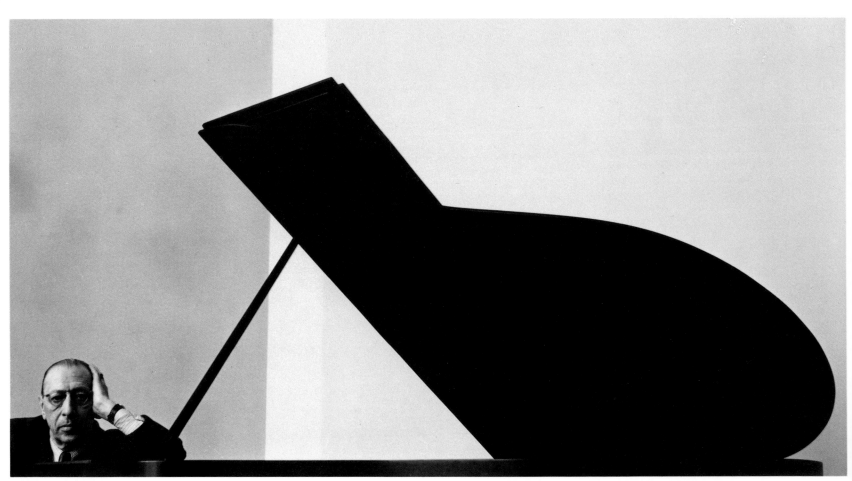

ARNOLD NEWMAN

IGOR STRAVINSKY / *Gelatin silver print, 1946*

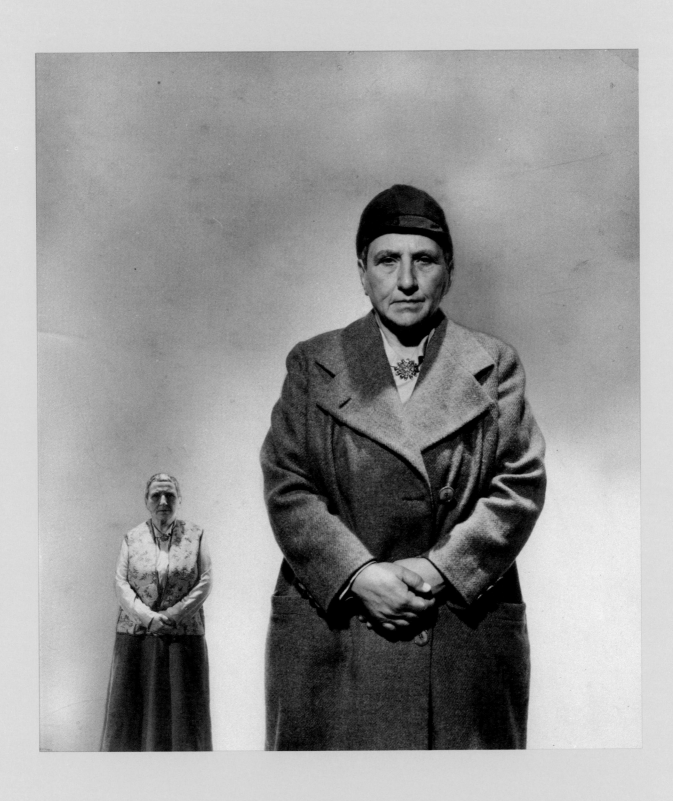

CECIL BEATON

GERTRUDE STEIN / *Gelatin silver photocollage , 1945*

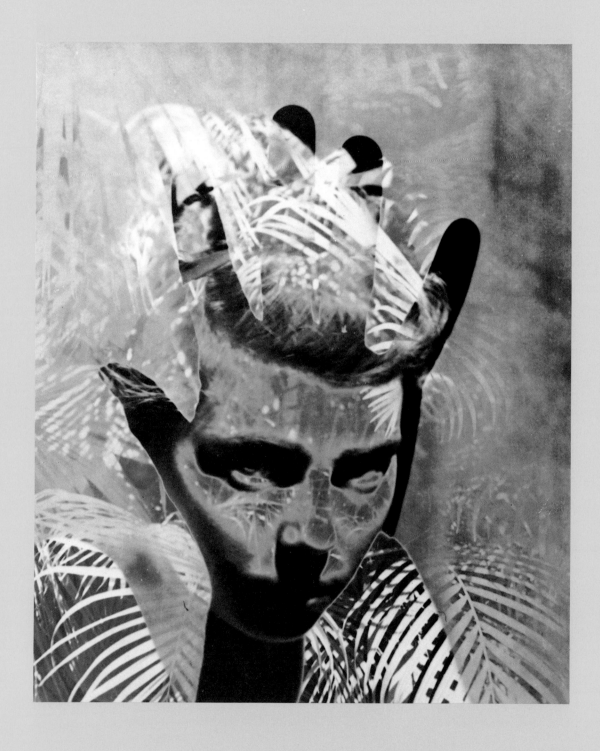

VAL TELBERG RETURN TO SUMMER: PALMETTO GNOME / *Gelatin silver print from multiple negatives, ca. 1948*

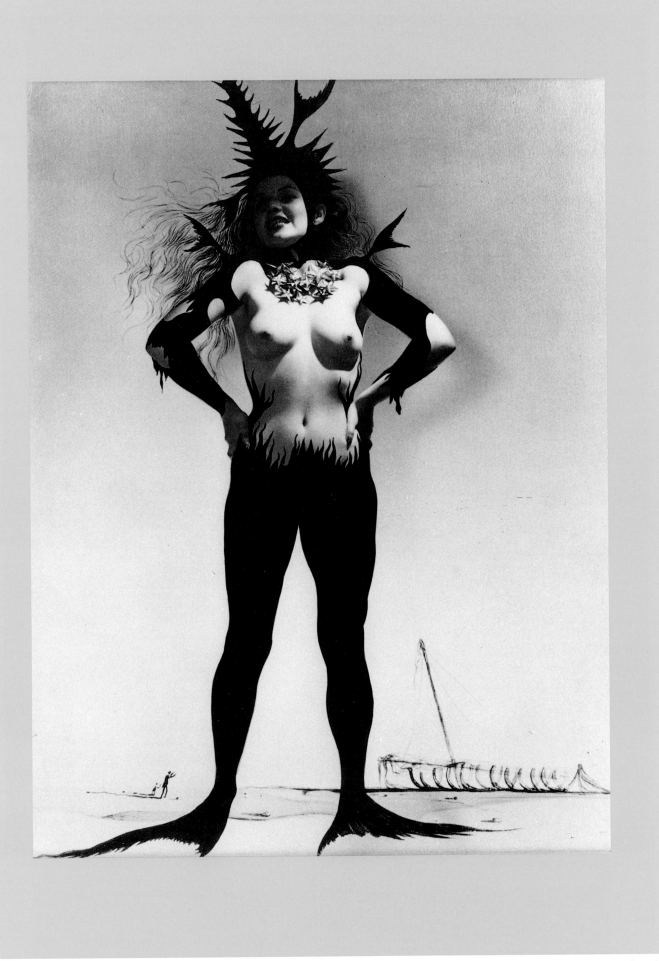

DALI, PLATT LYNES, *and* **HOYNINGEN-HUENE**

SCENE FROM *THE BIRTH OF VENUS* / *Gelatin silver print, 1949*

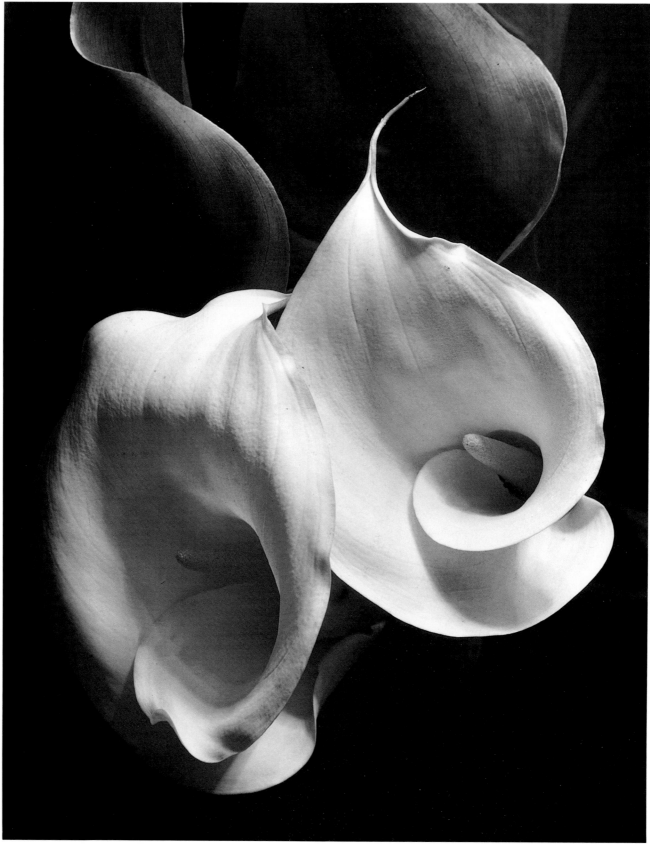

IMOGEN CUNNINGHAM

TWO CALLAS / *Gelatin silver print, 1929*

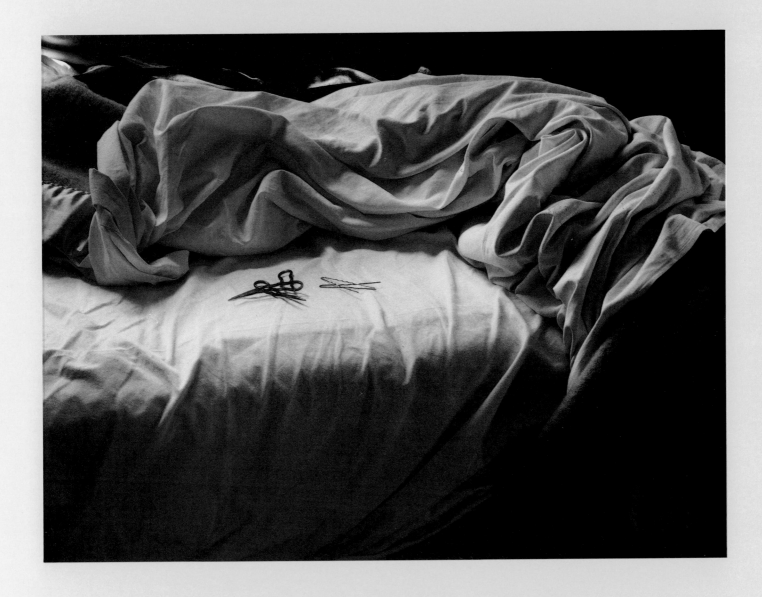

IMOGEN CUNNINGHAM

THE UNMADE BED / *Gelatin silver print, 1957*

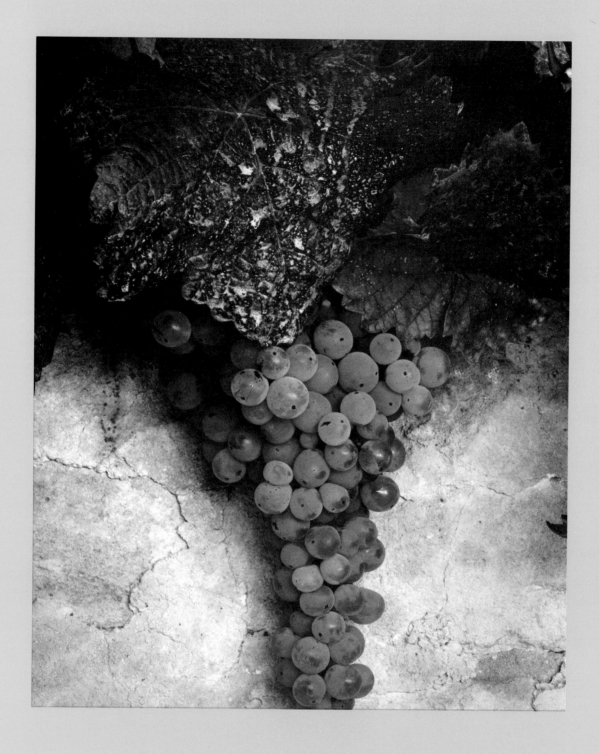

PAUL STRAND

GRAPES, CHARENTE, FRANCE / *Gelatin silver print, 1951*

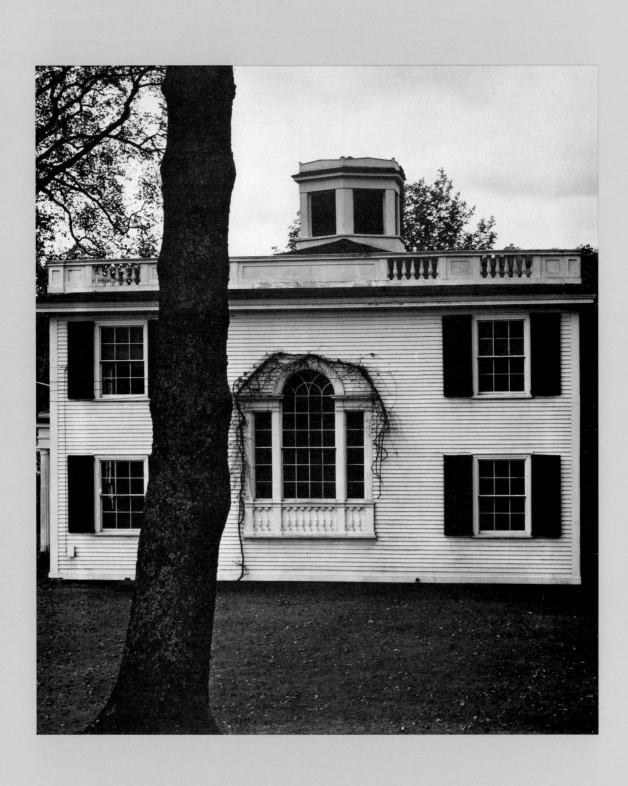

PAUL STRAND PALLADIAN WINDOW, MAINE / *Gelatin silver print, 1945*

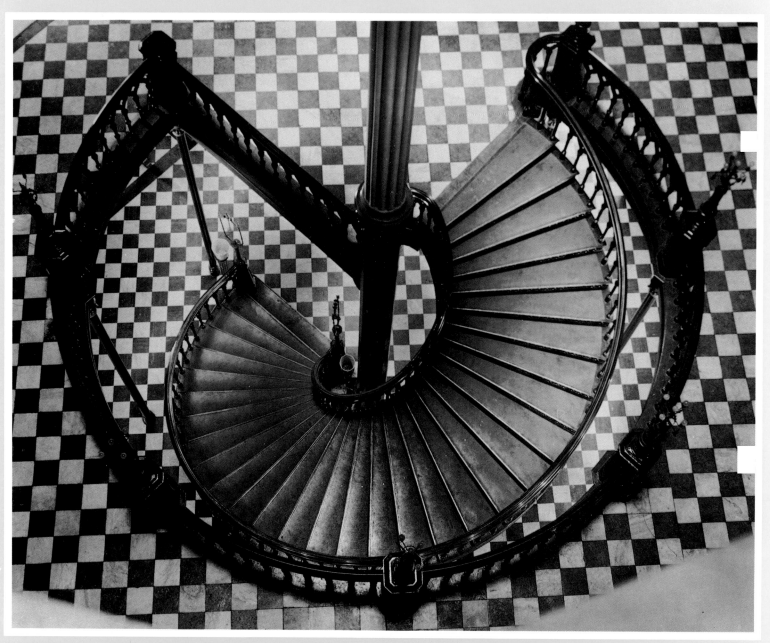

CLARENCE JOHN LAUGHLIN THE IRON SHELL (OLD LOUISIANA STATE CAPITOL, BATON ROUGE) / *Gelatin silver print, 1949*

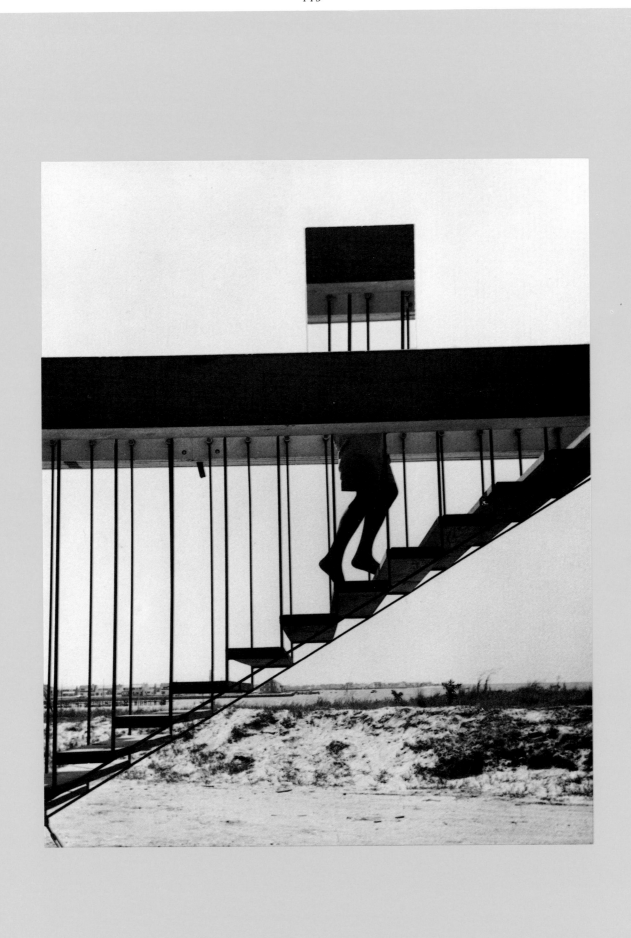

ANDRÉ KERTÉSZ

DISAPPEARING ACT / *Gelatin silver print, 1955*

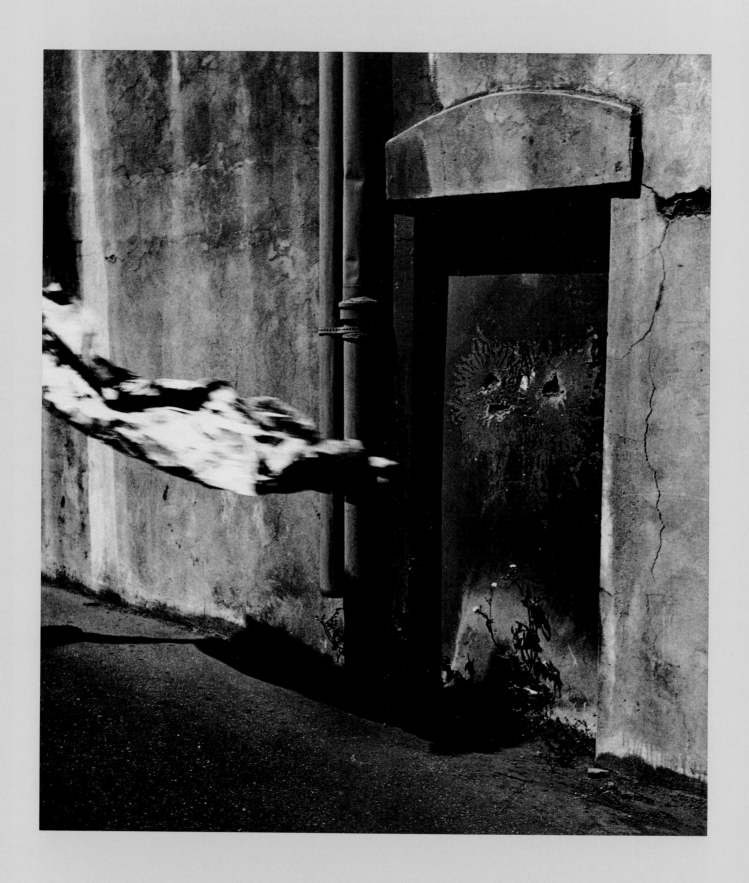

MINOR WHITE

FACE IN DOOR, SAN FRANCISCO, 1949 / *Gelatin silver print, 1949*

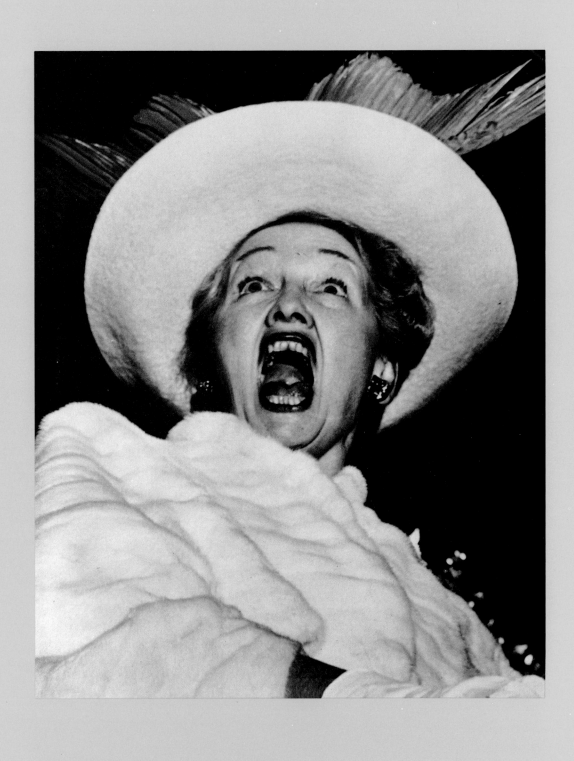

WEEGEE

HEDDA HOPPER / *Gelatin silver print, before 1953*

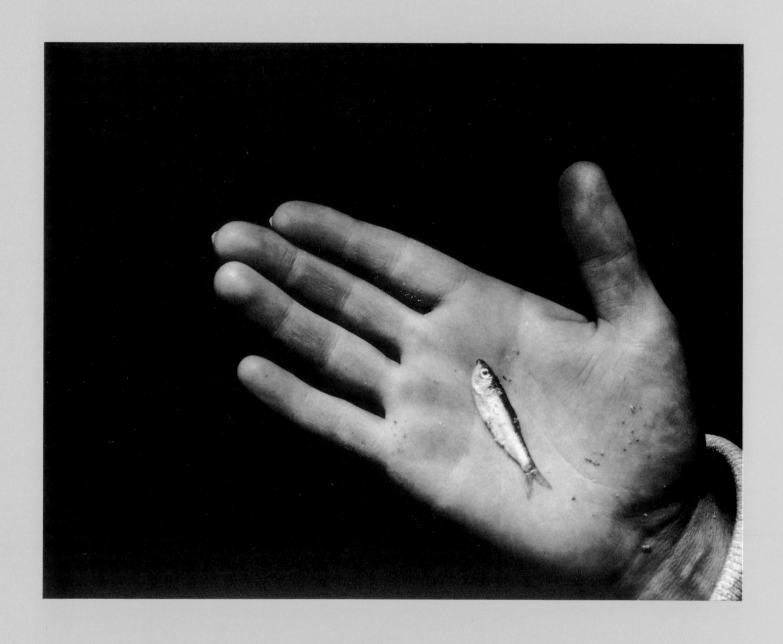

AARON SISKIND **FISH IN HAND** / *Gelatin silver print, 1939*

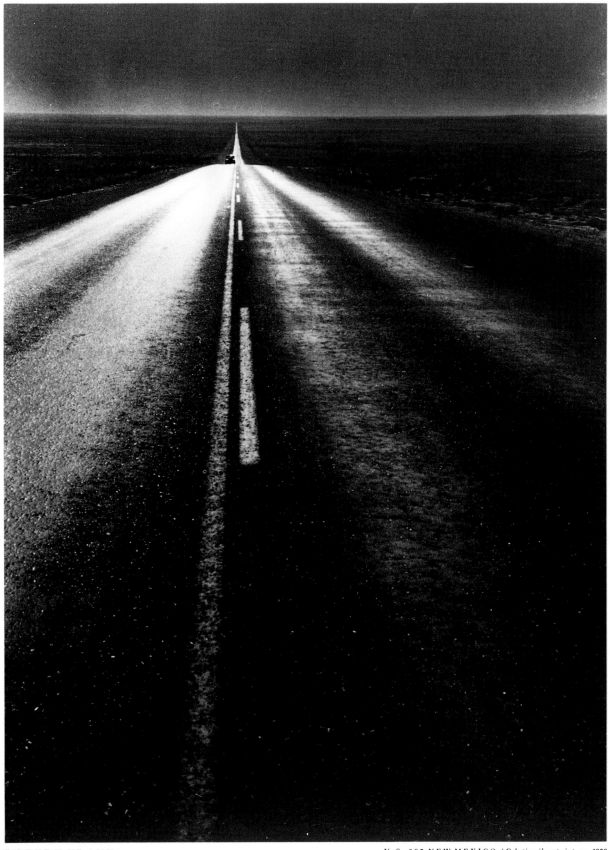

ROBERT FRANK

U.S. 285 NEW MEXICO / *Gelatin silver print, ca. 1956*

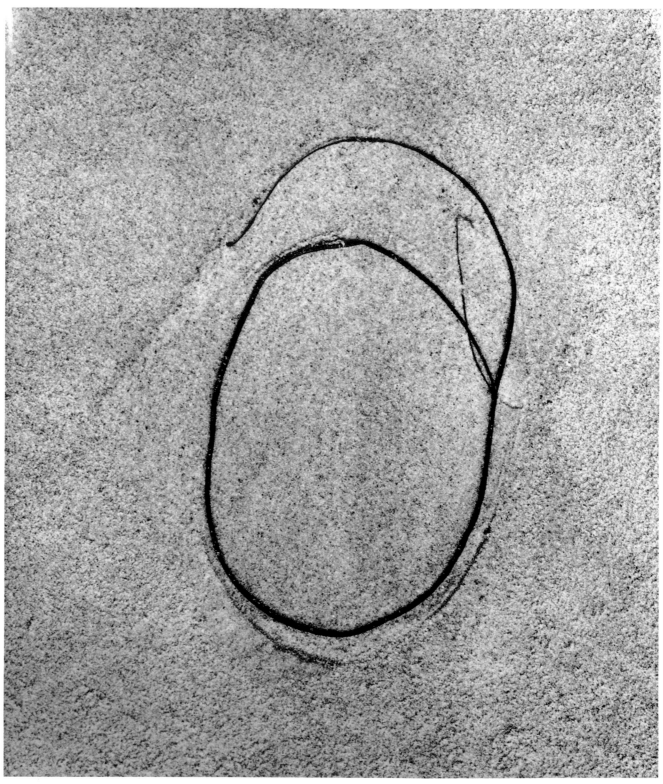

AARON SISKIND SEAWEED NO. 26 / *Gelatin silver print, 1953*

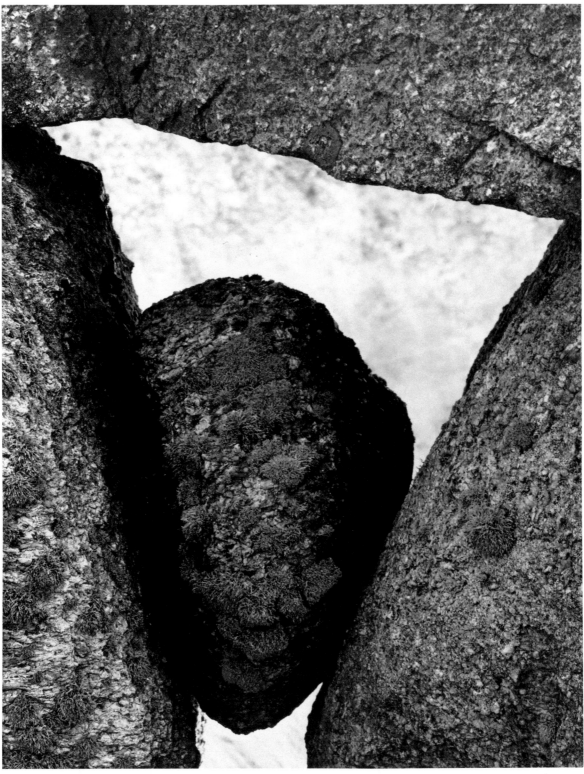

AARON SISKIND MARTHA'S VINEYARD NO. 112 A / *Gelatin silver print, 1954*

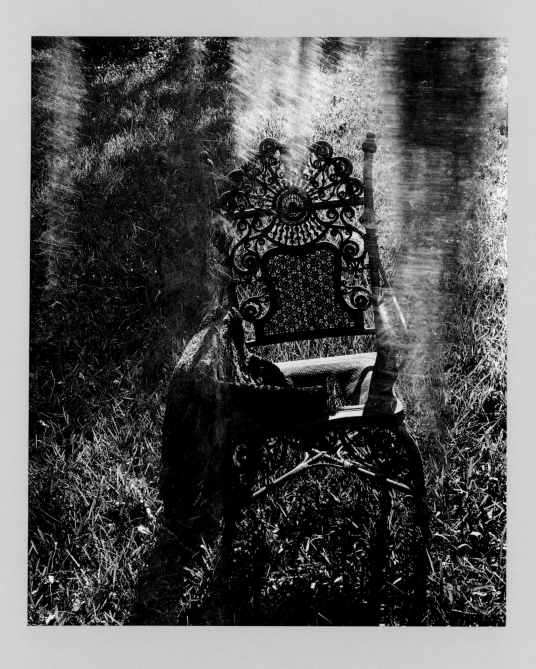

VAN DEREN COKE

WICKER CHAIR AND MOVING MOSS / *Gelatin silver print, 1960*

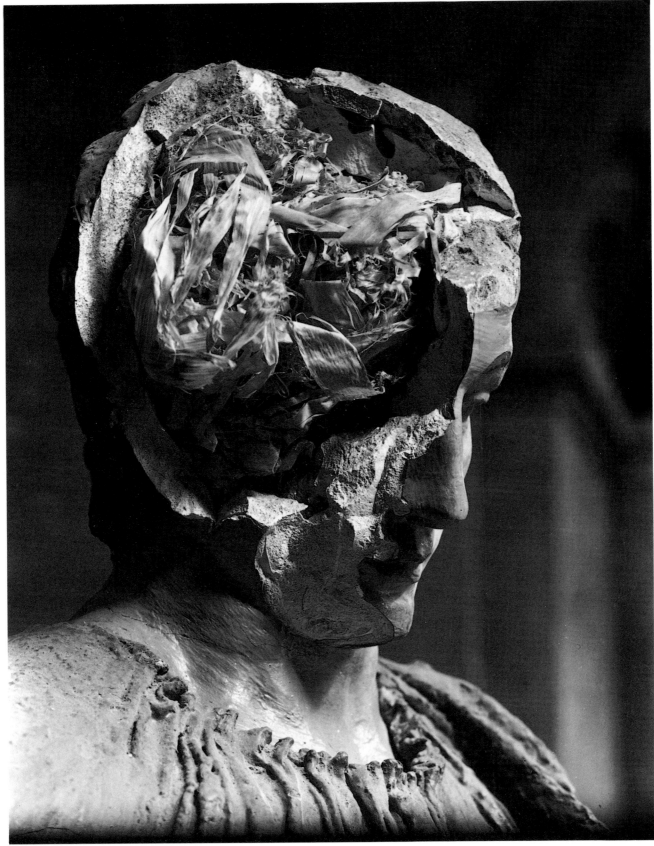

JOSEF SUDEK

UNTITLED / *Gelatin silver print, 1940*

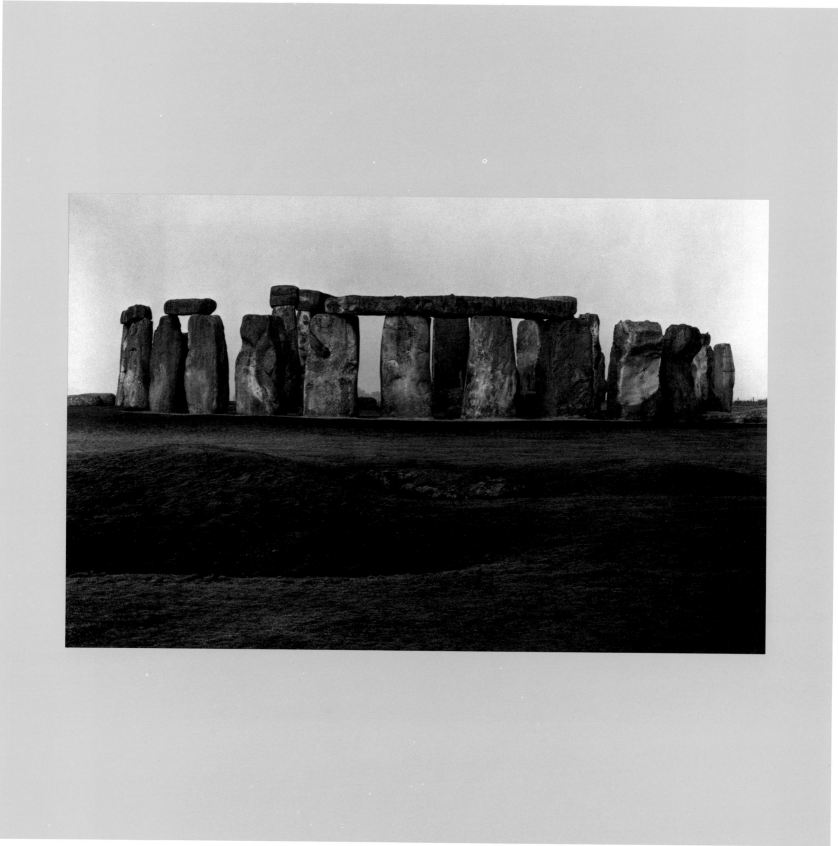

PAUL CAPONIGRO

STONEHENGE / *Gelatin silver print, 1967*

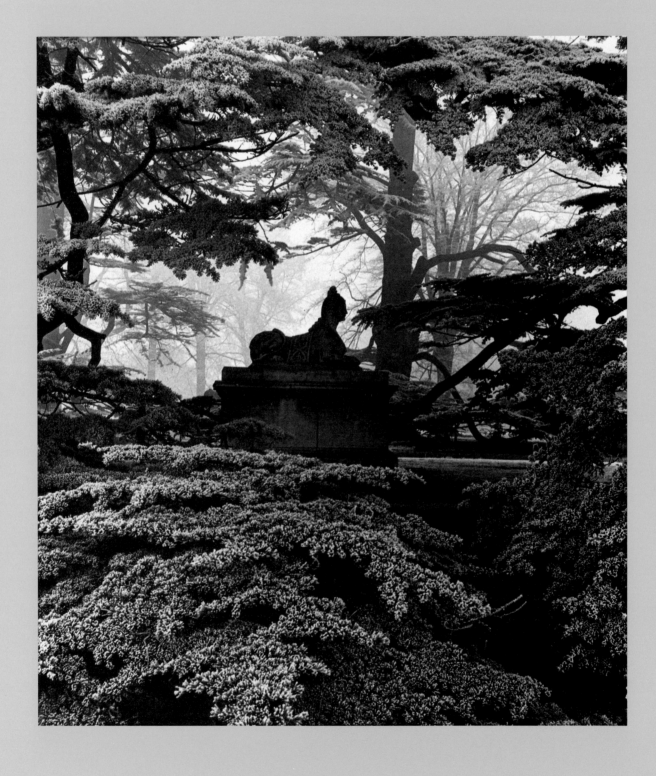

BILL BRANDT CHISWICK HOUSE GARDENS, EARLY MORNING IN THE PARK / *Gelatin silver print, 1958*

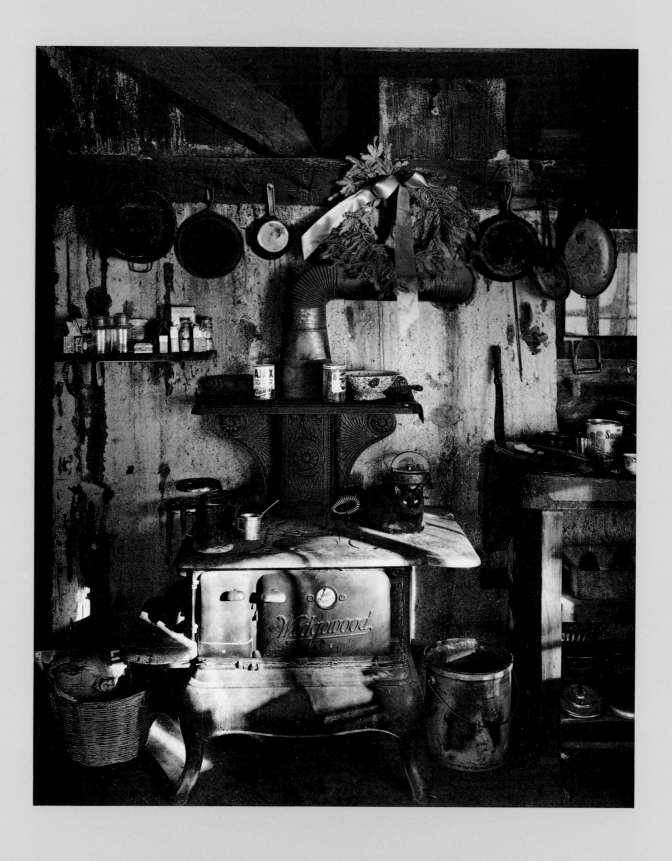

WYNN BULLOCK

CHRISTMAS, SANDY'S / *Gelatin silver print, 1956*

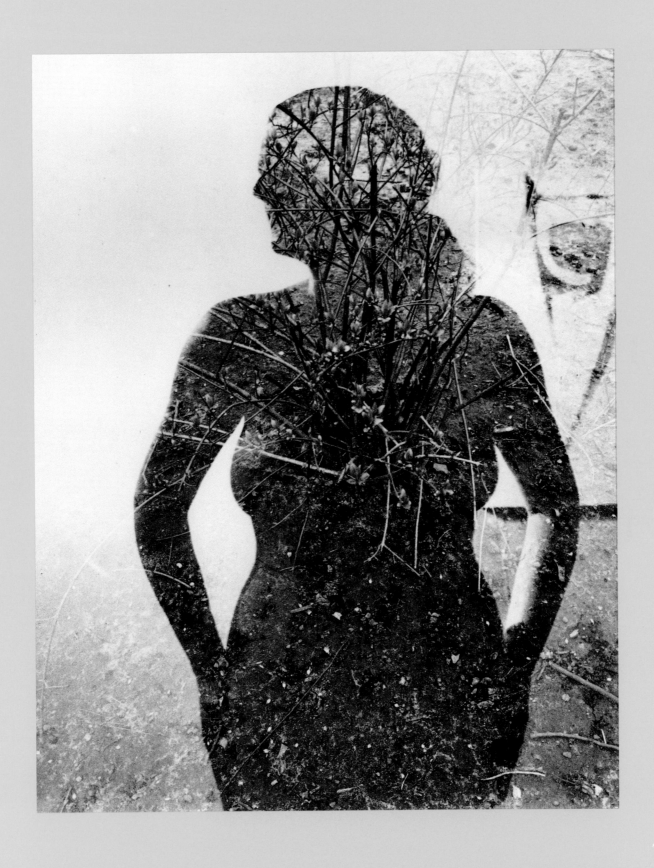

HARRY CALLAHAN

ELEANOR / *Gelatin silver print, ca. 1954*

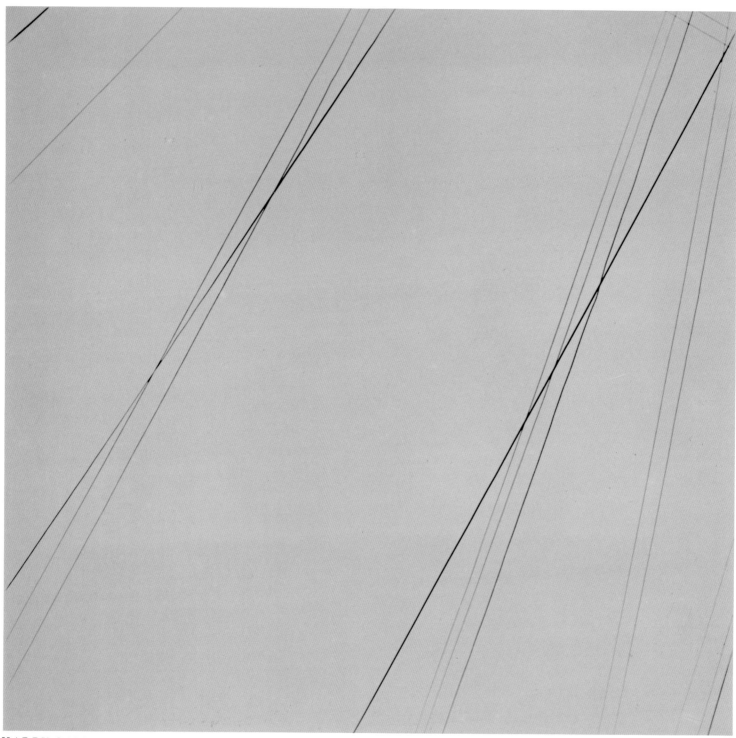

HARRY CALLAHAN TELEPHONE WIRES / *Gelatin silver print, ca. 1968*

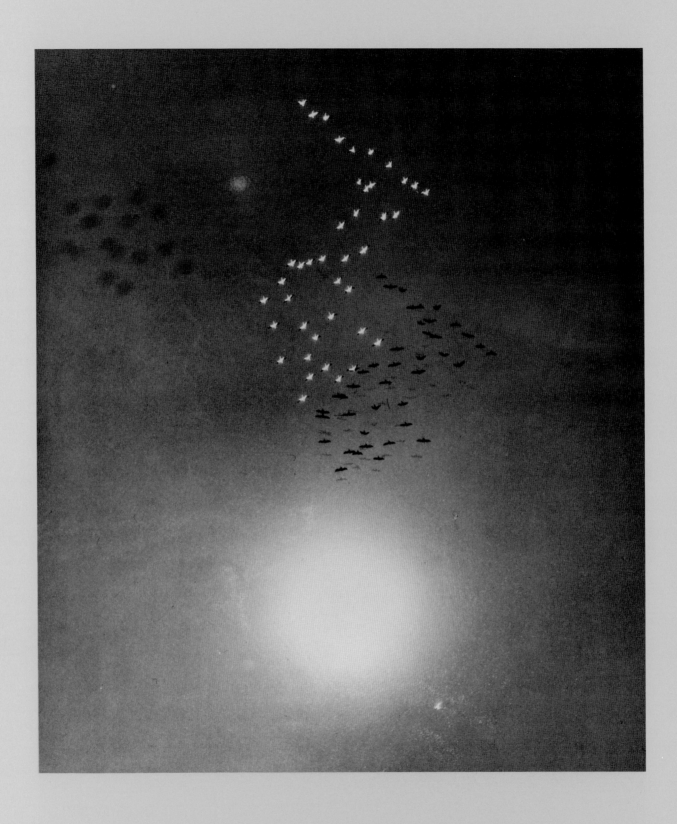

WILLIAM A. GARNETT SNOW GEESE WITH REFLECTION OF THE SUN OVER BUENA VISTA LAKE, CALIFORNIA / *Gelatin silver print, 1953*

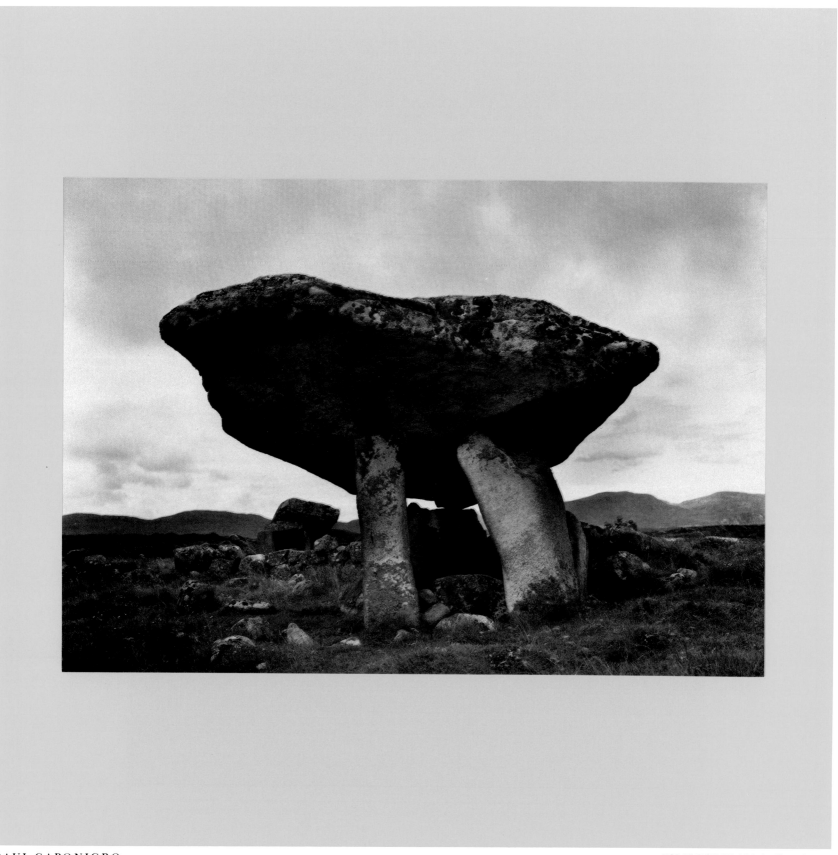

PAUL CAPONIGRO

KILCLOONEY / *Gelatin silver print, 1967*

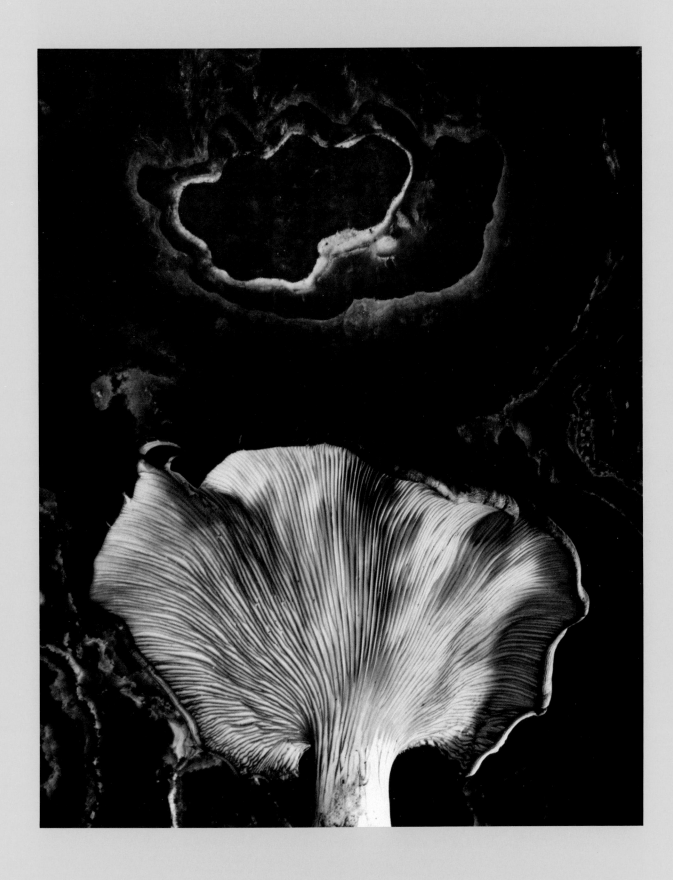

PAUL CAPONIGRO

FUNGUS, IPSWICH, MASSACHUSETTS / *Gelatin silver print, 1962*

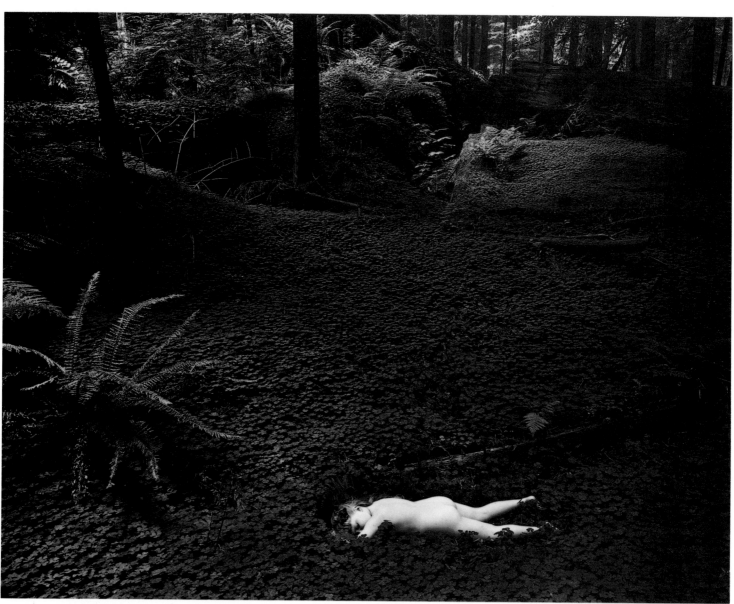

WYNN BULLOCK CHILD IN THE FOREST / *Gelatin silver print, 1951*

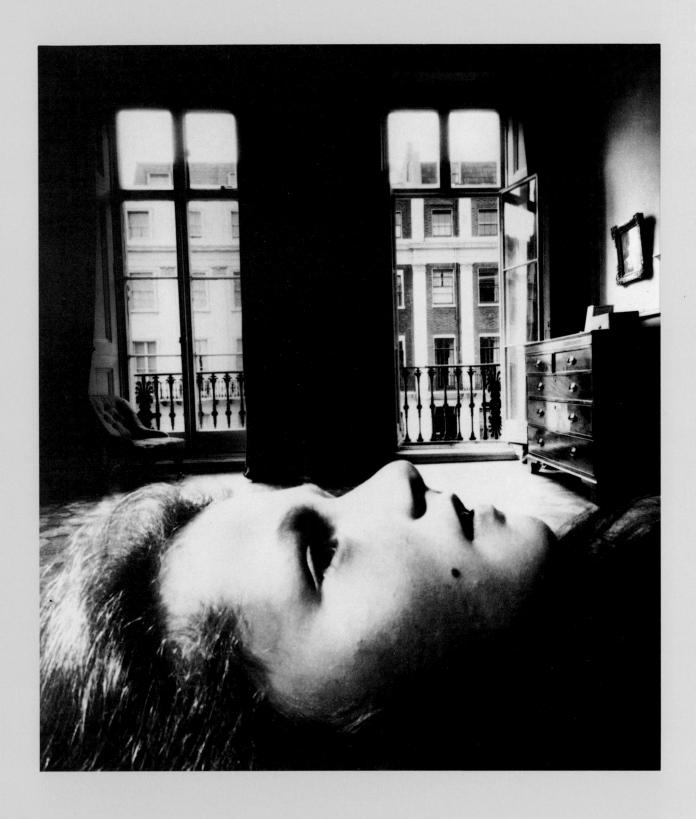

BILL BRANDT

PORTRAIT OF A YOUNG GIRL, EATON PLACE, LONDON / *Gelatin silver print, 1955*

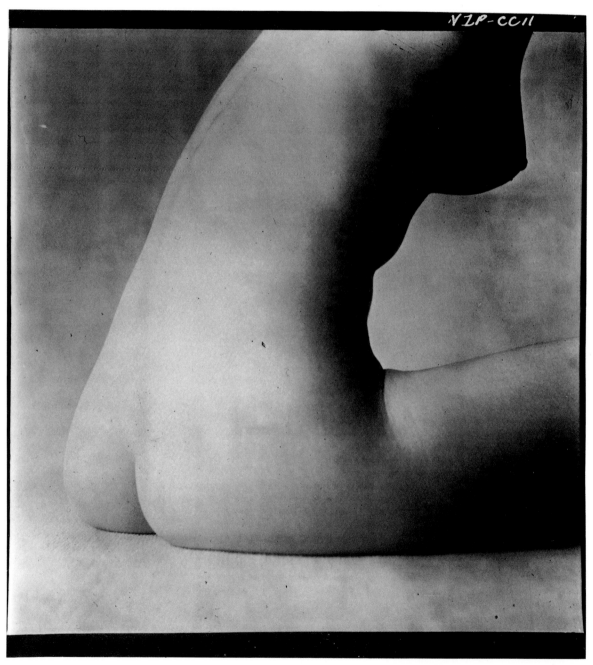

IRVING PENN SEATED NUDE / *Gelatin silver print, 1950*

IRVING PENN AFTER-DINNER GAMES / *Ektachrome transparency, 1947*

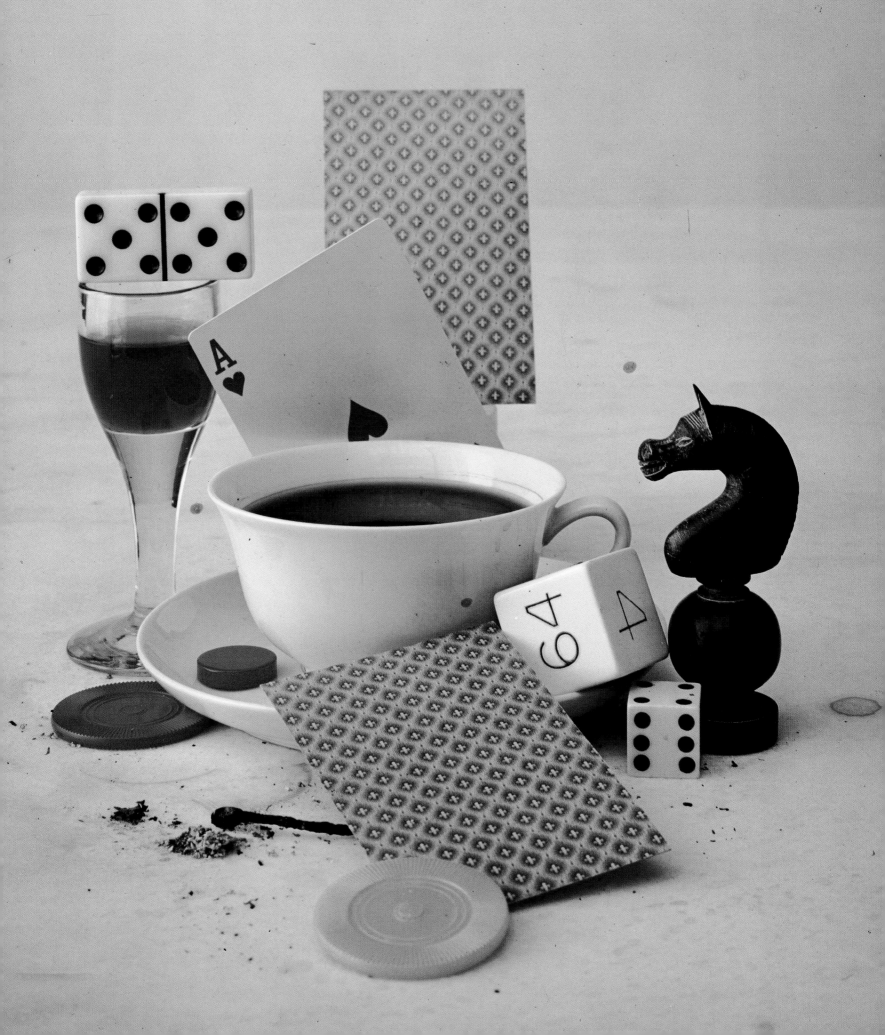

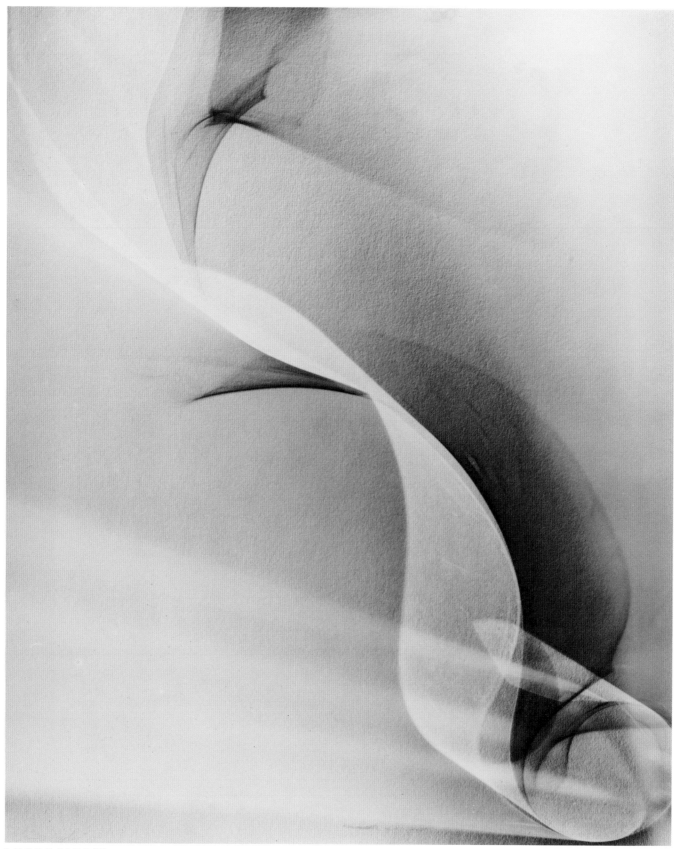

LOTTE JACOBI PHOTOGENTIC NO. 3 / *Gelatin silver print, 1946–1955*

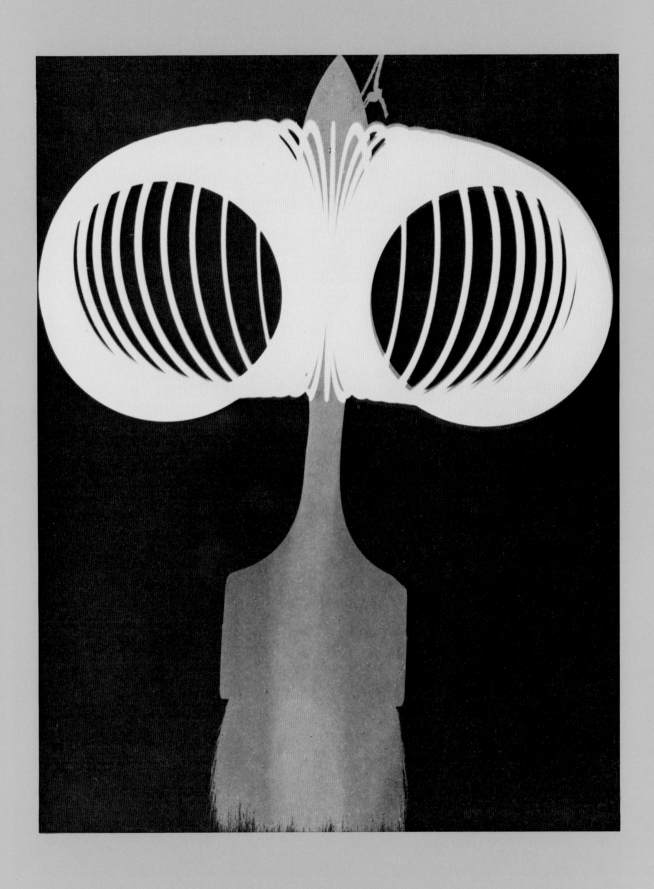

MAN RAY

RAYOGRAPH / *Gelatin silver print, 1955*

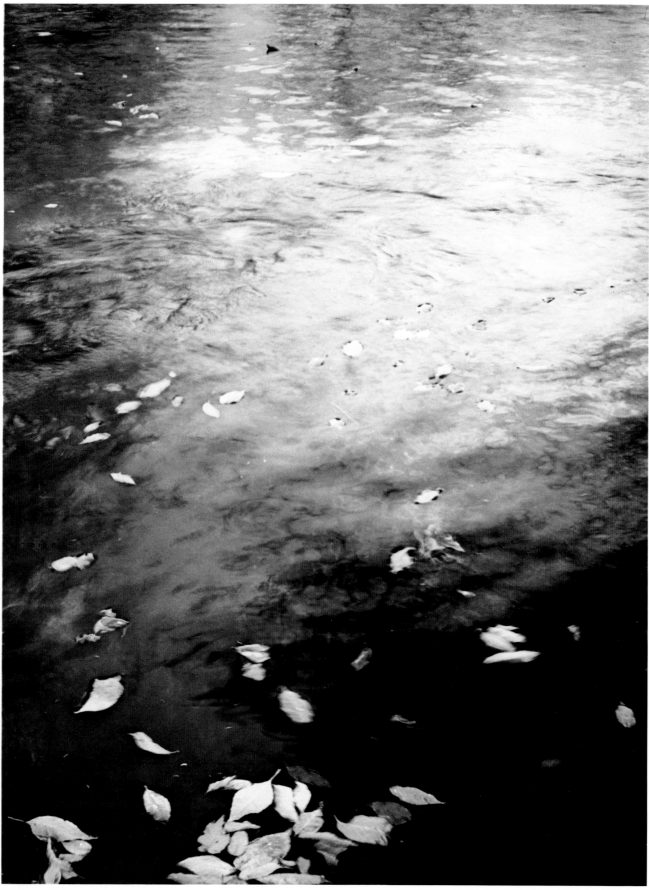

ELIOT PORTER POOL IN A BROOK, POND BROOK, NEAR WHITEFACE, NEW HAMPSHIRE.

OCTOBER 1953 / *Dye transfer print, 1953*

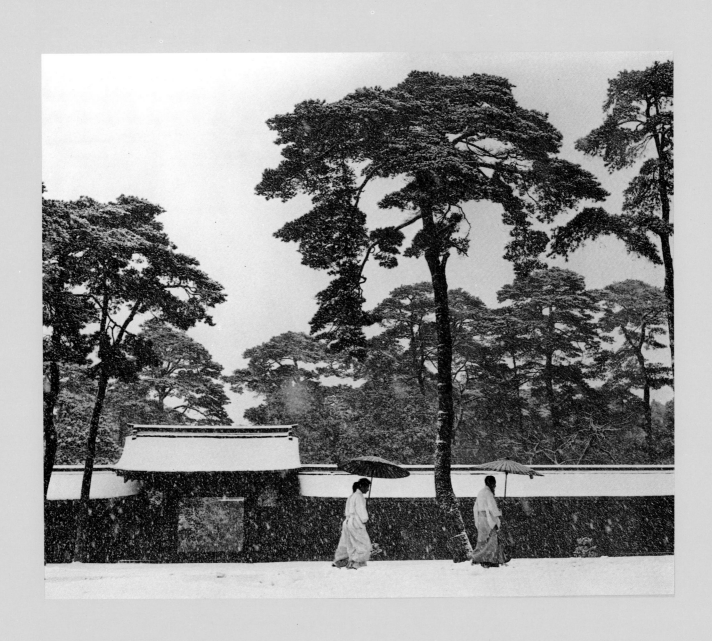

WERNER BISCHOF

SHINTO PRIESTS IN THE SNOW, JAPAN / *Gelatin silver print, 1951*

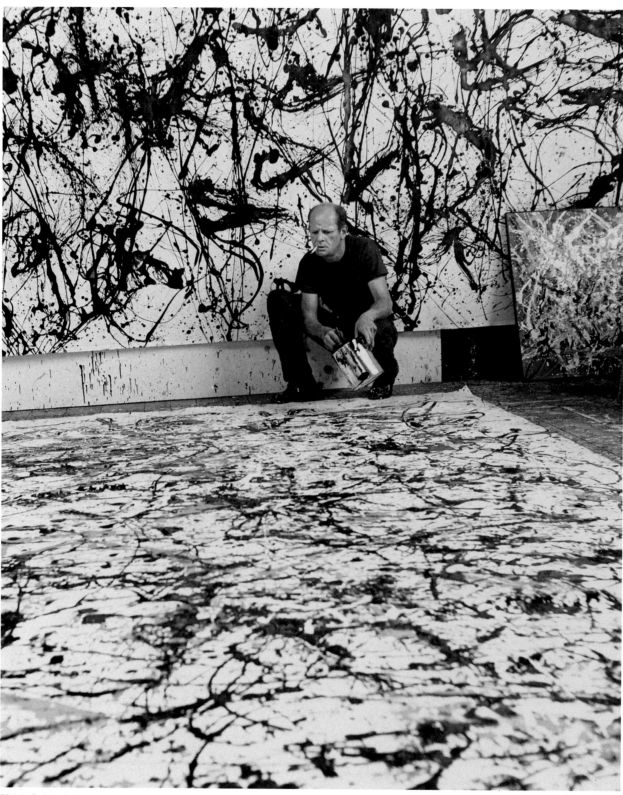

HANS NAMUTH JACKSON POLLOCK (WITH *PAINTING NO. 32*) / *Gelatin silver print, 1950*

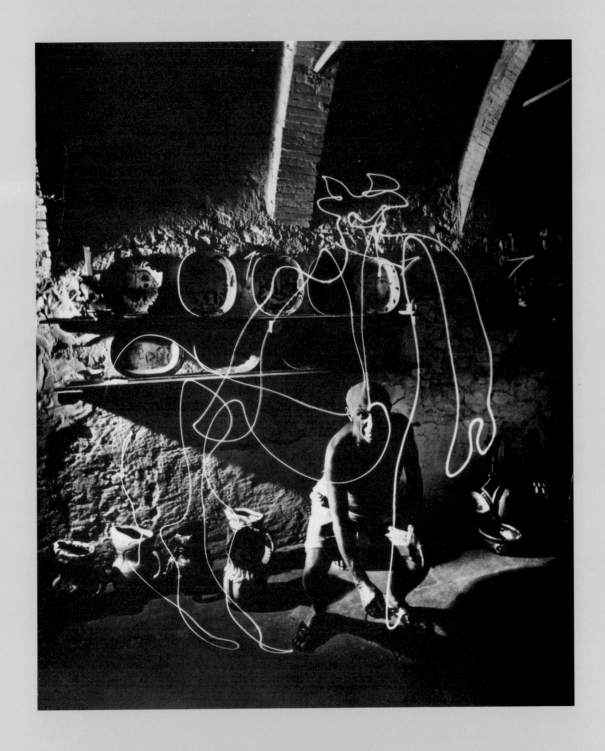

GJON MILI

PABLO PICASSO DRAWING *MINOTAUR WITH LIGHT* / *Gelatin silver print, 1950*

ALEXANDER LIBERMAN

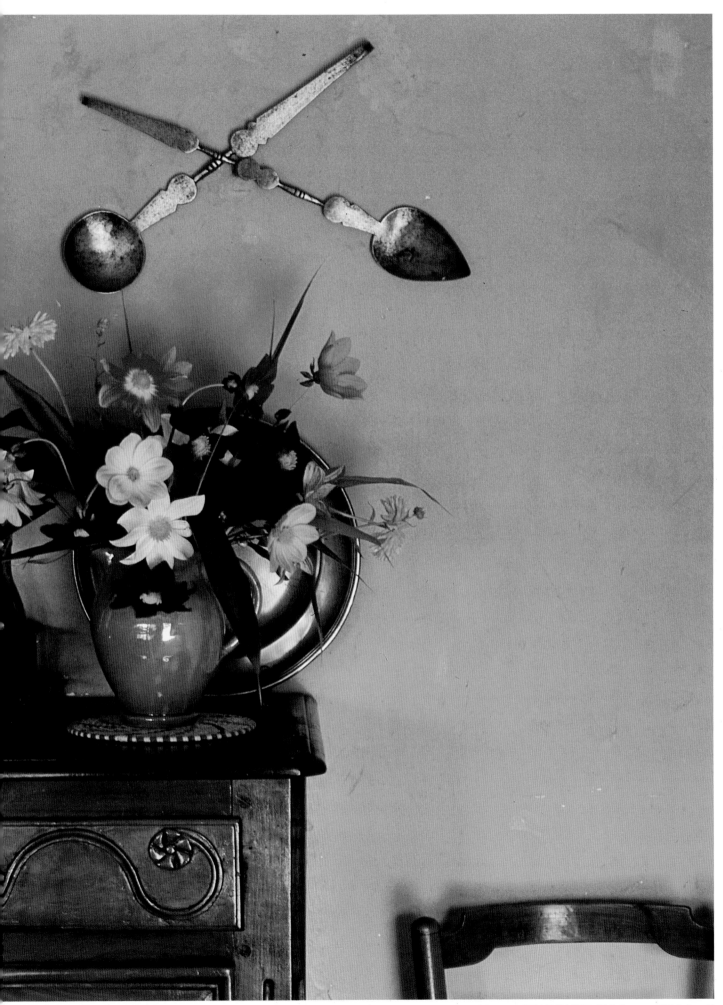

INTERIOR OF BRAQUE'S VARENGEVILLE HOUSE / *Kodachrome, ca. 1953* [*enlarged*]

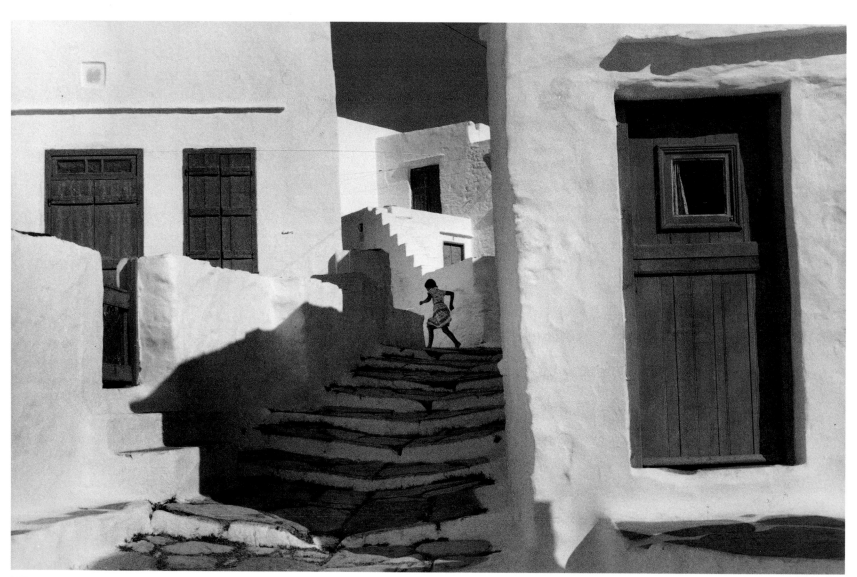

HENRI CARTIER-BRESSON

SIPHNOS, GREECE / *Gelatin silver print, 1961*

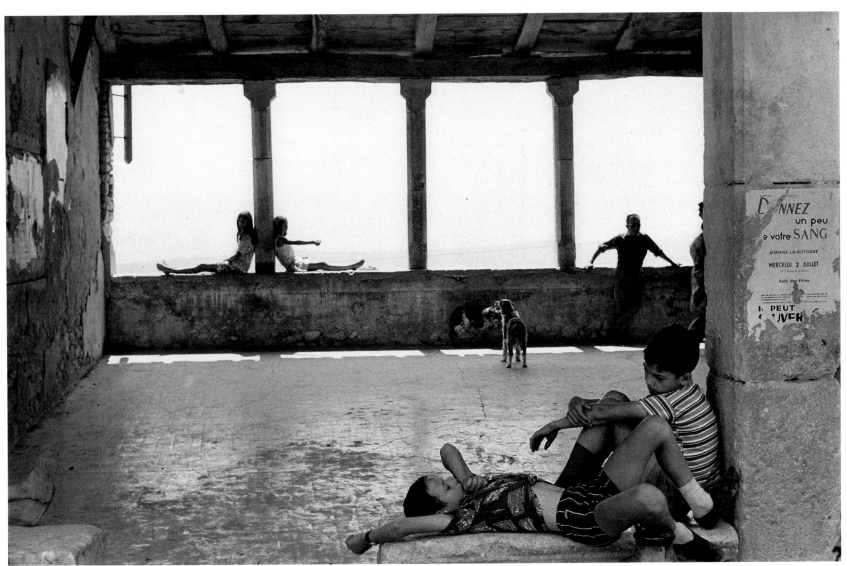

HENRI CARTIER-BRESSON SIMIANE-LA-ROTONDE (ALPES DE HAUTE-PROVENCE) / *Gelatin silver print, 1954*

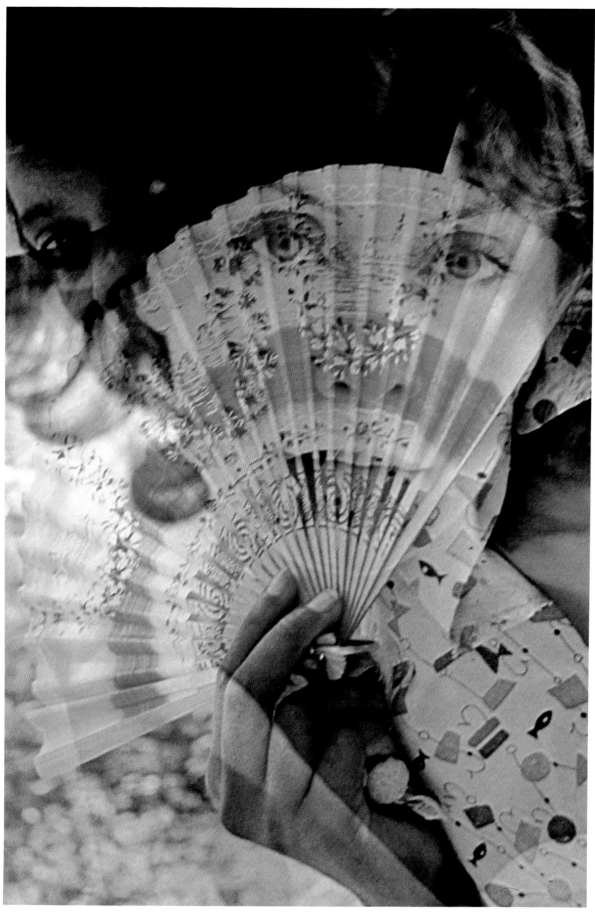

GORDON PARKS WOMAN WITH FAN / *Ektachrome, 1958* [*enlarged*]

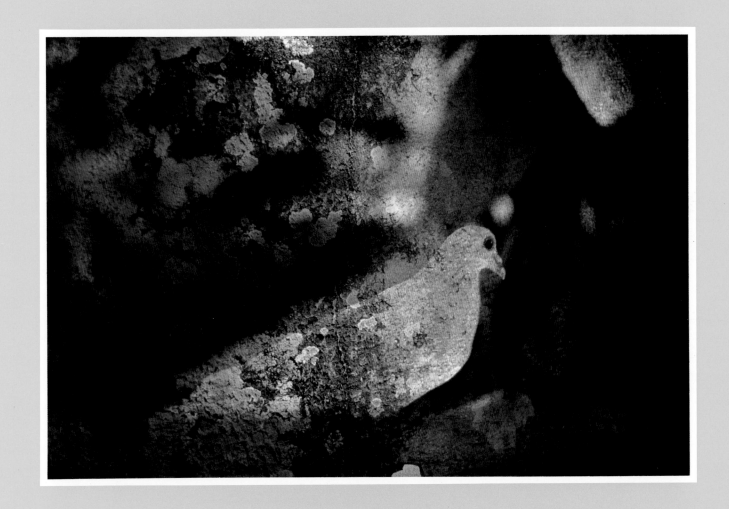

GORDON PARKS
THE DOVE / *Ektachrome, 1947 [enlarged]*

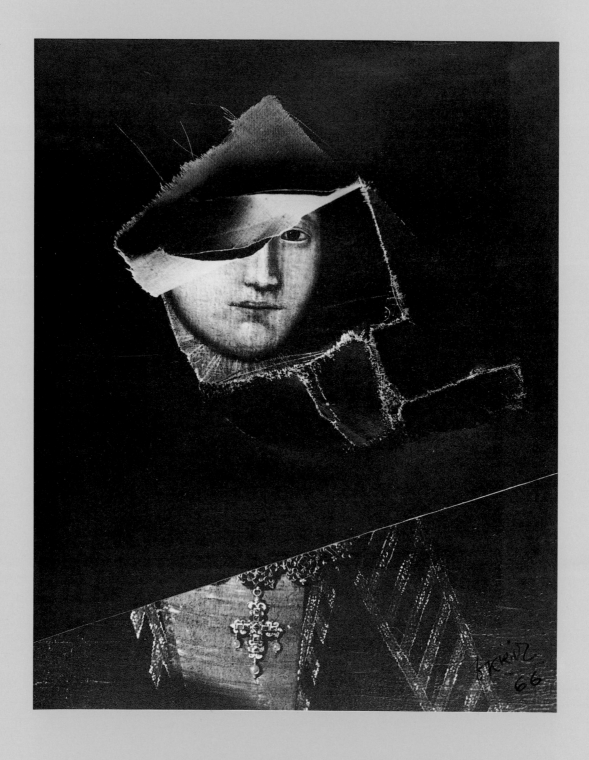

VILEM KRIZ **WOMAN FROM SIRAGUE** / *Gelatin silver print, 1966*

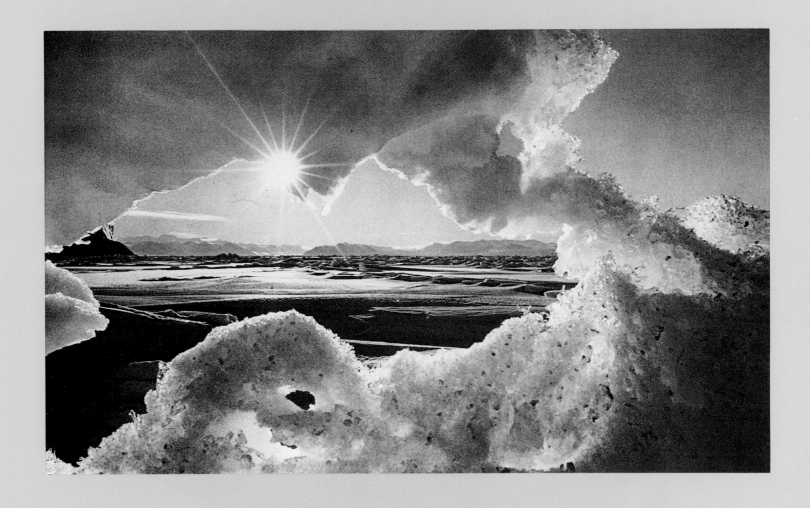

EMIL SCHULTHESS FROZEN ROSS SEA NEAR MARBLE POINT AT MIDNIGHT, NOVEMBER 16/17th, 1958 / *Gelatin silver print, 1958*

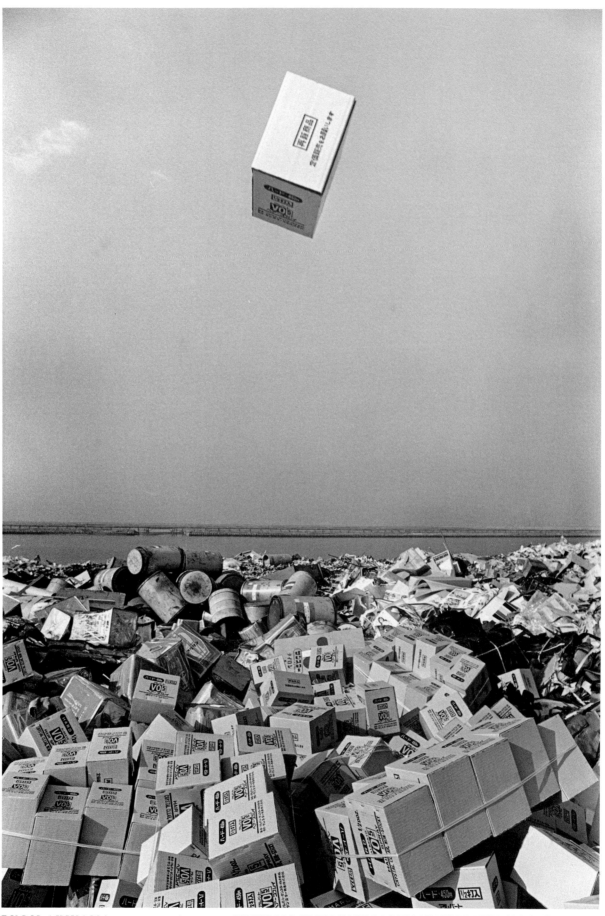

RYOJI AKIYAMA EMPTY BOX ON ITS WAY TO A RECLAMATION AREA / *Gelatin silver print, 1969*

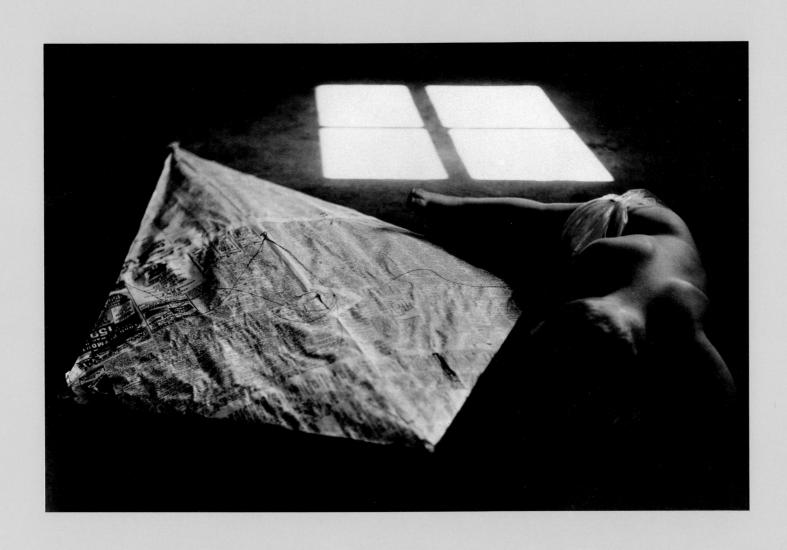

RALPH EUGENE MEATYARD

UNTITLED / *Gelatin silver print, n.d.*

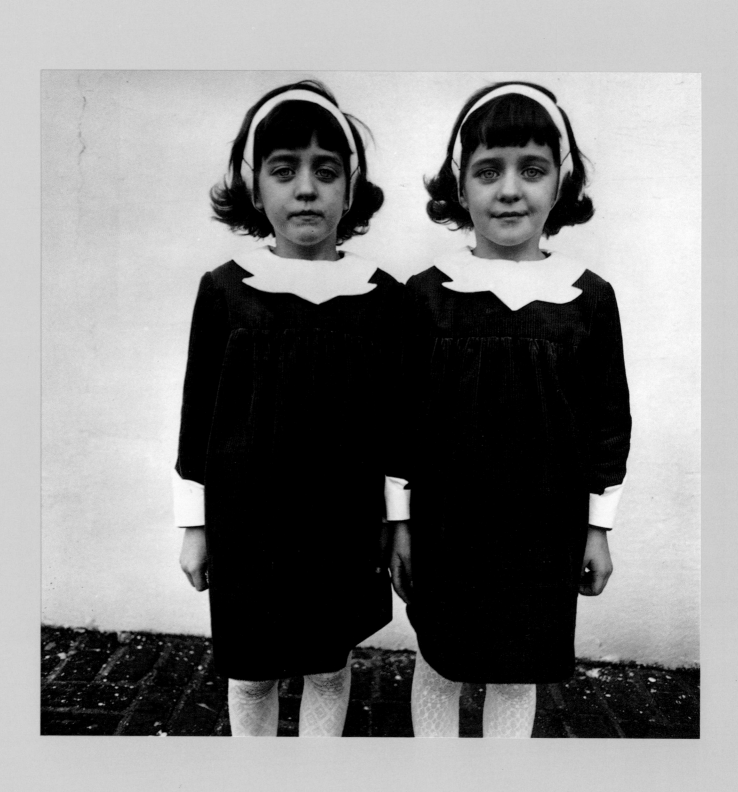

DIANE ARBUS IDENTICAL TWINS, CATHLEEN AND COLLEEN, ROSELLE, NEW JERSEY / *Gelatin silver print, 1967*

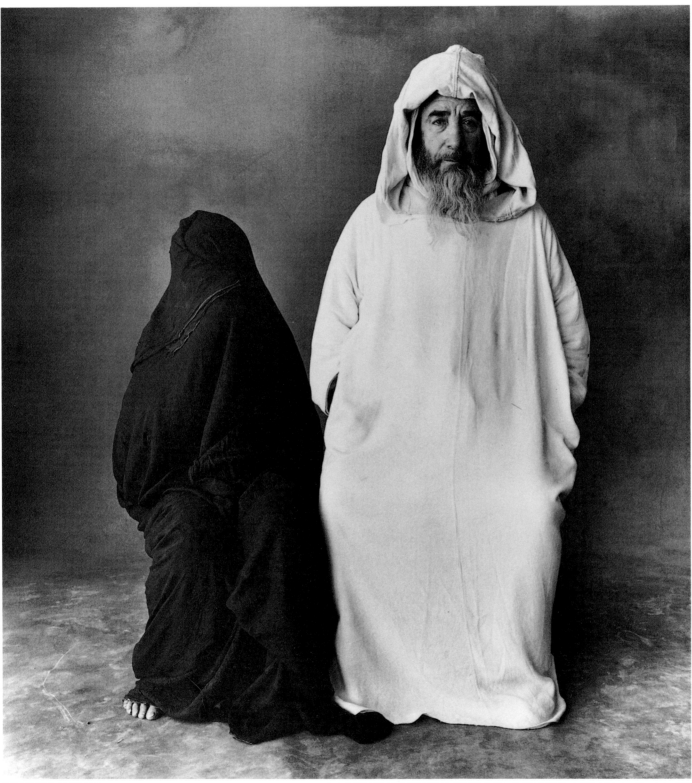

IRVING PENN MAN IN WHITE/WOMAN IN BLACK, MOROCCO, 1971 / *Gelatin silver print, 1971*

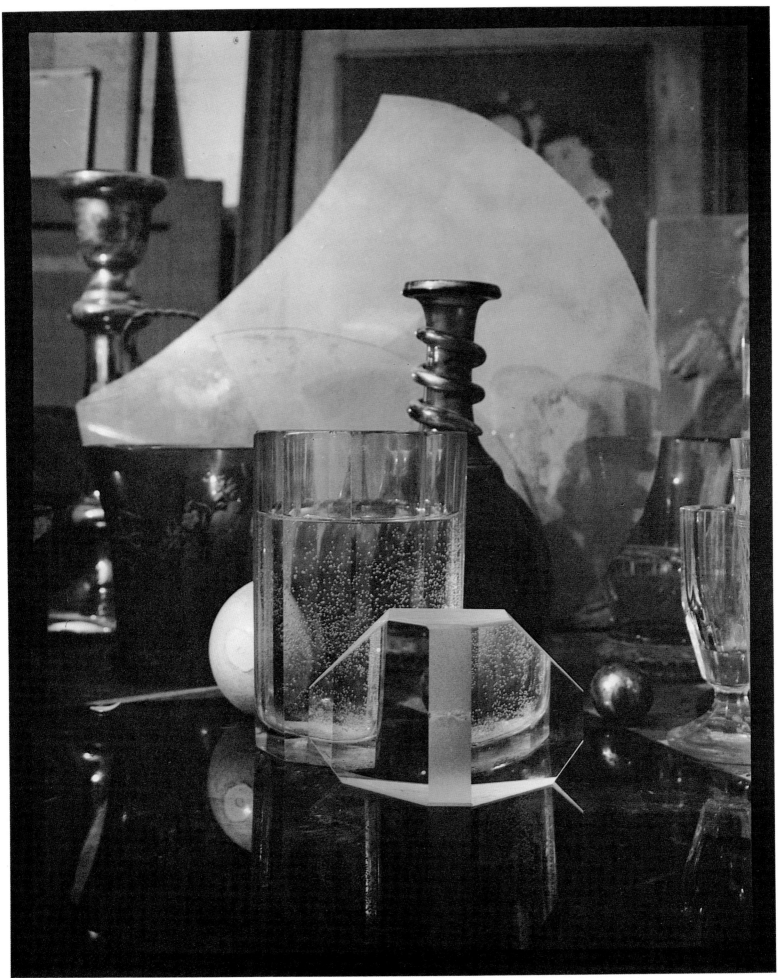

JOSEF SUDEK STILL LIFE FROM GLASS LABYRINTH / *Gelatin silver print, ca. 1967*

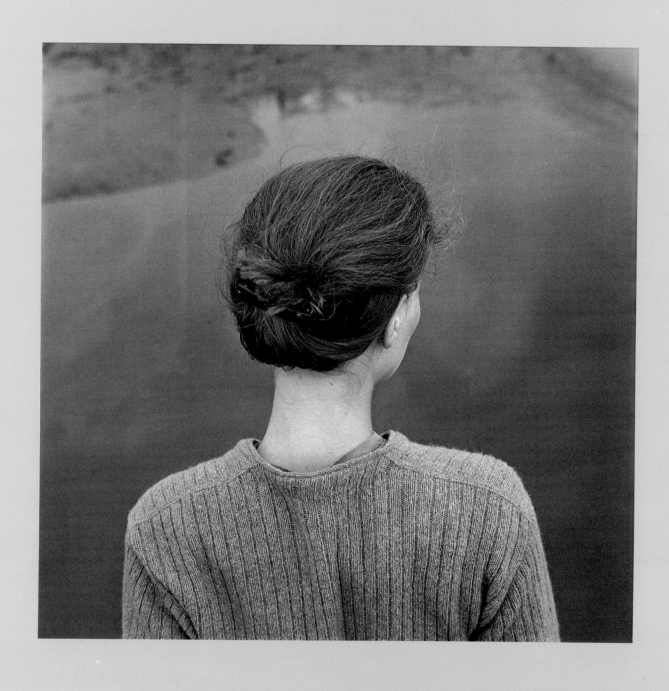

EMMET GOWIN EDITH, CHINCOTEAGUE, VIRGINIA / *Gelatin silver print, 1967*

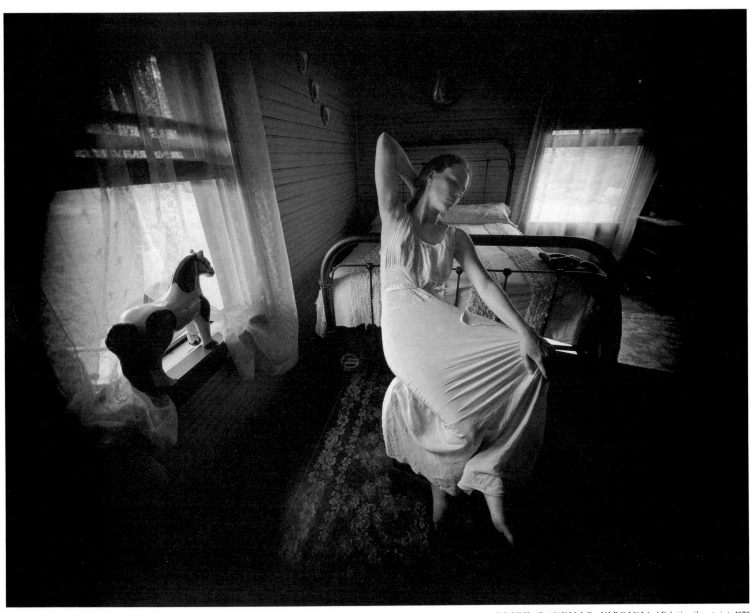

EMMET GOWIN

EDITH, DANVILLE, VIRGINIA / *Gelatin silver print, 1970*

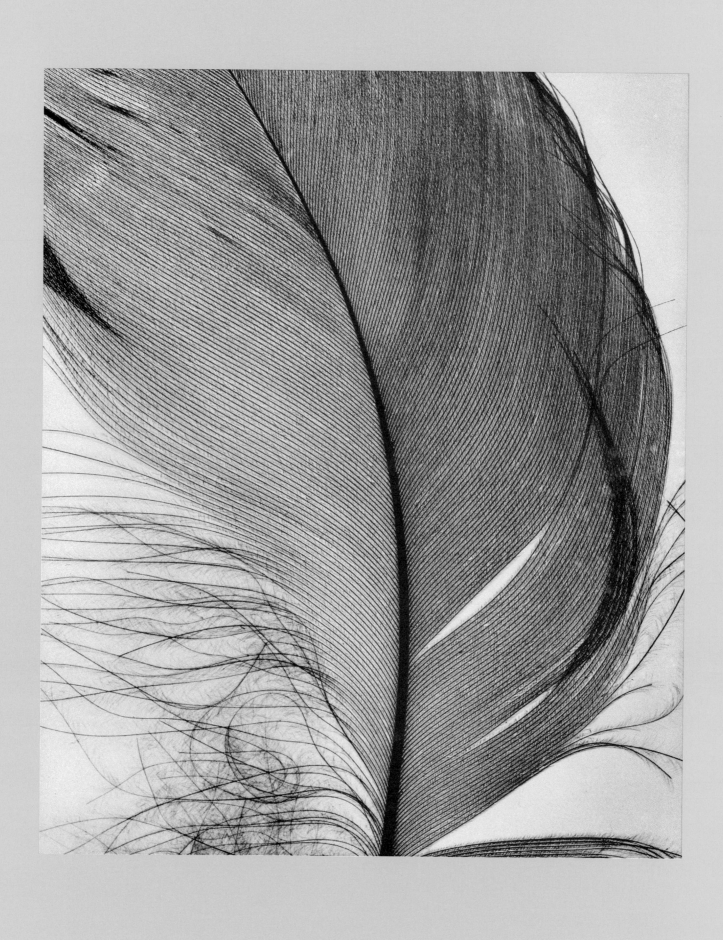

ANDREAS FEININGER

FEATHER / *Gelatin silver print, 1965*

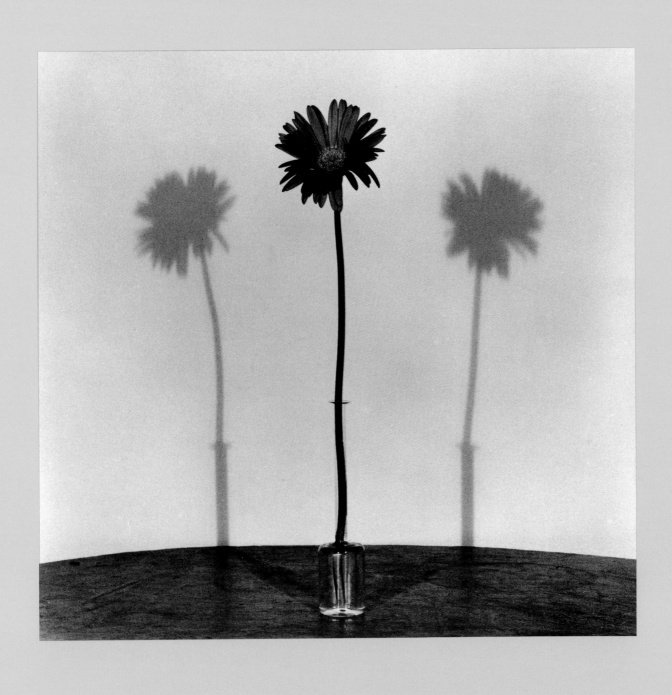

ROBERT MAPPLETHORPE

DAISY WITH TWO SHADOWS, TEXAS / *Gelatin silver print, 1979*

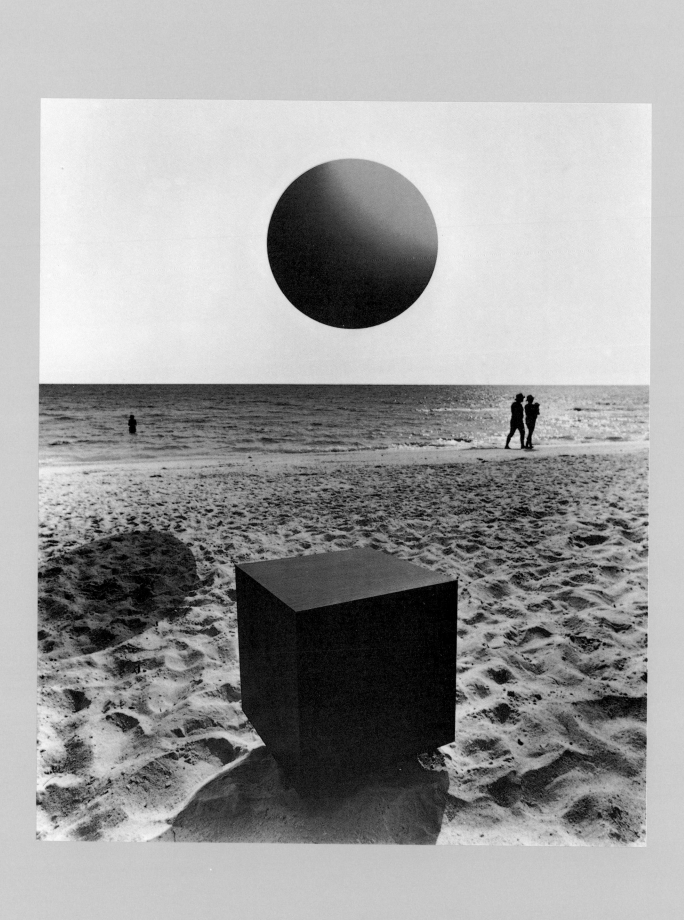

JERRY N. UELSMANN

UNTITLED / *Gelatin silver print from multiple negatives, ca. 1979*

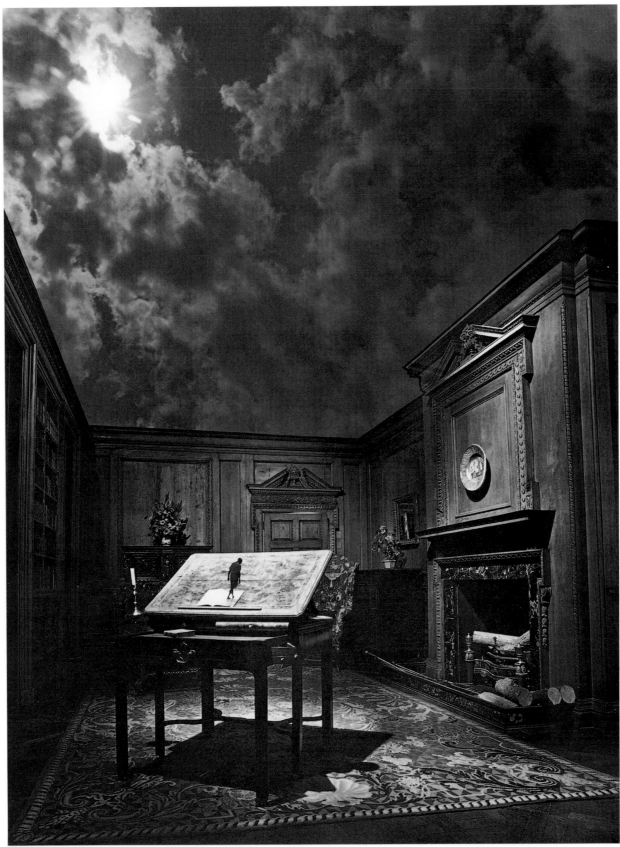

JERRY N. UELSMANN

UNTITLED / *Gelatin silver print from multiple negatives, 1976*

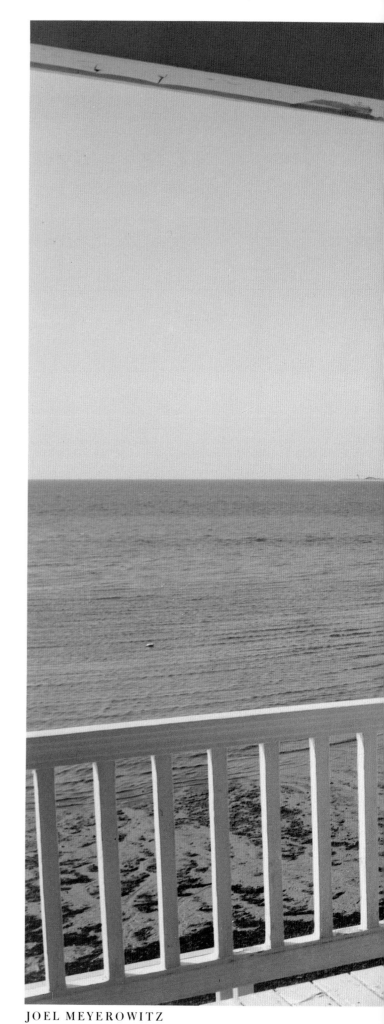

JOEL MEYEROWITZ

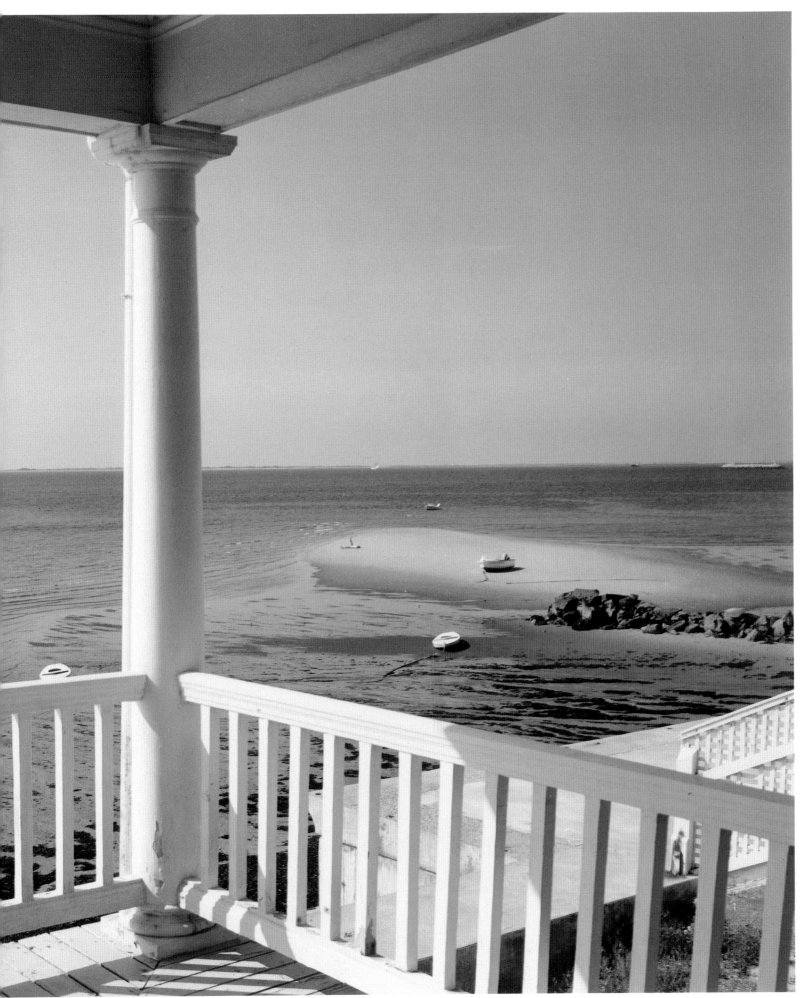

PROVINCETOWN PORCH, 1977 / *Dye-coupler (Type C) print, 1977*

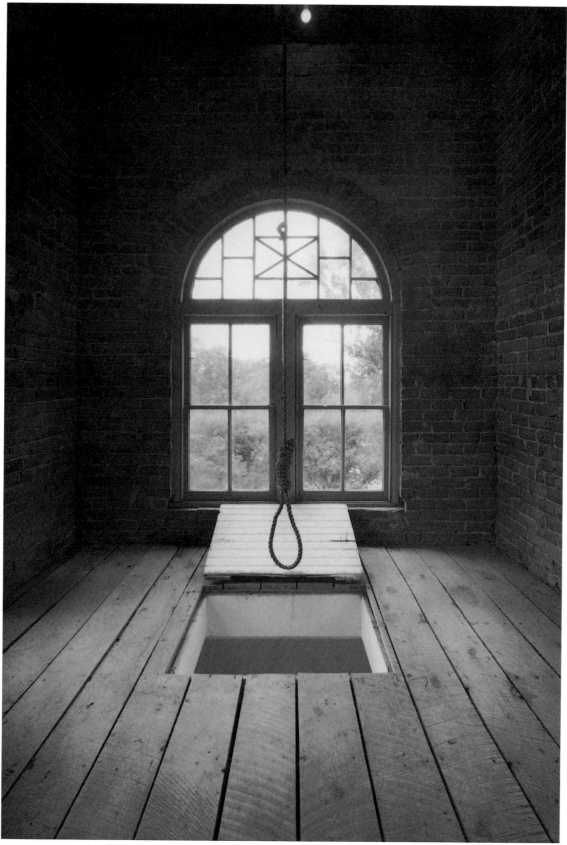

WILLIAM CLIFT HANGMAN'S NOOSE, OLD COLFAX COUNTY COURTHOUSE,
NEW MEXICO / *Gelatin silver print, 1976*

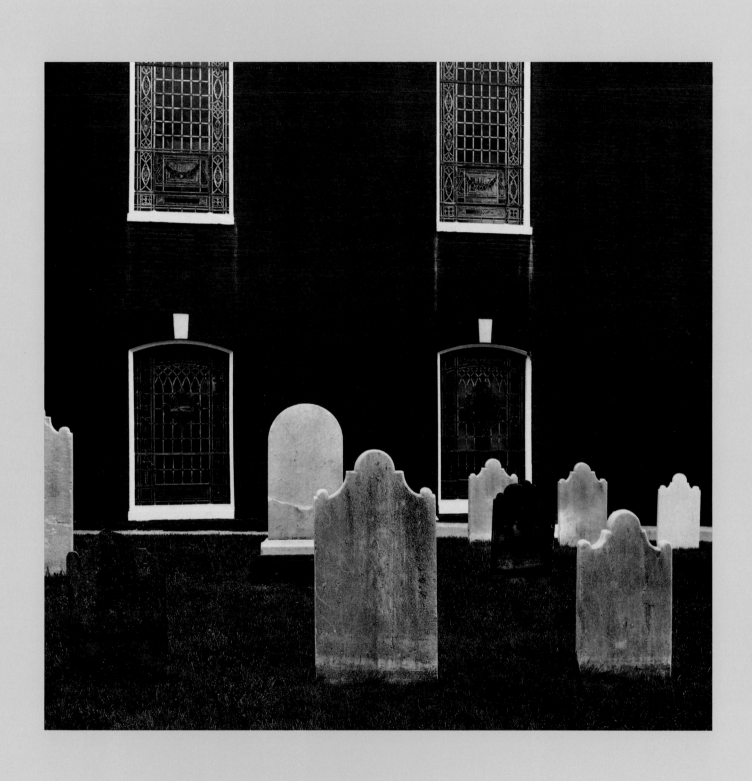

DAVID PLOWDEN

LANCASTER, PENNSYLVANIA / *Gelatin silver print, 1964*

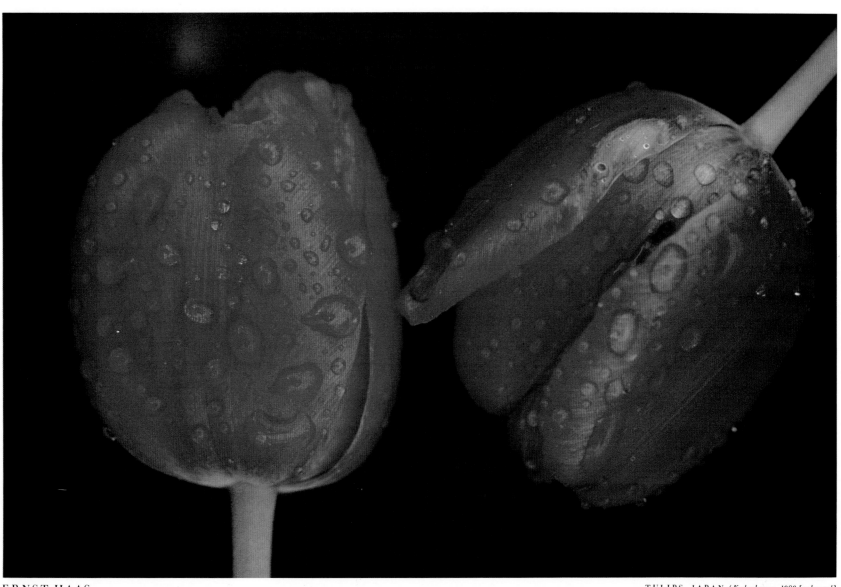

ERNST HAAS

TULIPS, JAPAN / *Kodachrome, 1980 [enlarged]*

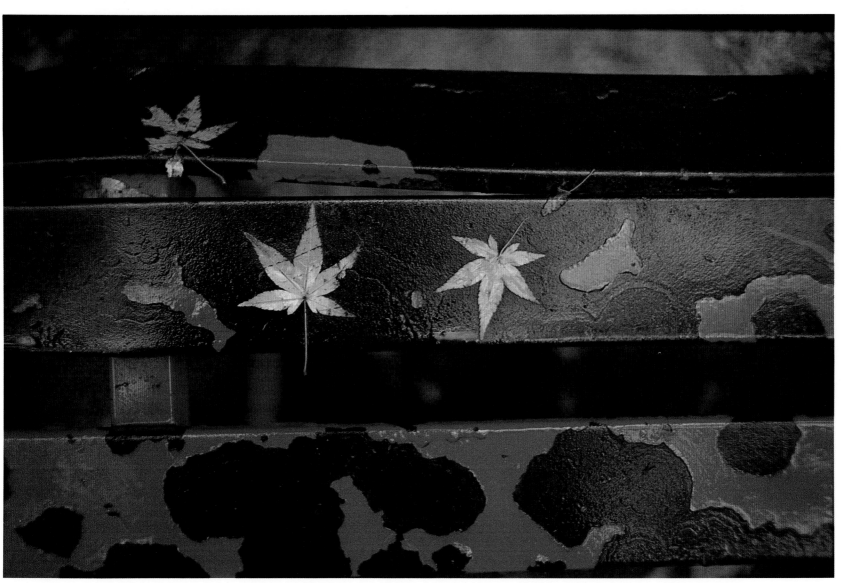

ERNST HAAS

PEELING PAINT ON IRON BENCH, KYOTO / *Kodachrome, 1981* [*enlarged*]

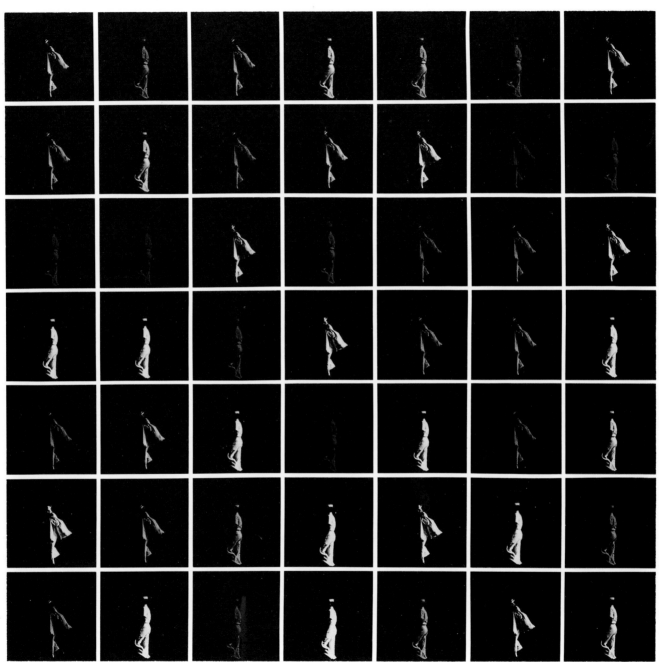

RAY K. METZKER UNTITLED / *Assembled gelatin silver prints, 1964*

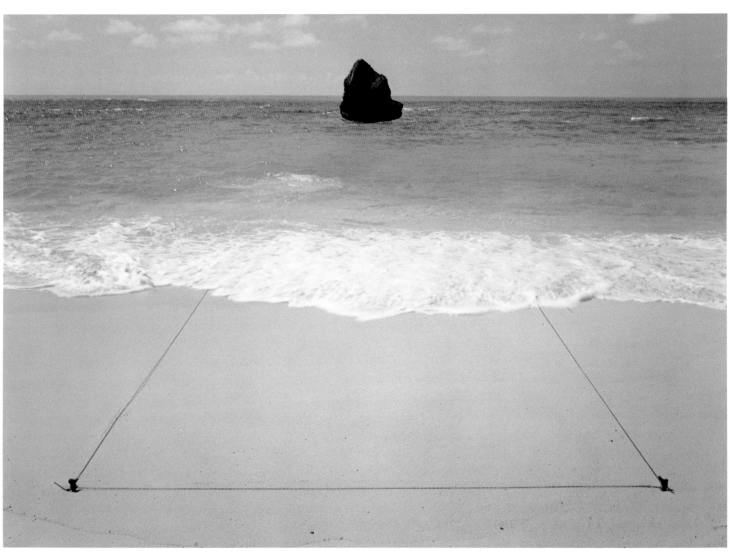

JOHN PFAHL TRIANGLE, BERMUDA / *Dye-coupler (Type C) print, 1975*

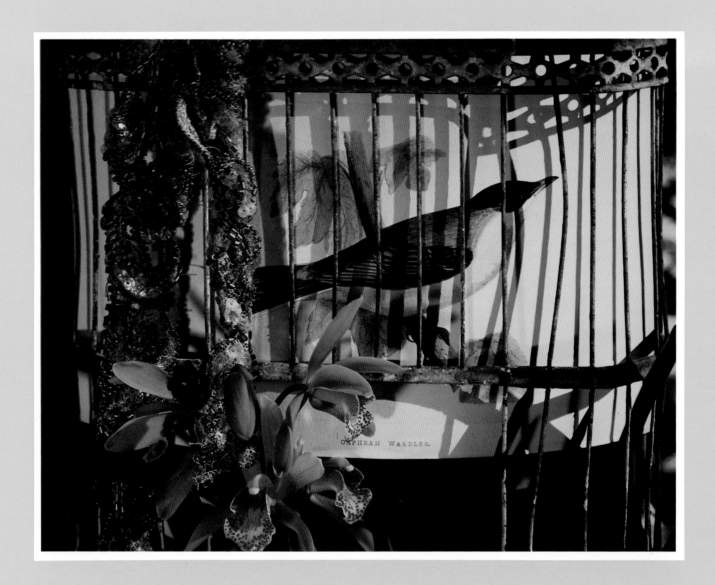

OLIVIA PARKER ORPHEAN WARBLER / *Dye-diffusion-transfer (polaroid) print, 1982*

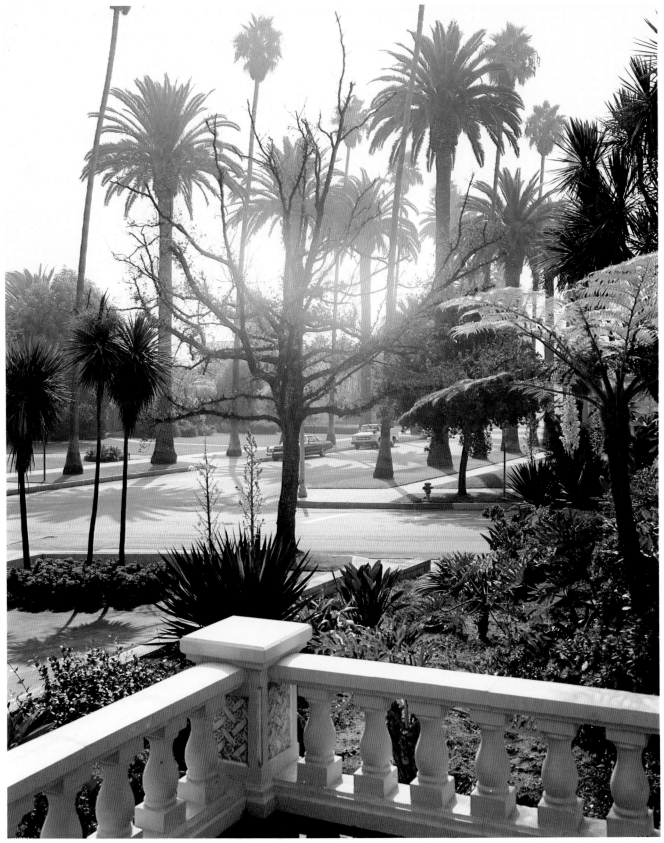

STEPHEN SHORE FOOTHILL ROAD, BEVERLY HILLS, CALIFORNIA, 9/10/74 / *Dye-coupler (Type C) print, 1974*

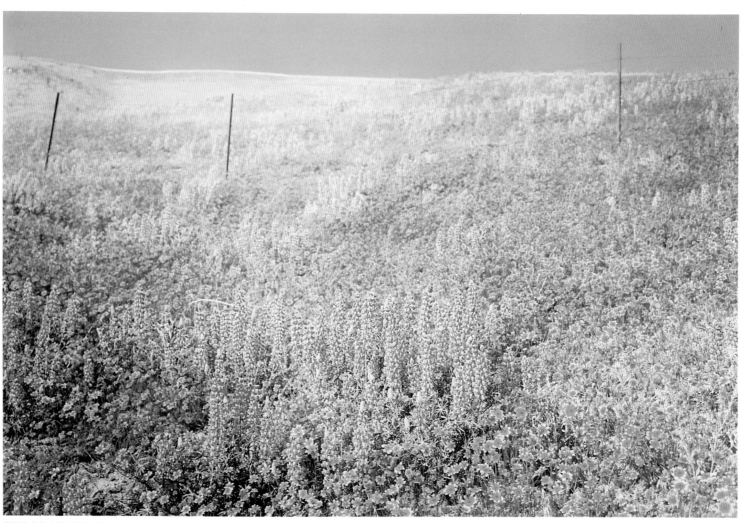

WILLIAM EGGLESTON YELLOW FLOWERS, HILLSIDE / *Dye transfer print, ca. 1974*

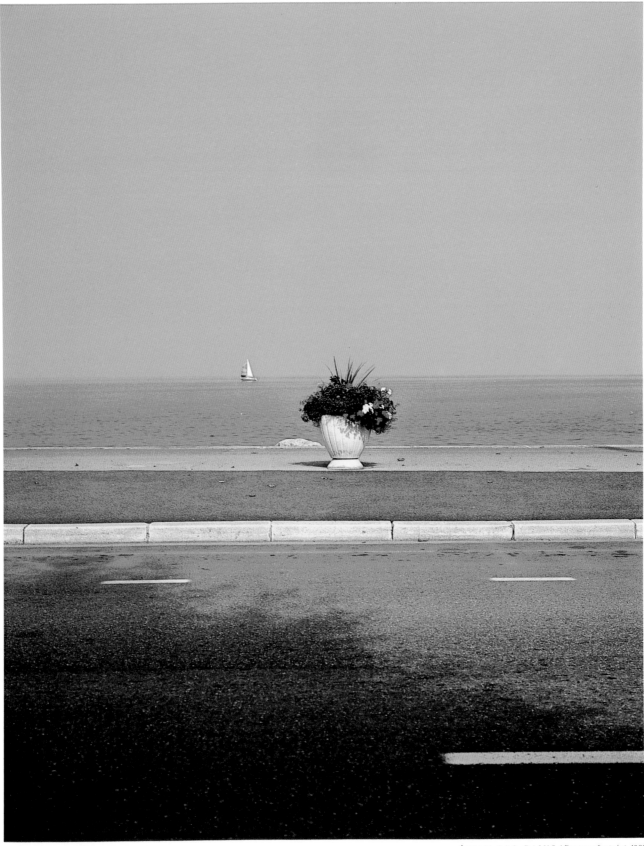

EVELYN HOFER

ÉVIAN-LES-BAINS / *Dye transfer print, 1980*

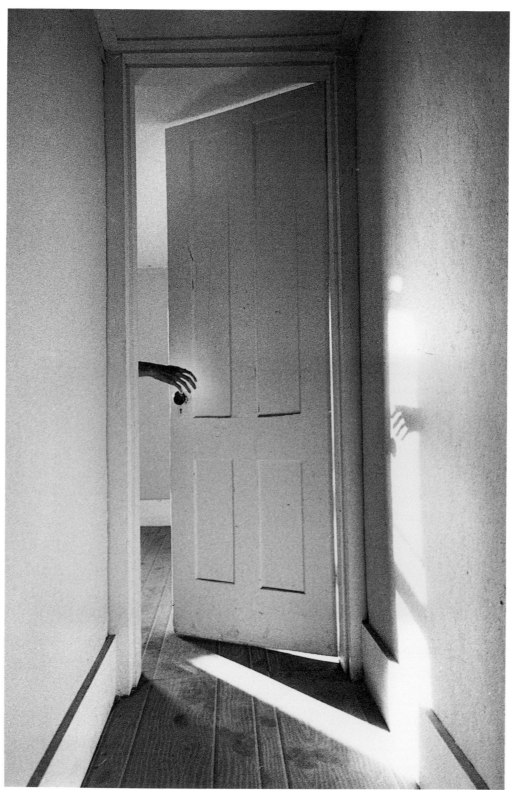

RALPH GIBSON UNTITLED (*from* THE SOMNAMBULIST) / *Gelatin silver print, 1969*

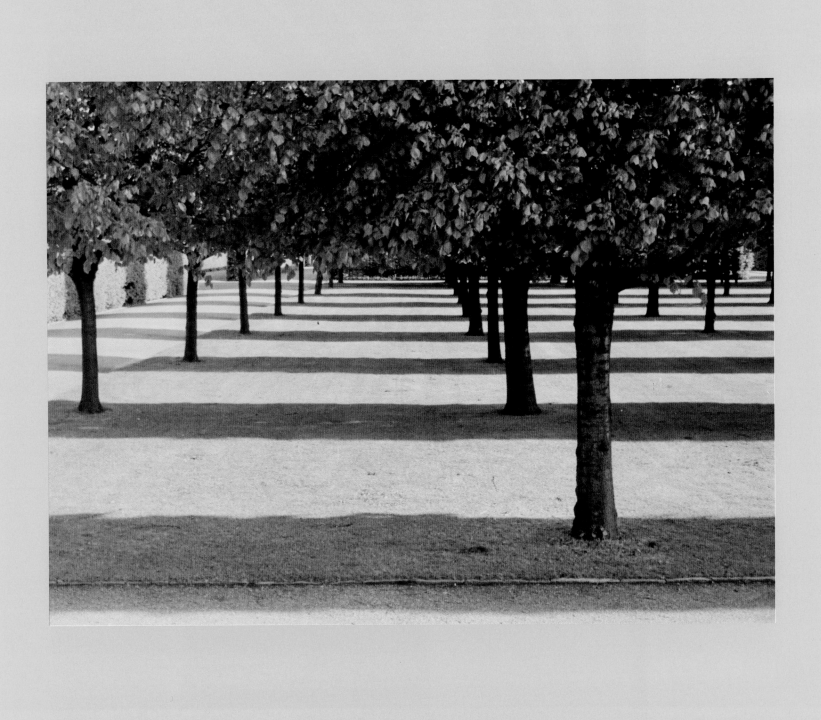

DAVID HOCKNEY

HERRENHAUSEN-HANOVER / *Dye-coupler (Type C) print, 1976*

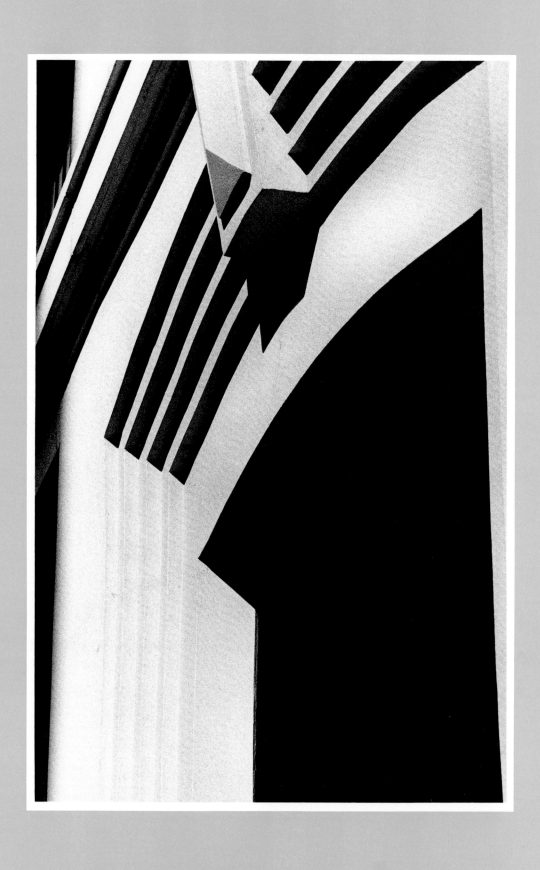

RALPH GIBSON

UNTITLED / *Gelatin silver print, 1980*

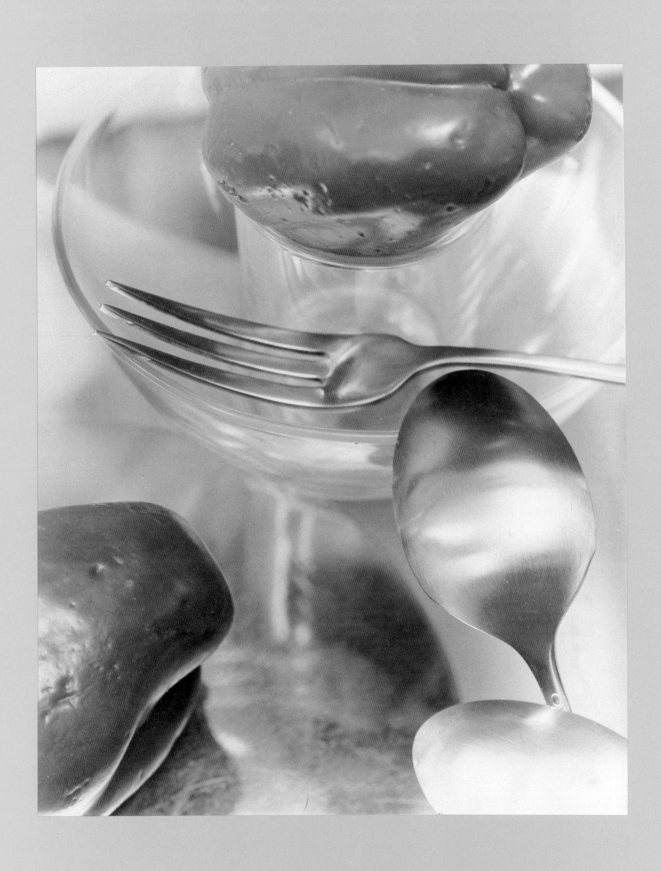

JAN GROOVER

UNTITLED / *Dye-coupler (Type C) print, 1979*

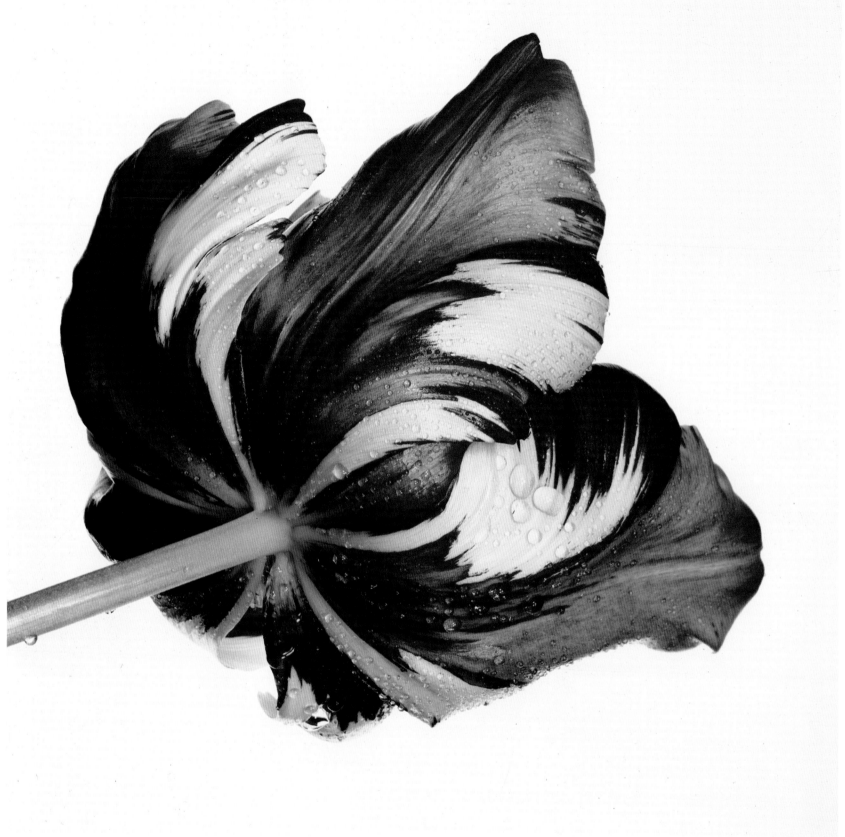

IRVING PENN

PURPLE TULIP / *Ektachrome, 1967*

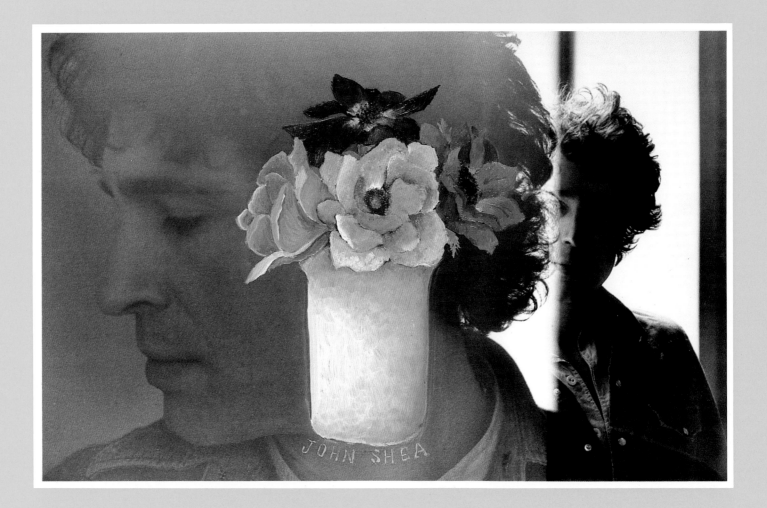

DUANE MICHALS JOHN SHEA WITH FLOWERS / *Gelatin silver print touched with oil pigment, 1980*

Plate List

The number preceding a plate listing refers to the page on which the photograph appears.

65 / ALFRED STIEGLITZ *The Steerage.* Photogravure, 1907. Collection Van Deren Coke, San Francisco, California.

66 / ROBERT DEMACHY *The Crowd.* Gray pigment oil print, 1910. The Metropolitan Museum of Art, New York, The Alfred Stieglitz Collection, 1949 (49.55.205).

67 / EDWARD STEICHEN *After the Grand Prix — Paris.* Gelatin-carbon print with selectively applied yellow tone, ca. 1911. The Metropolitan Museum of Art, New York, The Alfred Stieglitz Collection, 1933 (33.43.51).

68 / ALVIN LANGDON COBURN *The Rudder, Liverpool Docks.* Gum platinum print, ca. 1906. International Museum of Photography at George Eastman House, Rochester, New York.

69 / EDWARD S. CURTIS *Waiting in the Forest — Cheyenne.* Photogravure, 1911. The Metropolitan Museum of Art, New York, Jacob S. Rogers Fund 1976, (505.6pl.218).

70 / GERTRUDE KÄSEBIER *Portrait of a Woman.* Gum bichromate print, ca. 1900. International Museum of Photography at George Eastman House, Rochester, New York.

71 / SHINZO FUKUHARA *Woman, Paris.* Gum bichromate print, 1918. Japan Photographic Society, Tokyo.

72 / EDWARD WESTON *Shell.* Gelatin silver print, 1927. Collection Sam Wagstaff, New York. © 1981 Arizona Board of Regents, Center for Creative Photography, University of Arizona, Tucson, Arizona.

73 / ALFRED STIEGLITZ *Hands, Georgia O'Keeffe.* Palladium print, 1920. The Metropolitan Museum of Art, New York, Gift of Mrs. Rebecca S. Strand, 1928 (28.129).

74 / ADOLF DE MEYER *Still Life.* Photogravure, ca. 1907. International Museum of Photography at George Eastman House, Rochester, New York.

75 / EDWARD STEICHEN *Petunias.* Hicro color print, 1917. International Museum of Photography at George Eastman House, Rochester, New York.

76 / EUGÈNE ATGET *The Reflecting Pool of the Park at Sceaux.* Gelatin silver print, 1925. Bibliothèque Nationale, Paris.

77 / EUGÈNE ATGET *Fête du Trône.* Gelatin silver print, ca. 1921 – 1925. Courtesy The Witkin Gallery, Inc., New York.

79 / CHARLES SHEELER *Stairwell (Bucks County House).* Gelatin silver print, ca. 1914 – 1917. The Metropolitan Museum of Art, New York, The Alfred Stieglitz Collection, 1933 (33.43.261).

80 / PAUL STRAND *Matchboxes, Bowl and Bottle, Twin Lakes, Connecticut.* Platinum print, 1916. The Weston Gallery, Inc., Carmel, California. Copyright © 1950, 1977 The Paul Strand Foundation, as published in *Paul Strand: Time in New England,* Aperture, Millerton, New York, 1980.

81 / PAUL STRAND *Wheel and Mud Guard, New York.* Platinum print, 1920. The Metropolitan Museum of Art, New York, The Alfred Stieglitz Collection, 1949 (49.55.318). Copyright © 1976, The Paul Strand Foundation, as published in *Paul Strand: Sixty Years of Photographs,* Aperture, Millerton, New York, 1976.

82 / MAN RAY *Rayograph* (from *L'Ange Heurtebise*). Photogravure, 1925. Zabriskie Gallery, New York and Paris. © Juliette Man Ray.

83 / FRANCIS BRUGUIÈRE *Cut Paper Abstraction.* Gelatin silver print, ca. 1925. Robert Miller Gallery, New York. © Rosalinde Fuller, M.B.E.

84 / B. J. OCHSNER *Study in Circles.* Toned gelatin silver print, 1920s. Collection San Wagstaff, New York.

85 / EDWARD STEICHEN *Wind Fire: Thérèse Duncan on the Acropolis.* Gelatin silver print, 1921. International Museum of Photography at George Eastman House, Rochester, New York. Reprinted with the permission of Joanna Steichen.

86 / GÜNTHER HIRSCHEL-PROTSCH *Untitled.* Gelatin silver print photomontage, 1929. Prakapas Gallery, New York.

87 / WENZEL AUGUST HABLIK *Juggling.* Gelatin silver print, ca. 1929. Prakapas Gallery, New York.

88 / MARGRETHE MATHER *Pine Branch.* Platinum print, ca. 1930. The Metropolitan Museum of Art, New York, Purchase, Gift of Mr. & Mrs. Robert J. Massar, 1971 (1971.517.2). © 1979 Arizona Board of Regents, Center for Creative Photography, University of Arizona, Tucson, Arizona.

89 / ALFRED STIEGLITZ *Equivalent.* Gelatin silver print, 1930. The Metropolitan Museum of Art, New York, Alfred Stieglitz Collection, 1949 (49.55.27).

90 / HERBERT BAYER *Lonely Metropolitan.* Gelatin silver photomontage, 1932. Collection the artist. © 1932 Herbert Bayer.

91 / PAUL CITROËN *Untitled.* Gelatin silver print (touched by hand on both negative and print), 1930. Collection Dr. Martha Heineman Peiper, Chicago, Illinois. Reprinted courtesy of Paul Citroën/Rudolph Kicken Galerie, Cologne, West Germany.

92 / JOSEF SUDEK *Gramophone Discs.* Gelatin silver print, 1934. International Museum of Photography at George Eastman House, Rochester, New York.

93 / PAUL WOLFF (ATTRIB.) *Ship's Smokestack: The S.S. United States.* Gelatin silver print, 1930s. Sonnabend Gallery, New York. © Dr. Paul Wolff and Tritschler.

94 / ANSEL ADAMS *Rose and Driftwood, San Francisco, California.* Gelatin silver print, ca. 1932. Collection the artist. © 1982 Trustees of the Ansel Adams Publishing Rights Trust.

95 / BILL BRANDT *Early Morning on the River, London Bridge.* Gelatin silver print, ca. 1940. Philadelphia Museum of Art, Philadelphia, Pennsylvania, The Alfred Stieglitz Center Revolving Fund. © Bill Brandt/Photo Researchers.

96 / PAUL OUTERBRIDGE, JR. *Cheese and Crackers.* Platinum print, 1922. The Metropolitan Museum of Art, New York (29.82.7). © 1976 G. Ray Hawkins Gallery, Los Angeles, California.

97 / PAUL OUTERBRIDGE, JR. *Images de Deauville.* Three-color carbro print, 1938. The Museum of Modern Art, New York, Gift of Mrs. Ralph Seward Allen. © 1976 G. Ray Hawkins Gallery, Los Angeles, California.

99 / MINOR WHITE *Front Street, Portland, Oregon.* Gelatin silver print, 1939. Collection Professor and Mrs. R. Joseph Monsen, Seattle, Washington. Reprinted courtesy Minor White Archive, Princeton University. © 1982 Trustees of Princeton University.

100 / FRANTIŠEK DRTIKOL *Untitled.* Gelatin silver or bromoil print, ca. 1925. Stephen White Gallery, Los Angeles, California.

101 / GINGO HANAWA *Object.* Photocollage, 1931. Collection Sanya Nakamori, Osaka, Japan.

102 / EDWARD STEICHEN *Lily Damita.* Gelatin silver print, 1928. Collection Paul F. Walter, New York. Reprinted with the permission of Joanna Steichen.

103 / EDWARD STEICHEN *Gloria Swanson.* Gelatin silver print, 1920. Collection Sam Wagstaff, New York. Reprinted with the permission of Joanna Steichen.

104 / LÁSZLÓ MOHOLY-NAGY *Photo-plastik Jealousy.* Gelatin silver photomontage, 1928. Stephen White Gallery, Los Angeles, California. Reprinted courtesy Hattula Moholy-Nagy.

105 / CAS OORTHUYS *Untitled.* Gelatin silver photomontage, ca. 1932. Lydia Oorthuys/Prakapas Gallery, New York.

106 / EDWARD WESTON *Cabbage Leaf.* Gelatin silver print, 1931. International Museum of Photography at George Eastman House, Rochester, New York. © 1981 Arizona Board of Regents, Center for Creative Photography, University of Arizona, Tucson, Arizona.

107 / EDWARD WESTON *Nude.* Gelatin silver print, 1936. International Museum of Photography at George Eastman House, Rochester, New York. © 1981 Arizona Board of Regents, Center for Creative Photography, University of Arizona, Tucson, Arizona.

108 / ANDRÉ STEINER *Untitled.* Gelatin silver print from a solarized negative, ca. 1930. Collection Paul F. Walter, New York.

109 / MAN RAY *Gala Dali Looking at "The Birth of Liquid Desires."* Gelatin silver print, 1935. Boston Museum of Fine Arts, Boston, Massachusetts, Lucy Dalbiac Luard Fund. © Juliette Man Ray.

110 / MEHEMED FEHMY AGHA *Untitled.* Gelatin silver print, 1930. Janet Lehr, Inc., New York.

111 / LAURA GILPIN *Scissors, String and Two Books (P.P.A. Camp).* Gelatin silver print, 1930. Amon Carter Museum, Fort Worth, Texas, Laura Gilpin Collection.

112 / MAN RAY *Butterflies.* Three-color carbro print, 1940. Collection Sam Wagstaff, New York. © Juliette Man Ray.

113 / WERNER BISCHOF *Argonaut Shell and Snail Shell.* Gelatin silver print, 1941. Private collection, New York. © 1946 Werner Bischof Estate.

114 / RUTH BERNHARD *Creation.* Gelatin silver print, 1936. Stephen White Gallery, Los Angeles, California. Reprinted courtesy of Ruth Bernhard.

115 / ERWIN BLUMENFELD *Nude with Veil, Paris.* Gelatin silver print, 1936. Staley-Wise Gallery, New York. Reprinted courtesy of the Estate of Erwin Blumenfeld. © Yorick Blumenfeld.

116 / EDWARD WESTON *Burnt Stump.* Gelatin silver print, 1937. © 1981 Arizona Board of Regents, Center for Creative Photography, University of Arizona, Tucson, Arizona.

117 / ANSEL ADAMS *Frozen Lake and Cliffs, Sequoia National Park.* Gelatin silver print, 1932. Collection the artist. © 1982 Trustees of the Ansel Adams Publishing Rights Trust.

118 / MANUEL ALVAREZ BRAVO *Sparrow, of course (Skylight).* Gelatin silver print, 1938. International Museum of Photography at George Eastman House, Rochester, New York. © Manuel Alvarez Bravo.

119 / DOROTHEA LANGE *Funeral Cortege, The End of an Era in a Small Valley Town, California.* Gelatin silver print, 1938. The Dorothea Lange Collection, The Oakland Museum, Oakland, California.

120 / HERBERT LIST *Thirst, Greece, 1939.* Gelatin silver print, 1939. © Herbert List Estate/Max Scheler, Hamburg, West Germany.

121 / HERBERT LIST *Lake Lucerne.* Gelatin silver print, 1936. Sander Gallery, Inc., Washington, D.C. © Herbert List Estate/Max Scheler, Hamburg, West Germany.

123 / ALBERT RENGER-PATZSCH *Woods in Autumn.* Gelatin silver print, 1936. The Metropolitan Museum of Art, New York, Gift of Warner Communications, Inc. (1978.602.1). © Galerie Wilde, Cologne, West Germany.

124 / WALKER EVANS *Circus Poster.* Gelatin silver print, 1936. The Metropolitan Museum of Art, New York, Gift of Lincoln Kirstein, 1952 (52.562.16). Courtesy of the Estate of Walker Evans.

125 / BRETT WESTON *Untitled.* Gelatin silver print, 1940. The Witkin Gallery, Inc., New York.

126 / ANSEL ADAMS *Leaves, Mount Rainier National Park, Washington.* Gelatin silver print, ca. 1942. Collection the artist. © 1982 Trustees of the Ansel Adams Publishing Rights Trust.

127 / BRETT WESTON *Texas Desert.* Gelatin silver print, 1939. Collection Keith de Lellis, New York.

128 / CLARENCE JOHN LAUGHLIN *The Masks Grow to Us.* Gelatin silver print from multiple negatives, 1947. Robert Miller Gallery, New York. © 1973 Clarence John Laughlin/Historic New Orleans Collection.

In our society most of us wear protective masks (psychological ones) of various kinds and for various reasons. Very often the end result is that the masks grow to us, displacing our original characters with our *assumed* characters. This process is indicated in visual, and symbolic, terms here by several exposures on one negative—the disturbing factor being that the mask is like the girl *herself* grown harder, and more superficial.

C.J.L.

129 / BRASSAÏ *A Woman—Primitive Painter.* Gelatin silver print, ca. 1930s. The Metropolitan Museum of Art, New York, Gift of Brassaï, 1980 (1980.1029.10). © 1950 Brassaï.

130–31 / ANSEL ADAMS *Moonrise, Hernandez, New Mexico.* Gelatin silver print, 1941. Collection the artist. © 1982 Trustees of the Ansel Adams Publishing Rights Trust.

132 / YASUZO NOJIMA *Abstract Nude.* Gelatin silver print, 1940. Art Institute of Chicago, Chicago, Illinois. Courtesy of Toshio Fujii, Tokyo, Japan.

133 / ROLF TIETGENS *Untitled.* Gelatin silver print, 1945. Private collection, New York.

134 / ARNOLD NEWMAN *Igor Stravinsky.* Gelatin silver print, 1946. Collection the artist. © Arnold Newman.

135 / CECIL BEATON *Gertrude Stein.* Gelatin silver photocollage, 1945. Sotheby's Belgravia, London.

136 / VAL TELBERG *Return to Summer: Palmetto Gnome.* Gelatin silver print from multiple negatives, ca. 1948. Collection Laurence G. Miller, Inc., New York. © Val Telberg.

137 / SALVADOR DALI, GEORGE PLATT LYNES, and GEORGE HOYNINGEN-HUENE *Scene from The Birth of Venus.* Gelatin silver print, 1949. Robert Miller Gallery, New York

138 / IMOGEN CUNNINGHAM *Two Callas.* Gelatin silver print, 1929. Imogen Cunningham Trust, Berkeley, California. © 1970 Imogen Cunningham Trust.

139 / IMOGEN CUNNINGHAM *The Unmade Bed.* Gelatin silver print, 1957. The Imogen Cunningham Trust, Berkeley, California. © 1970 Imogen Cunningham Trust.

140 / PAUL STRAND *Grapes, Charente, France.* Gelatin silver print, 1951. Philadelphia Museum of Art, Philadelphia, Pennsylvania, The Paul Strand Retrospective Collection, 1915–1975, Gift of the Estate of Paul Strand. © 1952, 1971, 1976, 1980 The Paul Strand Foundation, as published in *Paul Strand: Sixty Years of Photographs,* Aperture, Millerton, New York, 1976.

141 / PAUL STRAND *Palladian Window, Maine.* Gelatin silver print, 1945. Philadelphia Museum of Art, Philadelphia, Pennsylvania, The Paul Strand Retrospective Collection, 1915–1975, Gift of the Estate of Paul Strand. © 1950, 1977 The Paul Strand Foundation, as published in *Paul Strand: Time in New England,* Aperture, Millerton, New York, 1980.

142 / CLARENCE JOHN LAUGHLIN *The Iron Shell (Old Louisiana State Capitol, Baton Rouge).* Gelatin silver print, 1949. The Metropolitan Museum of Art, New York, Purchase, David H. McAlpin Gift, 1962 (62.549.2). © 1973 Clarence John Laughlin/Historic New Orleans Collection.

And then, looking down from aloft in the dome, we can see the spiral staircase of cast iron. Its geometry is as pure as a nautilus shell; while the space between the first and second floors (which are covered with black and white marble squares) becomes strangely flattened.

C.J.L.

143 / ANDRÉ KERTÉSZ *Disappearing Act.* Gelatin silver print, 1955. Susan Harder Gallery, New York. © 1982 André Kertész.

144 / MINOR WHITE *Face in Door, San Francisco, 1949.* (From *Sequence 13: Return to the Bud*) Gelatin silver print, 1949. International Museum of Photography at George Eastman House, Rochester, New York. © 1982 Trustees of Princeton University, Princeton, New Jersey. Reprinted courtesy of Minor White Archive, Princeton University, Princeton, New Jersey.

145 / WEEGEE *Hedda Hopper.* Gelatin silver print, before 1953. Collection John Coplans, New York.

146 / AARON SISKIND *Fish in Hand.* Gelatin silver print, 1939. The Metropolitan Museum of Art, New York, Gift of Richard L. Menschel, 1977 (1977.677.1). © 1982 Aaron Siskind.

147 / ROBERT FRANK *U.S. 285 New Mexico.* Gelatin silver print, ca. 1956. Collection Harry Lunn, Washington, D.C. © 1958 Robert Frank.

148 / AARON SISKIND *Seaweed No. 26.* Gelatin silver print, 1953. The Metropolitan Museum of Art, New York, Gift of Richard L. Menschel, 1977 (1977.677.9). © 1982 Aaron Siskind.

149 / AARON SISKIND *Martha's Vineyard No. 112A.* Gelatin silver print, 1954. San Francisco Museum of Modern Art, San Francisco, California, Gift of Virginia Hassel Ballinger in memory of Paul Hassel. © 1982 Aaron Siskind.

150 / VAN DEREN COKE *Wicker Chair and Moving Moss.* Gelatin silver print, 1960. Collection the artist. © Van Deren Coke.

151 / JOSEF SUDEK *Untitled.* Gelatin silver print, 1940. International Museum of Photography at George Eastman House, Rochester, New York.

152 / PAUL CAPONIGRO *Stonehenge.* Gelatin silver print, 1967. The International Museum of Photography at George Eastman House, Rochester, New York.

153 / BILL BRANDT *Chiswick House Gardens, Early Morning in the Park.* Gelatin silver print, 1958. Collection Sam Wagstaff, New York. © Bill Brandt/Photo Researchers.

154 / WYNN BULLOCK *Christmas, Sandy's.* Gelatin silver print, 1956. The Metropolitan Museum of Art, New York, Loan, 1975. Reprinted courtesy of Wynn and Edna Bullock Trust. © 1973 Wynn Bullock.

155 / HARRY CALLAHAN *Eleanor.* Gelatin silver print, ca. 1954. Peter MacGill, New York. © 1982 Harry Callahan.

156 / HARRY CALLAHAN *Telephone Wires.* Gelatin silver print, ca. 1968. Center for Creative Photography, University of Arizona, Tucson, Arizona. © 1976 Harry Callahan.

157 / WILLIAM A. GARNETT *Snow Geese with Reflection of the Sun over Buena Vista Lake, California.* Gelatin silver print, 1953. Collection Daniel Wolf, Inc. © 1953 William Garnett.

158 / PAUL CAPONIGRO *Kilclooney.* Gelatin silver print, 1967. International Museum of Photography at George Eastman House, Rochester, New York.

159 / PAUL CAPONIGRO *Fungus, Ipswich, Massachusetts.* Gelatin silver print, 1962. International Museum of Photography at George Eastman House, Rochester, New York.

160 / WYNN BULLOCK *Child in the Forest.* Gelatin silver print, 1951. International Museum of Photography at George Eastman House, Rochester, New York. Reprinted courtesy of Wynn and Edna Bullock Trust, 1975. © 1971 Wynn Bullock.

161 / BILL BRANDT *Portrait of a Young Girl, Eaton Place, London.* Gelatin silver print, 1955. International Museum of Photography at George Eastman House, Rochester, New York. © Bill Brandt/Photo Researchers.

162 / IRVING PENN *Seated Nude.* Gelatin silver print, 1950. Collection the artist. © 1960 Irving Penn. Courtesy of *Vogue* magazine.

163 / IRVING PENN *After-Dinner Games.* Ektachrome transparency, 1947. Collection the artist. © 1949, 1977 The Condé Nast Publications, Inc. Courtesy of *Vogue* magazine.

164 / LOTTE JACOBI *Photogenic No. 3.* Gelatin silver print, 1946–1955. Collection the artist. © Lotte Jacobi.

165 / MAN RAY *Rayograph.* Gelatin silver print, 1955. Collection Van Deren Coke, San Francisco, California.

166 / ELIOT PORTER *Pool in a Brook, Pond Brook, near Whiteface, New Hampshire, October 1953.* Dye transfer print, 1953. The Metropolitan Museum of Art, New York, Gift of Eliot Porter in honor of David H. McAlpin, 1979 (1979.625.22). © 1953 Eliot Porter.

167 / WERNER BISCHOF *Shinto Priests in the Snow, Japan.* Gelatin silver print, 1951. The Metropolitan Museum of Art, New York, Gift of "Photography in the Fine Arts," 1959 (59.559.4). © Werner Bischof Estate.

168 / HANS NAMUTH *Jackson Pollock (with Painting No. 32).* Gelatin silver print, 1950. Collection the artist. © 1955 Hans Namuth.

169 / GJON MILI *Pablo Picasso Drawing Minotaur with Light.* Gelatin silver print, 1950. Life Picture Service, New York. Gjon Mili, *Life Magazine.* © 1950 Time Inc.

170–71 / ALEXANDER LIBERMAN *Interior of Braque's Varengeville House.* Kodachrome, ca. 1953. Collection the artist.

172 / HENRI CARTIER-BRESSON *Siphnos, Greece.* Gelatin silver print, 1961. Collection Magnum Photos, Inc., New York. © 1961 Henri Cartier-Bresson/Magnum Photos,Inc., New York.

173 / HENRI CARTIER-BRESSON *Simiane-la-Rotonde (Alpes de Haute-Provence).* Gelatin silver print, 1954. Collection Magnum Photos, Inc., New York. © 1970 Henri Cartier-Bresson/Magnum Photos Inc., New York.

174 / GORDON PARKS *Woman with Fan.* Ektachrome, 1958. Collection the artist.

175 / GORDON PARKS *The Dove.* Ektachrome, 1947. Collection the artist.

176 / VILEM KRIZ *Woman from Sirague.* Gelatin silver print, 1966. The Metropolitan Museum of Art, New York, Gift of the artist, 1967 (67.743.12). © 1975 Vilem Kriz.

177 / EMIL SCHULTHESS *Frozen Ross Sea near Marble Point at Midnight, November 16/17th, 1958.* Gelatin silver print, 1958. Private collection, New York. © Emil Schulthess.

178 / RYOJI AKIYAMA *Empty Box on Its Way to a Reclamation Area.* Gelatin silver print, 1969. Collection the artist.

179 / RALPH EUGENE MEATYARD *Untitled.* Gelatin silver print, n.d. Collection Van Deren Coke, San Francisco, California. © 1974 Aperture, Inc.

180 / DIANE ARBUS *Identical Twins, Cathleen and Colleen, Roselle, New Jersey.* Gelatin silver print, 1967. The Metropolitan Museum of Art, New York, Gift of Dorothy M. Beskind, 1969 (69.546.1). © 1967 The Estate of Diane Arbus.

181 / IRVING PENN *Man in White/Woman in Black, Morocco, 1971.* Gelatin silver print, 1971. Collection the artist. © 1974 Irving Penn, courtesy of *Vogue* magazine.

183 / JOSEF SUDEK *Still Life from Glass Labyrinth.* Gelatin silver print, ca. 1967. Stephen White Gallery, Los Angeles, California.

184 / EMMET GOWIN *Edith, Chincoteague, Virginia.* Gelatin silver print, 1967. Collection the artist. © 1982 Emmet Gowin.

185 / EMMET GOWIN *Edith, Danville, Virginia.* Gelatin silver print, 1970. Collection the artist. © 1982 Emmet Gowin.

186 / ANDREAS FEININGER *Feather.* Gelatin silver print, 1965. From the permanent collection at the International Center of Photography, New York, Gift of the photographer. © 1965 Andreas Feininger.

187 / ROBERT MAPPLETHORPE *Daisy with Two Shadows, Texas.* Gelatin silver print, 1979. Courtesy Fraenkel Gallery, San Francisco, California. © 1979 Robert Mapplethorpe.

188 / JERRY N. UELSMANN *Untitled.* Gelatin silver print from multiple negatives, ca. 1979. The Witkin Gallery, New York. © 1979 Jerry Uelsmann.

189 / JERRY N. UELSMANN *Untitled.* Gelatin silver print from multiple negatives, 1976. The Metropolitan Museum of Art, New York, Gift of Warner Communications, Inc., and matching funds from the National Endowment for the Arts, 1981 (1981.1073). © 1976 Jerry Uelsmann.

190–91 / JOEL MEYEROWITZ *Provincetown Porch, 1977.* Dye-coupler (Type C) print, 1977. Collection the artist. © 1982 Joel Meyerowitz.

192 / WILLIAM CLIFT *Hangman's Noose, Old Colfax County Courthouse, New Mexico.* Gelatin silver print, 1976. Collection the artist. © 1975 William Clift.

193 / DAVID PLOWDEN *Lancaster, Pennsylvania.* Gelatin silver print, 1964. Collection the artist. © 1970 David Plowden.

194 / ERNST HAAS *Tulips, Japan.* Kodachrome, 1980. Courtesy the artist. © 1980 Ernst Haas.

195 / ERNST HAAS *Peeling Paint on Iron Bench, Kyoto.* Kodachrome, 1981. Collection the artist. © 1981 Ernst Haas.

196 / RAY K. METZKER *Untitled.* Assembled gelatin silver prints, 1964. Courtesy Laurence G. Miller Inc., New York. © 1964 Ray K. Metzker.

197 / JOHN PFAHL *Triangle, Bermuda.* Dye-coupler (Type C) print, 1975. Robert Freidus Gallery, New York. © 1975 John Pfahl.

198 / OLIVIA PARKER *Orphean Warbler.* Dye-diffusion-transfer (polaroid) print, 1982. Collection Brent Sikkema, Inc./Vision Gallery, Boston, Massachusetts. © 1982 Olivia Parker.

199 / STEPHEN SHORE *Foothill Road, Beverly Hills, California, 9/10/74.* Dye-coupler (Type C) print, 1974. Collection the artist. © 1974 Stephen Shore.

200 / WILLIAM EGGLESTON *Yellow Flowers, Hillside.* Dye transfer print, ca. 1974. The Oakland Museum, Oakland, California. Reprinted with the permission of the artist.

201 / EVELYN HOFER *Évian-les-Bains.* Dye transfer print, 1980. Courtesy The Witkin Gallery, Inc., New York.

202 / RALPH GIBSON *Untitled* (from *The Somnambulist*). Gelatin silver print, 1969. Castelli Graphics, New York. © 1982 Ralph Gibson.

203 / DAVID HOCKNEY *Herrenhausen-Hanover.* Dye-coupler (Type C) print, 1976. Collection Paul F. Walter, New York. © 1976 Sonnabend Gallery.

204 / RALPH GIBSON *Untitled.* Gelatin silver print, 1980. Castelli Graphics, New York. © 1982 Ralph Gibson.

205 / JAN GROOVER *Untitled.* Dye-coupler (Type C) print, 1979. Sotheby Parke Bernet, New York. © 1979 Jan Groover. Reprinted courtesy of the artist.

206 / IRVING PENN *Purple Tulip.* Ektachrome, 1967. Collection the artist. © 1967 The Condé Nast Publications, Inc., courtesy of *Vogue* magazine.

207 / DUANE MICHALS *John Shea with Flowers.* Gelatin silver print touched with oil pigment, 1980. Sidney Janis Gallery, New York. © 1980 Duane Michals.

Acknowledgments

The publishers gratefully acknowledge the cooperation of THE LIBRARY OF WORLD PHOTOGRAPHY's photographic research department.

Director of photographic research: Joan Morgan

Photographic researchers: Joan Ades, Gail Buckland, Sally Eauclaire, Christopher Phillips, Toby Quitslund, Katherine Schlesinger, Ruth Silverman, Sally Stein

Assistant to project director: Ellen Bearn
Assistant to editor-in-chief: Tasha Hall
Chief coordinator of photographic research: Katherine Schlesinger

The publishers would also like to thank various collections, public and private, whose staff spent their valuable time in assisting the research department:

Amon Carter Museum of Western Art, Forth Worth, Texas
The Art Institute of Chicago, Chicago, Illinois
Bibliothèque Nationale, Paris
Boston Museum of Fine Arts, Boston, Massachusetts
The Center for Creative Photography, Tucson, Arizona
Christie's East, New York, N.Y.
Humanities Research Center, The University of Texas at Austin, Austin, Texas
International Center of Photography, New York, N.Y.
International Museum of Photography at George Eastman House, Rochester, N.Y.
The Library of Congress, Washington, D.C.
The Metropolitan Museum of Art, New York, N.Y.
The Museum of Modern Art, New York, N.Y.
The Oakland Museum, Oakland, California
Pasadena Public Library, Pasadena, California
Philadelphia Museum of Art, Philadelphia, Pennsylvania
San Francisco Museum of Modern Art, San Francisco, California
Sotheby Parke Bernet, Inc., New York, N.Y.
Sotheby's Belgravia, London
Stanford University Museum of Art, Stanford California

Castelli Graphics, New York, N.Y.
Fraenkel Gallery, San Francisco, California
The Gilbert Gallery, Chicago, Illinois
Lucien Goldschmidt, Inc., New York, N.Y.
Susan Harder Gallery, New York, N.Y.
G. Ray Hawkins Gallery, Los Angeles, California
Sidney Janis Gallery, New York, N.Y.
Janet Lehr, Inc., New York, N.Y.
Life Picture Service, New York, N.Y.
Lunn Gallery, Washington, D.C.
Magnum Photos, Inc., New York, N.Y.
Robert Miller Gallery, New York, N.Y.
Photo Researchers, Inc., New York, N.Y.
Prakapas Gallery, New York, N.Y.
Sonnabend Gallery, New York, N.Y.
Staley-Wise Gallery, New York, N.Y.
Vision Gallery, Boston, Massachusetts
Weston Gallery, Carmel, California
Stephen White Gallery, Los Angeles, California
The Witkin Gallery, Inc., New York, N.Y.
Daniel Wolf, Inc., New York, N.Y.
Zabriskie Gallery, New York, N.Y.

Van Deren Coke Collection, San Francisco, California
John Coplans Collection, New York, N.Y.
The Imogen Cunningham Trust, Berkeley, California
H. Kwan Lau Collection, New York, N.Y.
Keith de Lellis Collection, New York, N.Y.
Laurence G. Miller, Inc., New York, N.Y.
Joseph Monsen Collection, Seattle, Washington
Joan Murray Collection, Piedmont, California
Weston Naef Collection, New York, N.Y.
Pieper Collections, Chicago, Illinois
Sam Wagstaff Collection, New York, N.Y.
Paul Walter Collection, New York, N.Y.

The publishers would also like to thank the artists, who loaned us their photographs and contributed their expertise.

All text material was edited by Mark Greenberg.

Biographies

ANSEL ADAMS *American, 1902–1984 / Pages 94, 117–126, 130–131*
Ansel Adams had a long and publicized career as a photographer, gaining renown for his impeccably printed celebrations of the Western landscape. In 1916 Adams made his first photographs in the Yosemite Valley, a deeply emotional experience that significantly affected the direction of his career. Adams was influenced by soft-focus pictorialism, but soon after meeting Paul Strand in 1930, he embraced the "purist" aesthetic of straight photography. In 1932, with Edward Weston, Imogen Cunningham, and others, he founded the F/64 Group, which insisted on sharp focus in all details of the image. By the 1940s Adams had stated his photographic philosophy and codified his Zone System of printing that was disseminated in a series of influential handbooks. In 1939, with David McAlpin and Beaumont Newhall, Adams collaborated in the foundation of the Photography Department of The Museum of Modern Art. Long associated with the Sierra Club, Adams's photographs of the Sierra Nevada mountains, Yosemite Valley, the desert regions of California and New Mexico, and other national parks and monuments have served the cause of conservation as much as they have photography. Although best known for his landscapes, Adams also made many formal portraits and produced reportage on Japanese-Americans interned in California during World War II, and the Utah Mormons (with Dorothea Lange), among other social issues.

MEHEMED FEHMY AGHA *Turkish, born Russia, 1896–1978, active France, Germany, America / Page 110*
In 1929 Agha went to New York to serve as art director of *Vogue* and *Vanity Fair*, a position he held until 1942. He was responsible in the early 1930s for introducing modern concepts of picture layout, typography, and photography to American audiences. Agha wrote knowledgeably on the history of photography, and his own images reflect his whimsical, cosmopolitan personality.

RYOJI AKIYAMA *Japanese, born 1942 / Page 178*
Akiyama was born in Tokyo and graduated from Waseda University with a degree in literature in 1964. He began his career as a staff photographer for Asahi Newspapers and the Associated Press of Japan. In 1967 he turned to freelance photography.

MANUEL ALVAREZ BRAVO *Mexican, born 1902 / Page 118*
At the heart of Alvarez Bravo's work lies an aura of mystery and symbolism that has often caused it to be termed surrealist, although the photographer himself prefers the word "fantasy." He purchased his first camera in 1924, and within a few years his talent drew him into friendship with many of the leading artists of the era who were active in Mexico City, including Rufino Tamayo, Jose Clemente Orozco, and Diego Rivera. As his reputation grew, Bravo earned his living primarily by teaching photography, making stills and filming backdrops for Mexican movie producers.

DIANE ARBUS *American, 1923–1971 / Page 180*
After pursuing a successful career in commercial photography, in 1959 Arbus apprenticed herself to Lisette Model, whom she credited as being an important influence on her style. The recipient of two Guggenheim Foundation grants for her noncommercial photography, Arbus's haunting and disquieting portraits were quickly recognized for their originality and human insight. Although she is perhaps best known for uncompromising portraits of freaks, transvestites, nudists, and other bizarre subjects, her more commonplace subjects, such as crying babies, twins, suburbanites, and working-class couples also have a disturbing ingredient. Arbus analyzed her attraction to freaks in the following way: "Most people go through life dreading they'll have a traumatic experience. Freaks were born with their trauma. They've already passed their test in life. They're aristocrats."

EUGÈNE ATGET *French, 1857–1927 / Pages 18, 76, 77*
What led Atget to take up photography and exactly when remain mysteries, but in 1897—after working first as a sailor and then as an actor, he moved to Paris and spent the balance of his life photographing those aspects of the old city and its heritage that seemed threatened with extinction. Using simple equipment—a wooden camera that could be loaded with one 6 x 8 inch glass plate at a time—and a straightforward technique, Atget managed to distill an intimate, lyric poetry from his chosen subjects. However, he received little recognition for his art during his lifetime. He called his photographs "documents for artists" and sold them to painters, illustrators, architects, publishers, and historical museums. Shortly after his death in 1927, Atget's collection of prints and negatives was saved from oblivion by two young American photographers, Berenice Abbott and Julien Levy, who subsequently did much to bring Atget's remarkable project to the attention of a wide public.

CHARLES AUBRY *French, active mid-19th century / Page 42*
Even though he is now held in high regard by major collectors, Charles Aubry's reputation fell into eclipse faster than that of any photographer of France's Golden Age. A set of studies of leaves and flowers in the Bibliothèque Nationale, Paris, is the most significant Aubry group to be seen in one place. These photographs depict still-life ensembles derived from prototypes in painting and studies of leaves arranged against drapery backdrops or undifferentiated backgrounds.

ÉDOUARD DENIS BALDUS *French, 1820–1882 / Page 11*
One of the great architectural photographers of his epoch, Baldus was trained initially as a painter and exhibited in the Paris Salons of the 1840s. In the 1850s he left the studio and was one of the first photographers to work outdoors, documenting designated sites for the Commission des Monuments Historiques—the first government-sponsored photographic survey—and the rebuilding of the Louvre for the Ministry of the Interior. In 1855 he was commissioned by the Baron de Rothschild to photograph the new railway line between Paris and Boulogne, and four years later he received a similar commission to photograph the Marseilles-Lyons railroad line.

HERBERT BAYER *American, born Austria, 1900–1985 / Page 90*
While a student at the Bauhaus, the innovative German art and design institute, Bayer carried out a series of photographic experiments in which conventional picture relations were disrupted by means of extreme close-ups, unusually high or low vantage points, and the introduction of shadows as an independent graphic element. The resulting images went far toward confirming the camera's value as an instrument of a new, abstract vision. After leaving the Bauhaus in 1928, Bayer developed his highly personal approach to photomontage. In *Lonely Metropolitan*, as in much of the surrealist art of the same era, elements of photographic realism and dreamlike fantasy are evocatively mingled but Bayer's startling conception and technical polish far surpass the typical surrealist production.

FELICE BEATO *British, born Italy, ?–1903 / Page 56*
Felice Beato traveled more widely with a camera than perhaps any other person working before 1860. In 1855, in collaboration with James Robertson, the superintendent and chief engraver of the Imperial Mint, he photographed during the Crimean War, covering the siege of Sebastopol and the Russian retreat. From the Crimean battlefields, Beato and Robertson next established themselves in the eastern Mediterranean, where they produced tourist views and photographs of architecture. The Sepoy Mutiny in 1857 caused Beato and Robertson to move on to India where they photographed the aftermath of the uprising. Following its suppression, Beato was in China and recorded the aftermath of the Opium War. By 1862, he was in Japan producing studio photographs of the Japanese, often hand-tinted. For the next 22 years Beato remained in Japan, until 1886 when he established himself in Burma.

CECIL BEATON *British, 1904–1980 / Page 135*
The unconventional product of a conventional upper-class childhood, Beaton first attracted wide attention when his lively portraits of London society figures began to appear in *The Tatler* in the 1920s. In 1929 he traded his hand-held Kodak for a large studio camera and embarked on what proved a long association with *Vogue* magazine. Unhappy with the pared-down exactitude that Edward Steichen had popularized in fashion and portrait photography, Beaton injected into his own work an atmosphere of cultivated fantasy and studied theatricality.

RUTH BERNHARD *American, born Germany, 1905 / Page 114*
Initially a freelance advertising and fashion photographer, Bernhard is especially noted for her sensuous, romantic photographs of the female nude, as well as for her work with seashells, bones, fossils, plants, and other natural forms.

WERNER BISCHOF *Swiss, 1916–1954 / Pages 113, 167*
Bischof first won wide acclaim as a photojournalist when, at the end of World War II, he traveled through France, Holland, and Germany to survey the war's human consequences. In 1949 he was invited to join Magnum, the picture agency, and henceforth spent much of his time on assignment around the world. Bischof devoted an entire year to photographing in Japan in 1951, from which emerged his book *Japan*. In 1954, while on assignment in the Peruvian Andes, he was killed in an auto accident.

ERWIN BLUMENFELD *American, born Germany, 1897–1969, active Holland, France, America / Page 115*
In 1936, Blumenfeld moved to Paris to seek work as a photographer. His highly provocative photographs of nudes were published almost immediately in avant-garde periodicals such as *Verve*. Blumenfeld's long-standing preoccupation with the nude led him to employ solarization, double exposure, reticulation, high contrast, and many other experimental techniques. Finding his services in great demand for portraiture, advertising, and magazine editorial photography, Blumenfeld in 1938 began to work for French *Vogue*. In 1941, he made his way to New York and embarked on an extremely successful photographic career in the United States.

BILL BRANDT *British, 1904–1983 / Pages 95, 153, 161*
After an apprenticeship with Man Ray in Paris for several months in 1930, Bill Brandt returned to England where he worked as a photojournalist. Throughout the Thirties he produced three photography books chronicling lower-, middle-, and upper-class British life. Although working in a "straight" reportorial mode, his photographs of this period are frequently marked by a disturbing, subtle element of strangeness and disease, the legacy of French surrealism. After the war, Brandt largely abandoned photojournalism, and the surrealist aspect of his work became progressively dominant—nowhere more so than in his nudes.

BRASSAÏ (GYULA HALÁSZ) *French, born Transylvania / Page 129*
Brassaï was born in Brasso, Transylvania, from which he took his name. In 1924 he settled in Paris and worked for the next eight years as a journalist. His desire to capture scenes from his nocturnal wanderings led him to take up photography around 1929, following the example of his friend André Kertész. During the early 1930s Brassaï explored the dark glamor of Parisian nightlife, and his photographs of bistros, brothels, and other nighttime haunts were published in 1933 as *Paris de Nuit*. In 1937 he began to photograph artists such as Picasso, Braque, and Miró in their studios for *Harper's Bazaar*; from 1945 to 1965 he contributed regularly to that magazine.

ADOLPHE BRAUN *French, 1811–1877 / Pages 33, 41, 224*
Braun began his career as a designer for a textile firm in the Alsace district for which he produced floral designs taken from photographs. The large albumen prints of

flowers and flower arrangements he made were exhibited at the Exposition Universelle in Paris in 1855, where they were enthusiastically received. So influential were these images and so great the demand for them, that Braun left textile design altogether and set up a large commercial studio in Dornach where he and numerous hired photographic assistants compiled an extensive archive of prints that were to be sold for reference purposes. They included panoramas, reproductions of works of art, tourist views, portraits, and landscapes.

FRANCIS BRUGUIÈRE *American, active England, 1879–1945 / Page 83*
Around 1912, Bruguière began to explore a number of experimental techniques that served greatly to expand the range of imagery available through the photographic medium. In addition to his investigation of multiple exposure, Bruguière is remembered for his remarkable series of photographic abstractions made with light cast on cut paper. Along with the photograms of Man Ray and Moholy-Nagy, these represented a pioneering use of photography in the service of post-cubist vision.

WYNN BULLOCK *American, 1902–1975 / Pages 154, 160*
In the late 1930s, Bullock moved to Los Angeles from his native Chicago and began to study photography at the Los Angeles Art Center School. There, influenced by the work of Moholy-Nagy and Man Ray, he first experimented with solarization. In the following years Bullock supported himself through portraiture and commercial assignments but continued actively to pursue his personal photography, and he became a master of experimental techniques. After meeting Edward Weston in 1948, however, Bullock moved toward a more realistic style, working with a large-format view camera. In the following years, his best-known photographs included many expressive nudes and nature studies.

HARRY CALLAHAN *American, born 1912 / Pages 155, 156*
Callahan is by any reckoning one of the most talented and productive American photographers of this century. In 1946 he accepted an invitation to teach at Chicago's Bauhaus-oriented Institute of Design where he, Aaron Siskind, and Arthur Siegal fashioned a highly successful program of photographic instruction. From 1961 until his retirement from teaching in 1977, Callahan headed the photography department at the Rhode Island School of Design. From the very beginning his work has been marked by an extraordinarily refined sense of line: weeds might be displayed as lyrical calligraphic brushstrokes against the snow, or more angular rhythms perceived in telephone wires criss-crossing against the sky. Callahan has used Eleanor, his wife, as a recurring subject, and she appears in a variety of portraits, nude studies, sculpturesque abstractions, and experimental multiple exposures.

JULIA MARGARET CAMERON *British, 1815–1879 / Page 43*
Julia Margaret Cameron did not take up photography until the age of 48 when she was presented with a camera as a gift from her children. Conscripting friends, family, servants—even passers-by—as subjects for her photographs, Cameron worked exclusively with wet-collodion plates that were sensitized and developed in her own darkroom. For ten years she produced a stream of portraits and costumed tableaux that were strongly influenced by Pre-Raphaelite painting. Many of the towering personalities of Victorian arts, letters, and science were visitors to the Cameron residence, including Sir John Herschel, Alfred Lord Tennyson, and Thomas Carlyle—all photographed by Cameron. She experimented with extreme close-up, suppression of detail, and dramatic lighting that resulted in portraits of novel form and striking psychological intensity.

PAUL CAPONIGRO *American, born 1932 / Pages 152, 158, 159*
After studying music briefly at Boston University, Caponigro became an apprentice commercial photographer. He then served in the army, and subsequently returned to Boston where he worked as a freelance photographer while continuing his photographic studies under Alfred W. Richter and Minor White. Following a one-man exhibition at Eastman House, Caponigro became a consultant in the photo research department of the Polaroid Corporation. In 1966 Caponigro was awarded a Guggenheim grant to portray Ireland's megaliths, dolmens, and other ancient monuments.

ÉTIENNE CARJAT *French, 1828–1906 / Page 8*
A caricaturist, actor, and journalist, Carjat boldly changed professions, and in 1855 he directed a photographic studio in Paris hitched to the fad for cartes-de-visite. His was among the studios that furnished the periodical *Galerie Contemporaine* with portraits of the leading personalities of the day. His naturalistic style is related to that of his contemporary Nadar.

HENRI CARTIER-BRESSON *French, born 1908 / Pages 172, 173*
Cartier-Bresson initially studied with the cubist painter André Lhote. In 1930 he began to photograph seriously, finding in photography a means of drawing that "carves and shapes reality in an instant." He first acquired a 35mm Leica camera in 1933 and quickly developed a method of working almost intuitively with the small camera. Cartier-Bresson is inevitably associated with his notion of the "decisive moment," that split second when all of the visual elements are in temporary equilibrium and which the photographer must be prepared to anticipate and seize. During the 1930s he regularly supplied picture stories to the leading illustrated periodicals of Europe, and in 1947 he was one of the founding members of the Magnum photojournalistic cooperative. But Cartier-Bresson has always insisted that his main interest lies with the single photographic image and its potential for revelation and poetic expression.

PAUL CITROËN *German, born 1896 / Page 91*
At the end of World War I Citroën, along with his acquaintances in the Berlin Dada group, began to experiment with photomontage, a technique he continued to explore during the years 1922–25, when he studied at the Bauhaus in Weimar. There he produced his best-known photomontage, *Metropolis* (1923), a claustrophobic vision of the modern city. Since 1927 Citroën has remained active in painting and photography in The Hague and in Amsterdam, where in 1933 he founded the New Art School, modeled on Bauhaus principles of instruction.

WILLIAM CLIFT *American, born 1944 / Page 192*
Between 1963 and 1975 Clift concentrated on architectural photography in Boston. In 1975 he was among those commissioned by the Seagram Corporation to travel in the Southwest to portray county courthouses. Currently Clift lives in Santa Fe, New Mexico, and has turned to landscapes as his chief subject.

ALVIN LANGDON COBURN *British, 1882–1966 / Page 68*
At age 21 Coburn already enjoyed transatlantic acclaim as an art photographer and was welcomed into the two most prestigious turn-of-the-century photography circles, the Photo Secession and the Linked Ring. His earliest success sprang from his widely admired portraits of British literary personalities such as G.B. Shaw, H.G. Wells, and W.B. Yeats, a series that was published under the title *Men of Mark*. But Coburn proved an equally sympathetic interpreter of landscape and the city. His bold compositional devices—derived equally from the study of Japanese prints and Whistler's work—were considered unorthodox by his contemporaries.

VAN DEREN COKE *American, born 1921 / Page 150*
After establishing a reputation as a creative photographer, Coke became widely known as a photographic scholar, teacher, and curator. In addition to his straightforward black-and-white (and more recently color) photographs, he has frequently employed the expressive technique of flashing his prints quickly to achieve a partial reversion of certain elements in the picture. His subject matter is frequently the dream state, and he has produced manipulated images derived from older, anonymous prints and negatives. Coke's work has been characterized by its frequent incorporation of autobiographical detail and by its meditation on the changes wrought by time.

"CROMER'S AMATEUR" *French, active late 1840s / Pages 23, 25*
This French daguerreotypist, active in the late 1840s, has come to be known as "Cromer's Amateur" because his work was preserved by the pioneer French collector Gabriel Cromer, who sold his approximately 100 daguerreotypes to the George Eastman House, in Rochester, New York. Still lifes, landscapes, and genre scenes are the rarest daguerreotype subjects treated by this unidentified master who had the skill and intelligence of his most famous peers.

IMOGEN CUNNINGHAM *American, 1883–1976 / Pages 138, 139*
During a long and prolific career Imogen Cunningham defied pat categorization. She produced pictorialist nudes and portraits, became one of the founding members of the F/64 Group, created a series of classic studies of plants, did celebrity portraits, commercial assignments, studies of dancers, and experimented with manipulated prints and double exposures.

FRANCIS EDMUND CURREY *British, 1814–1856 / Page 44*
Currey's photographs of game took up a motif common to the painting of his time. To photography's inherently realistic rendering of tone and texture, Currey added his own surprising feeling for both suggestive line and compositional solidity.

EDWARD SHERIFF CURTIS *American, 1868–1952 / Page 69*
In 1896 Curtis embarked on a self-assigned lifetime project to create a visual record of every tribe of North American Indian. He produced the monumental *North American Indian* between 1907 and 1930; it comprises 20 volumes and contains 1500 photogravures. Curtis's immersion in the daily life, customs, costumes, and rituals of his subjects was unrivaled among photographers of Indian life. But his idealizing vision, while sympathetic, has been recently found to lack documentary authenticity because of Curtis's desire to pose and costume his subjects.

SALVADOR DALI *Spanish, born 1904 / Page 137*
GEORGE PLATT LYNES *American, 1907–1955*
GEORGE HOYNINGEN-HUENE *American, born Russia, 1900–1968*
By 1929 Dali began to exhibit his paintings in Paris while at the same time he fashioned an extravagant public personality. His paintings and photographs achieved lucid renderings of wholly fantastic scenes, usually involving the delirious transformation of commonplace objects. "Le surréalisme, c'est moi," proclaimed Dali, whose stated artistic intention was to "systematize confusion and contribute to the total discrediting of the real world."

Platt Lynes's work in the 1930s and 1940s centered on fashion, dance, literature, and artistic personalities. Some of his work employs surrealistic or neo-romantic concepts, and he occasionally worked with artists such as Tchelitchev and Dali.

Hoyningen-Huene was a well-known fashion photographer first in Paris and later in New York. After working in New York for *Harper's Bazaar*, he went to Hollywood where he photographed West Coast celebrities. Much of his work is noted for his sophisticated blend of literature and fantasy, and his ability to utilize props and background to set a theatrical stage for his photographs.

ROBERT DEMACHY *French, 1859–1937 / Pages 60, 61, 66*
As the leader of the French pictorial movement in photography, Demachy was an

effective advocate of the use of manipulated printing, the use of hand-colored water-color papers, and extensive handwork on prints and negatives. In 1894 he was among the first to work in the gum bichromate process, a then-obscure method capable of painterly effects. He decried "hideous glossy paper" and declared that "there can be no art without the intervention of the artist in the making of the picture." In 1906 he abandoned gum bichromate for the oil printing process, and in 1914 gave up photography altogether for sketching.

BARON ADOLF DE MEYER *American, born France, ca. 1868–1946 / Page 74*
By 1895 de Meyer had moved from Dresden, Germany, to London. In 1898 he was elected to the Linked Ring, in whose London salon he subsequently exhibited his photographs. In 1909 he exhibited at the Photo-Secession galleries in New York. By using a special lens that was sharply focused in the center but fell off toward the edges, de Meyer obtained shimmering highlight effects in his prints; occasionally to enhance this ethereal sheen he stretched silk gauze over his lens. At the outbreak of World War I de Meyer went to New York and successfully adapted his urbane style to fashion illustrations for *Vogue*.

FRANTIŠEK DRTIKOL *Czechoslovakian, 1878–1961 / Page 100*
Drtikol first produced distinctive portraits of artists and writers, landscapes, and the views published in *Prague Courts and Backyards* (1911). But he is most often remembered for the remarkable series of female nudes he made over many years. Frequently posing his models in attitudes drawn from the repertoire of modern dance, he made use of strong direct lighting to elicit striking shadows. By the 1930s he began to paint and construct cubistic settings against which to pose his models. In 1935 Drtikol gravitated from photography to painting.

THOMAS EAKINS *American, 1844–1916 / Pages 5, 59*
America's foremost realist painter of the late nineteenth century, Eakins aspired in his art to both scientific realism and psychological depth. His photographs share these same characteristics. Eakins's concern for the scrupulous description of the human figure lent to his photographs of the nude (which were often intended as studies for later paintings) an air of precision and sobriety. His disarmingly candid photographs of his family and friends testify to his lucid and penetrating eye, and they represent a notable departure from his era's prevailing taste for highly embroidered pictorial sentiment.

WILLIAM EGGLESTON *American, born 1939 / Page 200*
In 1962 Eggleston began seriously to pursue photography after an encounter with the work of Cartier-Bresson. Since 1966 he has photographed almost exclusively in color, taking as his subjects his family and friends and his meditations on the architecture, landscape, and vegetation of the Deep South. His images initially suggest the casual immediacy of the snapshot, but they quickly reveal a sensibility attuned to the poetic nuances of the everyday.

PETER HENRY EMERSON *British, born Cuba, 1856–1936 / Page 58*
Emerson strongly rejected the prevailing use of professional models and stilted studio portraiture and championed the idea of a "naturalist" aesthetic. Dispensing with artificial studio settings and combination printing, Emerson demonstrated his approach to photography in his folio *Life and Landscape on the Norfolk Broads* (1886) consisting of 40 actual platinum prints mounted into a book that depicted the land and people of this marshy region. In 1889 he published a treatise entitled *Naturalistic Photography* in which he argued for a photographic aesthetic based both on optical vision (sharp focus on the central object, softer focus on the surrounding area) and on the specific characteristics of the camera image. A year later, however, he published another manifesto, *The Death of Naturalistic Photography*, in which he recanted his earlier position and argued that photography could not aspire to art.

FREDERICK H. EVANS *British, 1853–1943 / Pages 6, 64*
In the 1880s Evans learned photomicrography, for which he was awarded a medal by the Royal Photographic Society in 1887. He began in 1894 what became an extended series of photographic studies of English cathedrals and French châteaux. At a time when many art photographers sought through elaborate processes and considerable handwork to impart to their prints the look of engravings or wash drawings, Evans advocated the careful, straightforward handling of negatives and prints. A meticulous craftsman, he was renowned for the gently lustrous tones he produced in his platinum prints. When platinum paper became unavailable during World War I, Evans ceased photographing.

WALKER EVANS *American, 1903–1975 / Page 124*
Born in St. Louis and raised near Chicago, Evans began to photograph in 1927 after his return from a year in France. Dissatisfied with what he considered the excessive aestheticism of Stieglitz and the commercialism of Steichen—the two most prominent photographers of the day—Evans fashioned what became an influential documentary style, one marked by a luminous clarity and unblinking directness. In 1935 he was hired by Roy Stryker of the Farm Security Administration to join the group of photographers documenting the social and economic effects of the Depression. Although Evans did not always agree with Stryker's policies, he nonetheless produced during this period some of his greatest work, in particular incisive portraits of tenant farmers in the rural South and studies of vernacular architecture.

C. FAMIN *French, active 1860s–1870s / Page 11*
C. Famin, like so many other photographers of the Second Empire, remains a cipher. He is not mentioned in the photographic journals, bulletins, or directories of the

period. His known work consists of collodion negatives and albumen prints, which were deposited for copyright purposes in the Bibliothèque Nationale, Paris. Adding to the mystery of Famin is the stylistic similarity to a body of photographs stamped with the name *A. Quinet* and the subsequent confusion of their work.

ANDREAS FEININGER *American, born France, 1906 / Page 186*
After emigrating to America from Nazi Germany, Feininger became a staff photographer for *Life* magazine from 1943 to 1962, during which time he completed 350 assignments and worked in nearly every genre, including portraiture, landscape, abstraction, and the nude. In structure and feeling Feininger's photographs convey a cool intellectual charge. An unrelenting perfectionist, he has systematically explored virtually every area of photographic technique, from optical experiments employing telephoto or wide-angle lenses, to darkroom manipulations involving extreme contrast, solarization, and negative printing.

ROGER FENTON *British, 1819–1869 / Page 32*
In 1847 Fenton was among a group of British amateurs who formed The Photographic Club, which later became The Royal Photographic Society. In 1854 Fenton went to the Crimea, becoming one of the first photographers of the battlefield. There he produced approximately 360 photographs of encampments and fortifications, as well as images of camp life and portraits of officers and enlisted men. Back in England he occupied himself with a variety of photographic activities, producing stereoscopic pictures, landscape and architectural photographs for travel books, and folios of photographic reproductions of works of art.

LADY FILMER *British, ca. 1840–1903 / Page 49*
Little biographical information is available concerning Lady Filmer, who was active in photography in the 1860s. The hand-colored photograph presented here recalls the strong Victorian tendency to embellish all kinds of everyday images—a process that might go so far as the combination of cut-out photographs and imaginative drawings in family picture albums.

ROBERT FRANK *American, born Switzerland, 1924 / Page 147*
Frank left his native Zurich in 1947 for New York, where he worked for a number of magazines on freelance photographic assignments. In 1955, with the aid of a Guggenheim grant, he began a series of cross-country travels aimed at producing an "authentic contemporary document" of America and its people. Published as *The Americans* in 1959, Frank's grainy, black-and-white photographs conveyed a harsh vision that swung between affirmation and disillusion. His fluid, seemingly intuitive work with the 35mm camera proved immensely influential to the next generation of American photographers, as did his ability to combine intensely personal perspectives with ironic social commentary. After 1960, Frank largely abandoned still photography for filmmaking.

FRANCIS FRITH *British, 1822–1898 / Pages 30, 31*
Frith is one of the earliest and most important topographical and archeological photographers, and his large-plate photographs of Egyptian monuments are landmarks in nineteenth-century photography. He also established the first photographic publishing house that had true commercial success. In 1850 Frith opened a printing firm and began to experiment with photography. Six years later he sold the business and embarked on a photographic expedition to the Middle East where he exposed hundreds of plates using the wet-collodion method. They were exhibited, published, and widely acclaimed. In 1857 he returned to the Middle East, and the photographs taken during that second trip were published in England as *Egypt and Palestine Photographed and Described by Francis Frith*, in which actual photographs were mounted onto a page; the edition ran to 2,000. Further trips to Egypt and Palestine resulted in additional publications with mounted photographs. Frith's establishment remained in business until 1968, specializing in photographic views and postcards of landscape, architecture, and foreign places.

SHINZO FUKUHARA *Japanese, 1883–1948 / Page 71*
With Yasuzo Nojima, Fukuhara was active in the Japanese artists association Kokuga Kai, founded in 1932 to explore concepts of Western art and aesthetics. While most of his associates were attracted to realism or avant-garde experimentalism, Fukuhara took up a more old-fashioned pictorialism. He likened his method to that of Japanese haiku poets who obliquely suggest subject matter rather than presenting it directly.

WILLIAM A. GARNETT *American, born 1916 / Page 157*
During a cross-country flight in 1945 Garnett was suddenly struck with the idea of photographing the American landscape from the air. Piloting his own polished-aluminum single-engine plane, he prospects for suitable subjects on the earth below just as a street photographer must ply the streets for his subjects. As John Szarkowski has written, "Garnett is not a flyer who photographs, but a photographer who flies. His plane's function is to hold his camera in precisely the right spot at precisely the right moment, in order to achieve not a map but a picture." The resulting photographs, many resembling expressionist painting, use as their material the pattern, texture, and color of the land below.

ARNOLD GENTHE *American, born Germany, 1869–1942 / Page 21*
Genthe emigrated from Germany to San Francisco in 1895 to serve as a German tutor to the family of a German businessman. His spare time was occupied with photography that soon turned into a thriving portrait business. He also photographed in the streets with a miniature camera, and San Francisco's Chinatown was a favorite subject. Using a hastily borrowed camera, Genthe recorded the aftermath of the 1906 San

Francisco earthquake and fire. In 1911 Genthe moved to New York and rapidly acquired a reputation as a collector of art and as a talented portraitist. Many celebrated figures of the day, particularly theatrical and screen personalities, found themselves before his camera. In 1926 he began to photograph dancers, and this became for a time Genthe's speciality; his subjects included luminaries such as Pavlova, Isadora Duncan, and Eleanora Duse.

RALPH GIBSON *American, born 1939 / Pages 202, 204*
Gibson studied at the San Francisco Art Institute and worked as an assistant to Dorothea Lange; in 1966 he moved to New York where he became an apprentice to Robert Frank. A period of photojournalistic documentation ultimately led to a subjective, metaphysical approach that yielded dreamlike imagery with a strong surrealist inspiration. The sense of the subconscious unfolding with dreamlike logic is enhanced by its presentation in rigorously ordered sequences in book form.

LAURA GILPIN *American, 1891–1979 / Page 111*
Supporting herself primarily through portraiture and commercial assignments, in 1919 Gilpin began to photograph throughout the Southwest. In 1930 she began a photographic study of the Navajo Indians that continued over many decades and culminated in her book *The Enduring Navajo* (1968). During World War II Gilpin became involved with aerial photography and later, at age 81, she produced a series of photographs of Canyon de Chelly, Arizona, made both from the air and the ground.

EMMET GOWIN *American, born 1941 / Pages 184, 185*
Emmet Gowin, whose work has influenced contemporary art photographers, unites the elegance and formal qualities of the large format negative with the spontaneity and intimacy of the snapshot. Born in Virginia, he has taken many of his best known photographs in that state. Often using as his subject members of his family, especially his wife Edith, Gowin has thereby continued in the tradition of Alfred Stieglitz and Harry Callahan. Gowin studied with Callahan at the Rhode Island School of Design, and presently teaches photography at Princeton University. Regarded as an exceptional craftsman who makes prints of exquisite subtlety, his work also includes landscapes and rephotographed collage in color and black and white.

JAN GROOVER *American, born 1943 / Page 205*
In the mid-1970s Groover's work consisted of multiple color images mounted together, the concern of which is space and time rather than the nominal subjects represented. Complex and formally innovative still lifes of kitchen objects characterized by near monochromatic color combinations replaced the diptych and triptych phase. Her most recent work, starting in 1980, has been done in platinum and palladium and consists of still life, landscape, and studio portraits.

ERNST HAAS *American, born Austria, 1921–1986 / Pages 194, 195*
In Vienna as a student, Haas presented a photographic portfolio in the pictorialist style to Arthur Kubler, the editor of the picture magazine *Du*. Kubler responded by showing him the work of the photojournalist Werner Bischof that deeply influenced Haas's direction. Haas returned to Austria where he photographed the return of Austrian prisoners-of-war, thus launching a career as a photojournalist. In 1950 Haas emigrated to the United States where he became a *Life* magazine staff photographer and a member of the Magnum picture agency. He is best known for his poetic color studies, including special effects of motion and color.

WENZEL AUGUST HABLIK *Czechoslovakian, 1881–1934 / Page 87*
Hablik was educated in Vienna and Prague, where he made his reputation as an architect and fabric designer. In 1909 he participated in the Berlin Secession exhibition, and he worked with Walter Gropius in about 1916–17. The discovery in 1980 of a small but fascinating group of photographs proved Hablik to be a talented photographer.

GINGO HANAWA *Japanese, ?–1957 / Page 101*
Hanawa was an amateur photographer in the city of Osaka. In the late 1920s to the early 1930s, there was a new movement in photography in Japan. In Osaka especially, this new movement was more experimental than in other parts of Japan. Hanawa belonged to an avant-garde photography group whose pictures stressed geometric abstractions and patterns.

DAVID OCTAVIUS HILL
ROBERT ADAMSON
ALEXANDER MCGLASHAN
Hill, a widely-exhibited Scottish painter, in 1843 conceived a monumental painting to commemorate the establishment of the Free Church of Scotland. As an aid in assembling a study collection of likenesses of the nearly 500 ministers to be portrayed, Hill turned to photography—specifically, the calotype process recently invented by Fox Talbot. Hill was introduced to the young photographer Robert Adamson and that summer they collaborated on the portrait photographs for the painting. Soon Hill and Adamson expanded their subject matter to include the inhabitants of Scottish seashore villages, architectural monuments, landscapes, and non-clerical portraits. By the time Adamson died prematurely in 1848, the collaboration had produced some 2500 calotypes. Hill became inactive in photography after Adamson's death and in 1860 collaborated briefly with Alexander McGlashan to produce a portfolio of 15 photographs entitled *Some Contributions Toward the Use of Photography as an Art.*

GÜNTHER HIRSCHEL-PROTSCH *German, active 1920s–1930s / Page 86*
Hirschel-Protsch attended the Bauhaus in the 1920s, and his photographs appeared in some German publications of that era. Little is currently known of his life and work.

DAVID HOCKNEY *British, born 1937 / Page 203*
David Hockney is an artist of international reputation in many media: painting, photography, drawing, and printmaking. Over the last 20 years Hockney has gathered nearly 30,000 machine-processed snapshots into albums. In 1982 he presented an exhibition of what he designated as "camera drawings," mosaics comprised of dozens of 4-inch-square Polaroid prints. Hockney says, "I am not, after all, a photographer. I just happen to take photographs."

EVELYN HOFER
British and Mexican, born Germany, active America, contemporary / Page 201
Evelyn Hofer is best known for her photographs accompanying several classic books on various cities, notably *The Stones of Florence* (1959), *London Perceived* (1962), and *Dublin: A Portrait* (1967). Her carefully composed, direct and precise photographs, taken with a view camera, express notions of decorum, poise, and order. She has done photographic essays as well as studies of architecture and cities.

WILLIAM HENRY JACKSON *American, 1843–1942 / Page 29*
In 1869, while conducting a photographic survey along the route of the Union Pacific Railroad, Jackson was invited by Dr. F.V. Hayden to join his 1870 expedition of the United States Geological Survey. As official photographer for the Survey until 1879, Jackson had the opportunity to photograph many previously unseen natural wonders in the Yellowstone region, in the Grand Tetons, and in the Colorado Rockies. Despite the difficulties involved in transporting his bulky wet-plate equipment (occasionally including 20-by-24-inch glass negatives) to remote areas, Jackson's photographs were successful in helping persuade Congress to set aside the Yellowstone area as a national park. In 1874 Jackson established a photographic studio in Denver, where he specialized in making mammoth landscapes depicting the routes along newly opened railways in the United States, Canada, and Mexico. In 1898, near the end of his career as an active photographer, Jackson moved to Detroit and founded the Detroit Publishing Company to distribute photographs of views from around the world.

LOTTE JACOBI *American, born Germany, 1896 / Page 164*
A fourth-generation photographer whose great-grandfather learned the process directly from Daguerre, Lotte Jacobi in 1929 took over her father's portrait studio in Berlin. Her portrayals of the leading figures of German theater and film won her a reputation as one of the outstanding portraitists of her day. In 1935 she fled Nazi Germany for the United States, and in New York she continued portraiture. In the 1950s she began to experiment with a cameraless technique she called "photogenics." Related to the photograms of Moholy-Nagy and Man Ray, these delicate abstractions were produced by casting light directly on sensitized photographic paper.

GERTRUDE KÄSEBIER *American, 1852–1934 / Page 70*
After studying painting at the Pratt Institute in New York, Käsebier took up photography and in 1897 opened a portrait studio on Fifth Avenue. She brought to commercial portraiture a naturalness and expressive range that set her quite apart from her competitors; after only a few years she was considered one of the leading portrait photographers in the United States. Käsebier was a master of all of the photographic processes popular at the turn of the century, including platinum, gum bichromate, and carbon printing. In 1900 she became the first woman elected to Britain's prestigious Linked Ring and in 1902 was a founding member of the Photo-Secession. A prodigious worker, Käsebier left behind over 100,000 negatives. She said of her sitters, "Each one was for a time the whole world to me. They were in a way my children. I was creating them."

DIANE KEATON *American, born 1946 / Page 19*
In 1980 the actress Diane Keaton first exhibited her recent photographs of hotel interiors, frequently taken in decaying establishments in cities such as Miami and Atlantic City. Keaton's flash-lit photographs of deserted rooms, lobbies, and lounges revealed her nimble visual wit, as well as unaffected taste for what she calls "borderline" environments.

ANDRÉ KERTÉSZ *American, born Hungary, 1894–1985 / Page 143*
Kertész began to photograph in his native Hungary before the First World War. In 1925 he left Budapest for Paris where he worked as a freelance photographer for the European illustrated press. He acquired a Leica in 1927, and became a pioneer in the use of the handheld camera.
While best known for his keen-eyed observations of the commonplace, Kertész produced a rich variety of work, including a series of surreal images made with a funhouse mirror in the 1930s. Active until his death at age 91, Kertész ranks as one of the most important photographers of the century. Weston Naef has written, "When the history of modern photography in Europe is finally written, we shall find that André Kertész is a little like Christopher Columbus, who discovered a new world that, in the end, was named for someone else."

VILEM KRIZ *American, born Czechoslovakia, 1921 / Page 176*
In post-World War II Paris, Kriz became a close friend of the poet Jean Cocteau and developed the surrealistic approach that informed his subsequent photographs. In 1949 Kriz and his family emigrated to California where his poetic, mysterious imagery was out of step with the local F/64 realism.

DOROTHEA LANGE *American, 1895–1965 / Page 119*
Lange studied photography in New York with Arnold Genthe and Clarence White. In 1919 she opened a portrait studio in San Francisco, but in the early 1930s, responding to the social hardships of the Depression, she turned to documentary reportage and

resolved henceforth to "photograph the *now*, rather than the timeless." From 1935 to 1940 Lange photographed throughout the West and South as part of the Farm Security Administration team. Her most celebrated pictures captured what she called "human erosion," in particular the desperate plight of migrant families and the struggles of sharecroppers and tenant farmers in the South. By the late 1930s Lange, like the other Farm Security Administration photographers, broadened her viewpoint to include visual journalism on all segments of American society. In the 1950s she contributed photographic essays to *Life* and other magazines.

CLARENCE JOHN LAUGHLIN *American, 1905–1985 / Pages 128, 142*
Laughlin began to photograph in 1934 and from 1936 to 1940, while employed by the United States Engineer's Office in New Orleans, made over 4000 negatives of ironwork designs, statues, and venerable buildings of that city. In 1940 Laughlin's photographs of New Orleans were exhibited with Atget's of Paris at the Julien Levy Gallery in New York. Laughlin began work in 1946 on *Ghosts Along the Mississippi*, a haunting study of the abandoned plantation architecture of the Deep South. He frequently called upon multiple exposure techniques to invoke the ghostly presence of the past. About his work he has said, "I especially want to make it clear that I am an extreme romanticist."

RENÉ LE BÈGUE *French, active late 19th and early 20th centuries / Page 2*
Along with Robert Demachy, Constant Puyo, and Maurice Bucquet, Le Bègue helped organize the French Photographic Salon in 1894. Like Demachy and many other pictorialists, he employed the gum-bichromate process and engaged in elaborate handwork to impart an artistic effect to his prints. In 1906 examples of his work were exhibited at the Photo-Secession Galleries in New York and represent the most extreme form of anti-naturalist photography to have been shown or collected by Alfred Stieglitz.

GUSTAVE LE GRAY *French, 1820–1882 / Pages 28, 34*
Originally a painter of portraits and landscapes, Le Gray learned the daguerreotype process in the late 1840s and opened a portrait studio in Paris in 1848. He quickly won a reputation as a superb craftsman and a ceaseless experimenter with a wide range of photographic processes that won him a coveted place on the staff of the Commission des Monuments Historiques in 1851. Le Gray is known for four bodies of work: a set of remarkable views of the military exercises staged for Napoleon III at Camp Châlons, seascapes whose actual subjects are light and atmosphere, forest scenes that embody the intimacy of Barbizon painting, and portraiture. His championing of the purely aesthetic merits of the photographic print elicited admiration, but commercial success eluded him.

ALEXANDER LIBERMAN *American, born Russia, 1912 / Pages 170–171*
Born in Kiev, Liberman grew up in Moscow, London, and Paris. In 1932 he joined the staff of the famous French illustrated magazine *Vu*, serving first as art director (furnishing photomontages for the magazine's cover), then as managing editor. While at *Vu* Liberman worked regularly with Cartier-Bresson, Brassaï, and Kertész. In 1941 he fled from occupied France to New York and within two years became *Vogue*'s managing editor. Liberman began his series of photographs of artists' studios in 1948; the project lasted 13 years, during which time he photographed the studios of Picasso, Braque, and Matisse, among many others.

HERBERT LIST *German, active England, 1903–1975 / Pages 120, 121*
After receiving some technical instruction from Andreas Feininger, List advanced from a photography amateur to a professional. A fugitive from Nazi Germany, List fled first to London and then to Paris where his photographs began to appear in *The Studio*, *Verve*, and the French edition of *Vogue*. List's rather abstract still lifes and photographs of Greece have been displayed at the Galerie du Chasseur d'Images in Paris, an exhibition that immediately established his reputation. Influenced by French and Italian surrealism, List's photographs combine elements derived from German new objectivity as well.

MAN RAY *American, active France, 1890–1976 / Pages 18, 82, 109, 112, 165*
After moving to Paris from Philadelphia in 1921, Man Ray began to produce the witty, expressive photograms that he called Rayographs, and in the following years he experimented with a host of creative darkroom techniques, including solarization, reticulation, negative printing, and relief printing. From 1940 to 1951 he lived and worked in Los Angeles, before finally returning to Paris. Like his friend Marcel Duchamp, Man Ray was a self-described "practical dreamer" who delighted in challenging artistic conventions.

ROBERT MAPPLETHORPE *American, born 1946 / Page 187*
Raised in New York, Mapplethorpe received art training at the Pratt Institute between 1963 and 1970 where he studied photography. His roommate was the musician and poet Patti Smith whom Mapplethorpe credits as a strong influence. Still life and erotic subjects dominate the early work. Portraiture of art, fashion, and music personalities soon became central to his work.

ÉTIENNE-JULES MAREY *French, 1830–1904 / Page 15*
In the early 1880s Marey, France's leading scientific authority on animal locomotion, began to introduce a variety of innovative photographic techniques to his investigations. To help solve the enigma of how birds fly, for example, he devised an ingenious camera shaped like a rifle that, with its telephoto lens, could make a series of rapid exposures on revolving photographic plates. Subsequently he pioneered in making multiple exposures of a moving subject sequentially on a single photographic plate.

Some images anticipate a certain strain of twentieth-century modernism. A model in black tights, with a white stripe running down the side from shoulder to ankle, was photographed in sequence of motion on one plate, yielding an astonishing geometric abstraction that resembled a mobile stick figure.

MARGRETHE MATHER *American, 1885–1952 / Page 88*
Mather was already an accomplished photographer in her own right when she met Edward Weston in 1912. For ten years they shared work space in Weston's portrait studio, occasionally producing joint photographs. In her own work Mather concentrated on portraiture and still life; her spare compositions and subtle tonalities suggest more than a passing familiarity with Japanese art.

RALPH EUGENE MEATYARD *American, 1925–1972 / Page 179*
Photographing children, friends, and family in Lexington, Kentucky, Meatyard developed a style wherein everyday life in provincial America became tinged with strangeness and mystery. He created a vernacular surrealism independent of his contemporaries.

RAY K. METZKER *American, born 1931 / Pages 1, 196*
After studying with Aaron Siskind and Harry Callahan in the late 1950s, Metzker created large-scale one-of-a-kind photomosaics during the 1960s that employed a variety of strategies for combining, repeating, or superimposing dozens of images in one composition. More recently, returning to the single print, Metzker began experimenting with the procedure of partially blocking his lens with a piece of paper, thereby creating a variable tonal screen that gives rise to unexpectedly skewed shapes and patterns in the resulting picture—a series he calls "pictus interruptus."

JOEL MEYEROWITZ *American, born 1938 / Pages 190–191*
After working as an advertising art director and designer and collaborating with Robert Frank on a commercial assignment, in 1976 Meyerowitz began to work with a view camera on Cape Cod that resulted in the celebrated work published as *Cape Light* (1978). In it he offered a keenly observed sense of place, a lush chromatic palette, and frequent confrontations of natural and man-made light. In 1977 Meyerowitz began a commissioned series of photographs in downtown St. Louis, published in 1980 as *St. Louis and the Arch*.

DUANE MICHALS *American, born 1932 / Page 207*
Michals first achieved recognition for his inventive photographic sequences of fantastic narratives drawn from dreams, memories, and imagination; frequently he used multiple exposures to heighten the impression of shifting temporal states. Michals now generally works with the single image—incorporating painted images applied directly to the surface of the photographic print. Of his work, Michals says, "I use photography to help me explain my experience to myself.... When you look at my photographs, you are looking at my thoughts."

GJON MILI *American, born Albania, 1904–1984 / Page 169*
In 1937, while employed as a research engineer for Westinghouse Electric Company, Mili met Dr. Harold Edgerton of the Massachusetts Institute of Technology, who had recently invented a powerful electronic flash capable of taking pictures in 1/100,000 second or less. Mili said of the effect of seeing Edgerton's photographs: "They shook me. for the first time, I realized that time could truly be made to stand still." Mili established a studio in New York and became one of the first to specialize in ultra-short duration flash photography; from the late 1930s, his photographs of celebrities in motion appeared regularly in *Life* magazine.

LÁSZLÓ MOHOLY-NAGY *American, born Hungary, 1895–1946 / Page 104*
Moholy-Nagy was trained in law, which he gave up after World War I, to pursue a career in the fine arts. An influential teacher at the Bauhaus, he applied his talent to typography, graphic design, stage design, and photography. Moholy's writings and exhibitions helped fuel the experimental German photography movement of the 1920s; in his most important book, *Painting-Photography-Film* (1925), he proposed that photography was the medium best suited to convey the new sensations of speed and rapid change that characterize modern life. His own photographic works included photomontages, abstract photograms, and camera-produced images that emphasized unusual vantage points, provocative visual textures, and inventive graphic design. After leaving the Bauhaus in 1928, Moholy worked as a freelance designer, photographer, and filmmaker; in 1937, he went to the United States to found the New Bauhaus (later called the Institute of Design) in Chicago.

EADWEARD MUYBRIDGE *American, born England, 1830–1904 / Pages 46–47*
After establishing himself as a successful bookseller in San Francisco, Muybridge in the mid-1860s turned to a new career as a photographer. After apprenticing to C.L. Weed and working for Thomas Houseworth, he quickly made an international reputation for his mammoth photographs of Yosemite (1872). After 1875 Muybridge turned his attention to the photographic analysis of human and animal movement, which inspired Marey. Using a bank of 12 (sometimes 24) cameras, he succeeded in capturing rapid sequential photographs of a galloping horse, thus proving that at a gallop a horse's legs are all simultaneously off the ground at one point in the stride.

NADAR (GASPARD FÉLIX TOURNACHON)*French, 1820–1910 / Page 27*
Nadar must be reckoned not only among the greatest photographers of the nineteenth century, but as one of the great personalities of his age. His incisive and sympathetic portraits of the writers, artists, politicians, intellectuals, and personalities of the Second Empire rank among the highest achievements in photographic portraiture because of his skill at using natural light and natural poses. A journalist and caricaturist, Nadar initially employed photography as an aid to his "Galerie Contemporaine"—a series of caricatures of Parisian notables. In 1854 he opened the first of his photography studios; it prospered as much through Nadar's personal charisma and popularity as it did from the quality of his work. Nadar gloried in experiments; he was among the first to photograph in artificial light, which he employed in his studies of the Paris sewers and

catacombs, and he was the first to make aerial photographs from a balloon. In 1886, with his son Paul, he invented the photo interview, and throughout his long life, produced a stream of books, articles, and essays.

HANS NAMUTH *American, born Germany, 1915 / Page 168*
Hans Namuth left Germany for Paris at the age of 18 and established himself as a freelance photojournalist. Soon he volunteered to photograph the Spanish Civil War for *Vu* and other picture magazines. After World War II he and his family settled in New York, which became the base for assignments around the world for *Life, Look, Paris Match, Fortune, Vogue,* and many other publications. In 1950 he met and photographed the painter Jackson Pollock, eventually publishing a remarkable series of the painter at work in a book entitled *L'Atelier de Jackson Pollock.* In addition to Pollock, Namuth has photographed over 200 other artists, including Franz Kline, Willem de Kooning, Alexander Calder, and Joseph Cornell.

CHARLES NÈGRE *French, 1820–1880 / Page 35*
Trained as a painter, Charles Nègre first began to make daguerreotypes in 1844, but by 1850 he had switched to the calotype, and began an architectural survey of his native Midi district. By the mid-1850s Nègre received a number of official commissions to document Chartres cathedral, the Imperial Asylum at Vincennes, and to photograph works of art in the Louvre. Nègre's goal after 1854 was to develop and perfect a commercially viable way to photomechanically reproduce photographs in printer's ink. He devised a reliable method of transferring the photographic image to copper and steel printing plates that survived in its basic principles until the invention of offset lithography in the early twentieth century.

ARNOLD NEWMAN *American, born 1918 / Page 134*
In 1946 Newman opened his own portrait studio in New York and his portraits were soon sought after by editors of magazines such as *Life, Look, Fortune,* and *Esquire.* The acknowledged twentieth-century master of environmental portraiture, Newman scrutinizes the character of his subjects and then portrays them in environments that reflect directly on their personalities or work. Newman has had the pleasure of seeing many of his portraits become the image by which a particular sitter—Igor Stravinsky, for example—is known to the world.

NICÉPHORE NIÉPCE *French, 1765–1833 / Page 9*
Niépce's interest in lithography led him to investigate ways to copy engravings directly onto printing plates coated with light-sensitive substances. This, in turn, led him to consider the possibility of permanently fixing the image produced in the camera obscura. By 1826, using a polished pewter plate that had been sensitized with bitumen of Judea, Niépce succeeded in obtaining a permanent image of his courtyard. The exposure lasted roughly eight hours, accounting for the fact that the sun seems to shine on both sides of the courtyard. In 1829 Niépce repeated the view on a copper plate and sent it to Daguerre in Paris; the two men formed a partnership aimed at perfecting the photographic process, but Niépce died before this goal was reached. A decade later Daguerre presented to the public a greatly modified process, the daguerreotype.

YASUZO NOJIMA *Japanese, 1889–1964 / Page 132*
The son of a bank president, Nojima possessed the requisite means to open three art galleries and to publish a serious journal of photography. His role in the development of modern Japanese photography has been compared with that played by Alfred Stieglitz in America. In 1926, having encountered the art of the European modernists, Nojima helped establish a Japanese artists' association called the Kokuga Sosaku, which included a photography section. In 1932, Nojima played a leading role in organizing a successor organization, the Kokuga Kai, that reflected the attitudes of the German New Objectivity movement of the previous decade. It called for Japanese photographers to relinquish their attempt to imitate painting and urged that the photographic medium be appreciated for its own unique merits.

B. J. OCHSNER *American, active 1920s / Page 84*
A member of the Pictorialist Photographers of America, Ochsner showed his work regularly in the international photographic salons that sought to keep alive romantic pictorialism long after sharp-focus objectivity had come to dominate the aesthetics of photography.

CAS OORTHUYS *Dutch, 1908–1975 / Page 105*
Forced by the economic conditions of the 1930s to abandon his plans to become an architect, Oorthuys established a design studio in Amsterdam. A designer and a contemporary of Dutch avant-garde artists such as Piet Zwart and Paul Schuitema, he began to incorporate his own photographs into his designs. By 1936 he had turned to photojournalism, and during the Nazi occupation of Amsterdam he was arrested for carrying out surreptitious picture reportage. After the war he reported on the Nuremberg trials and remained active as one of Holland's socially concerned photographers.

TIMOTHY H. O'SULLIVAN *American, ca. 1840–1882 / Page 53*
Timothy O'Sullivan received his early photographic training in Mathew Brady's New York portrait studio, but the training that left the strongest imprint on O'Sullivan was done on Civil War battlefields where he pictured ruins, encampments, and casualties, employing the wet-collodion process he was to utilize throughout his career. Many of his powerful photographs were subsequently to become part of Gardner's *Photographic Sketchbook of the War,* a set of 50 original prints mounted in a limited edition set. In 1867 O'Sullivan became the official photographer for Clarence King's 40th parallel survey, the first government-sponsored survey organized after the war to map and describe the unexplored land west of the Mississippi. O'Sullivan subsequently worked as official photographer for the Darien Survey in Panama, and in 1871 he returned west, this time photographing for Lt. George Wheeler's 100th meridian

geological survey.

PAUL OUTERBRIDGE. JR. *American, 1896–1958 / Pages 96, 97*
In 1921 Outerbridge enrolled at the Clarence White School of Photography, and by the following year began to see his commercial work reproduced in the leading magazines of the day. Outerbridge's specialty was the still life arranged with the Spartan sense that less is more. In 1929 he mastered the costly, laborious carbro color technique, of which he became a virtuoso practitioner. With the publication of his *Photographing in Color* in 1940, Outerbridge was recognized as a leading authority on the subject. Only after his first posthumous exhibition in 1976 were Outerbridge's provocative, often fetishistic studies of the female nude made public.

OLIVIA PARKER *American, born 1941 / Page 198*
An inveterate collector of detritus, Parker began to photograph found objects in evocative still-life arrangements. In 1978 the Polaroid Corporation invited her to work with its new large-format instant print materials. The resulting idiosyncratic combinations of objects and images in boxlike enclosures create an uneasy atmosphere that is both nostalgic and claustrophobic.

GORDON PARKS *American, born 1912 / Pages 174, 175*
A photographer, filmmaker, novelist, poet, and composer, Parks told the story of his early life in *A Choice of Weapons* (1966). He took up photography in 1937 after seeing the work of the Farm Security Administration documentary team; five years later he became the first black photographer to join that group. Parks became a staff photographer for *Life* in 1949 and went on to cover a wide range of subjects for that magazine, including his most celebrated work which focused national attention on the plight of black Americans. More recently Parks has turned to color photographs to reflect his own poetic imagination; the images are frequently accompanied, in fact, by his own poems.

IRVING PENN *American, born 1917 / Pages 162, 163, 181, 206*
A prolific and inventive artist, Penn favors the controlled environment of his studio, using only the simplest equipment and accessories. Penn's early still lifes for *Vogue* relied on the unstudied arrangement of commonplace objects animated by his unerring sense of design. His monumental nudes, dating from 1949–1950, portray the female figure in primordially sculptural terms.

JOHN PFAHL *American, born 1939 / Page 197*
In 1974 Pfahl embarked upon a witty series of unmanipulated color photographs that depict picturesque natural sites into which he has painstakingly laid out his own designs, deploying colored string, foil, tape, or other materials that are like drawings on the land. The "drawings" call to mind a magician's sleight of hand and focus our attention on the issues of truth and illusion in camera art. More recently he has produced a series of photographs that dryly present picturesque vistas framed by the window through which he observes the view.

DAVID PLOWDEN *American, born 1932 / Page 193*
In 1962 Plowden began to create photographic essays dealing with America's rural and urban landscape, and with the changes wrought by an increasingly industrialized society. The author of 13 books, Plowden is currently associate professor at the Institute of Design of the Illinois Institute of Technology.

ELIOT PORTER *American, born 1901 / Page 166*
After having taken his degree in medicine Porter taught biochemistry at Harvard for a decade. An amateur photographer since childhood, he was invited in 1938 to exhibit his photographs at Stieglitz's gallery, An American Place. At the urging of Stieglitz and Ansel Adams, Porter decided to devote his full energies to photography. A 1941 Guggenheim Fellowship to photograph birds in color allowed him to work largely in color when few serious photographers considered color a worthy artistic medium. Natural landscapes and animal life form the subjects of preference for Porter, who says, "…my emotions, instincts, and interests are all with nature." His own meticulous color prints are made by the painstaking dye-transfer process.

WILLIAM LAKE PRICE *British, ca. 1810–1896, active 1850s / Page 37*
A painter and watercolorist who from 1828 to 1852 exhibited regularly at the Royal Academy and the Water Colour Society, Price took up photography in 1854. The next year he attracted wide attention with his carefully worked-up version of Don Quixote, done in the manner of the Royal Academicians. Price followed up this success with a series of photographs conceived as illustrations for *Robinson Crusoe.* He asserted that "If photography is to take a stand as art, those who practice it must qualify to study for artistic requirements." Along with Rejlander and Robinson, Price became one of the best-known British advocates of art photography, delivering influential lectures on the relation of art and photography, and publishing articles notable for offering photographers aesthetic rather than technical instruction.

OSCAR GUSTAVE REJLANDER *Swedish-British, 1813–1875 / Page 36*
Originally a painter, Rejlander learned photography in 1853 and opened a portrait studio in Wolverhampton, England. The difficulty of photographing elaborately staged allegorical scenes with the slow collodion process led Rejlander to pioneer a technique of combination printing in 1855. Using a number of separate negatives, he printed them to form a single complex picture. In 1857 his most famous composition—the allegorical treatment of virtue and vice called "The Two Ways of Life," made from 30 negatives—was first shown, occasioning a public outcry because of what was considered excessive nudity and a too-vivid depiction of the vices. "Hard Times," made three years later, employs a double exposure to suggest the grave night-

time thoughts of a destitute carpenter whose wife and child sleep nearby.

ALBERT RENGER-PATZSCH *German, 1897–1966 / Page 123*
In 1928 Renger-Patzsch published *Die Welt Ist Schön* ("The World Is Beautiful"), which was to be originally called *Die Dinge* ("Things"). This series of photographs of organic and inorganic forms, animals, people, and architecture sought to depict the underlying order—both symbolic and formal—in all manner of natural and man-made objects and in living creatures. Enormously popular and influential in its time, Renger-Patzsch's photography was of signal importance for the New Objectivity developed in Weimar Germany. He continued to publish and exhibit up until the 1960s.

BARON VON STILLFRIED RETINIZ
 Austrian, active Japan, 1871–1885 / Page 57
An Austrian nobleman, Retiniz first came to Japan in 1871 and operated several photographic studios there. Primarily a studio portraitist and a photographer of genre scenes, he was able to complete a series of photographs of Samurai warriors in traditional costume before the Emperor Meiji forbade the wearing of swords and Samurai headdress. Retiniz's legacy to later Japanese photography sprang from his training of a number of Japanese apprentices who went on to establish their own studios.

LOUIS ROBERT *French, 1810–1882 / Page 39*
Early in the 1850s Louis Robert began working with the calotype process, producing photographs of the village of Sèvres and its environs, as well as the parks of St. Cloud and Versailles. A member of the Société Française de la Photographie, he subsequently worked with other photographic processes including wet-collodion plates and albumen negatives. His subjects included portraits, landscapes, and architecture, and throughout his career he conducted numerous experiments dealing with photographic chemistry and photomechanical reproduction.

HENRY PEACH ROBINSON *British, 1830–1901 / Page 51*
Robinson, a bookstore clerk and amateur painter, learned photography in 1852. After seeing Rejlander's "The Two Ways of Life" in 1857, Robinson began to produce elaborate combination prints of a sentimental nature. He felt that for photography to qualify as art, it must go beyond documentation. Robinson became Britain's best-known pictorial photographer of his time, and his 1869 book *Pictorial Effect in Photography*, which applied academic rules of painting to photography, was one of the most widely read photographic treatises of the nineteenth century. Even after technical advances rendered combination printing unnecessary, Robinson's work was marked by his proclivity for genre scenes and Victorian sentimentality.

EMIL SCHULTHESS *Swiss, born 1913 / Page 177*
From 1941 to 1957 Emil Schulthess was the art director of the Swiss picture magazine *Du*, where he began as a photographer in 1942. Schulthess completed major assignments in the United States in 1953–55, followed by a ten-month stint in Africa in 1955–56. These in turn led to other assignments, photo features, and books—largely in color.

CHARLES SHEELER *American, 1883–1965 / Page 79*
Among the first photographs Sheeler exhibited were a number made in 1914 of a home in Doylestown, Pennsylvania, that he shared with the painter-photographer Morton Schamberg. During the 1920s and 1930s Sheeler divided his time between painting in a highly photographic ("precisionist") style and commercial photography for *Vogue* magazine and advertising clients. During this period he also carried out extended photographic studies of the Ford Motor Company River Rouge plant and Chartres cathedral. During the 1940s Sheeler was employed by The Metropolitan Museum of Art to photograph objects in its collection.

STEPHEN SHORE *American, born 1946 / Page 199*
While still in his teens, Stephen Shore made the photographs of Andy Warhol and his studio that were published in the book *Andy Warhol* (1968). His first major solo exhibition of black-and-white photographs was held at The Metropolitan Museum of Art in 1971. In 1973 Shore began to photograph exclusively in color with an 8 x 10 view camera, and in so doing was the leader of a movement away from black-and-white favored by artist-photographers. Shore professes to have been deeply influenced by Walker Evans, with whom he shares a sensitivity to the often ironic interplay of America's indigenous architecture and natural landscape, and for his ability to crowd the picture frame with subtly interacting shapes, patterns, and colors.

AARON SISKIND *American, born 1903 / Pages 146, 148, 149*
Aaron Siskind began his career in photography with a deep social consciousness that led him to be an active member of the New York Film and Photo League. By the time he completed his series on Tabernacle City—a religious community in Bucks County, Pennsylvania—Siskind had begun to gravitate towards a style concerned with form and order. Documentary projects, such as the Harlem Document, were superseded by studies of inorganic objects, rocks, peeling walls, torn posters, etc., in which space was flattened and the image reduced to a play of shapes, tones, and patterns. Siskind's close relationships with several of the abstract-expressionist painters of the New York School reinforced this direction.

W. EUGENE SMITH *American, 1918–1978 / Page 19*
From 1942 to 1945 Smith covered World War II for *Life* magazine. In 1945 he was seriously wounded on Okinawa; after two years' convalescence he returned to *Life* and in the following years completed many of that magazine's best-known picture essays. Driven by feelings of personal responsibility to *Life*'s vast audience and insist-

ing that "superficiality to me is untruth," Smith sought intense emotional involvement with the subjects of his photographs. In 1954 he resigned from *Life* to protest the editor's treatment of his Albert Schweitzer pictures and subsequently joined the Magnum cooperative before turning to freelance assignments. In 1972 Smith spent an extended period in the Japanese fishing village of Minamata, whose inhabitants had been afflicted by mercury poisoning brought on by industrial pollutants. The photographs that resulted focused international attention on the village and its plight.

EDWARD STEICHEN
 American, born Luxemburg, 1879–1973 / Pages 67, 75, 85, 102, 103
Encouraged by Alfred Stieglitz, Steichen emerged as one of the leading figures of the Photo-Secession, making his debut in 1898. A master of a wide array of processes, such as gum-bichromate and platinum printing, he produced landscapes, cityscapes, and portraits that show the pictorial style at its most evocative and compelling. During World War I Steichen commanded a photographic division of the Army Air Services in France. In 1922 he destroyed his remaining paintings and, returning to New York, became chief photographer for *Vogue* and *Vanity Fair* magazines. Until he closed his studio in 1938, Steichen was recognized as one of the leading portrait, fashion, and advertising photographers in America; his brilliant studio technique and pared-down compositions helped shape contemporary practice. From 1947 until his retirement in 1962 he served as Director of the Department of Photography at The Museum of Modern Art, where in 1955 he organized the immensely successful *The Family of Man* exhibition.

ANDRÉ STEINER *Possibly French, active 1930s / Page 108*
No other information is available in the standard references.

ALFRED STIEGLITZ *American, 1864–1946 / Pages 62, 65, 73, 89*
Stieglitz is unquestionably the central figure in the rise of modern art photography in America. As the editor of *Camera Notes* in New York from 1897 to 1902, he waged a successful campaign on behalf of pictorial photography; he was likewise the animating spirit behind the Photo-Secession (1902) and edited its superb publication, *Camera Work*. In the Little Galleries of the Photo-Secession (known as "291"), Stieglitz presented exhibitions by kindred spirits including Edward Steichen, A.L. Coburn, and Clarence White; Cézanne, Picasso, and Matisse were introduced to Americans at Stieglitz's gallery.

The Steerage (1907), Stieglitz's most celebrated single image, combines purely direct photographic rendering with a strong underpinning of abstract form. A decade later he began what was to become an extended, intimate portrait of the painter Georgia O'Keeffe, whom he married in 1924. Stieglitz's photographs of clouds, begun in the 1920s, were originally called "Songs of the Sky"; they inaugurated the idea of the photograph as providing an equivalent for the artist's moods, feelings, and emotions—for Stieglitz, in fact, an evocation of "my philosophy of life."

PAUL STRAND *American, 1890–1976 / Pages 80, 81, 140, 141*
Paul Strand was one of the towering figures in American photography for more than 50 years, and a major force in establishing sharp-focus, nonpictorial photography as the dominant mode of art photography after the First World War. A student of Lewis Hine at the Ethical Culture School, Strand was introduced to Alfred Stieglitz in 1907. After the war, he worked as a motion picture cameraman, collaborating on the short film *Mannahatta* with Charles Sheeler. In the 1930s, he produced a series of photographs of vegetation and other natural forms while continuing to work in films such as *The Plow that Broke the Plains*. After a period photographing in Mexico, Strand returned briefly to films until 1942 when he devoted full time to still photography. In 1946–47, he collaborated on the classic *Time in New England*.

JOSEF SUDEK *Czechoslovakian, 1896–1976 / Pages 92, 151, 183*
During World War I, as a conscript in the Hungarian army, Sudek lost his right arm, thus forcing him to abandon his trade as a bookbinder. He became a professional photographer, training himself even to change film singlehandedly. Sudek's highly romantic sensibility was expressed in lyrical, atmospheric photographs such as the series taken from his Prague studio window. Czechoslovakia's most renowned photographer, he is best known for these window studies, photographs of Prague, still lifes, and landscapes.

WILLIAM HENRY FOX TALBOT *British, 1800–1877 / Page 9*
Frustrated by his inability to sketch exactly scenes from the Italian lake region, Fox Talbot determined to fix the image he sought in the camera obscura. In 1835, exposing writing paper coated with salt and silver nitrate, he obtained the first photographic negatives and prints. He neglected, however, to announce his discovery until 1839, after Daguerre's process had been proclaimed in Paris. In 1844, in order to popularize his improved process, the calotype, Talbot published *The Pencil of Nature*, containing 24 of his own photographs as well as an accompanying text that prophesied many of photography's eventual applications.

VAL TELBERG *American, born Russia, 1910 / Page 136*
In the 1940s Telberg turned from painting to photography, aligning himself with the surrealist painters and avant-garde filmmakers. Telberg uses multiple exposures in the camera or prints from multiple negatives. In 1954, at the request of Anaïs Nin, he entered into a four-year project that culminated in the publication of a special series of his photographs for the 1958 edition of Nin's book *The House of Incest*.

ROLF TIETGENS *American, born Germany, 1911–1984 / Page 133*
With the exception of a brief period spent in film school in Berlin, Tietgens began

as a completely self-taught photographer. In 1933, when he was 22, he traveled through New Mexico and Arizona to photograph the American Indian, which became the 1936 book, *The Rain Drums*. Appalled by conditions in Hitler's Germany, Tietgens immigrated in 1938 to the United States. From the late 1930s through the mid-1960s, he maintained a photographic studio in New York and supported himself primarily through advertising and editorial still-life work for such magazines as *Vogue, Harper's Bazaar,* and *House Beautiful*. During this period Tietgens also undertook numerous personal photographic projects, including a series done at night in Times Square. After closing his studio, he gave up photography and turned to painting.

JERRY N. UELSMANN *American, born 1934 / Pages 188, 189*
Uelsmann coined the phrase "post-visualization" to describe his work that takes its principal form in the darkroom after the negatives have been made. He regards the darkroom as his "visual research lab" for experimentation in multiple-printing techniques, and he employs a number of different negatives and enlargers to achieve his immaculate illusions. Through his unlikely juxtapositions of images, he introduces photographic realism to the realm of the fantastic, seeking "an innermost world of mystery, enigma, and insight."

JULIEN VALLOU DE VILLENEUVE *French, 1795–1866 / Page 10*
Vallou de Villeneuve is best known for his calotypes of nudes or partially draped models. A painter and lithographer before he took up photography, Vallou may have made his studies as artist's aids. Several of his photographs of nudes were used, for example, by Gustave Courbet. A member of the Société Française de Photographie, Vallou's other known work consists of portraits of actors and actresses of the Comédie Française.

HENRI VOLAND *French, active mid-19th century / Page 38*
Almost nothing is known about Henri Voland, whose few known photographs were rediscovered in the Dépôt Légale of the Bibliothèque Nationale. These include a number of startlingly modern-looking nude studies, which may have been made as artist's aids. Additionally, there is a series of stereoscopic views of China deposited in the Bibliothèque Nationale in 1859, which may be by him. Voland's name appears in the photographic revue *La Lumière* in 1860, and he is also cited in the *Gazette des Beaux Arts* of the same year.

ADAM CLARK VROMAN *American, 1856–1916 / Page 55*
A former railroad employee in Illinois, and subsequently a successful bookseller, Vroman photographed actively for only 15 years. In 1895 he attended a Hopi Indian snake dance which proved to be a pivotal experience in his development as a photographer. Overwhelmed by the religious intensity and symbolism of the dance, he returned year after year to observe it. Thus began his commitment to the Indian cause, manifested through photographs, articles, and public lectures. For almost ten years he employed a direct, brilliantly sharp photographic technique that contrasted to his pictorialist contemporaries.

CARLETON E. WATKINS *American, 1829–1916 / Page 52*
After beginning as a studio portrait photographer, Watkins journeyed to Yosemite Valley in 1861 for the first series of western landscapes with which he was to establish his reputation. Returning to the Yosemite wilderness repeatedly through the 1860s and 1870s, he developed a photographic approach that rested on a surprising but convincing perception of classical order and proportion. Having lost his negatives to creditors when his studio failed in the early 1870s, he was forced to rephotograph many landscapes. Even though he had the misfortune of losing the bulk of his prints and negatives in the 1906 San Francisco earthquake and fire, enough examples of Watkins's work survive to establish him as one of the preeminent nineteenth century photographers of the West, and one whose productive life extends over a longer period than that of any of his contemporaries.

WEEGEE *American, born Austria-Hungary, 1900–1968 / Page 145*
Weegee, whose real name was Arthur H. Fellig, emigrated to the United States when he was ten years old. For many years he worked in the darkroom of a picture agency in New York City, photographing by night. He billed himself as "Weegee the Famous"; the name "Weegee" referred to a Ouija board, in tribute to his magical ability to arrive at the scene of a crime almost at the time it was committed (he had a police radio in his car). His subject matter encompassed all aspects of the drama of the city between the 1930s and 1950s, from gruesome aftermath of murder and disaster to the smiles of celebrities. Integral to his style was the power of shock effect, which he achieved by the use of a flash to isolate people in the black landscape of night. After the publication of his book *Naked City* he found himself extremely well-known by the police.

BRETT WESTON *American, born 1911 / Pages 125, 127*
The second son of the photographer Edward Weston, Brett Weston learned photography from his father when he was 14. He soon became an active partner in the Weston portrait studio in Glendale, California. In 1929 a large group of his pictures was included in the *Film und Foto* exhibition in Stuttgart, bringing his work to international attention. After operating his own studio in Santa Barbara for a decade, Weston was drafted in 1941 and, while stationed in New York, photographed that city with a large 11 x 14 camera. During the 1940s he fashioned an unmistakable personal style, one more insistently graphic and pattern-oriented than his father's.

EDWARD WESTON *American, 1886–1958 / Pages 72, 106, 107, 116*
Weston opened a portrait studio in Glendale, California, in 1911 and soon became one of the leading pictorialist photographers in the West. By 1922 he had moved toward a style that combined both sharp-focus realism and an underlying sense of abstract form to emphasize the "aesthetic beauty of the thing itself." After a long interlude in Mexico, Weston returned to California in 1927 and began a series of close-up studies of sculpturesque natural forms; at the same time he began his famous series of the coast at Point Lobos. In 1932 he was a founding member, with Ansel Adams and Imogen Cunningham, of the F/64 group, and in 1937 he received the first Guggenheim Fellowship awarded to a photographer. Weston's credo of pre-visualization—that the finished print should be seen in the mind's eye before the film is exposed—proved enormously influential among younger photographers, as did his insistence on using photography's "heightened sense of reality" to reveal "the vital essence of things."

JOHN WHISTLER *British, 1836–1897 / Page 50*
Whistler was active in the 1840s to 1860s and worked primarily in Dorset, England. Most of his work was done on salt paper prints.

CLARENCE H. WHITE *American, 1871–1925 / Page 63*
White became an active amateur photographer in 1893. By 1898, when he exhibited ten prints in the first Philadelphia Photographic Salon, he had begun to acquire a reputation for his intimate, softly diffused images, often depicting poignant family scenes or allegorical figures. In 1898 White visited Alfred Stieglitz in New York, and four years later figured as one of the founding members of the Photo-Secession. After moving to New York in 1906, he became a lecturer on photography at the Teachers College of Columbia University. In 1914 he founded the Clarence White School of Photography in New York, which for a decade served as a training ground for a number of outstanding young photographers including Paul Outerbridge, Jr., and Margaret Bourke-White.

MINOR WHITE *American, 1908–1976 / Pages 99, 144*
One of the foremost teachers of photography in this century, White worked as a photographer for the Works Progress Administration in Oregon in 1938-39, and after military service in World War II joined the photographic faculty of the California School of Fine Arts in San Francisco. In 1952 he became the founding editor of *Aperture*. White served as assistant curator at the George Eastman House from 1953 to 1956; he taught at the Rochester Institute of Technology from 1955 to 1964; and he was named professor of creative photography at the Massachusetts Institute of Technology in 1965. White extended Stieglitz's notion of the photographic "equivalent" to encompass the search for spontaneous symbols that served to mirror the psyche. His study of esoteric literature—especially the teachings of Gurdjieff, Zen, and the I Ching—led him to favor the use of constantly changing subjects, such as water, ice, and clouds so that the "sensitized mind" of the photographer might seize glimpses of a transcendental realm.

STANISLAW IGNACY WITKIEWICZ *Polish, 1855–1939 / Page 18*
Known in Europe primarily as a dramatist, Witkiewicz pursued multiple goals and interests throughout his life. At age 15 he began an exceptional photographic series devoted to the *Locomotive*. This was followed by a study of his father whom he portrayed through the onset and conclusion of a grim terminal illness. The style prefigured conceptual photography which followed a half century later.

After 1905 Witkiewicz concentrated on self-portraits. Later he was drawn to the human face as ritualized mask, which in turn was related to his fascination with the theater. The volatile eccentricity that Witkiewicz demonstrated in his portraiture, in the end, evolved inexorably into madness, resulting in his suicide in 1939.

PAUL WOLFF *American, born Germany, 1887–1951 / Page 93*
Wolff opened a portrait studio in Frankfurt after World War I, and in 1926 he won a 35mm Leica—then a revolutionary camera—as a prize in an exhibition. He quickly realized the potential of the miniature camera for journalistic and industrial photography. His picture essays were widely published in the German illustrated press of the 1930s, and have been credited with greatly contributing to the acceptance of the Leica style during that decade. A meticulous technician, Wolff developed a procedure for making sharp, virtually grainless prints from 35mm negatives, thus overcoming what had been considered a major limitation of the small-format camera. His pictures aroused so much interest in Germany that in 1934 Wolff brought out the first of many books devoted to Leica photography, *My Experiences with the Leica*. He fled Nazi Germany a few years later, and lived the balance of his life in the United States.

Glossary

ALBUMEN PRINT Albumen printing paper was invented by a Frenchman, Louis Blanquart-Evrard, around 1850. By 1855 it had become the major photographic printing technique, and it remained dominant until the 1890s. The great majority of nineteenth-century photographs were printed on albumen papers. The paper was prepared commercially by coating large sheets with a solution of egg albumen and ammonium or sodium chloride. It was dried, cut into smaller sheets, and sold in this form. Photographers sensitized it themselves by floating the paper, albumen-side-down, in a tray containing a silver nitrate solution. The silver nitrate combined with the chloride in the albumen coating to produce silver chloride, which darkens on exposure to light. After drying the paper, the photographer printed it by contact beneath a negative, exposing it to sunlight. The image appeared during exposure — no development was necessary. It was then toned in a solution of gold chloride and fixed in sodium thiosulfate (hypo). Albumen papers largely replaced plain salted papers, although the latter process remained in limited use because it was inexpensive and could be simply prepared at home or in a studio. Albumen had the advantage of a glossy surface, which could preserve image detail better than the matte surface of salted papers and also made the blacks appear deeper.

AUTOCHROME Introduced by the Lumière brothers in 1907, this was the first commercially successful color process. It produced a positive transparency and was based on the additive color system. Although the theoretical basis of color reproduction had been understood as early as the mid-nineteenth century, color photography had to wait until the invention of panchromatically sensitized silver emulsions — meaning emulsions sensitive to all visible wavelengths, not just to blue light as the earlier "color-blind" emulsions had been. In the Autochrome process a glass plate was first covered with a mixture of starch grains. The mixture was made up of separate grains dyed green, red, and blue. They were transparent enough to act as tiny color filters. A panchromatic, black-and-white emulsion was then coated on top. The plate was exposed through the glass side, so that the light had to pass through the grains. The separate grains allowed only light of their own color to reach the emulsion. The plate was bleached and redeveloped, which resulted in a positive image that could be viewed by placing a light behind. In the white parts of the image, light passed through all three types of starch grains, combining to give the illusion of white. No light passed through in the shadows. The other colors were produced by a combination of red, green, and blue, passing through in various proportions. Because the grains were so tiny, the colors blended together. Autochrome images were somewhat grainy, and the colors soft and pastel-like in quality. Autochrome plates were used until the 1930s, when the much superior Kodachrome process became available.

CALOTYPE Invented by William Henry Fox Talbot in 1840, the calotype was the first practical method for making photographic negatives based on the principle that certain salts of silver are sensitive to light and darken when exposed. Talbot first brushed a solution of silver nitrate over a sheet of paper, then dipped the paper in potassium iodide. It could be stored in this form until needed. Talbot sensitized the paper by brushing over a solution of silver nitrate and gallic acid. He placed it in the camera for exposure, then developed it by again brushing on the silver nitrate/gallic acid solution. He fixed it in sodium thiosulfate (hypo). To make this fairly dense paper negative more transparent, Talbot applied a coating of wax. He made prints from the negative using the salted paper process he invented in 1834. Because of the texture of the paper, prints from calotype negatives did not have the minute detail possible with the daguerreotype, the rival process at the time. But the calotype had a great advantage over the daguerreotype in that any number of prints could be made. The calotype was supplanted in the early 1850s by the wet-plate negative. Since it used a glass support instead of paper, the wet plate could better retain image details.

CIBACHROME This modern process makes color prints directly from color slides. Cibachrome is one of the simplest color printing methods yet devised. The paper contains three silver-halide emulsions, sensitized one each to red, green, and blue light. The appropriate image dye of the complementary color is incorporated in each emulsion. Cibachrome is a dye-destruct process — dye is removed from the emulsion wherever the silver halide is exposed. After exposure the image is developed, bleached, and fixed.

DAGUERREOTYPE The announcement of Louis Jacques Mandé Daguerre's revolutionary process came in January 1839. It was the first time the public learned of photography. Daguerre had begun his experiments around 1826, and four years later formed a partnership with Joseph Nicéphore Niépce, another early experimenter. Following up on one of Niépce's discoveries, Daguerre found that an iodized silver plate, exposed to light, would produce an image if developed with mercury fumes. The daguerreotype process involved first sensitizing a silver-coated copper plate by placing it in a box filled with iodine vapor. This created light-sensitive silver iodide. After exposure in a camera, the plate was developed in another box containing mercury, which was heated until it vaporized. The resulting positive image was then toned in a solution of gold chloride and fixed in sodium thiosulfate (hypo). Because there was no negative, each daguerreotype was a one-of-a-kind image and, like the image in a mirror, was reversed from left to right.

DYE TRANSFER Eastman Kodak introduced this color printing process in 1946 as a method for making color prints from color transparencies. Three color separation negatives are first made from the transparency and each negative is printed on a sheet of gelatin-coated matrix film. The matrices are developed in hot water, which removes the gelatin from the unexposed areas. The result is a gelatin relief, higher in the shadows than in the highlights. The reliefs are soaked one each in solutions of cyan, magenta, and yellow dyes. They absorb their respective dyes in proportion to the thickness of the gelatin. Then the matrix images are transferred successively, in registration, onto a sheet of dye-transfer paper to make the final positive print. The gelatin itself does not transfer, only the dyes, and because of this the matrices can be used repeatedly to make additional prints.

FRESSON Théodore-Henri Fresson introduced this process around 1900. It was an improved version of a printing method first marketed by Victor Artigue in 1893, called *Charbon Velour*. The exact details of the Fresson process have remained secret, but the paper apparently consisted of a layer of fairly hard colloid (consisting of gelatin and possibly other substances) over which was coated a softer colloid containing finely ground pigment. The paper was sensitized in potassium dichromate and printed by contact under a negative. Exposure hardened the colloid, and the image was developed by pouring a mixture of water and fine sawdust over its surface. This treatment removed the unexposed colloid and its pigment, leaving the image behind. The process was much like gum printing, except that it allowed a much deeper black than usually possible through a single application of gum, and the photographer had to purchase the paper rather than make it by hand.

GELATIN SILVER A general term for photographic printing papers containing light-sensitive silver chloride or silver bromide in a gelatin emulsion. Papers of this type first became available in the 1870s and are still in use. Before their introduction, most photographic printing was done on albumen papers. The various gelatin silver papers were superior to albumen in that they came ready to use (photographers first had to sensitize albumen paper themselves before printing), were far more sensitive to light, and were available in different contrast grades to suit different negatives. They made printing and enlarging with artificial light practical.

GUM PLATINUM This is a combination process in which the image is first printed on platinum paper and processed in the normal manner. Then a gum printing solution is applied over the platinum image. The original negative is placed in registration with the image and the gum coating exposed and developed as described below under Gum Print. The result is a gum print over a platinum print. By itself, the platinum process is not capable of a truly deep black. By superimposing a gum print, a much deeper black is possible. A gum print, on the other hand, often fails to show the fine details in an image; but a platinum print can. Thus, if the photographer wishes, gum platinum can combine the virtues of both processes in a single print. The gum printing can also add color to the platinum image. Gum printing was also done over silver bromide prints. The only restriction was that the bromide print had to have a matte surface; otherwise the gum solution would not stick.

GUM PRINT *also* **GUM BICHROMATE** Alphonse Louis Poitevin patented the first gum printing process in 1855. It was based on a discovery made in 1839 that paper coated with potassium dichromate (then called *bi*chromate) darkens on exposure to light. About 1852, William Henry Fox Talbot, the inventor of the calotype process, had found that when a water-soluble colloid such as gum arabic or gelatin was mixed with potassium dichromate and exposed to light, the colloid became hardened and insoluble in all except very hot water. Building on this, Poitevin coated paper with a solution of gum arabic, finely ground pigment, and dichromate, and exposed it to sunlight beneath a negative. In the shadow areas the colloid became completely insoluble, but it remained soluble in the highlights and partly soluble in the middle tones. He then developed it in a tray of water. The soluble gum dissolved in the water, carrying the pigment with it. In the exposed parts the pigment remained on the paper, forming the image. One disadvantage of the process was that the image was less sharp and the tonal scale less accurate than was possible on the then-popular albumen paper. One important advantage was that pigments could be chosen that were far more permanent than the silver in an albumen print. The gum process was largely forgotten until the 1890s when it was revived by pictorial photographers, who found it especially useful for creating effects resembling those in Impressionist paintings. One of their methods was to develop the image locally with a brush or a stream of water to modify the tones or eliminate unwanted details. It was also possible to recoat the dry image with a gum solution of the same or a different color and print it again in registration under the negative. This deepened the tonal scale, adding rich shadows, and also allowed color effects to be introduced into the image.

HELIOGRAPHY This was the technique used to produce the first permanent photographic image. Its inventor was Joseph Nicéphore Niépce, who began experimenting with light-sensitive substances while looking for a way to prepare lithographic plates without having to draw them. Around 1822, Niépce discovered that an asphalt known as bitumen of Judea, which is normally soluble in oil of lavender and turpentine, becomes insoluble after exposure to light. The bitumen forms a light-colored deposit. Niépce made the world's first photograph in 1826 by spreading a bitumen coating on a pewter plate and exposing it in a primitive camera for about eight hours. He dissolved away the unexposed bitumen in his oil of lavender and turpentine solution. The insoluble bitumen left behind represented the light parts of the scene, while the dark pewter represented the shadows. The major drawback of Niépce's process was the long exposure necessary—much longer than required by the silver-halide processes that ultimately replaced it.

HICRO COLOR Frederic E. Ives put his Hicro color camera on the market in 1915. The camera produced a set of color-separation negatives directly from the subject, exposing its three glass-plate negatives through their appropriate filters simultaneously rather than one at a time—the more typical case with early three-color cameras. The separation negative taken through the red filter was printed on blue-print paper (cyanotype) and the other two negatives on special transparent films of dichromated gelatin. After exposure and processing in warm water to remove the unaffected gelatin, the film made under the green-filter negative was dyed magenta and the film made under the blue-filter negative was dyed yellow. In each case only the gelatin recording the image absorbed the dye. The two films were then superimposed over the blue print and cemented in place to form a full-color image.

OIL AND BROMOIL The oil process was introduced in 1904 by a pictorial photographer named G. E. H. Rawlins. Rawlins based it on the collotype process, a technique that takes advantage of the repulsion between water and greasy inks. Paper for oil printing was coated with gelatin sensitized with potassium dichromate and printed by contact under a negative. Exposure hardened the gelatin in proportion to the light passed through. Afterwards, the paper was allowed to soak in a tray of warm water, which caused the unhardened gelatin to swell. Its surface was then wiped dry and a greasy ink dabbed over it with a brush or applied with a roller. The ink took to the dry shadows but not to the water-swollen parts. By varying the action of the brush or roller or the consistency of the ink, it was possible to control the tonal scale and subtract details or even draw them in. Inks of different colors could also be used. The process had two important modifications. One was *bromoil*, in which a standard gelatin-emulsion silver bromide print was treated in a special bath that bleached out the silver image while hardening the gelatin in the same manner as on an oil print. It could then be inked in the same way. The second modification was the *transfer* process, in which an inked oil or bromoil print was placed in contact with a plain sheet of paper and sent through a press. This caused the ink to transfer to the sheet. The original print could then be re-inked and printed again on a separate sheet, or printed in registration on the first sheet in order to build up image density or add a new color.

PALLADIUM PRINT The sensitizing and printing procedures for palladium are virtually identical to those for platinum. Palladium is a slightly less expensive metal and gives permanent brown-tone prints in a plain oxalate developer, used cold.

PHOTOCOLLAGE AND PHOTOMONTAGE A photocollage is made up of multiple images, each printed on a separate sheet of paper and then glued or otherwise assembled on a common support. A photomontage is made by printing several images on the same sheet of paper, giving the paper a series of exposures with different negatives. During each exposure the paper is protected by masks so that only the intended area is affected. Photocollage and montage techniques came into practice as early as 1850. The montage technique was often used to add clouds to landscape scenes.

PHOTOGRAVURE Karl Klic, a Viennese printer, introduced photogravure in 1879. It wasn't entirely Klic's invention—he based it on principles laid down in the early 1850s by William Henry Fox Talbot (the inventor of salted paper and the calotype, in addition to an early form of photogravure called *photoglyphy*). The process involves first dusting a copper plate with resin and melting the resin with heat to produce a grain pattern. Next, a sheet of gelatin-coated paper, sensitized with potassium dichromate, is exposed to light under a transparent positive. The paper is then soaked in water and laid gelatin-side-down over the grained surface of the plate. The paper backing is stripped off and the gelatin, now attached to the plate, is developed in warm water. The unexposed gelatin dissolves, leaving behind a layer of exposed gelatin that is thicker in the highlights than in the shadows. After the gelatin dries, the plate goes into an etching bath consisting of ferric chloride. This penetrates the gelatin and begins to dissolve the copper in the open spaces between the resin grains. In the shadow areas, where the gelatin layer is thin, the ferric chloride quickly penetrates to the copper and begins to etch. It takes longer to penetrate in the highlights, where the gelatin is thick. As a result, tiny pits are etched into the plate—the shadow pits starting sooner and thus being etched more deeply than those in the highlights. After the gelatin and resin grain are removed, the plate is ready for printing. The printer warms the plate, spreads

etching ink over its surface, then wipes it with a rag. The rag forces the ink into the pits but removes it from the unetched surface of the plate. A sheet of paper goes on top and the plate and paper pass through an etching press to transfer the ink. The shadow pits, being the deepest, hold the most ink and print darkest.

PLATINUM PRINT The platinum process was a favorite of pictorial photographers around the turn of the century because of its beautifully soft, delicate tonal scale and matte surface. Platinum prints were regarded as more artistic in appearance than prints on glossy albumen or silver papers. Although commercial production of platinum paper ended in the 1930s, it can easily be made by hand and is still used by photographers who prepare it themselves. The platinum process was first patented by William Willis in 1873. It is based on the light-sensitivity of ferric (iron) salts. The paper is coated with ferric oxalate and potassium chloroplatinite and contact-printed in sunlight or under an ultraviolet lamp. Exposure reduces the ferric salts to the ferrous state. Development in a solution of potassium oxalate in turn causes the ferrous salts to reduce the platinum to the metallic state. The unreduced platinum and unexposed ferric salts are removed from the print in a bath of dilute hydrochloric acid. The result is an image in metallic platinum, an extremely stable material. Platinum prints have the important advantage of being considerably more permanent than photographic prints containing silver.

POLACOLOR The first instant color film, Polacolor was introduced by the Polaroid Corporation in 1963. It consists of a negative with three light-sensitive layers. The layers are sensitized one each to red, green, and blue light, and each layer incorporates a dye developer of the complementary color. After exposure, the negative is placed in contact with a special image-receiving sheet. At one end of the sheet is a foil pod containing the processing reagent. The negative and receiving sheets are pulled together between metal rollers. Pressure from the rollers ruptures the pod and forces the reagent to spread in an extremely thin layer between the two surfaces. The dyes then migrate from the negative to the receiving sheet. After 60 seconds the two are peeled apart, revealing the image. In Polaroid's SX-70 system (introduced in 1972) the negative and receiving layers are contained in one completely enclosed unit. Processing is timed chemically and the color image does not have to be peeled open.

SALT PRINT Invented by William Henry Fox Talbot in 1834, this was the first truly successful photographic printing method. Talbot coated a sheet of paper with common salt (sodium chloride), then brushed it over with a solution of silver nitrate. The two chemicals combined to form silver chloride, a substance that darkens spontaneously on exposure to light. The photosensitivity of silver chloride had been known before Talbot's time, and others had experimented along the same lines, but Talbot discovered that its sensitivity could be greatly increased if prepared using an excess amount of silver nitrate, so that some silver nitrate was left over after the reaction forming silver chloride. He also discovered that he could fix the exposed image, so that it could be viewed in the light without continuing to darken, by washing it in a solution of common salt, thus reversing the nitrate/chloride balance. This crucial fixing method had eluded the earlier experimenters. Even so, Talbot did not reveal his discoveries until January 1839, prompted only by the announcement of the daguerreotype. Salted paper was popular from the 1840s through the 1860s as a printing paper for both calotype and wet-plate negatives. It was sensitized by the photographer, printed by contact in sunlight until the image had fully appeared, then fixed in sodium thiosulfate (hypo) — which had been found to do a better fixing job than salt. Sometimes the image was toned using gold chloride, before the fixing bath. Albumen paper began to replace salted paper beginning in the 1850s, but the process was revived for a time by pictorialist photographers in the 1890s.

SILVER BROMIDE AND CHLOROBROMIDE Papers containing silver bromide in a gelatin emulsion were introduced in the 1870s and are still in use. Silver bromide is extremely sensitive to light, and so papers of this type are most often used for enlarging. The image color is usually black but can be modified by changing the developer formula or through toning baths. Chlorobromide papers contain silver chloride in addition to silver bromide. They are usually less sensitive than bromide papers and produce an image browner in tone.

SOLARIZATION AND SABATTIER EFFECT These terms are often misused. The Sabattier effect occurs when a partially developed negative or print is briefly exposed to light, while still in the developer. The result is partial or complete reversal of tones in the image — light tones become dark and darks light. This happens because the areas of original exposure are desensitized when development begins and are not affected by the second exposure. But the areas originally unexposed are affected and they quickly darken, reversing the normal tones. Solarization is also a reversal of image tones, but one that occurs as the result of prolonged exposure or exposure to an extremely bright light. It is not the result of exposure during development, although the term is often mistakenly used this way.

STEREOGRAPH Stereoscopic cameras have two lenses, usually placed about 2½ inches apart, the same distance apart as the human eyes. The camera makes two simultaneous exposures. After printing and mounting, the images are placed in a viewer to recreate the illusion of three dimensions. If the taking lenses are placed further apart than 2½ inches, the illusion of depth becomes greater than normal. Stereoscopic photographs can also be taken with standard, single-lens cameras by making two exposures. Between exposures the camera is shifted a few inches to the side. The first stereoscopic photographs were probably made in 1842, but the technique only caught on in the 1850s, after the introduction of the wet-plate negative and albumen print. Then it became the rage. Millions of stereoscopic photographs were sold during the 1850s alone. Apart from the illusion of three dimensions, stereoscopic photography is important historically as the first photographic medium used for widespread distribution of photographic images from all over the world. In the nineteenth century, if you wanted to know what a distant place was like, you either traveled there or looked at a stereo photograph.

THREE-COLOR CARBRO The carbro process first came into use around 1919. Based on the much older carbon process (1866), it involved making a bromide print, sensitizing a sheet of carbon pigment tissue in a special bath, and pressing the bromide in face-to-face contact with the tissue. A chemical reaction took place that hardened the gelatin on the tissue, creating an image exactly corresponding to that on the bromide print. The tissue was then stripped from the bromide, the pigmented gelatin transferred to a final support, and the image developed in warm water. In the three-color carbro process three bromide prints were made from color separation negatives and used to treat cyan, magenta, and yellow tissues. The three separate images were developed and then placed in registration to make a full-color print. Three-color carbro was one of the first commercially practical color printing methods, and was used extensively during the 1930s and 1940s.

TYPE-C PRINT Type C is the general name for the various color printing papers used with color negatives. Type-C paper contains three separate emulsions, one sensitive to blue, one to green, and one to red light. Each emulsion also contains color-couplers that form dyes when the exposed silver is developed. After development, the silver is bleached in an acid bath, leaving only the dye image behind.

WET PLATE Invented by Frederick Scott Archer in 1851, the wet-plate, or collodion process, was the most popular method of negative making until the introduction of the gelatin dry plate in the 1880s. The photographer first coated a sheet of glass with collodion mixed with potassium iodide. The collodion formed a clear film. Next, he sensitized the plate by dipping it in a bath of silver nitrate, placed it in the camera for exposure, and afterwards developed the image in ferrous sulfate and fixed it in sodium thiosulfate (hypo). The process got its name from the fact that all of this had to be done while the collodion remained moist; otherwise the plate lost its sensitivity. Collodion negatives were usually printed on albumen paper.

WOODBURYTYPE In this photomechanical process the image was printed from a lead mold. Its inventor was Walter B. Woodbury, who patented the earliest version in 1864. The technique remained in use through the 1890s and was praised for its beautiful results. Woodbury first covered a sheet of glass with a thin layer of collodion (the same material used in the wet-plate process, but minus the sensitizing ingredients). Over the collodion, he applied a gelatin solution, sensitized with potassium dichromate. Next, he stripped the collodion/gelatin film from the glass and exposed it with the collodion side in contact with a negative. The gelatin became hardened as a result of the exposure. Since the exposure was through the collodion, the hardening started at the base of the gelatin and worked its way out to the gelatin's surface. Technically, this was an essential point. Then Woodbury developed the image in hot water, dissolving the unhardened gelatin while the hardened gelatin remained in place. The result was a continuous-tone relief image in which the shadows were physically higher than the highlights, with the middle tones in between. After letting it dry, Woodbury placed the gelatin relief on top of a soft lead plate in a hydraulic press and pressed it into the plate under a pressure of about five tons per square inch. The gelatin was tough enough to withstand this pressure and cause the plate to be indented according to the contours of the image. When the gelatin was finally stripped away, the result was a lead intaglio mold. The mold was deepest in the shadows (about 0.13 mm or 0.005 inch), less deep in the middle tones and highlights. For printing, the interior of the mold was first lightly greased and then a small amount of warm, pigmented gelatin poured into its center. A smooth sheet of paper was placed on top and pressed down with a metal platen. This forced the gelatin to spread through the mold. After about a minute, when the gelatin had cooled and set, the paper could be stripped away, carrying the gelatin image with it.